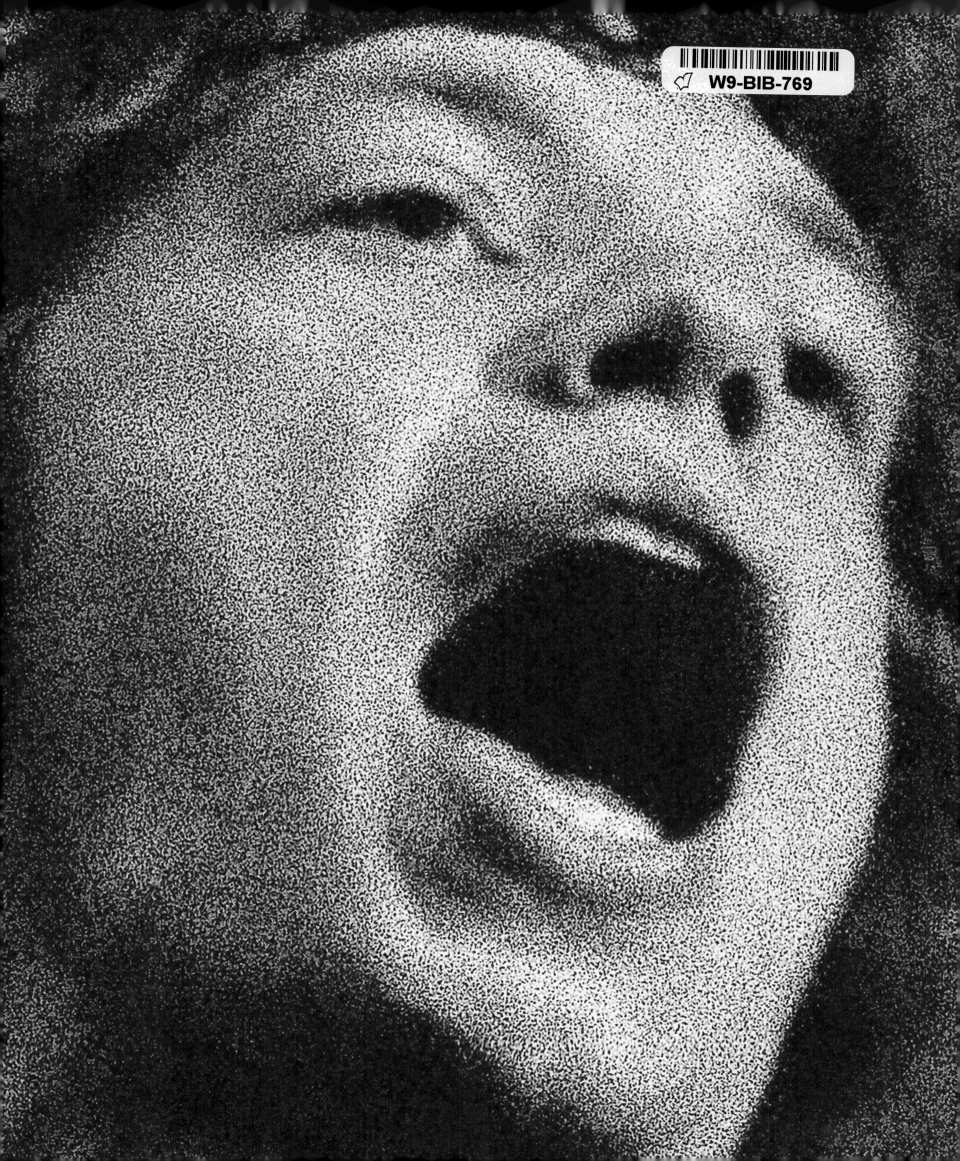

THE ROLLING STONES

in the beginning

THE ROLLING STONES
in the beginning

Bent Rej

Foreword by Bill Wyman

FIREFLY BOOKS

CONTENTS

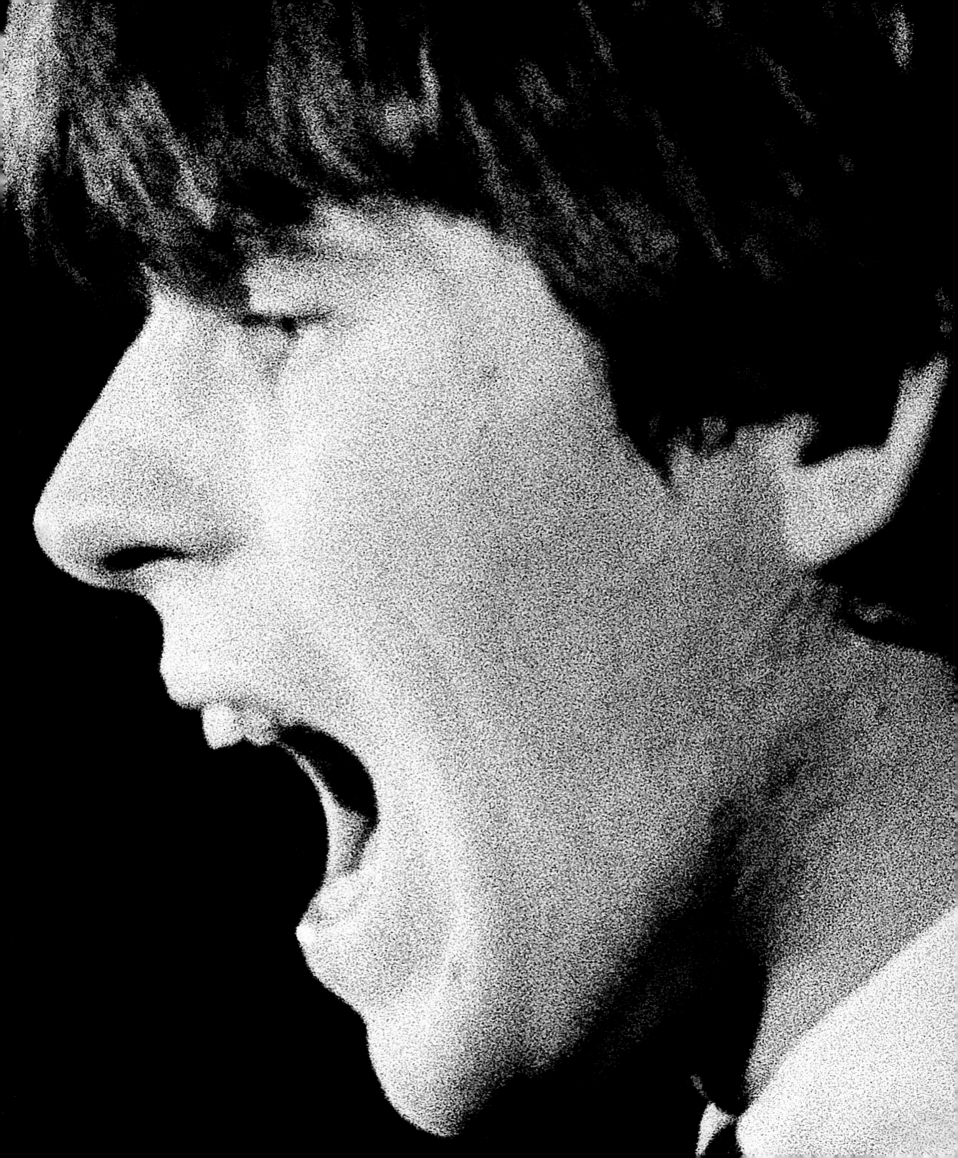

FOREWORD by Bill Wyman

When the Danish photographer, Bent Rej, first showed me his collection of photographs of The Rolling Stones, taken between Spring 1965 and early Summer 1966, I was amazed. I had no idea that he had taken so many, nor had I point of reference for the scope of the collection. No photographer up to this point in our career, or since for that matter, has had the access to the Stones that Bent had. He was right there, on the spot, at a crucial period in our career, and in our lives like no other photographer before or since. It's this closeness that makes what Bent has done unique.

Some may say what's all the fuss about? It's just a collection of photographs about a group, and one that's been photographed much more than most at that. This, of course, is true, but like most things in life that seem to go right, it's all about timing. Bent was there when we were a group in transition. When he took his first photos of us in March 1965 we had been together for a little over two years. We were already a very big group, we had toured America, we had topped the charts and we had caused outrage among an older generation unable to get to grips with what we were all about. We were also beginning to appreciate how very big we could become. But at the time we were just enjoying ourselves and not thinking too hard about how long it might last.

Initially, like almost every other group, including The Beatles, we covered a lot of songs written by other people. By March 1965, Mick and Keith had written their first No.1 and by the time Bent stopped taking pictures of us regularly they had become a songwriting force that, if not quite a match for John and Paul, was at least able to establish us as a band that had potential staying power. But, having said that, the Stones were not just about writing songs that could both sell and last – we were much more than that – the Stones were a band that had something that no other band has been able to come close to competing with. As a live band able to excite and captivate an audience there have been few bands that have come close.

Bent's pictures have helped me to see what it was like to go from being a group with the potential to succeed to one that absolutely knew that it would. We were never short of self-belief, always sure of success, but somehow you never quite know that you have succeeded until just after you have. If you compare how we were in the opening pages of the book to what we had become by the end you can visibly see the change. It wasn't just because we had won awards, had No.1s, filled concert halls, and caused riots – although all that helps – it's the mystical quality that comes when you go from being fairly popular to becoming world-wide stars.

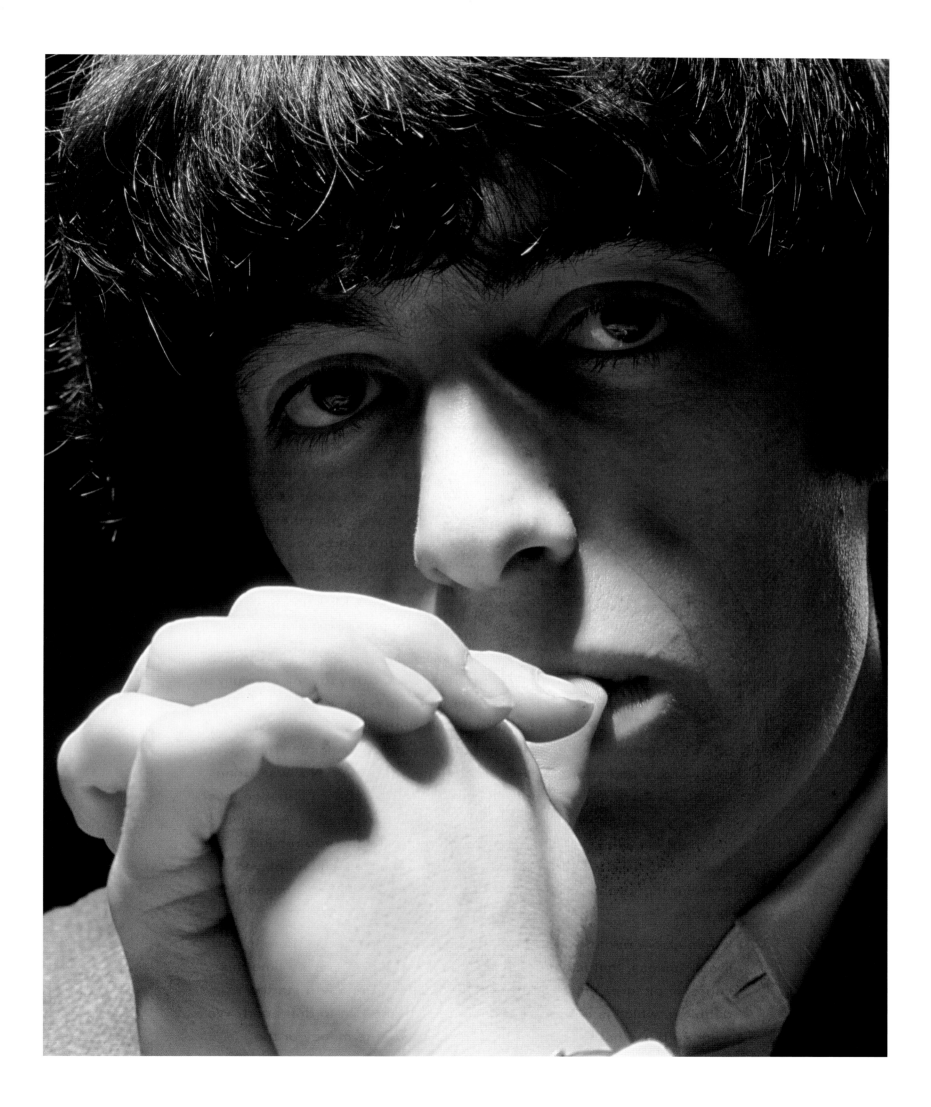

Bent's particular genius as a photographer (he is now more famous for his landscapes and flower photography) springs from his ability to cover so many disciplines and styles: he captured us "off duty", and off our guard; he could produce publicity shots and formal portraits; and, amazingly, he could capture the rough-edged excitement and movement of the Stones whether in performance, or simply fleeing from our fans. When his pictures look "posed" that's because they usually were, but even these, it seems to me now, have an innocent self-consciousness. Above all the sheer quality of the photography shines through — many look as if they were shot only yesterday.

What do I remember of those times? Well I remember them as being bloody hard work, but at the same time they were bloody good fun. We were very much a band at this point in time, and although the cracks

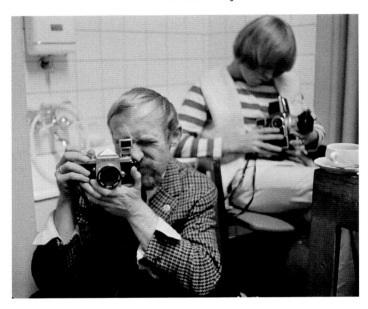

with Brian had begun to appear, they were not immediately recognizable as the critical fissures that would almost bring us to the point of breaking up. Up until this moment we were as much Brian's band as we were Mick and Keith's. It was Brian that formed the Stones, named us, and chose much of what we played in the early days. It was, of course, true that Mick as the lead singer took an increasing amount of the limelight but, in the days when style and "look" mattered, it was Brian that gave us the edge in that particular race. If you look carefully at the shots of Brian as you move on through the book, you can see how much he started to create a look with his clothes and hairstyle that other bands began to emulate on both sides of the Atlantic. There were no sweaters and sports jackets or cardigans for Brian. Nor was Brian any handicap to us in the musical sense. He was able to enhance much of what we recorded with his musicality. I am pleased that Bent also captured Ian Stewart, "Stu", in a typical pose. It serves to remind everyone that he was an integral part of the band in which I played bass for thirty years. Stu died in 1985, and he is still sadly missed by all of us.

It was also a period when drugs had not begun to be a feature in our lives — unless, that is, you count "Scotch-and-Coke". By the time this series of pictures finish, in the middle of 1966, Brian had started dabbling, which is in part what caused Bent and him to drift apart. We were so busy that we had no time, nor had we the money or the

opportunity. What you see from these pictures is a band that is going places, that had suddenly begun to earn the kind of money that everyone thought we had been getting for years. We were able to buy good houses, great cars, and as Keith said at the time, we were able to eat in places that our fans couldn't afford to. Bent has captured the moment, and captured it brilliantly. The fact that these photographs have, for the most part, lain dormant for the last forty years, while Bent got on with his career and we got on with ours, is in itself remarkable.

Somebody once said The Rolling Stones were the most photographed people on the planet – possibly true, but this is an hitherto unrevealed treasure trove. And it is a great pleasure to be able to offer some opening remarks by way of introduction to what I believe is the finest single collection of Stones photographs that I have ever seen.

I know I will cherish this "phototrack" to our early career and, in years to come, I hope my daughters, who are all very young, will be able to look through this book to get some idea of what their Dad's life as a Rolling Stone in the mid-Sixties was all about. I can think of no better way for them to find out.

Bill Wyman
Chelsea, May 2006

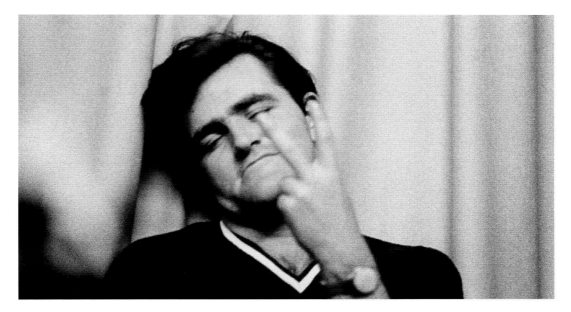

Ian "Stu" Stewart.

INTRODUCTION by Bent Rej

I was born in 1940, and at sixteen I began studying photography. In 1960 I started working for Ekstra Bladet, one of Denmark's leading newspapers, taking sport, showbiz, and crime pictures; you had to be an all-rounder. After two years I went freelance and went into fashion photography; I also took celebrity pictures and photographs of the Danish royal family. By late 1964 I started taking pictures of pop stars that were visiting Denmark — my first subjects were The Beatles.

When The Rolling Stones arrived I was in the right place at the right time. I saw immediately that these five individuals were different from the other groups. The Scandinavian promoters were friends of mine and so I was introduced to them and travelled with them throughout Scandinavia. I quickly developed a close relationship with the band, and especially Brian who became a close friend to my wife and me. He would spend time with us in Copenhagen, where he could recover and enjoy good home cooking.

Between sessions with the Stones I shot other groups — new names like The Who, Cream, and Jimi Hendrix. Brian would tell me those worth photographing. When the Stones toured Germany in September 1965, the sponsor, Bravo magazine, needed a photographer to cover the tour. I was the only one the Stones would accept — "Bent's a member of the family" — they said.

Staying with Brian in London I took a series of photos in his home. When I saw the results I thought, why not do it with all of them — it will show they are real people. Bill and Charlie quickly accepted the idea, but Keith had no place of his own and so we rented a suite at the Hilton. Mick was the last to agree. He thought you should not show pop stars in their private world. He finally agreed when I told him that I could make some good money from doing this — but only if he was included.

People began smoking grass at our parties, which had been fuelled by Scotch-and-Coke, in the Spring of 1966, and soon other potentially more harmful drugs were appearing. One day, when I was staying at Brian's home, we had a take-out dinner together with Anita Pallenberg; it was accompanied by Mateus Rosé, which Brian spiked with something — he told me this later. It made me feel terrible, I could not sleep; in fact I spent four days in the bathtub reading Barbarella books. I was in London to take photos of Nancy Sinatra — I felt so bad that I didn't even turn up! That is when my friendship with Brian ended.

In late 1966 I more or less quit Rock photography — too many drugs had appeared and the fun was over. The following year I built a studio in Copenhagen to concentrate on fashion and advertising work. By the Seventies I was producing commercials as well. I had a large number of clients, a staff of twenty, and I was working all over the world — this was real work! My wife Inge and I bought a farm near Copenhagen and moved there

with our two daughters, Camilla and Cathrine, and two dogs; here we bred Hereford cattle. In 1980 I sold my studio and farm, and retired to Lanzarote in the Canary Islands. There I got involved with a time-share sports development and then in 1983 we bought an old hotel in Skagen, Denmark, rebuilt it and made it into an exclusive time-share project. Two years later we moved to the South of France and have lived there ever since.

I continued working in design and architectural photography, travelling all over the world to shoot homes and houses for international magazines and books. In the last fifteen years I have worked on special assignments including the photography for Carlsberg's "probably the best lager in the world" campaign. I have also worked on several books and exhibitions with the famous flower artist, Tage Andersen.

After being asked by friends about "the old days" I finally searched through my old boxes of photographs for the pictures of the Stones; I had not looked at them for nearly 40 years. It became a trip down memory lane, and for the last two years I have been working on this book. It's been a lot of hard, but enjoyable, work to get it all together. I hope you have as much fun looking at these photographs as I had taking them, and creating this book.

Bent Rej
Vence, May 2006

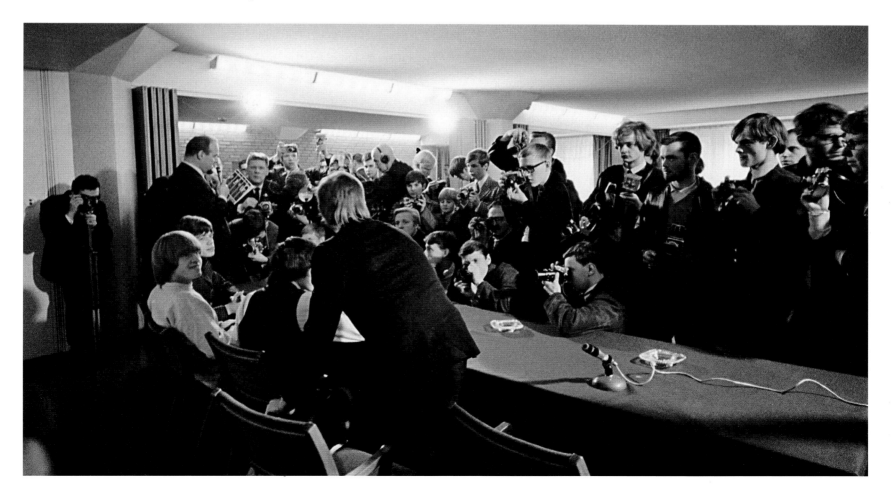

"Ladies and gentlemen of the press...

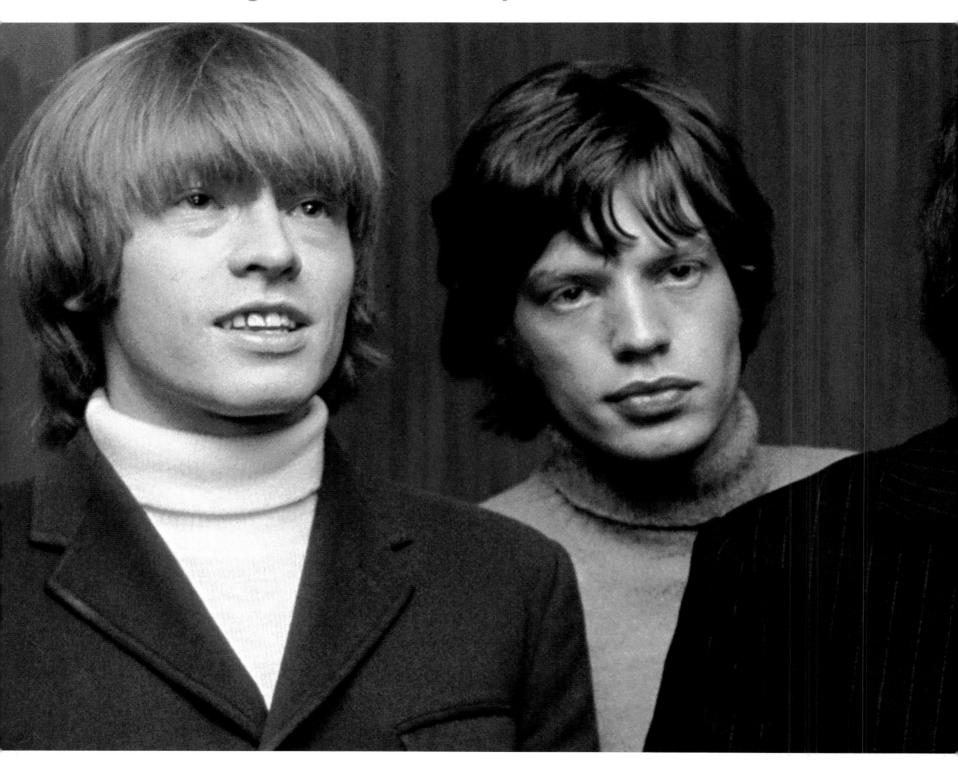

The... Rolling... Stones"

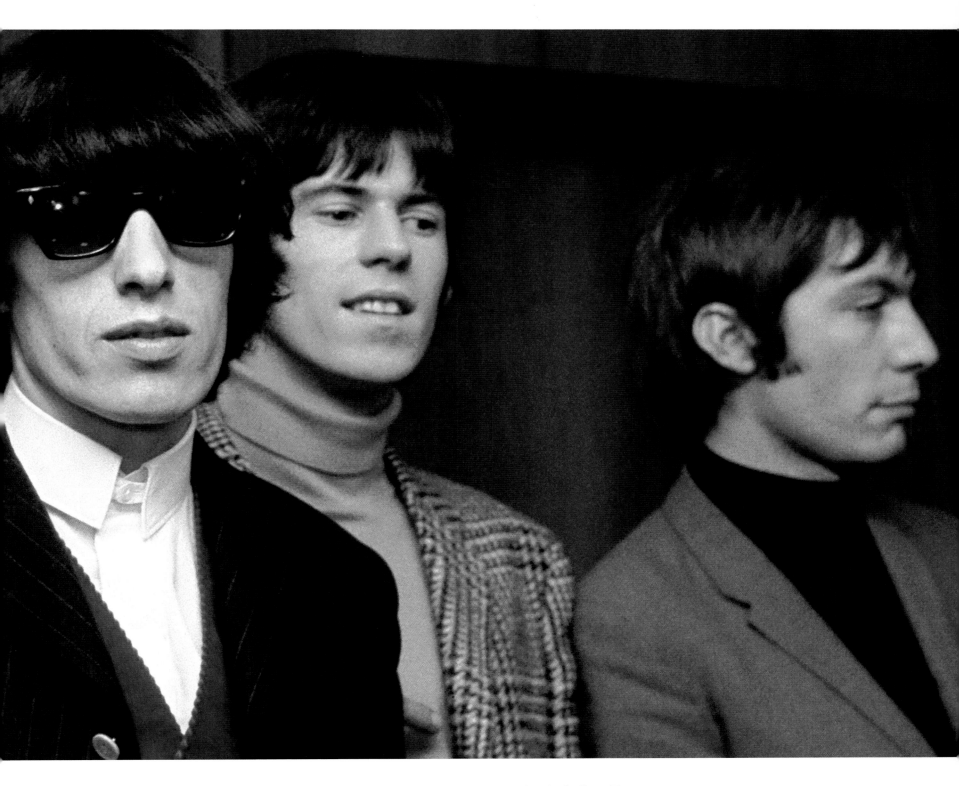

The Rolling Stones arrived in Denmark to begin their first European tour having played hundreds of clubs and concerts in Britain as well as having completed two American tours. **The Last Time** was at No.1 in the UK, their third consecutive single to top the charts. On the day they arrived, a press conference was held in Copenhagen's Royal Hotel for 33 journalists and 101 photographers.

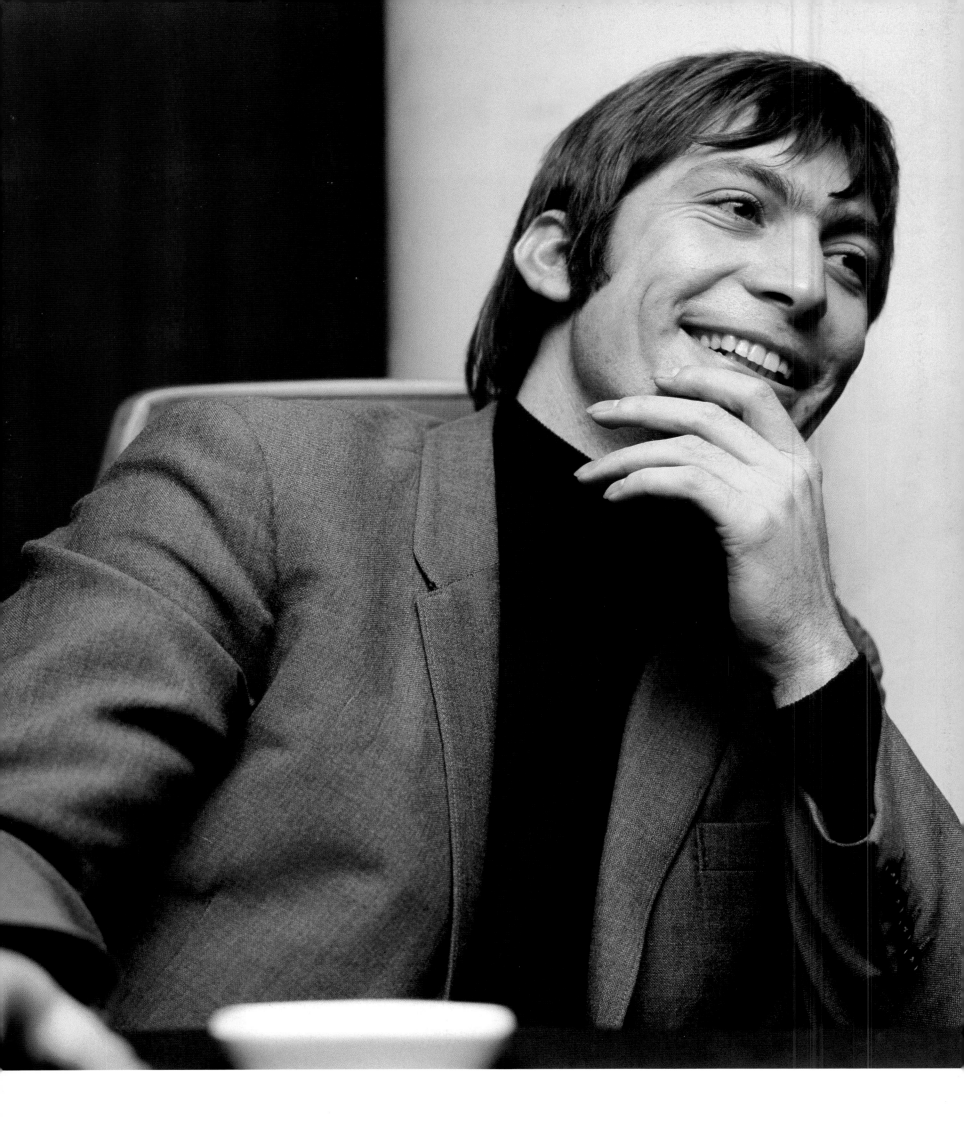

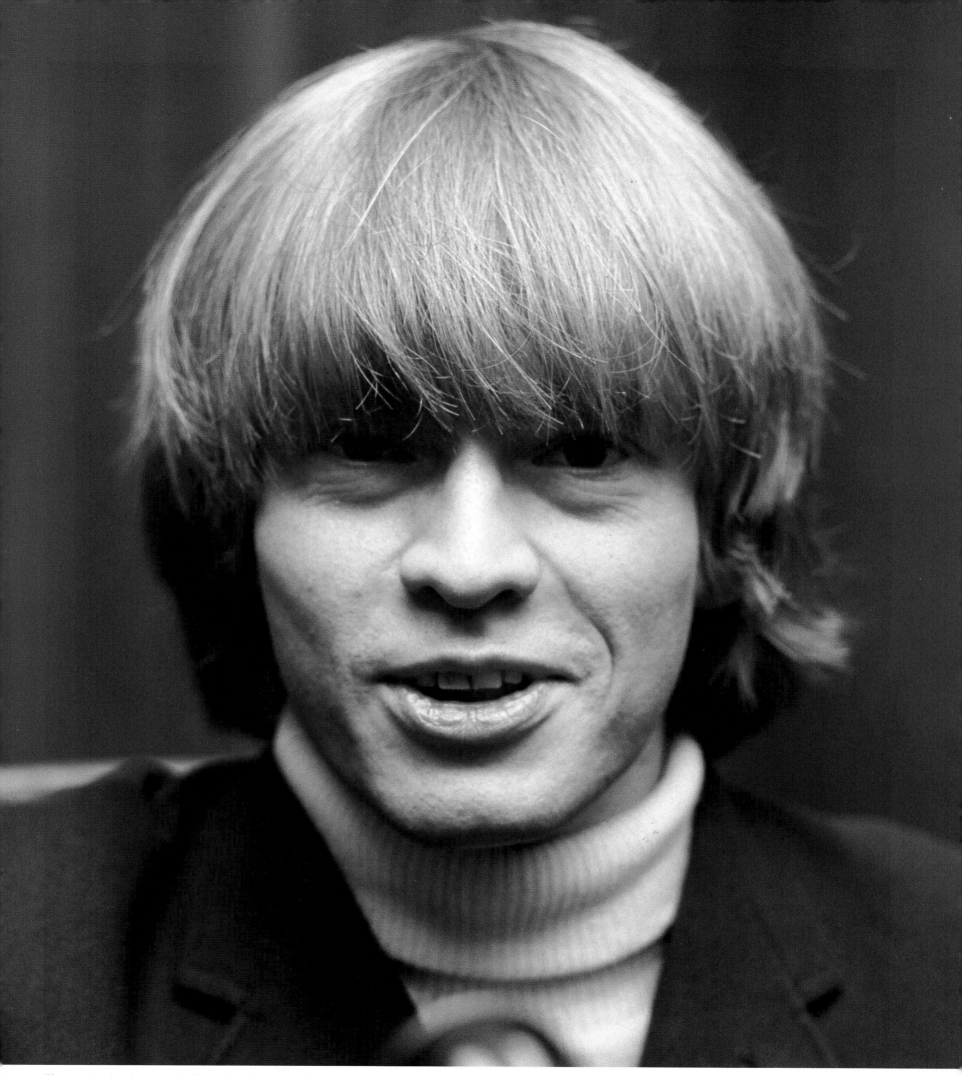

"I spotted who the jokers in the band were and quickly established a rapport with them: Charlie and Brian." BR

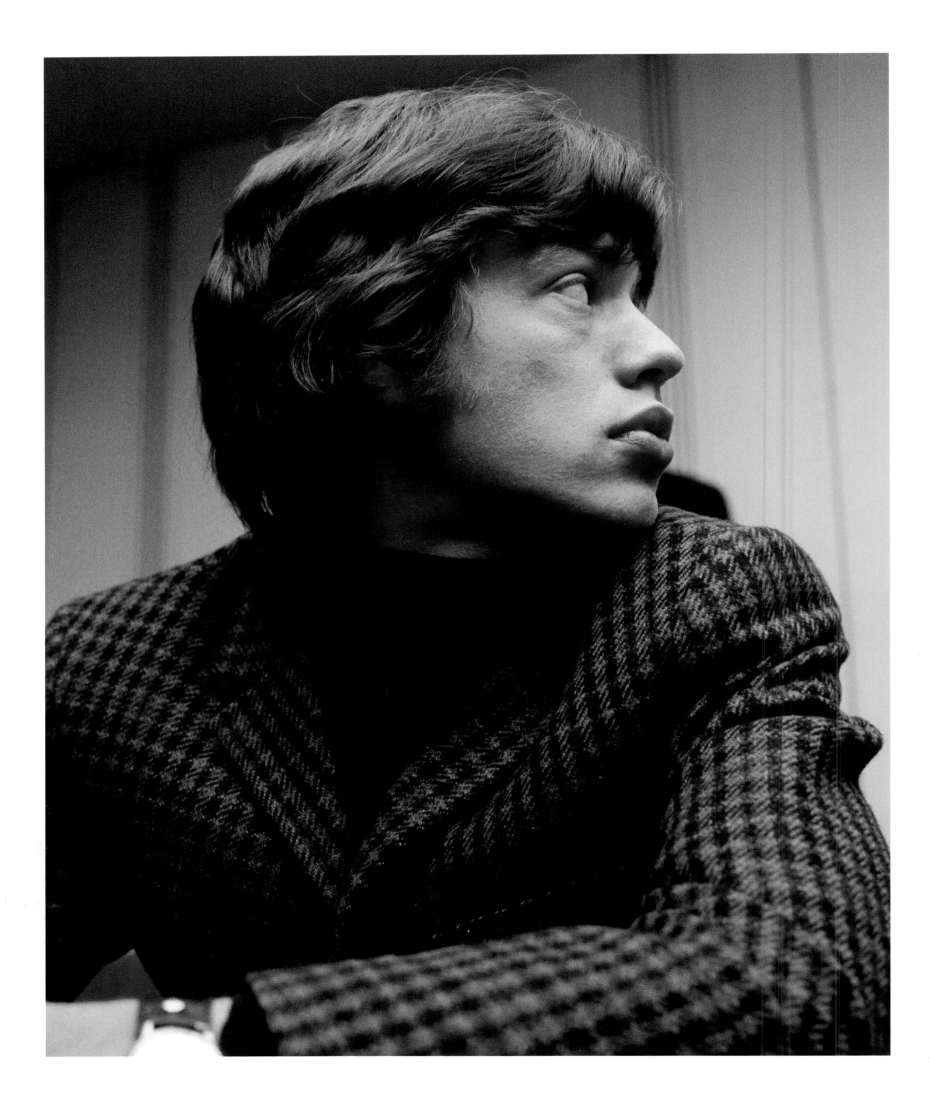

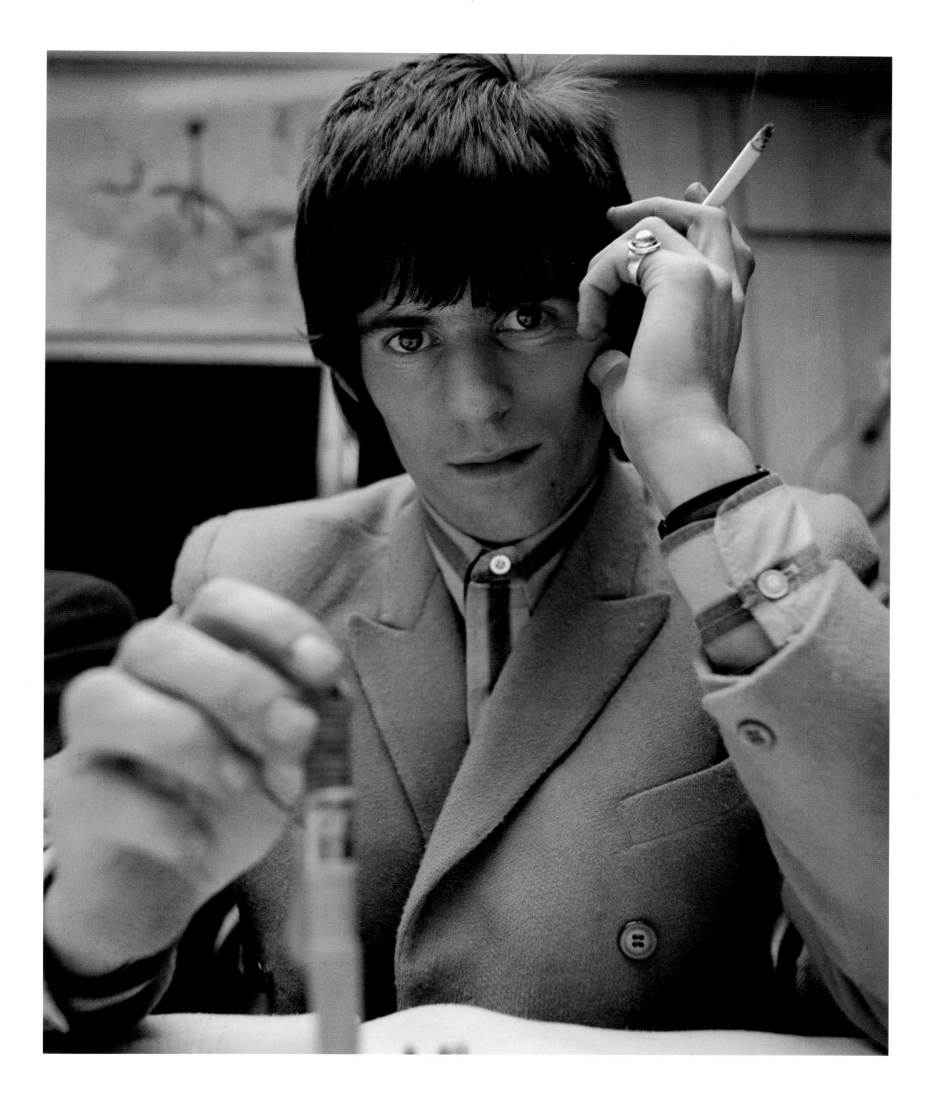

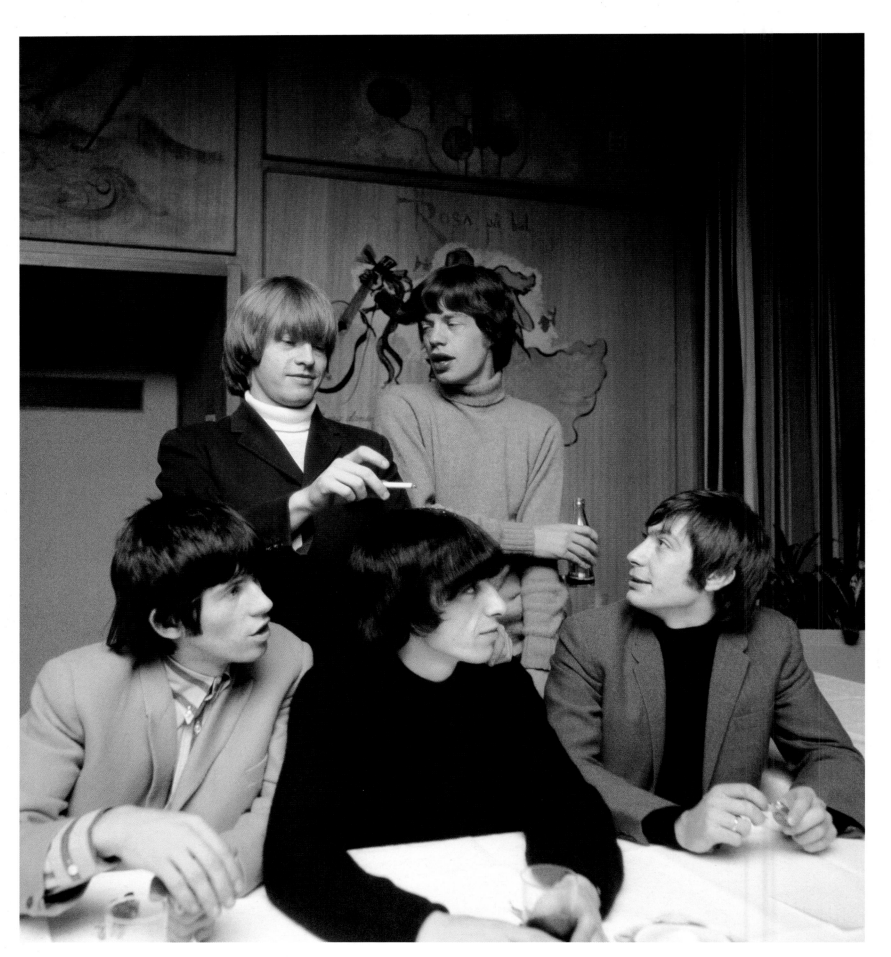

"After the photographers had been allowed to take their pictures it was the turn of the journalists to ask their probing questions. Press conferences were boring for the band and their love of fun and practical jokes was in evidence early in the proceedings." BR

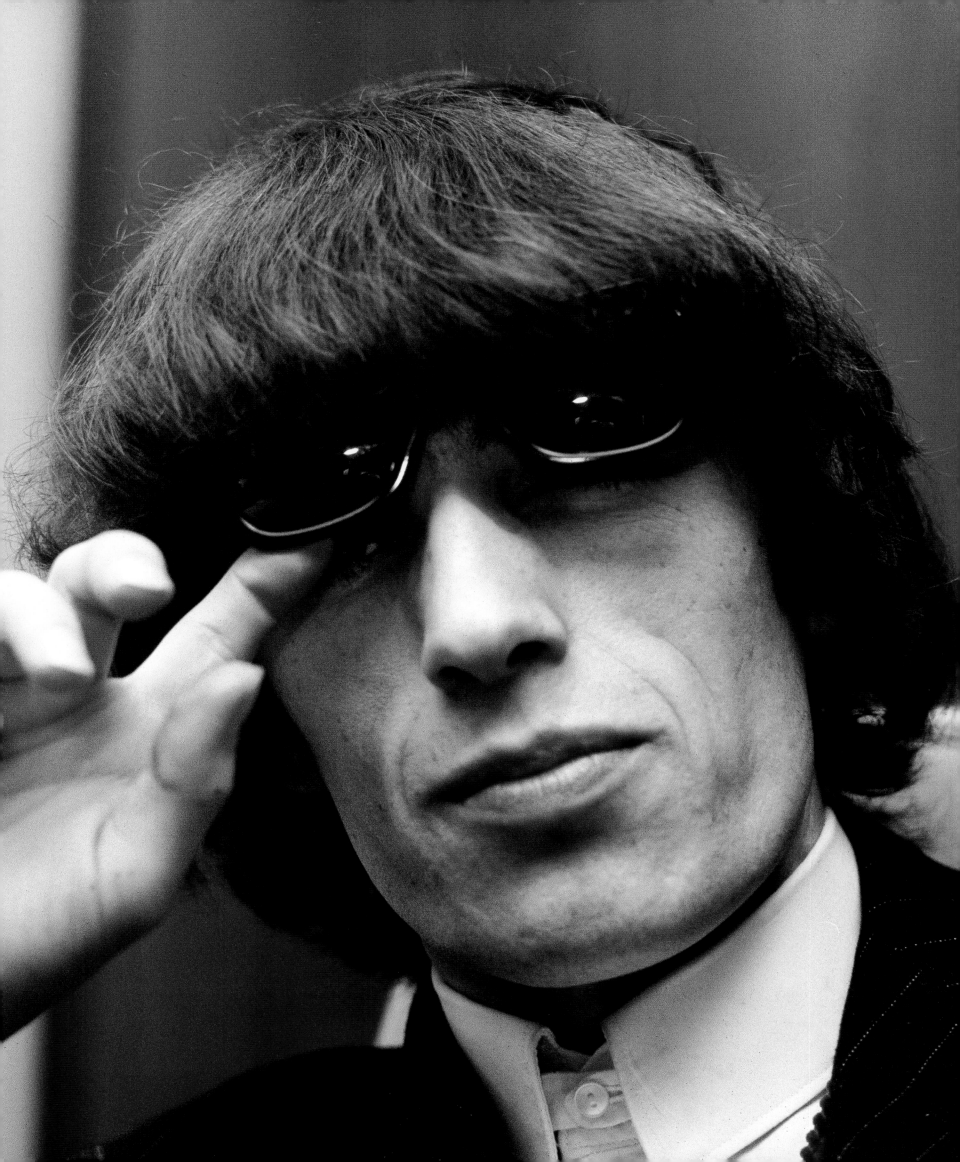

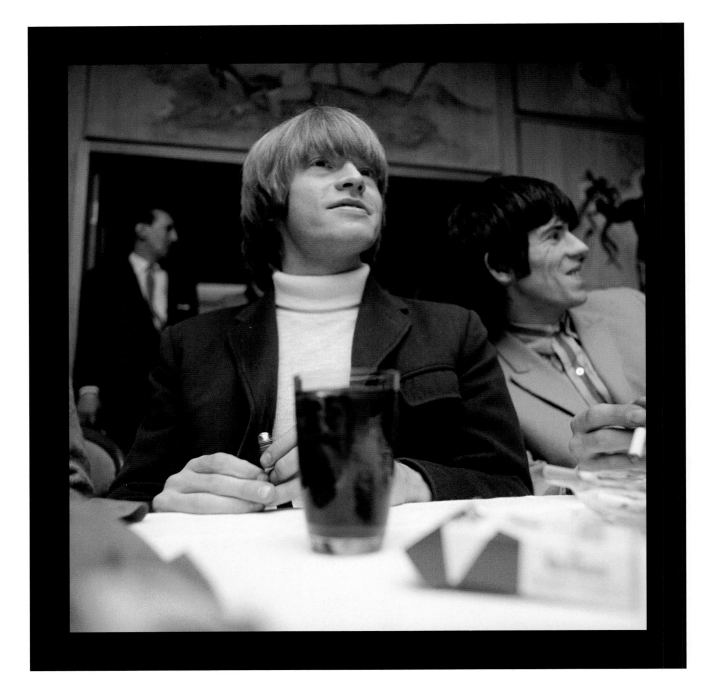

When one Danish journalist asked Brian what he would do when the
Sixties ended, he answered, "Sit comfortably in a Cadillac and take it easy."
To another who asked, "Have you read books about the Stones' career?"
Brian answered, "Sure, we laugh loudly at them, they're so full of mistakes."

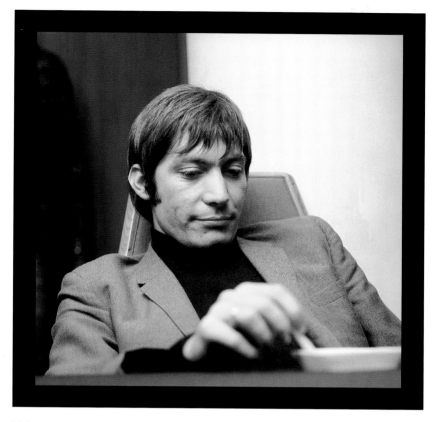

When asked "Who writes your answers to the press conferences?", Charlie answered "Ringo".

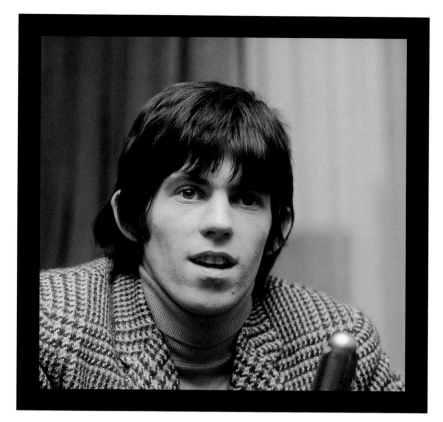

"I am very glad to be here in Copenhagen. We're in one of the best hotels I have ever been in." KEITH

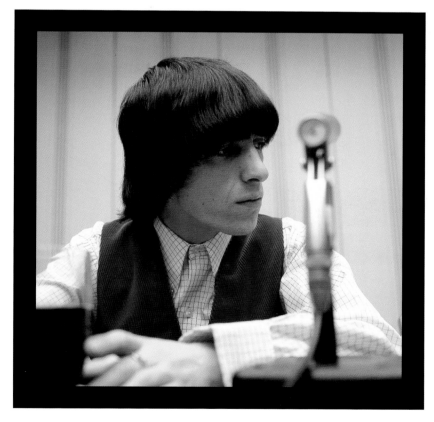

"First of all we're ugly, and we don't like each other — in fact we're not even friends." BILL

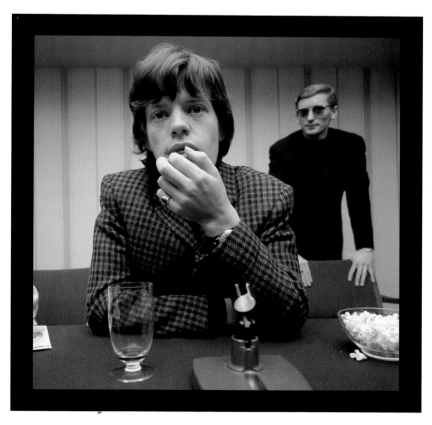

Asked why they didn't drink gin-and-tonic Mick replied, "It's only for the upper classes."

IN THE VERY BEGINNING

Brian Jones formed a band he called "The Rolling Stones", or as they were sometimes billed, "The Rollin' Stones", that performed publicly for the first time at London's Marquee club in July 1962. Brian, who was calling himself Elmo Lewis at the time, along with Mick, Keith, Ian Stewart, Dick Taylor — later of The Pretty Things — and Mick Avory, who played with The Kinks, were the first manifestation of the greatest Rock and Roll band in the world. Back then they were a Blues band that received most of their press coverage in the jazz magazines. More gigs were to follow, including a residency at the Ealing Blues Club where Mick and Keith had first clapped eyes on Brian while he was sitting in with Alexis Korner's band. By October the band had cut a demo disc on which drummer Tony Chapman (he had been in Bill's band, The Cliftons) was featured after he had joined the fledgeling Stones during mid-summer. By the autumn, Dick Taylor had left to study at the Royal College of Art and the band were in desperate need of a bass player.

Enter Bill with his quality amps, and love of Rock and Roll rather than the Blues, who played his first gig with the band in mid-December 1962. In January, Charlie, who Brian had been trying to persuade to join the band since they had started, finally joined after Tony Chapman was sacked. On 12 January 1963 the six-man Stones, because it also included Stu, played their first gig at Ealing Blues Club. Besides Ealing they played at the Red Lion pub in Sutton, Surrey, where they met engineer Glyn Johns and, a month later, Giorgio Gomelsky — the son of a French milliner and a Russian surgeon.

Giorgio became the band's manager, but it was an unofficial position, not one formalized by contract. He provided the Stones with a stage, which was to become legendary in the band's history at the Richmond Jazz Club on Sunday nights at the Station Hotel, appropriately opposite Richmond train station. For his part Giorgio guaranteed the band £1 each for playing at his club. The Stones' first Richmond gig was on 24 February 1963 in front of about thirty people. This coincided with finishing their residency at Ealing, and from then the band began to branch out, playing Ken Colyer's Studio 51 Club in Soho as well as the Ricky Tick in Windsor, the Wooden Bridge Hotel near Guildford, and the Haringey Jazz Club. All this activity meant they were playing double the number of gigs that they had been in January and were appearing somewhere in London three to four nights a week, although some gigs were in the afternoon.

Another recording session in early March, overseen by Glyn Johns, produced a demo record that Giorgio used in an attempt to get the band a deal. After trying at least half a dozen labels there was no deal — "they are just not commercial" was the general consensus. Giorgio had a new plan and began making a short film about the band. In late April the Stones cut

a couple of songs for the soundtrack and also auditioned for the BBC's Jazz Club, but minus Bill and Charlie because it was during the day and neither of them could get the time off work.

A week later, and two weeks after The Beatles had been to see the Stones at the Richmond club, managers Andrew Loog Oldham and Eric Easton turned up, "48 hours ahead of the rest of the industry," as Andrew recalled. Within days they had "officially" signed the band and Giorgio was out of the frame. Not that their connection was entirely severed as the Stones continued to play his club.

Two weeks later Dick Rowe at Decca Records, the man who had turned down The Beatles — and he wasn't going to be wrong twice — had signed the band, and a month later, on 7 June, the band's first single, a cover of Chuck Berry's **Come On**, was released. A month after that and they were appearing on ITV's Thank Your Lucky Stars wearing matching dogtooth jackets and looking almost as smart as every other band of the time — though their hair was a trifle too long to be called "smart". With a moderate chart placing for **Come On** (it got to No.21) there was hope that the band could go on to become another fairly successful "Beat Boom" band. On the back of the single, the Stones started to play somewhat further afield from the London clubs and over the course of the summer travelled up and down the country in their beaten-up van driven by Stu, who Andrew had insisted be removed from the band.

By September they had secured a spot on the Everly Brothers' package tour and played twice a night in cinemas and theatres the length and breadth of Britain — sometimes even wearing matching outfits. Mid-way through the tour they recorded John Lennon and Paul McCartney's **I Wanna Be Your Man**, and two days before they finished with the Everlys it was released and managed to make No.12 on the UK charts.

Over the course of the next year and half, a steadily improving run of singles, albums, and EPs, hits on both sides of the Atlantic, gigs almost nightly around the UK, two tours of North America, one in Australasia, and you have a band who feel they've made the big time — even if their personal earnings are still not what the public would have imagined them to be. As they arrive in Scandinavia to begin their first European tour they have their third No.1 record — the first written by Mick and Keith — and they've stopped wearing matching outfits!

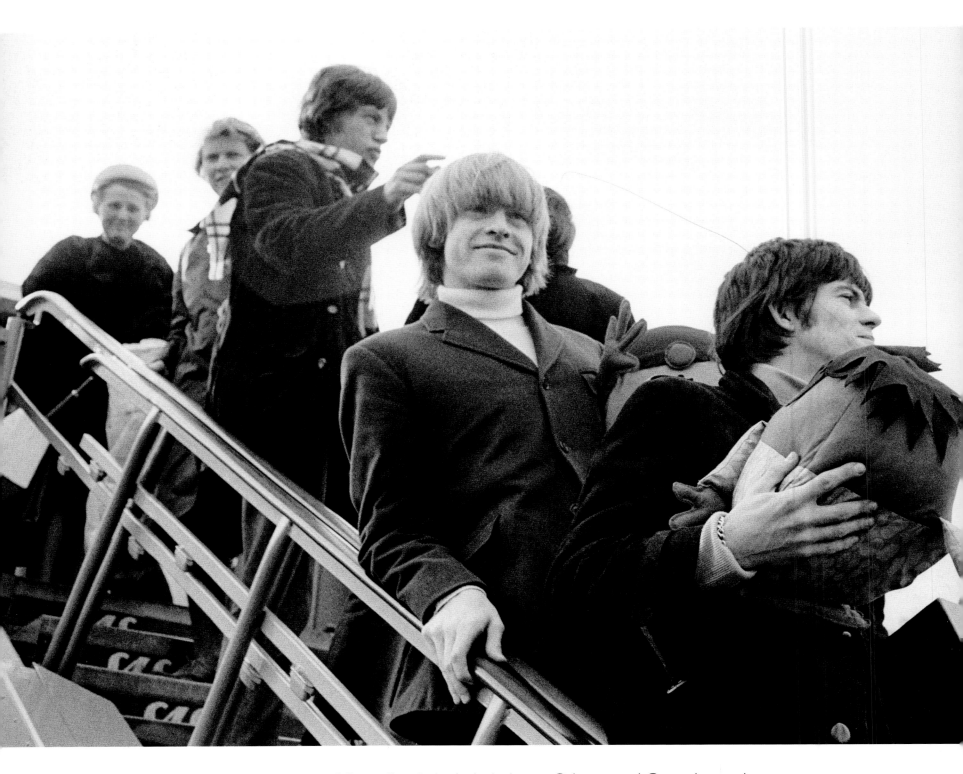

The short tour of Scandinavia included gigs at Odense and Copenhagen in Denmark as well as Gothenburg and Stockholm in Sweden. They flew to Odense from Copenhagen on the morning of 26 March. A few months earlier the Stones had agreed to endorse a Russian 8mm movie camera and were given one each by the manufacturer – this is the camera that Keith is using.

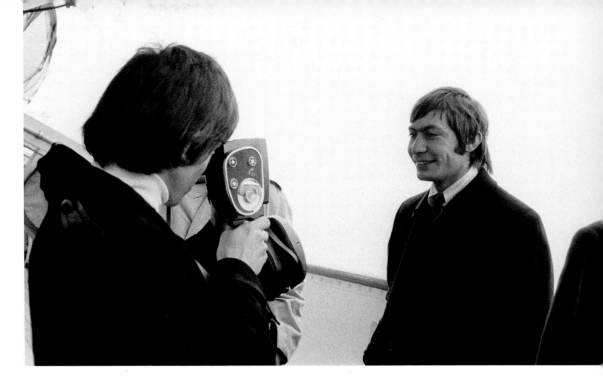

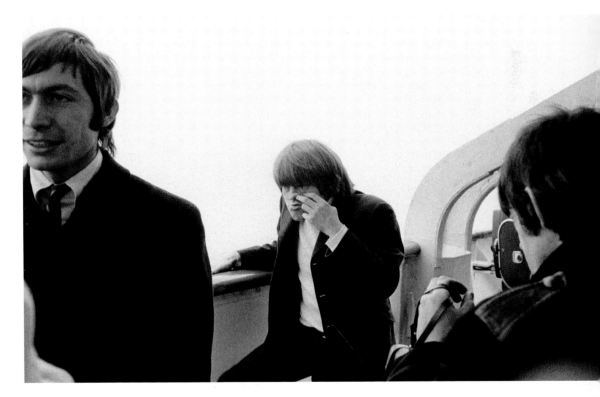

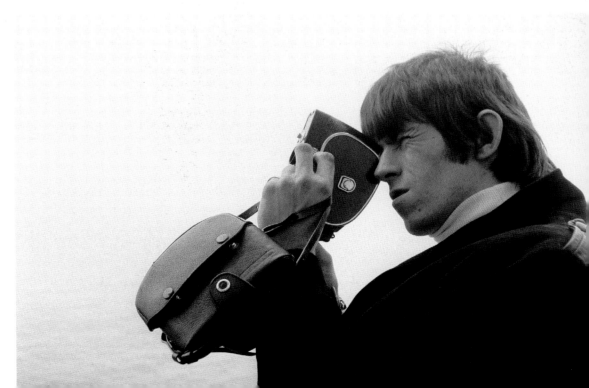

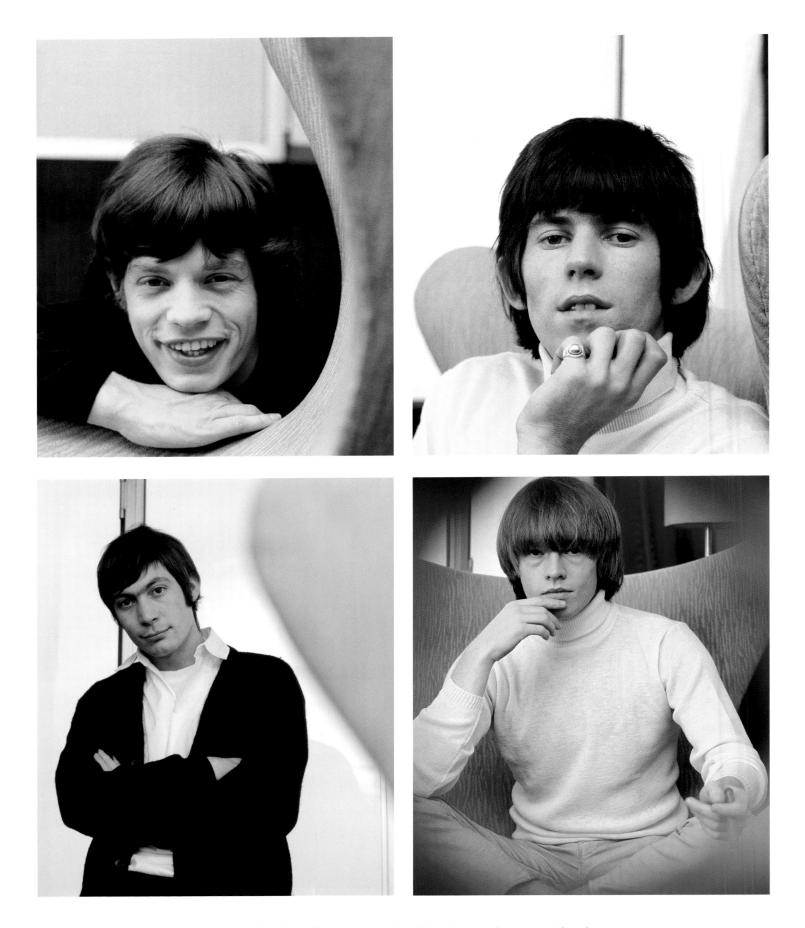

"I did a shoot in the band's suite at the Royal Hotel among the famous 'Swan and Egg' chairs designed especially for the hotel by the world-famous Danish architect Arne Jacobsen." BR

THE ROYAL HOTEL, COPENHAGEN

"I first saw The Rolling Stones when they landed at Copenhagen's Kastrup Airport. When Niels Wenkens, the Danish promoter, had met Mick in London at the Ad Lib club he had joked about having a black book in which he kept the telephone numbers of some pretty Danish girls. When Mick met Niels at the airport he reminded him of their conversation and suggested he ask some of them to meet us at the Royal Hotel.

"Niels phoned around and later in the day ten girls turned up in the Stones suite on the nineteenth floor. Brian, Keith, and Mick were on their toes and Bill and Charlie stayed in the background. Mick said, 'All ten should stay.' That night there was a great party and the next day we were almost thrown out of the hotel because of our behaviour.

"Niels stayed in the hotel all week and it was he that had to sort things out. The maids had seen what was going on and reported the 'shocking' scenes they had witnessed on the nineteenth floor. Reception called Niels and demanded his attendance in the manager's office. The manager insisted that the Stones leave immediately, but fortunately Niels talked him round. The Royal Hotel was totally unprepared for the Stones, despite the fact that The Beatles had spent a night at the hotel — maybe it was just because The Beatles were so well-behaved.

"One night I went with some of the band to a nightclub where Keith spotted four girls he wanted to have a drink with. Later we took them back to the hotel and instead of taking them through the reception, which was heavily guarded, we walked up all nineteen floors on the outside fire escape. When we went in through the door there were two security guards to meet us. They escorted the girls from the hotel and ruined a great evening. This prompted the Stones to want to move, but there was nowhere to go, as no other hotel in Copenhagen would have them to stay. On subsequent nights we solved the problem of getting girls back by using the goods lift to the nineteenth floor, which for some reason the hotel never caught on to.

"It was not all about girls. One evening Charlie and Bill went to the Tivoli Gardens and saw The Oscar Peterson Trio, Erroll Garner, and Ella Fitzgerald in concert. Afterwards they went backstage and met Erroll Garner and Ray Brown, his bass player.

"My overriding memory of the first trip to Denmark by the Stones was how generous they were to everyone around them. They were a pleasure to be with and great fun was had by all of us." BR

Brian had 500 grams of Beluga caviar...

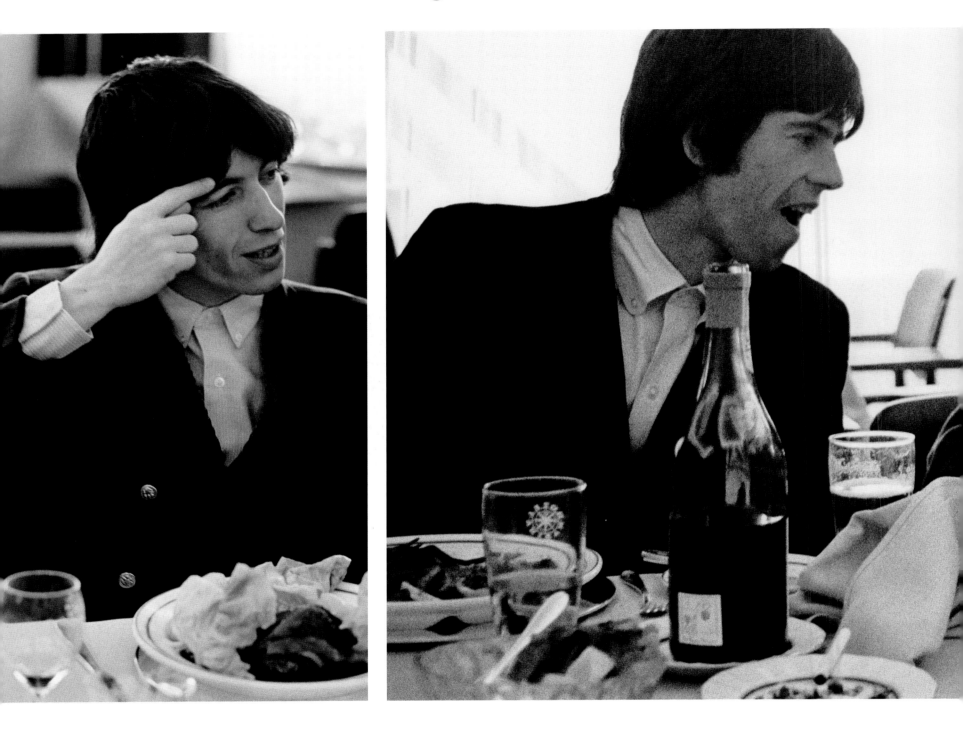

...before lunch.

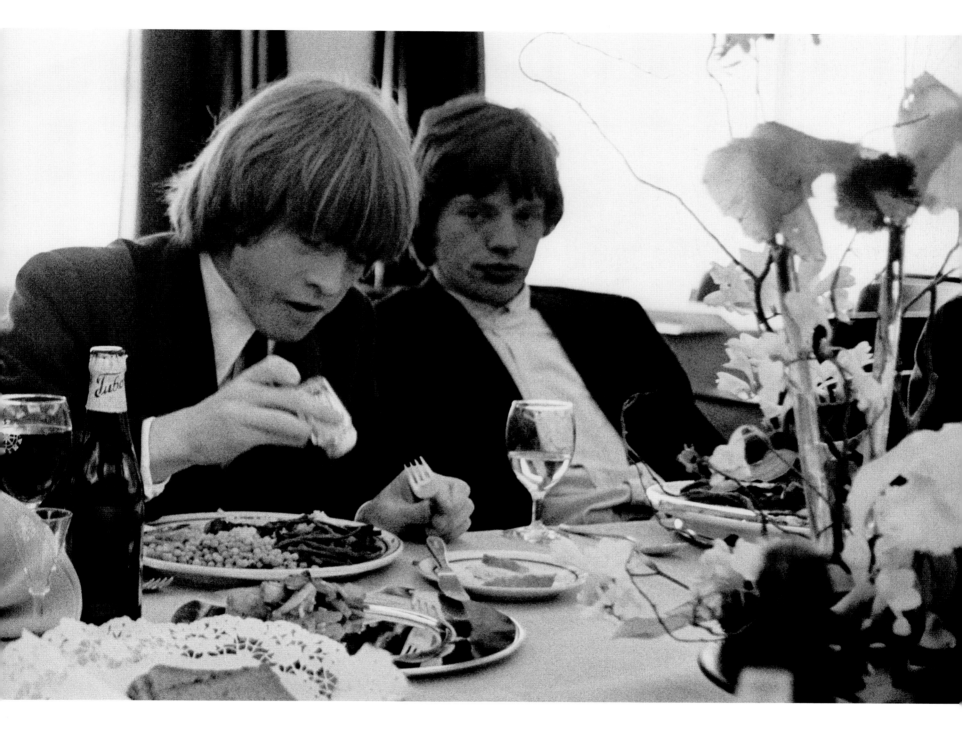

"At a lunch, organized by the band's record company, at the Marina Hotel Brian ordered from the menu by covering the description of the article and picking what was the most expensive item. It turned out to be Beluga caviar. When it came he did not really like it and used most of it as ammunition in a food fight." BR

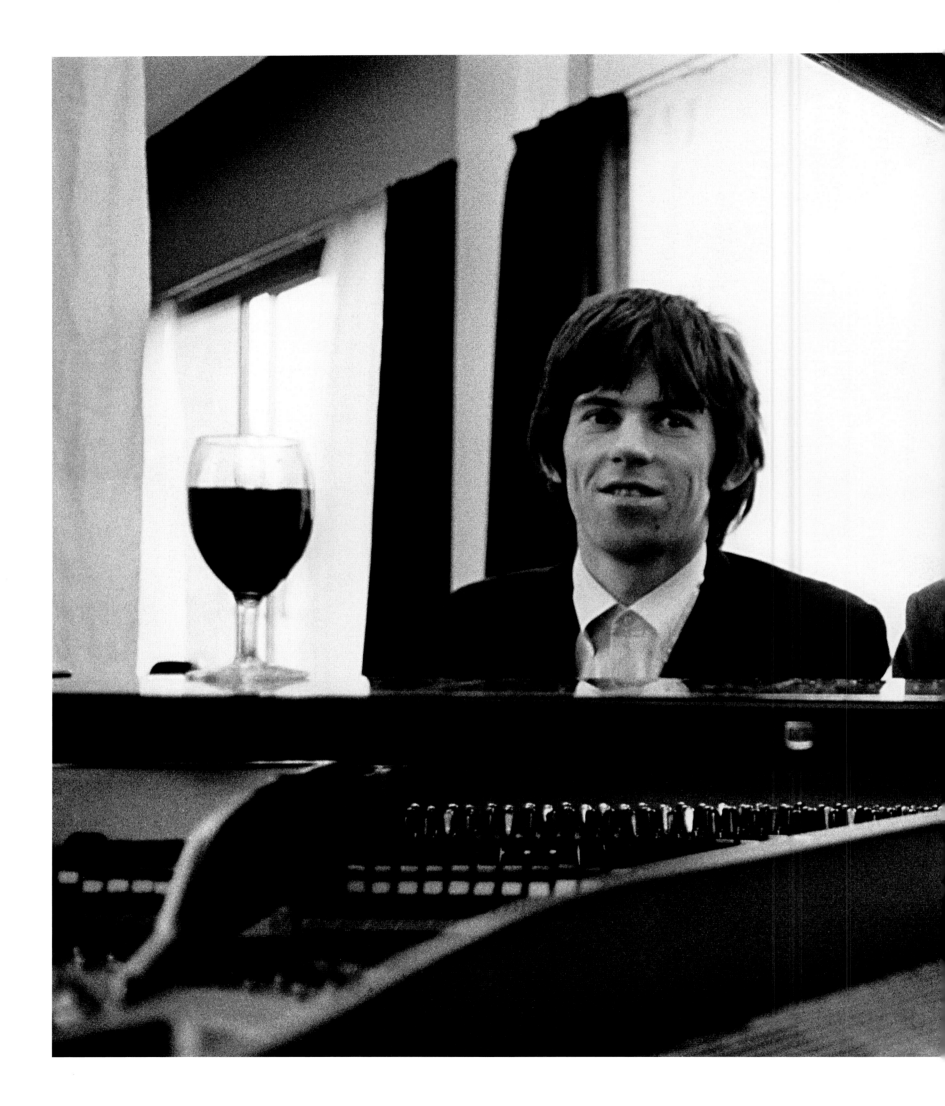

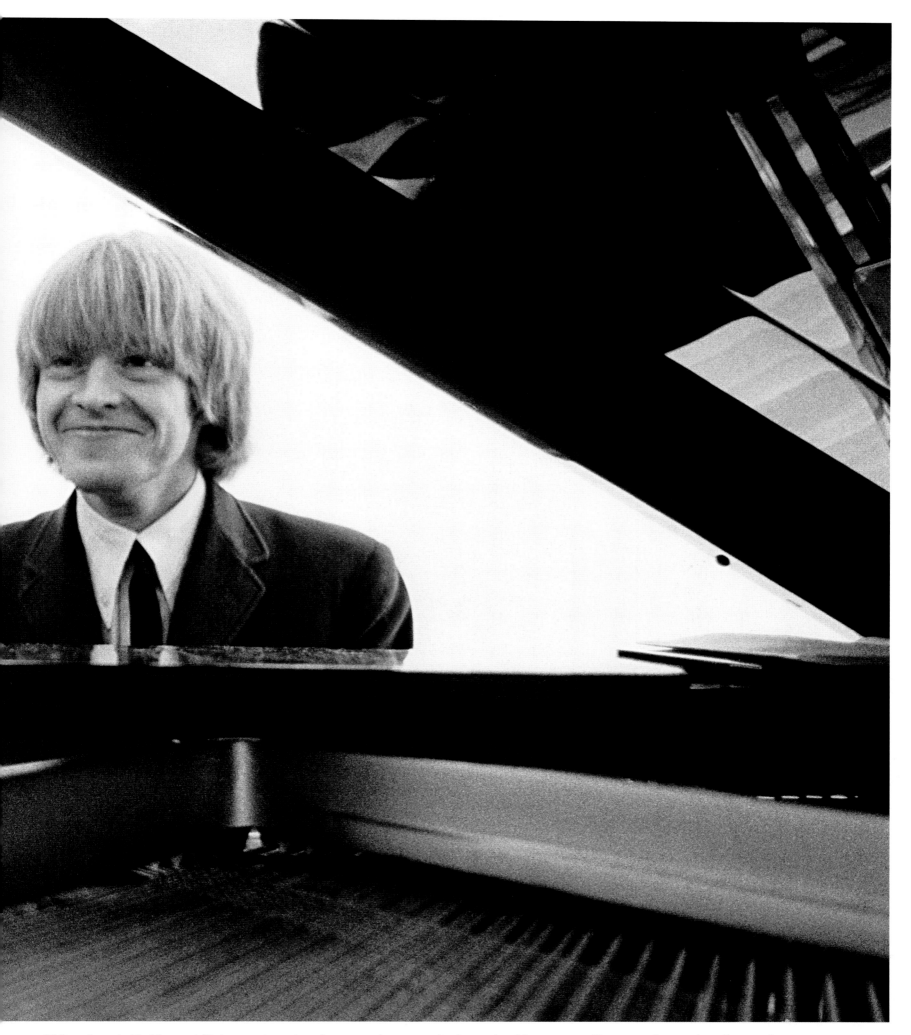

"After lunch Keith and Brian entertained us on the grand piano, looking more like naughty schoolboys than pop stars. They were accompanied by the most expensive wine on the wine list." BR

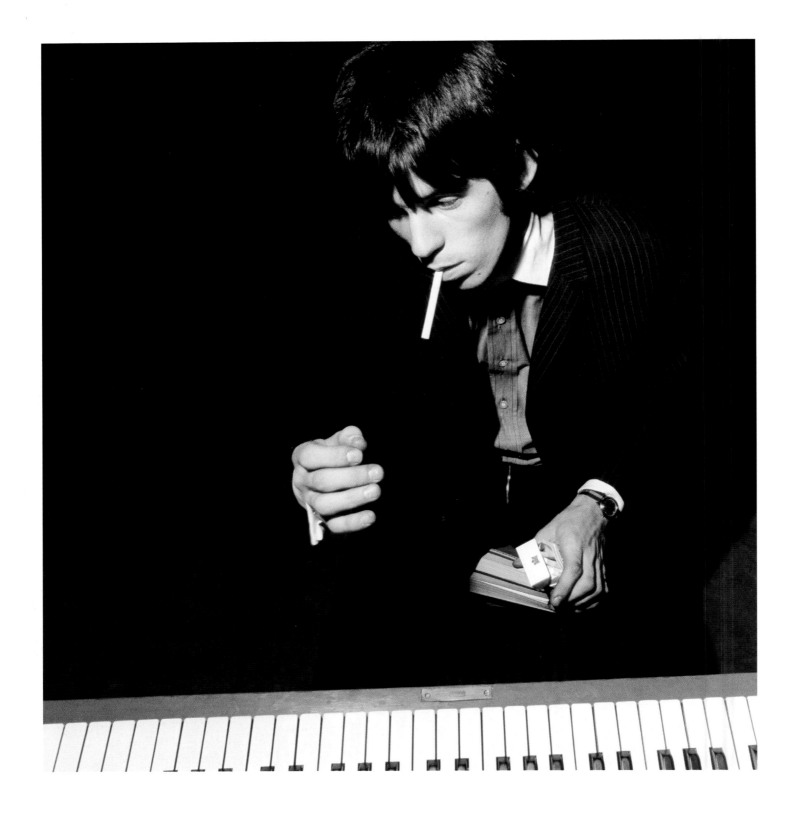

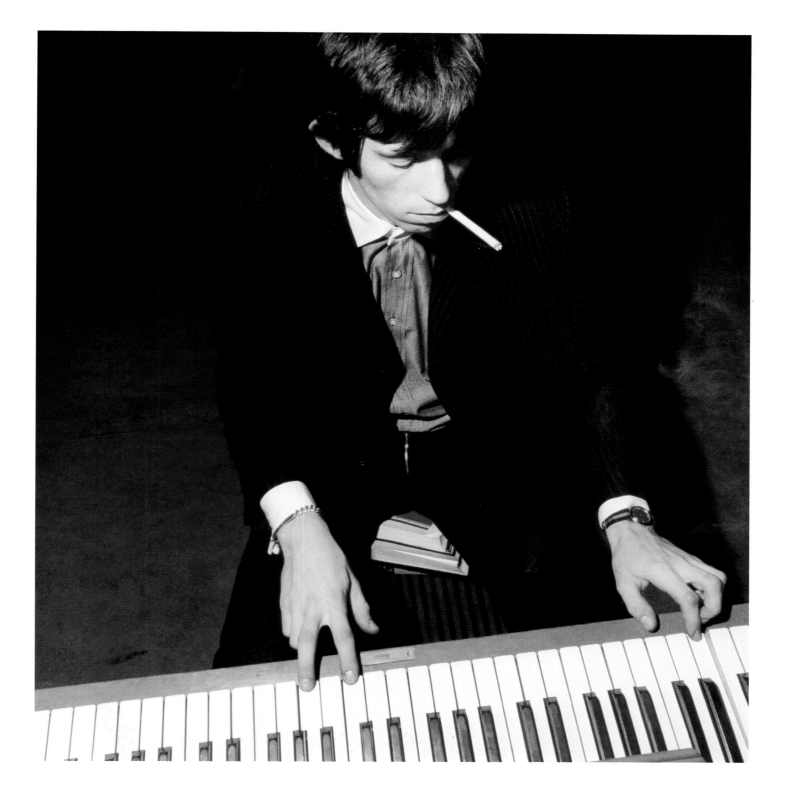

"Keith's love of music was very evident from the first few days I spent with them. He couldn't pass by an instrument without trying it out to see what sounds he could get from it." BR

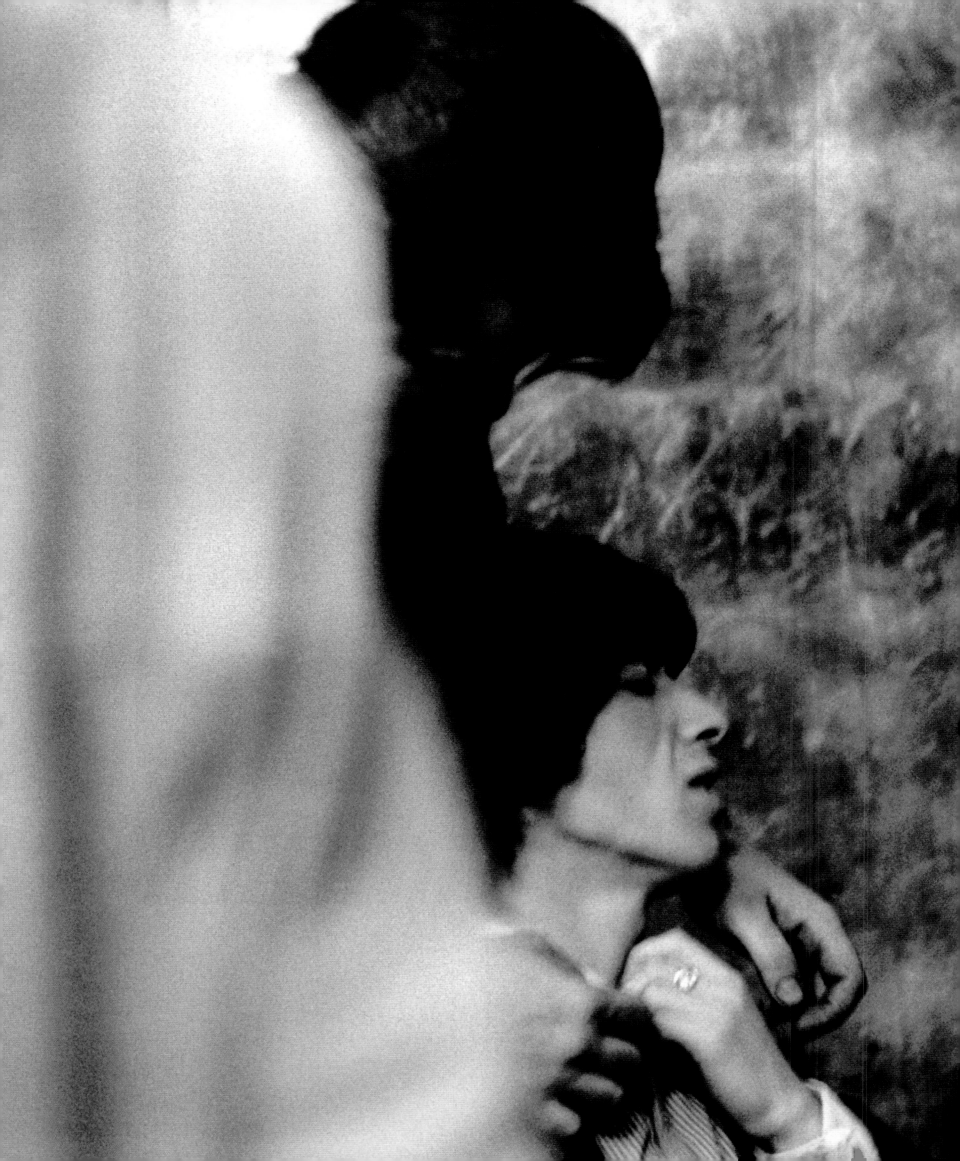

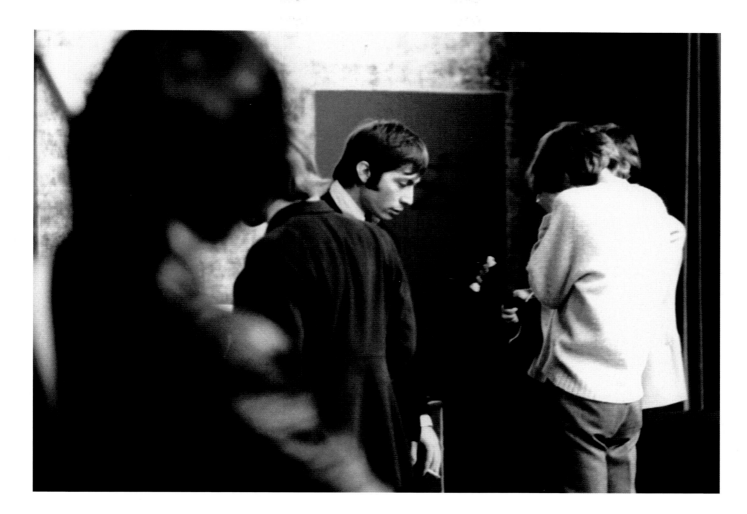

"After lunch we were driven to Fyns Forum for a sound check prior to our two shows. We were getting ready to play and Mick went over to the mike stand and as he touched it he immediately started dancing around the stage. I thought he was just messing about but Brian realized what was happening and he went over and pulled the plug out; just before he did Mick fell against me and knocked me unconscious." BILL

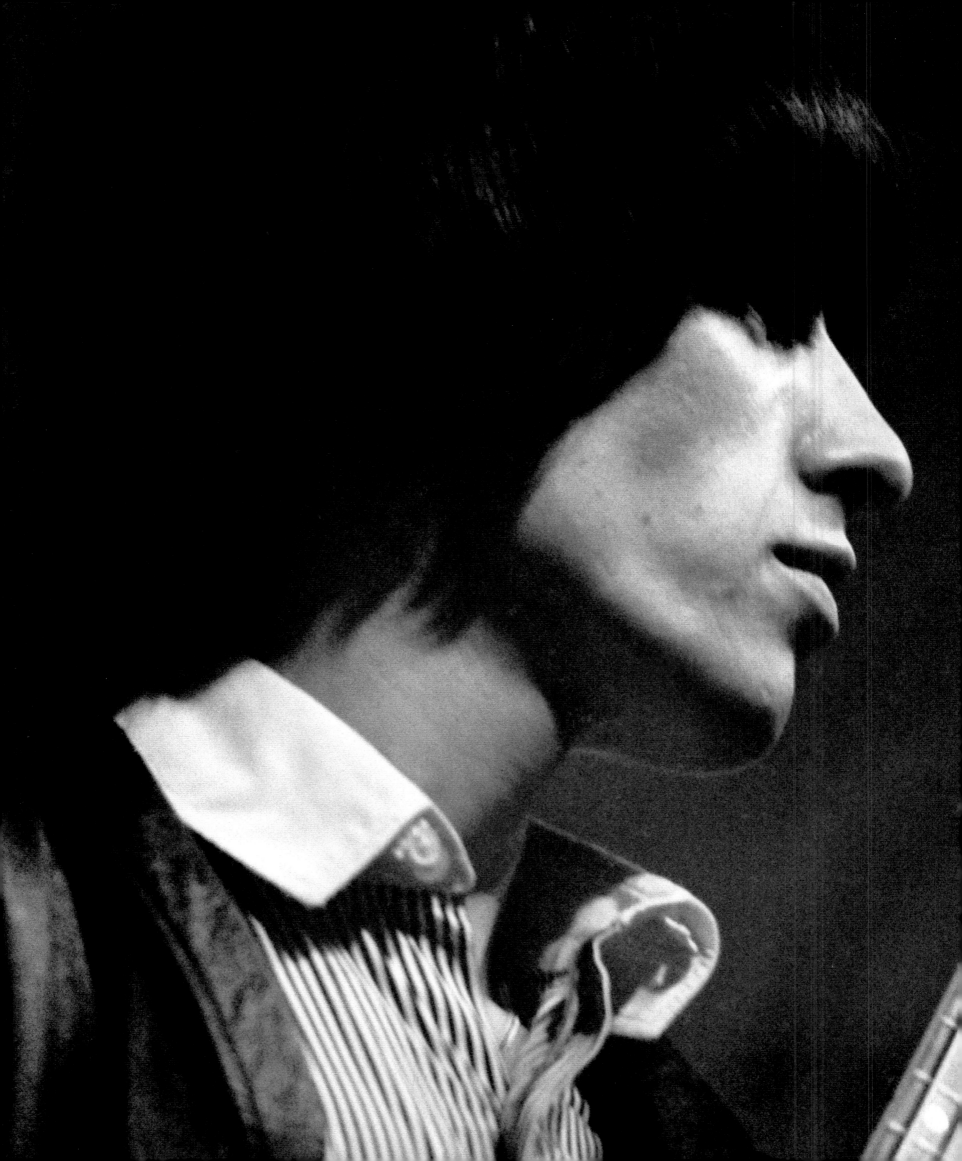

"We called an ambulance immediately, but Bill regained consciousness after a few minutes and refused to go to hospital. I thought at first it was just a bit of horseplay, when Mick started jumping about on the stage. It wasn't until I saw Bill lying unconscious that I realized it was no joke. I thought we would have to cancel the concert."

KNUD THORBJORNSEN (SBA CONCERT PROMOTER)

"The concert went ahead as planned and afterwards an older man was heard to say. 'These five gentlemen are more dangerous than Hitler.'" BR

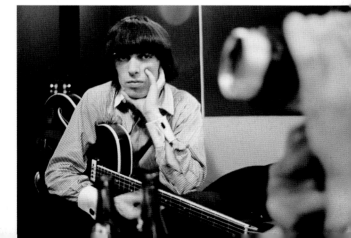

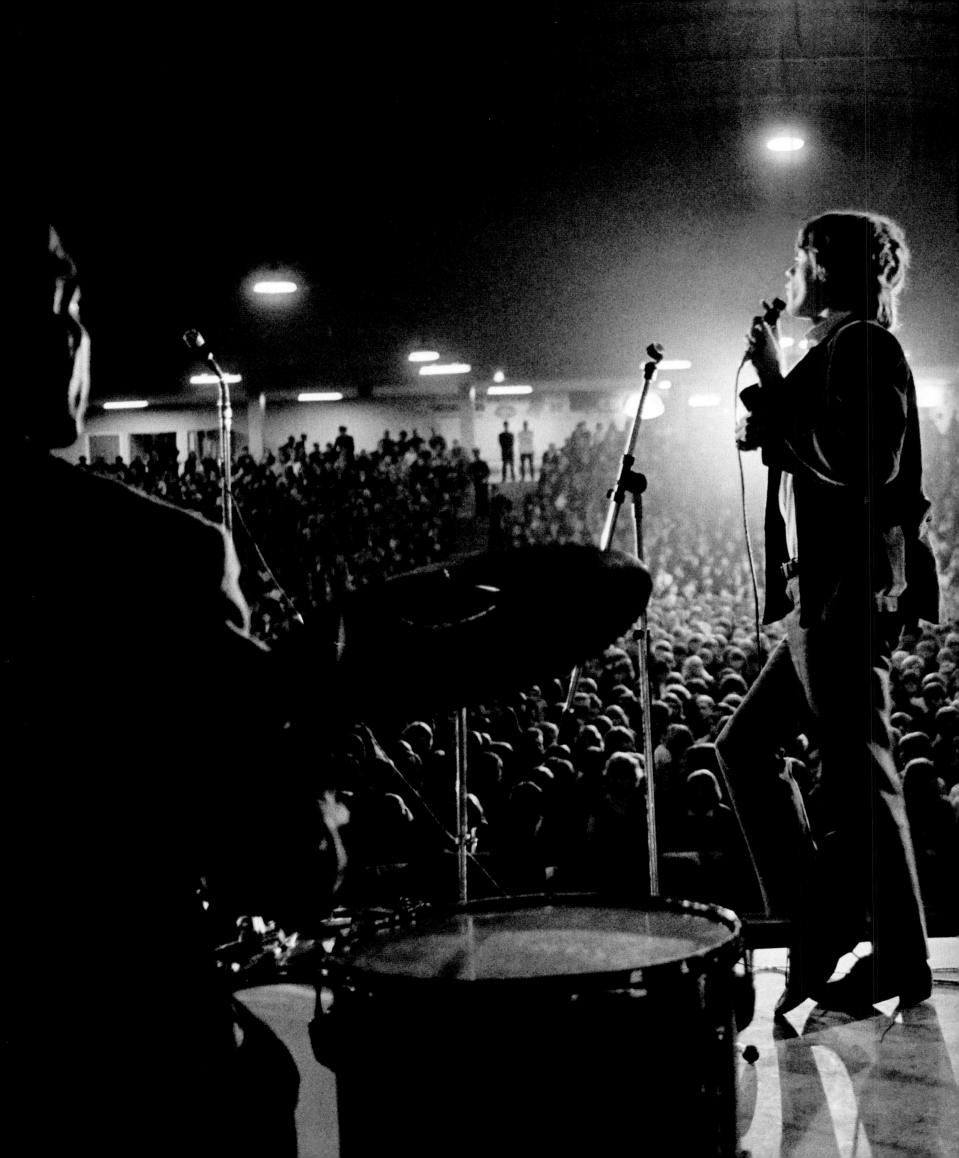

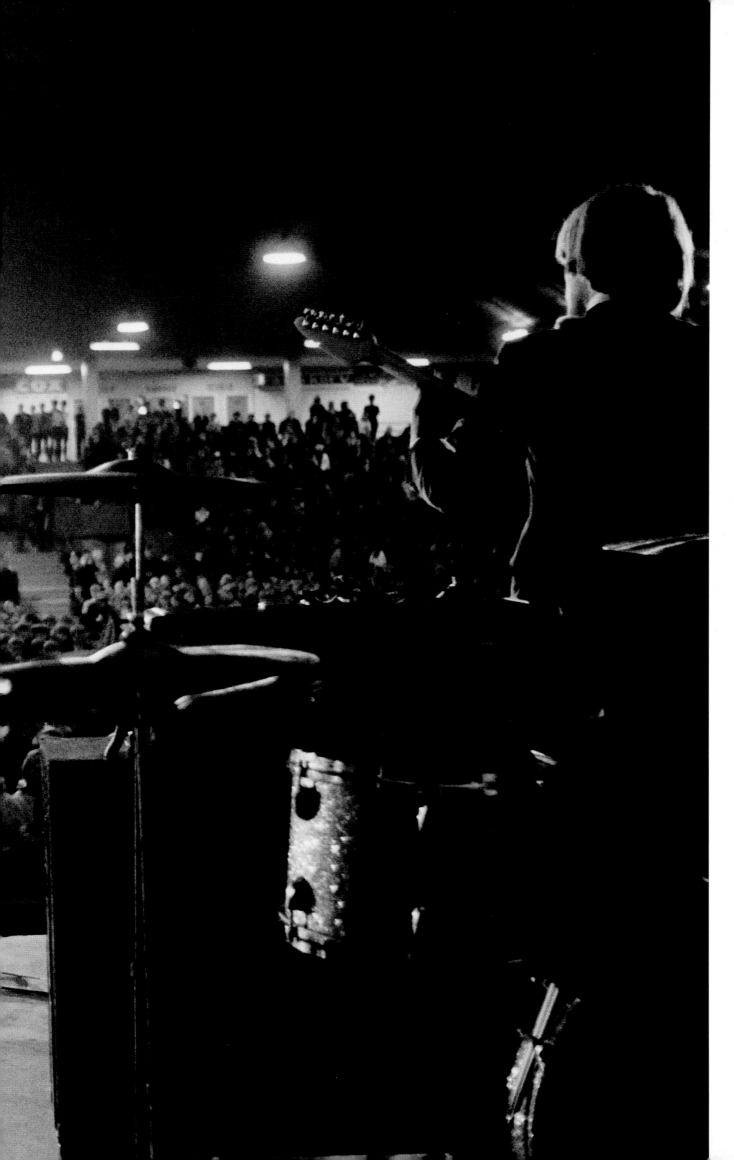

The Stones only played for 25 minutes, which was the normal length for a concert at the time. Their set list was usually:

Everybody Needs Somebody to Love

Tell Me

Around and Around

Time Is On My Side

It's All Over Now

Little Red Rooster

Route 66

The Last Time

"Brian decided he wanted to go to Copenhagen Zoo and, given that he had loved buses since he was a kid, he wanted to take the bus. Boarding the No.29 Brian found it full of schoolchildren. As soon as they realized who it was, the noise on board rose to that of a jet aircraft taking off. It was so noisy that the bus driver, not knowing who Brian was, demanded that he

got off the bus. Niels Wenkens, one of the Danish promoters who was with him, persuaded the driver to let Brian stay on board. Once they were at the zoo, Brian enjoyed looking at the animals but more than that he liked studying people's reaction to him; it was though he was checking on his popularity. I took these pictures later but I'm unsure whether Brian's antics were inspired by his trip to the zoo." BR

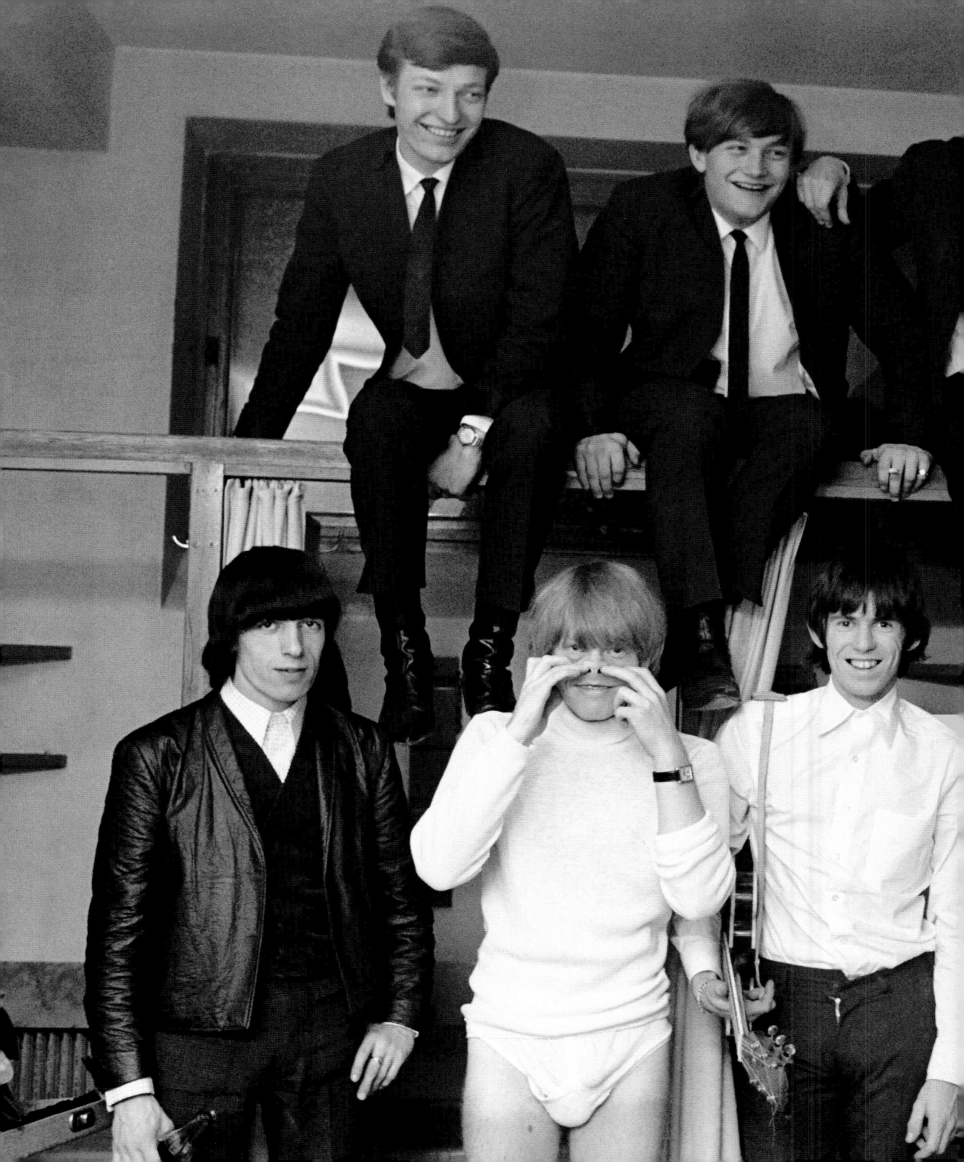

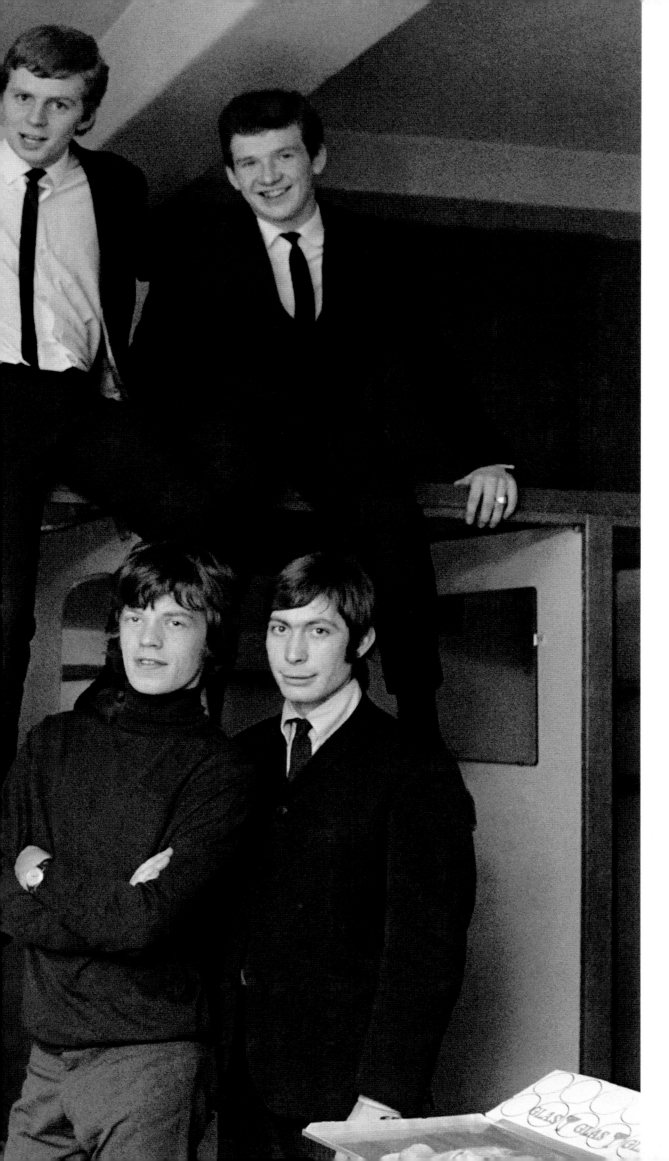

"Backstage at the Tivoli Gardens in Copenhagen together with the Danish support band, The Defenders — then Scandinavia's most popular group. Mick said he thought they were a little too good to be the support band! This is probably the only known shot of Brian, or any of the Stones, in their underpants." BR

"Mick was being generous, the only time we ever felt threatened by a support band was when we played with James Brown and His Famous Flames." BILL

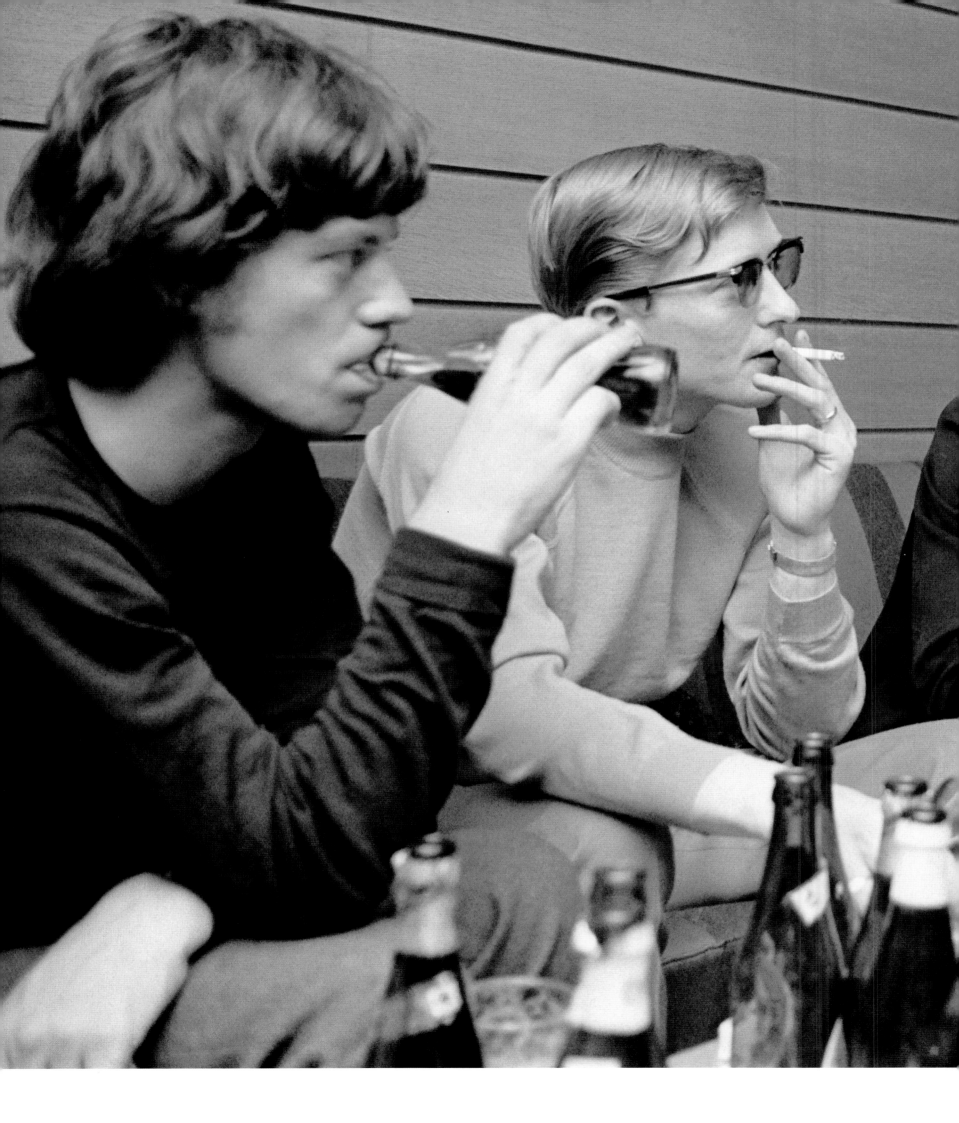

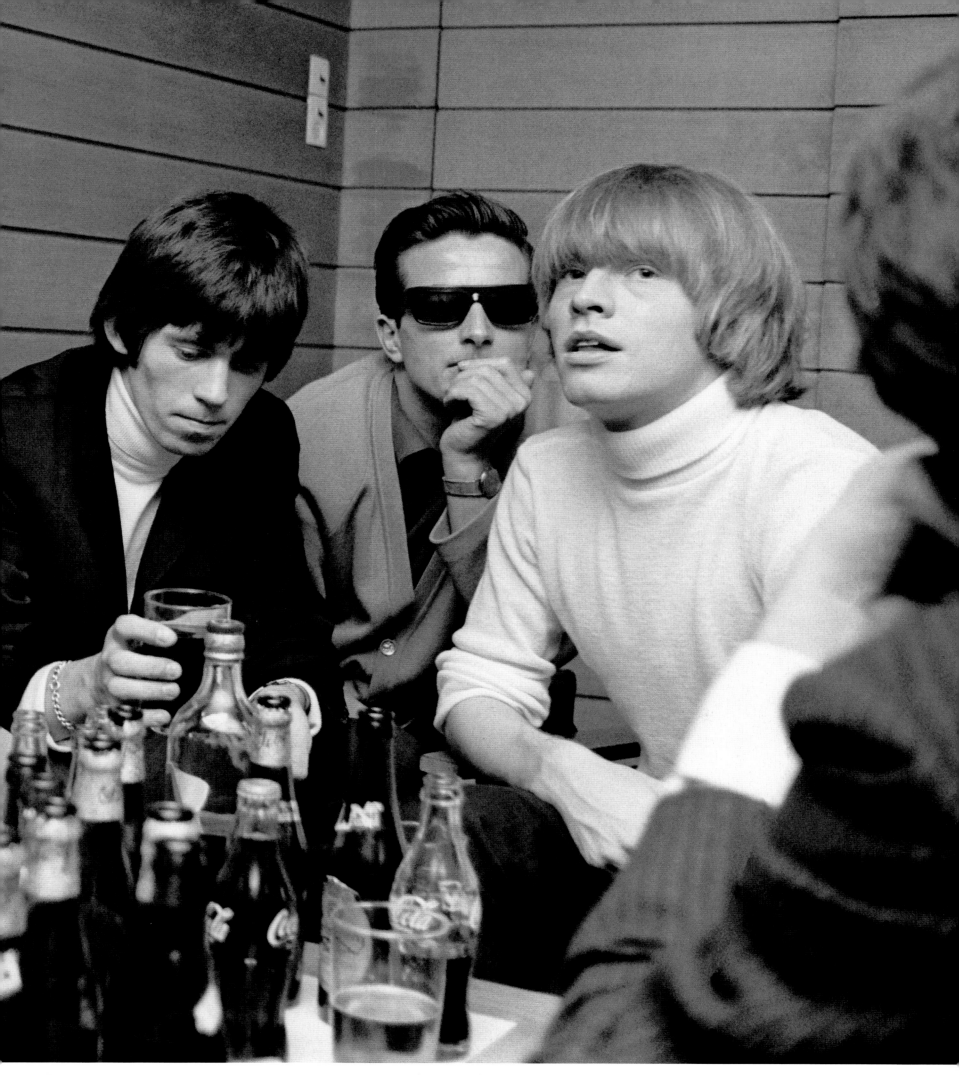

Backstage between shows with Knud Thorbjornsen (smoking) and Mike Dorsey (Stones roadie in sunglasses); the band enjoying Johnnie Walker Red Label and Coke, along with some Danish beer.

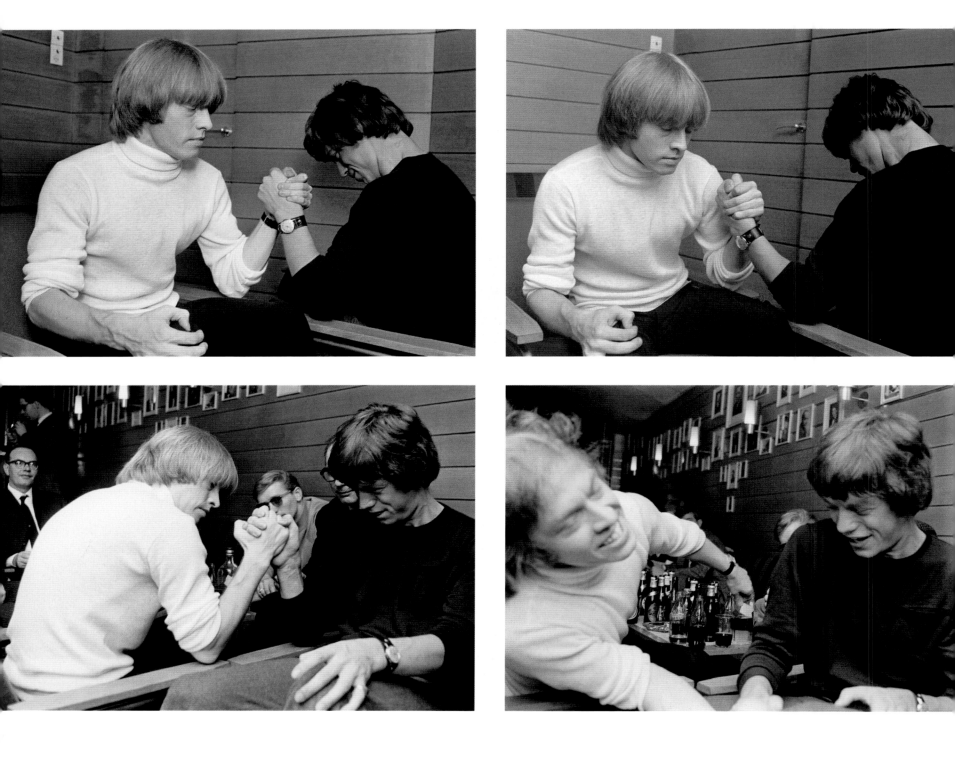

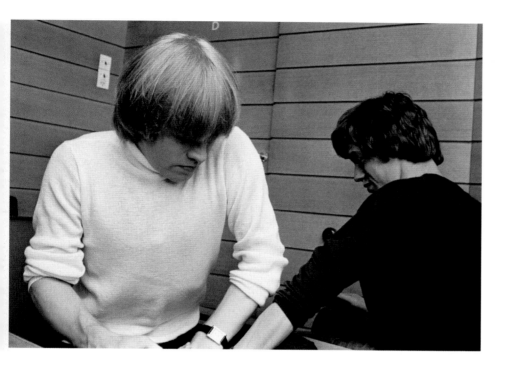

Mick and Brian got down to a little arm-wrestling. Brian had the strongest left arm, Mick the strongest right arm. It symbolizes the power struggle that was developing as to who was the real leader of the band. While it was Brian who had put the band together, Mick, as the front man, was increasingly becoming the centre of attention. While the balance of power may have remained equal, like the arm-wrestling, with the addition of Keith on Mick's side of the equation it was to be no contest.

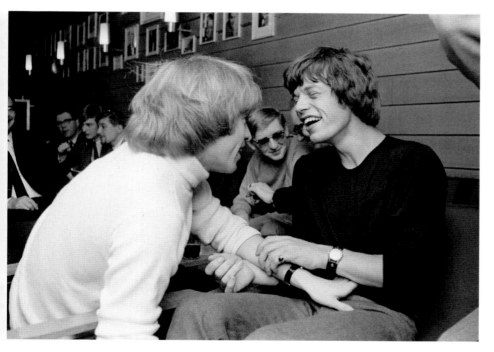

Charlie had secretly married Shirley in October 1964. She would sometimes go on the road with Charlie, and in Scandinavia they tended to go their own way when the band were not performing.

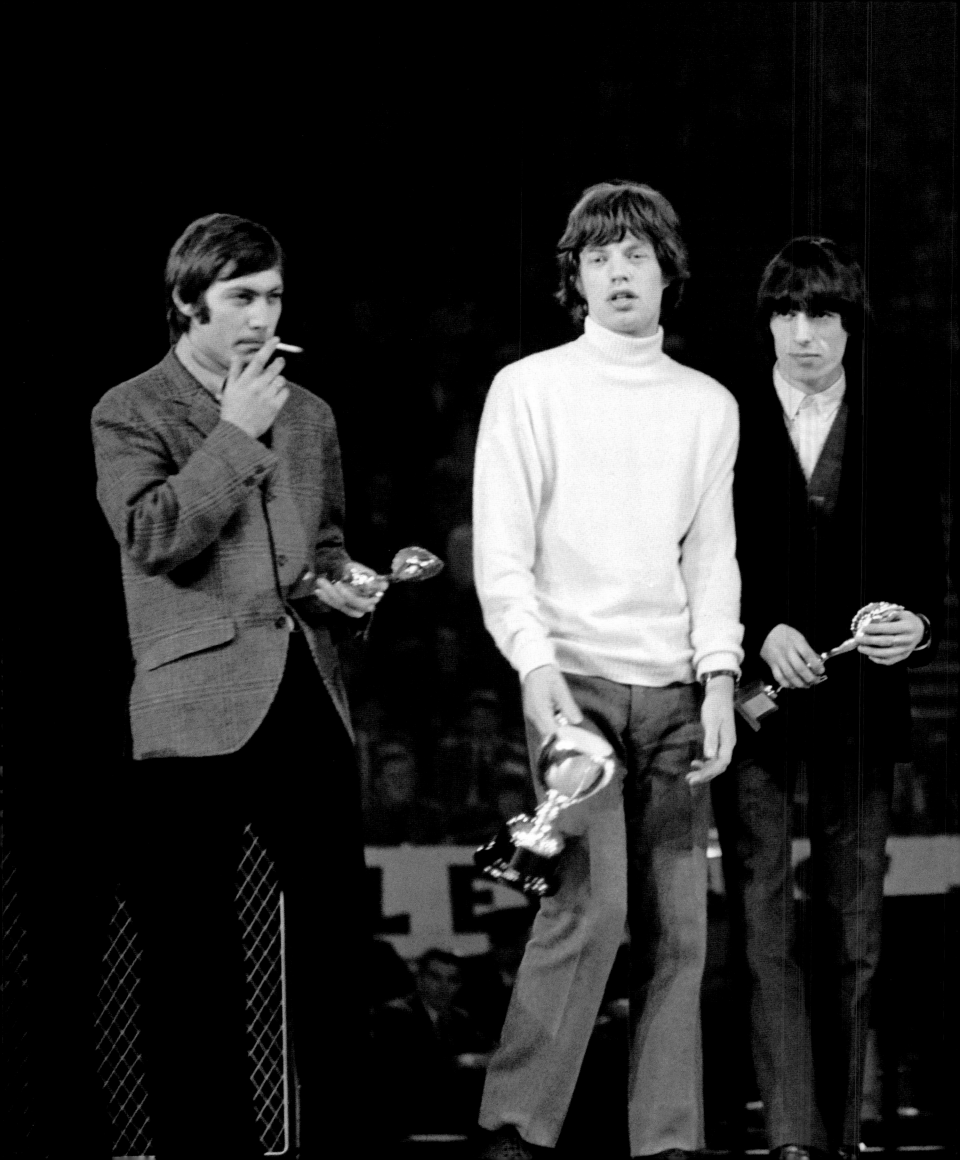

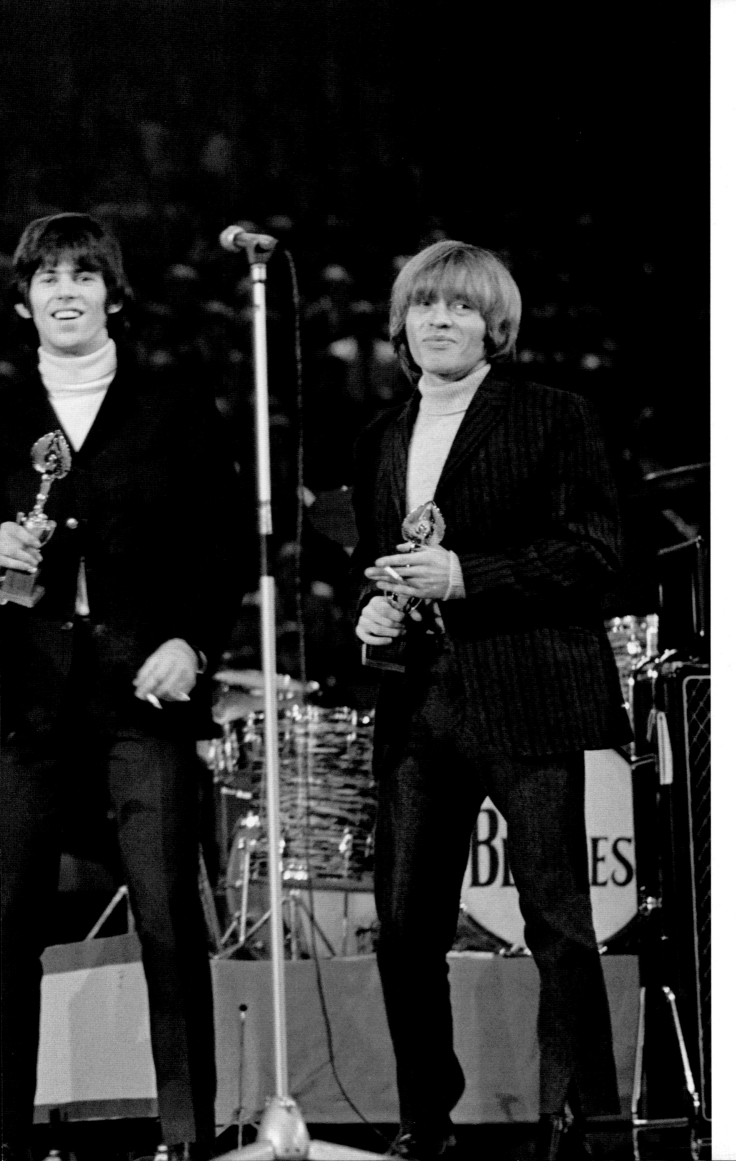

The New Musical Express Poll Winners' Concert: "The Stones flew back to London for the event. I also flew to London and shot the Stones at the concert at the Empire Pool, Wembley. The Stones closed the first half and The Beatles closed the second half of the show in front of 10,000 screaming fans. Other artists on the bill were The Moody Blues, DJ Jimmy Saville (compere), Freddie and The Dreamers, Georgie Fame, Twinkle, The Seekers, Cathy McGowan (compere), Herman's Hermits, The Ivy League, Sounds Incorporated, The Bachelors, Wayne Fontana and The Mindbenders, The Rockin' Berries, Cilla Black, Donovan, Them, Tom Jones, The Searchers, Dusty Springfield, and The Animals." BR

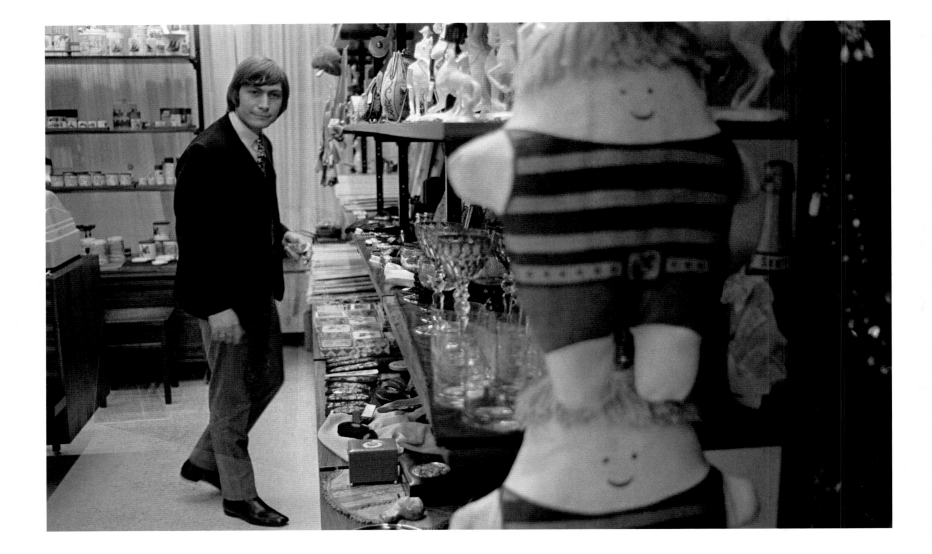

"Bill went shopping for some clothes and a present for his son with the immaculately dressed Niels Wenkens in Copenhagen's main shopping street, and walked around without attracting too much attention. Charlie bought some porcelain horse figurines for Shirley." BR

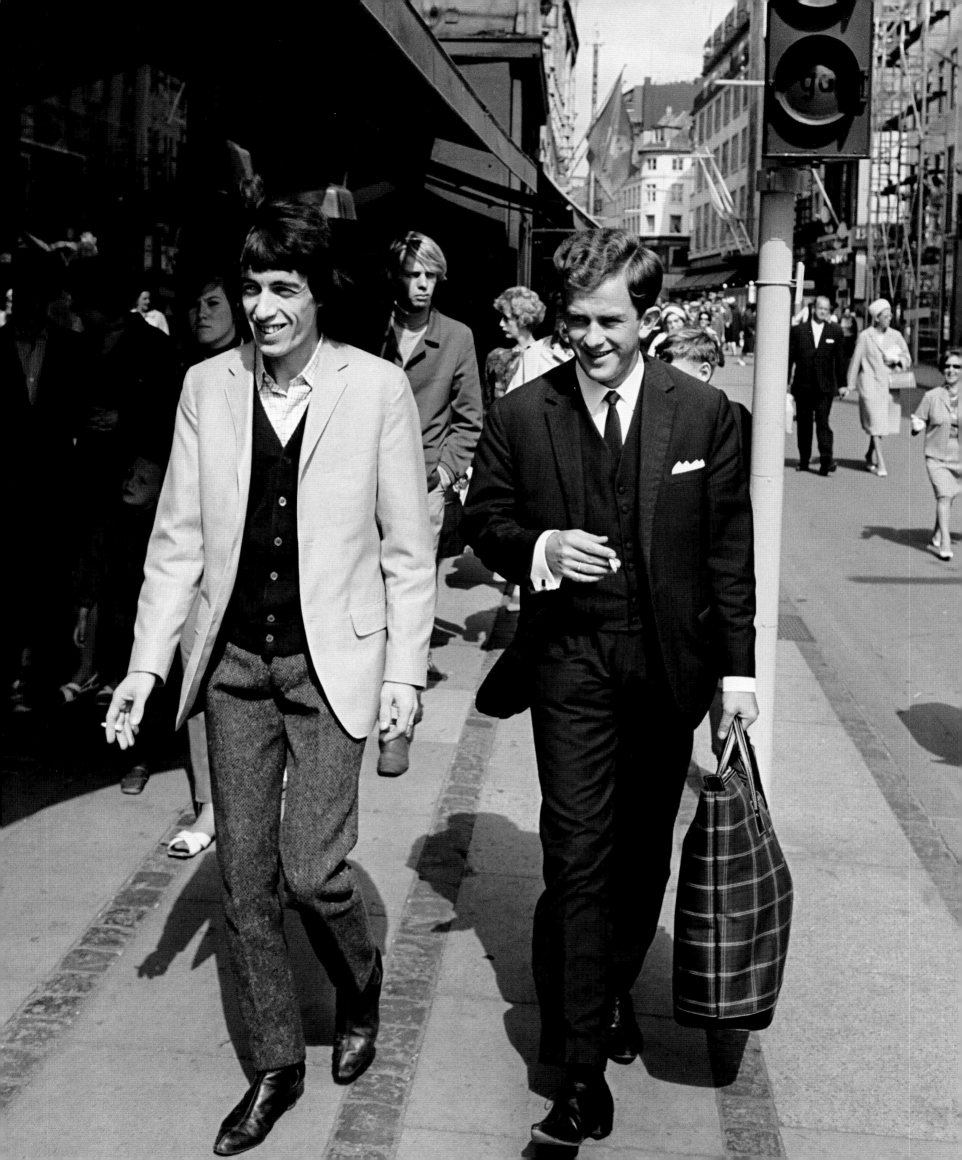

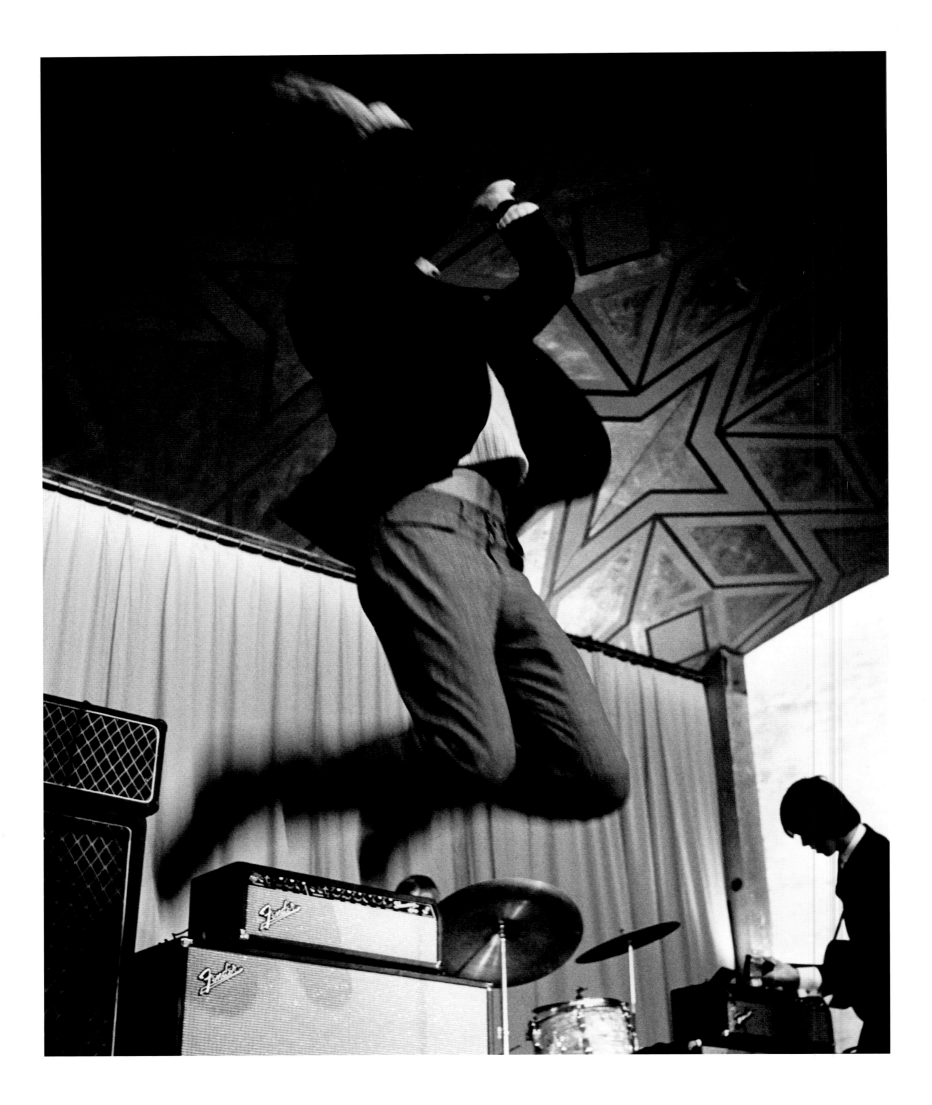

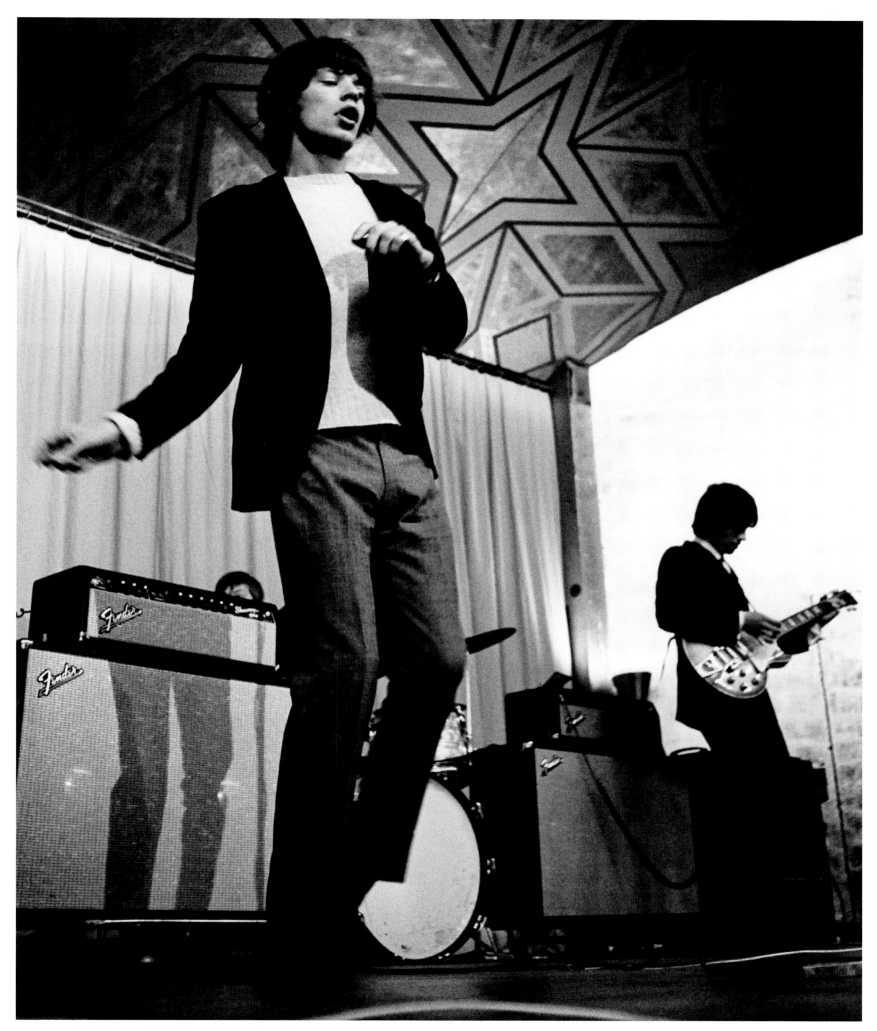

"Brian and Keith were using Fender amps which they had bought in America. I was still using a 100-watt Vox amp and two speakers. I placed one speaker cabinet on each side of the stage." BILL

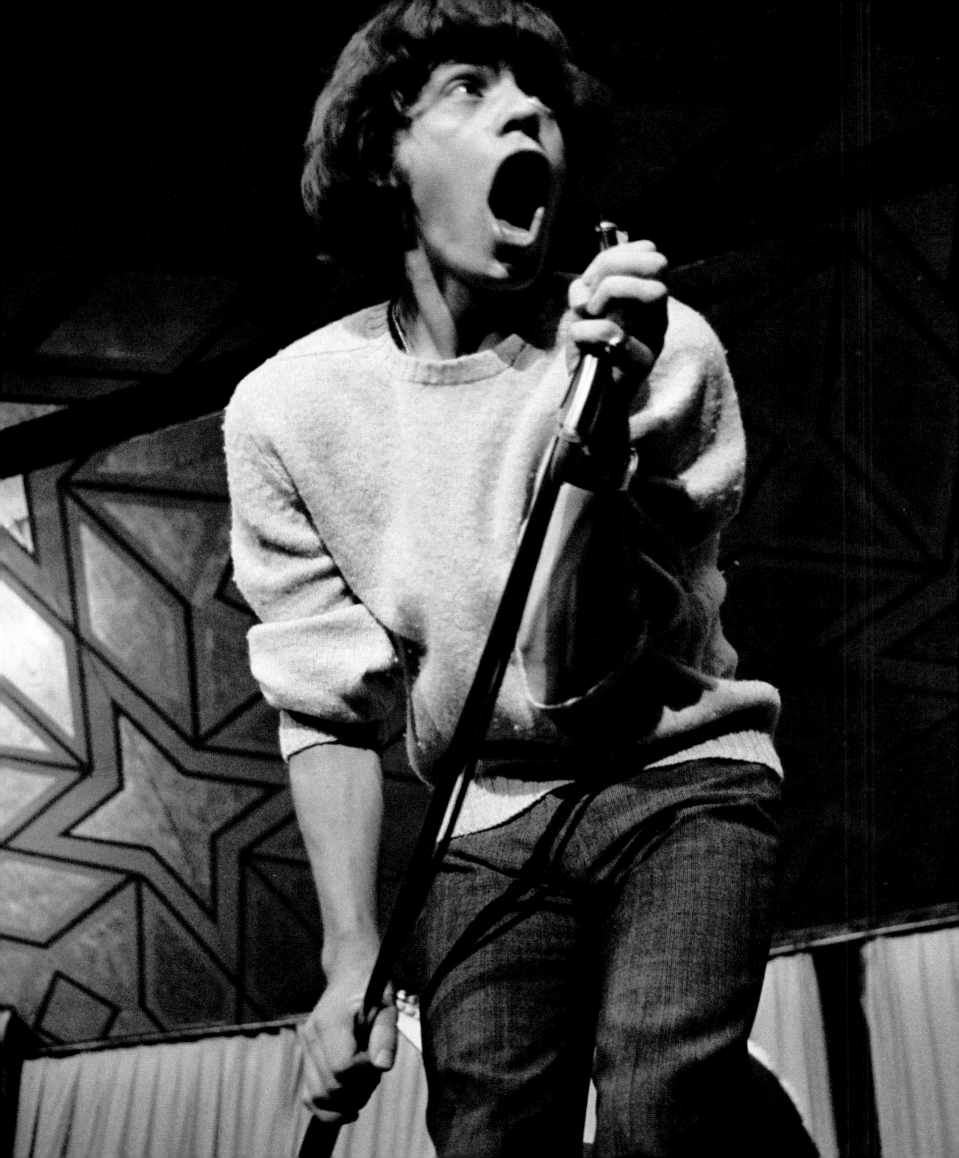

"The Stones took the ferry from Copenhagen to Malmö to play two shows
at 6pm and 8.30pm at the Baltiska Hall. They played to 2,000 typical
Scandinavian fans, before taking the ferry back to Copenhagen." BR

"Ladies and gentlemen... Charlieeee... Watts."

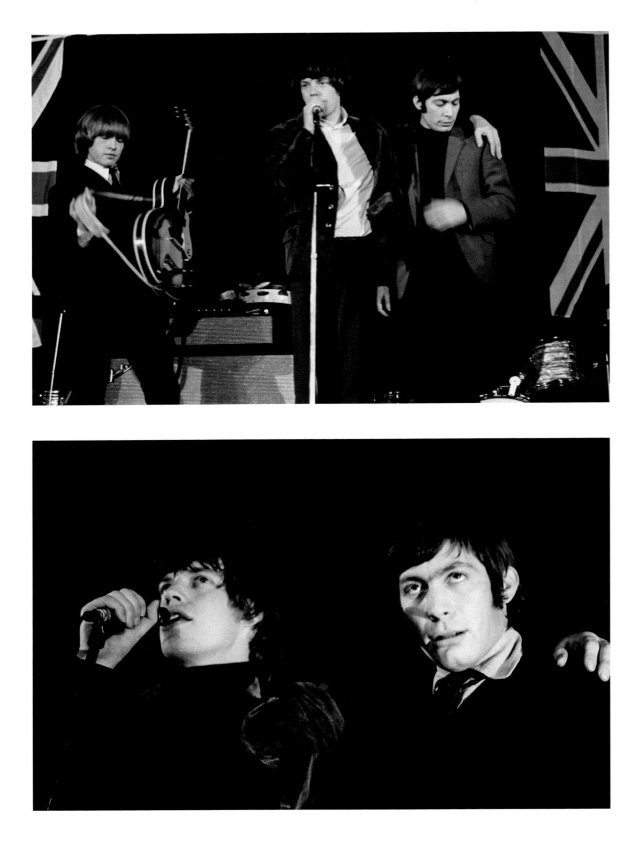

Simple staging was the order of the day; at best there was just a Union Jack on the back wall for stage decoration. All the band's equipment could fit into Ian Stewart's van. Mick would always introduce Charlie at some point during the show.

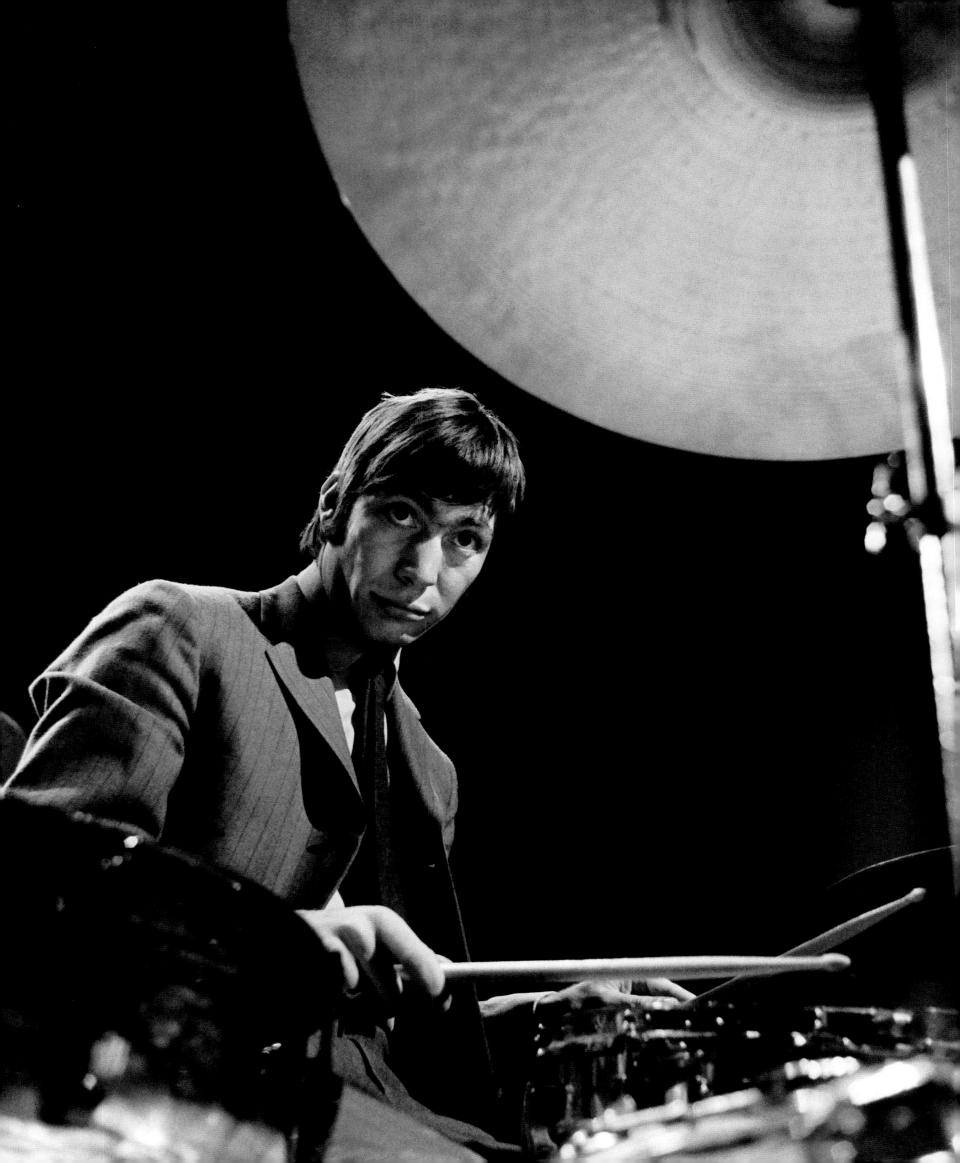

"Between shows in Malmö there was nowhere to eat at the venue and so Niels Wenkens went knocking at people's homes and persuaded them to make up some open sandwiches so the band could eat. Keith and Brian had a food fight, and ended up turning an open sandwich into a closed sandwich. They also threw some sandwiches out of the window to the waiting fans. Malmö was the last night of the tour and after the rest of the band flew home to London Brian stayed at my house in Copenhagen for a holiday." BR

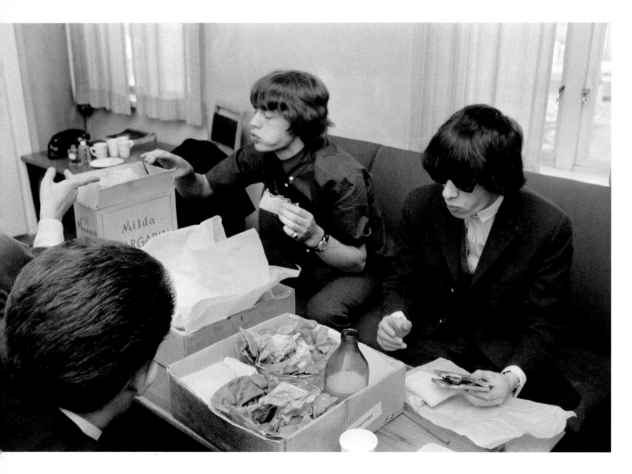

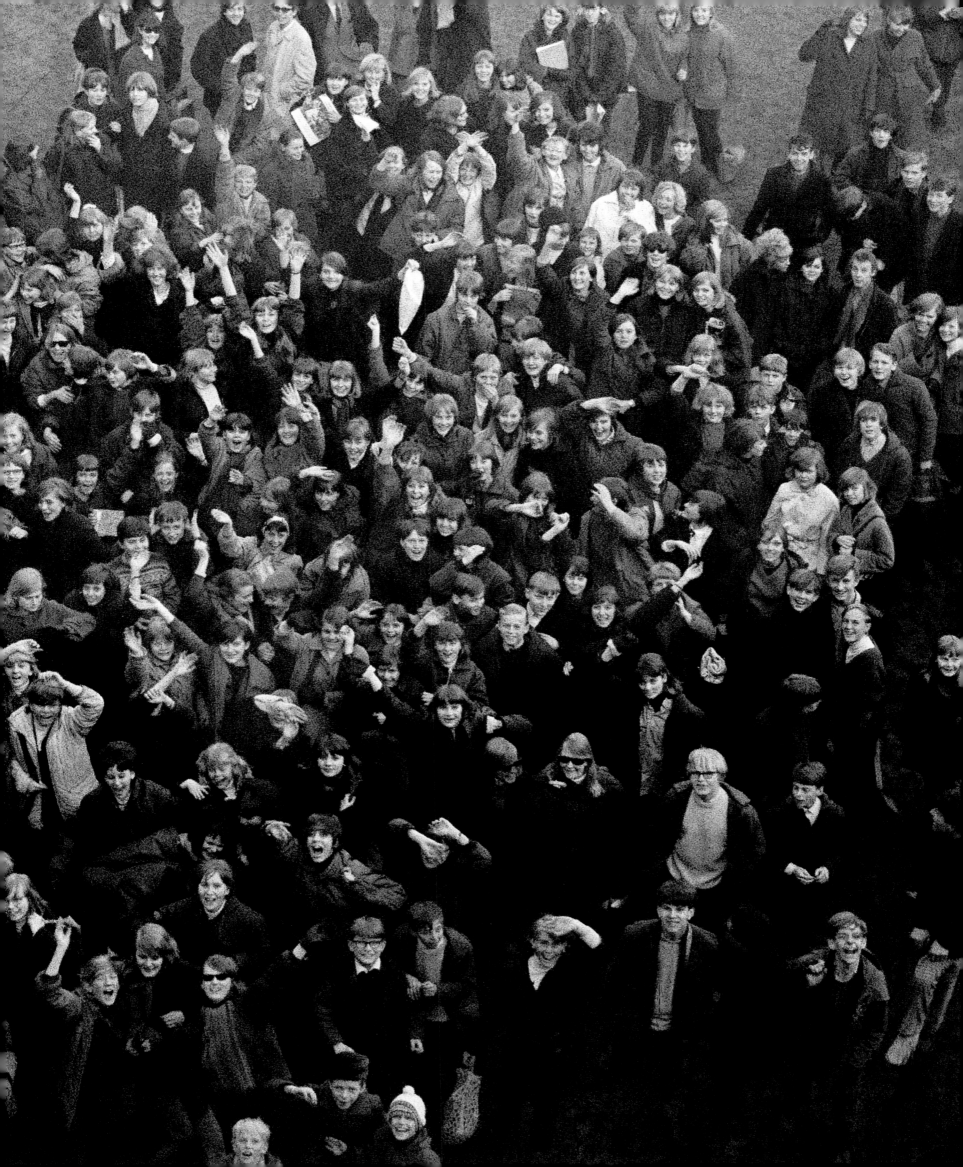

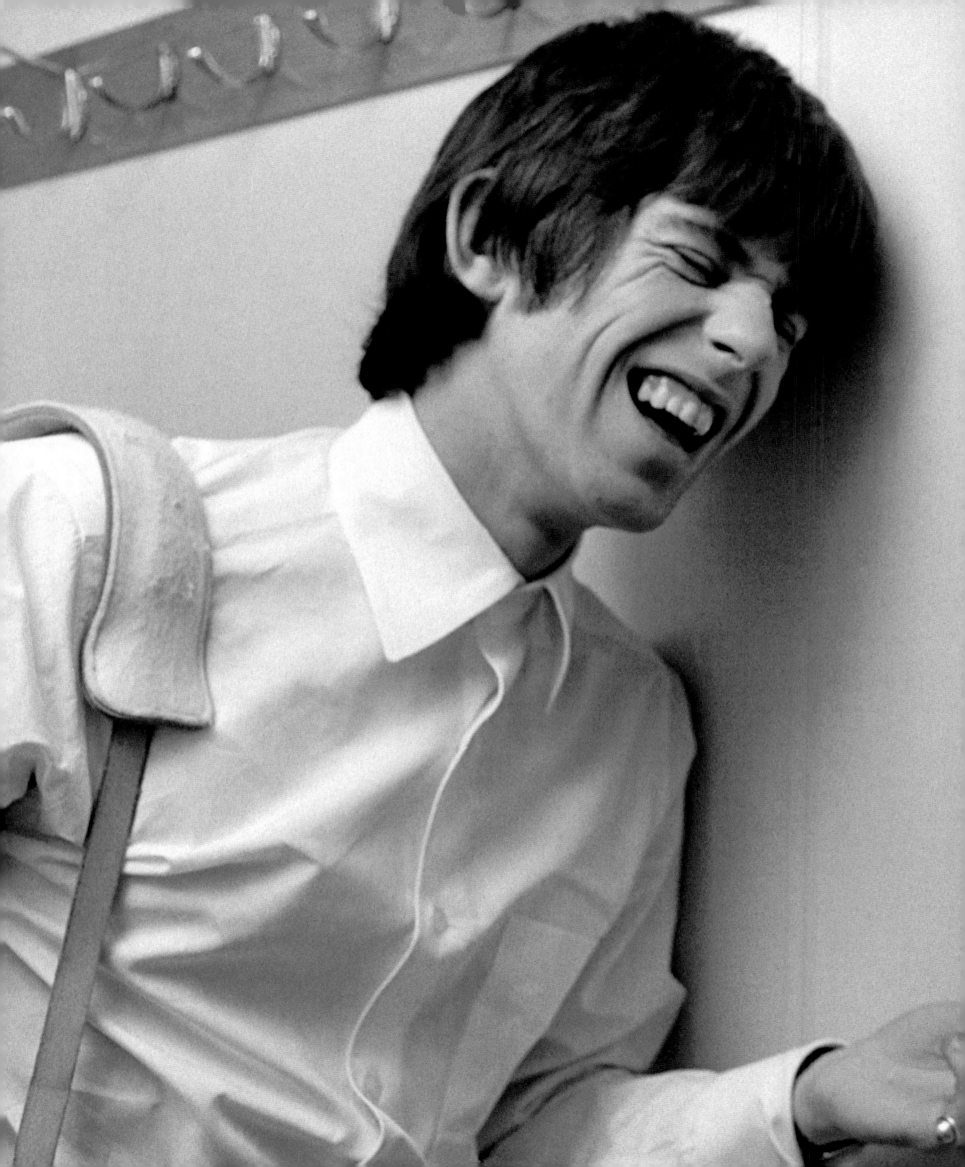

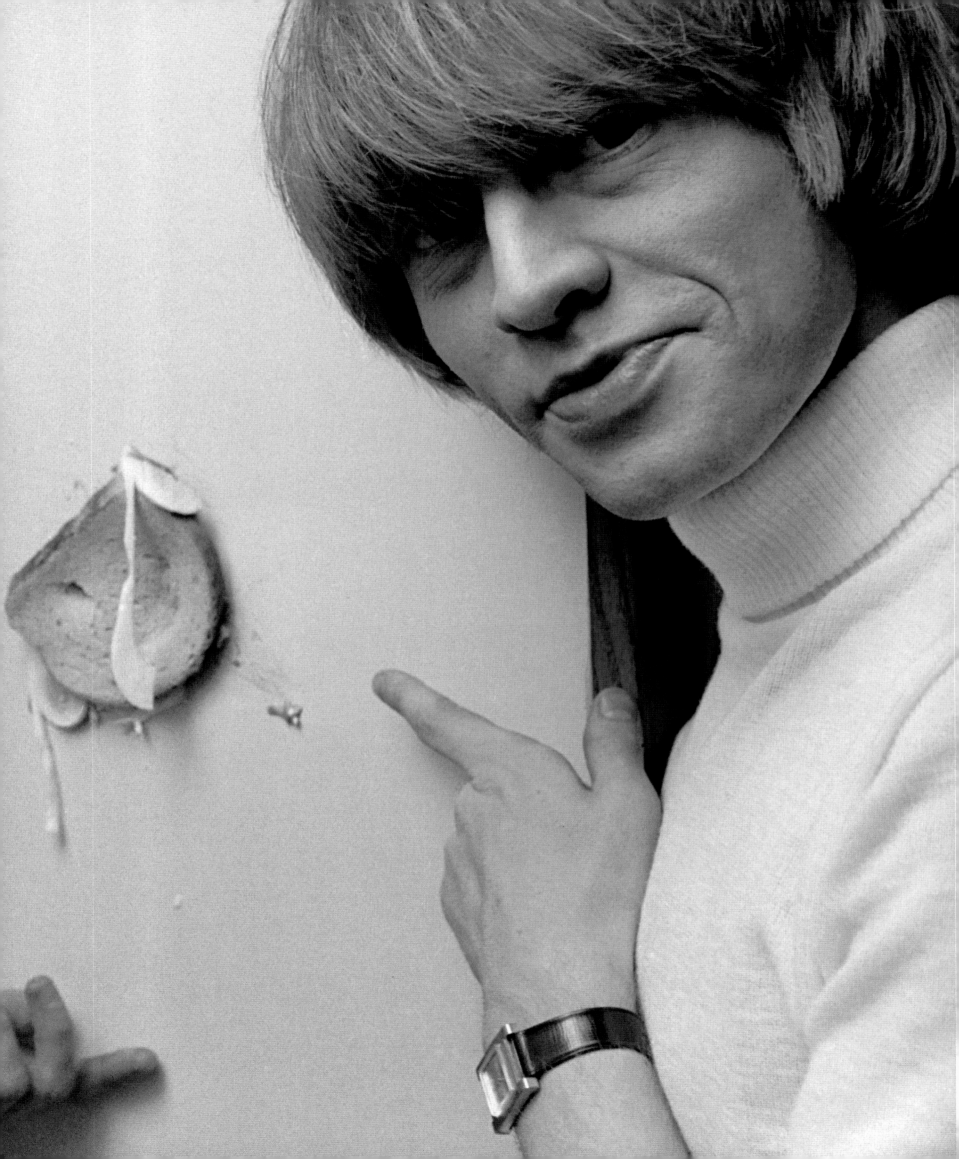

brian jones

LEWIS BRIAN HOPKIN JONES

Lewis Brian Hopkin Jones was born in Cheltenham, Gloucestershire, into a middle-class family on 28 February 1942. Brian's parents, Lewis and Louisa, came from Wales but had lived in Cheltenham since 1939. Lewis senior was an aeronautical engineer and Louisa taught the piano. Brian's father dabbled with the piano, played the organ, and led the choir at their church. Brian's sister, Pauline, was born in 1945 and died two years later from leukaemia. His second sister, Barbara, was born in 1946.

Soon after Brian started school, his mother began teaching him the piano — which would prove an important element in Brian's ability to pick up almost any instrument and get something from it. Later Brian moved to a fee-paying school where he not only showed promise in English and Music, but also the rebellious side of his character. In 1953 he went to Cheltenham Grammar School where, aged fourteen, he became First Clarinet in the school orchestra — he was known at the time as "Buster"! Eventually he got seven O-levels and entered the Sixth Form to study Physics, Chemistry, and Biology. However, it was not hard work that got Brian through school but an IQ of 135

Sometime in 1957 Brian heard a Charlie Parker record, and as a result he persuaded his parents to buy him a saxophone. Two years later Brian's first illegitimate child was born to a 14-year-old Cheltenham schoolgirl. The child was adopted and Brian had nothing more to do with either of them. His attention was focused on playing in a Skiffle group, like many others his age. He also started working in London, but it did not last long; Brian went hitchhiking in Europe instead.

In 1959 Brian met a girl in Surrey, had an affair with her, and she gave birth to his second illegitimate child, which she and her husband adopted. By 1960 Brian was at art college and playing in a local jazz band. But after he saw the Chris Barber Band with Sonny Boy Williamson, Brian fell in love with the Blues. Brian also fell in with a local Cheltenham girl and she too became pregnant, and although this relationship lasted slightly longer than the previous two, Brian was far from faithful.

Sometime in early 1962 Brian met Paul Pond, who (as Paul Jones) later fronted Manfred Mann. The two made a tape together, calling themselves "Elmo and Paul". Paul lived in Oxford, and Brian, when travelling between London and Cheltenham, often passed through Oxford, and slept on Paul's couch. It was in the spring of that year that Brian, sitting in with Alexis Korner at the Ealing Club, met Mick and Keith.

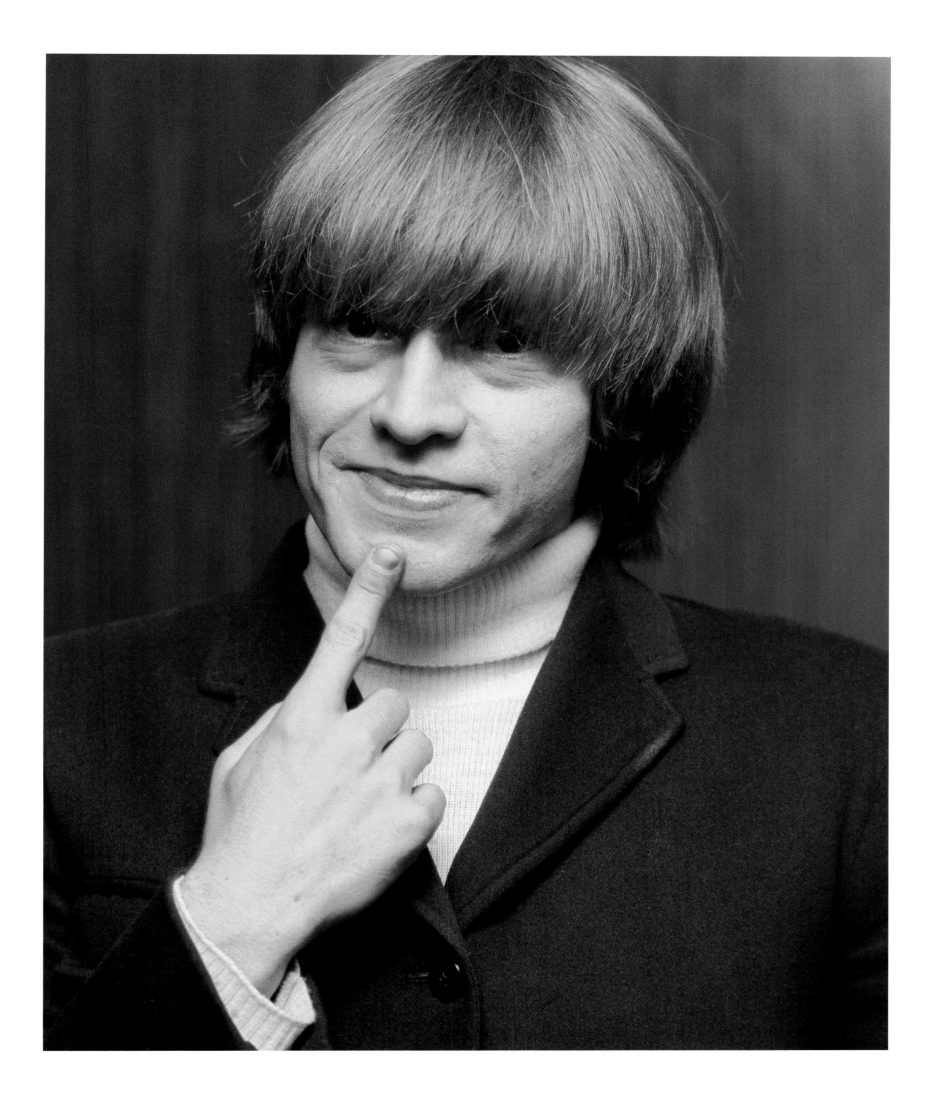

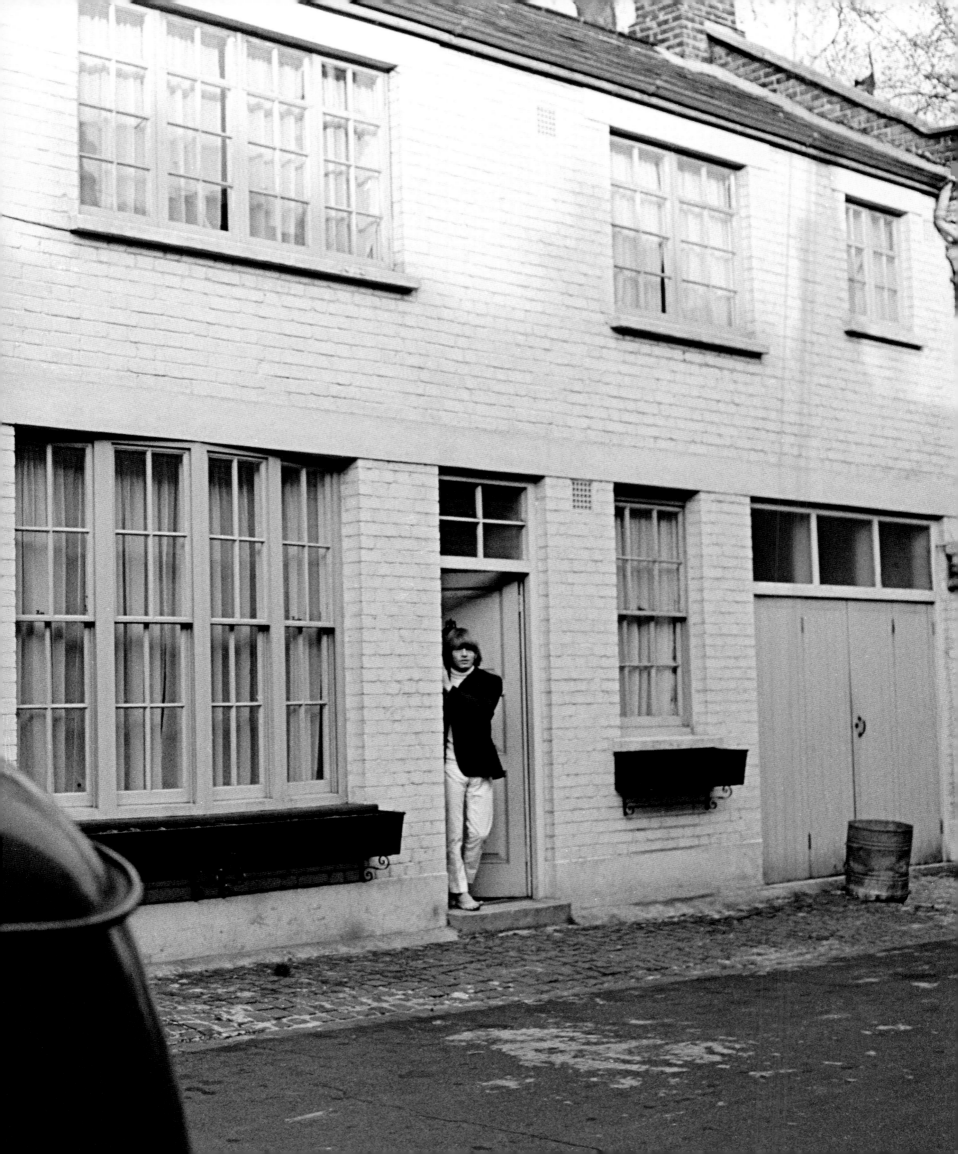

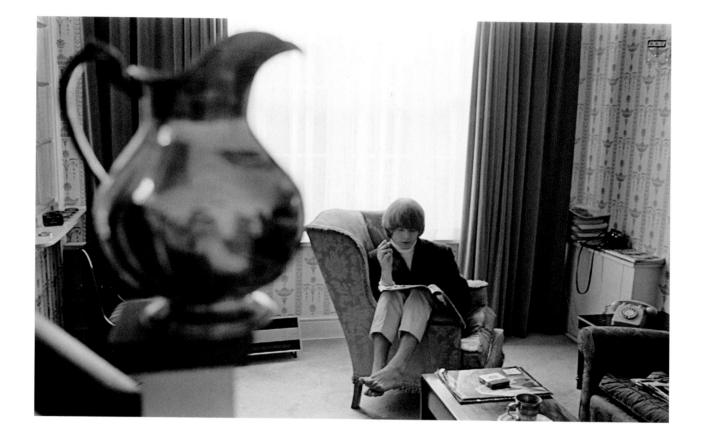

"After Brian had stayed with me in Copenhagen, I went to stay at Brian's rented house, 14 Elm Park Mews in Chelsea, which he had moved into in March 1965. I stayed in Brian's home on all my visits to London over the next year. I had my own key, my own room and bathroom, and came and went as I pleased. As often as not there were fans outside in the street but not on this particular occasion." BR

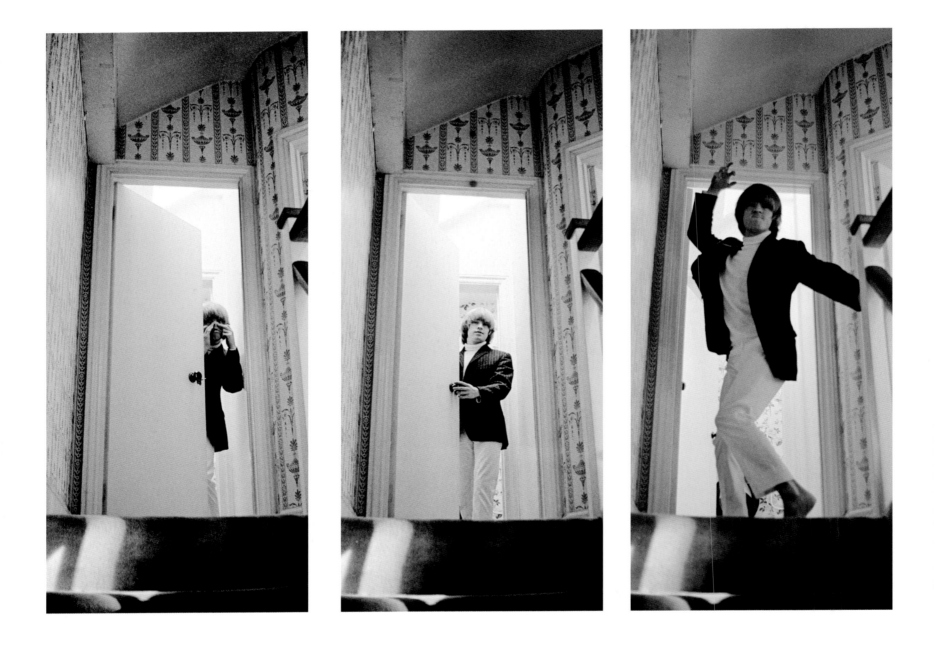

"Everything in Brian's house was rented and that's probably why it lacks much of an identity. The telephone was very important to Brian; he would often spend hours on it talking to Bob Dylan in the USA. I remember Eric Easton, one of the Stones' managers, being shocked by the size of Brian's phone bill. This was, after all, in a time when many of the houses in Britain still didn't have a telephone." BR

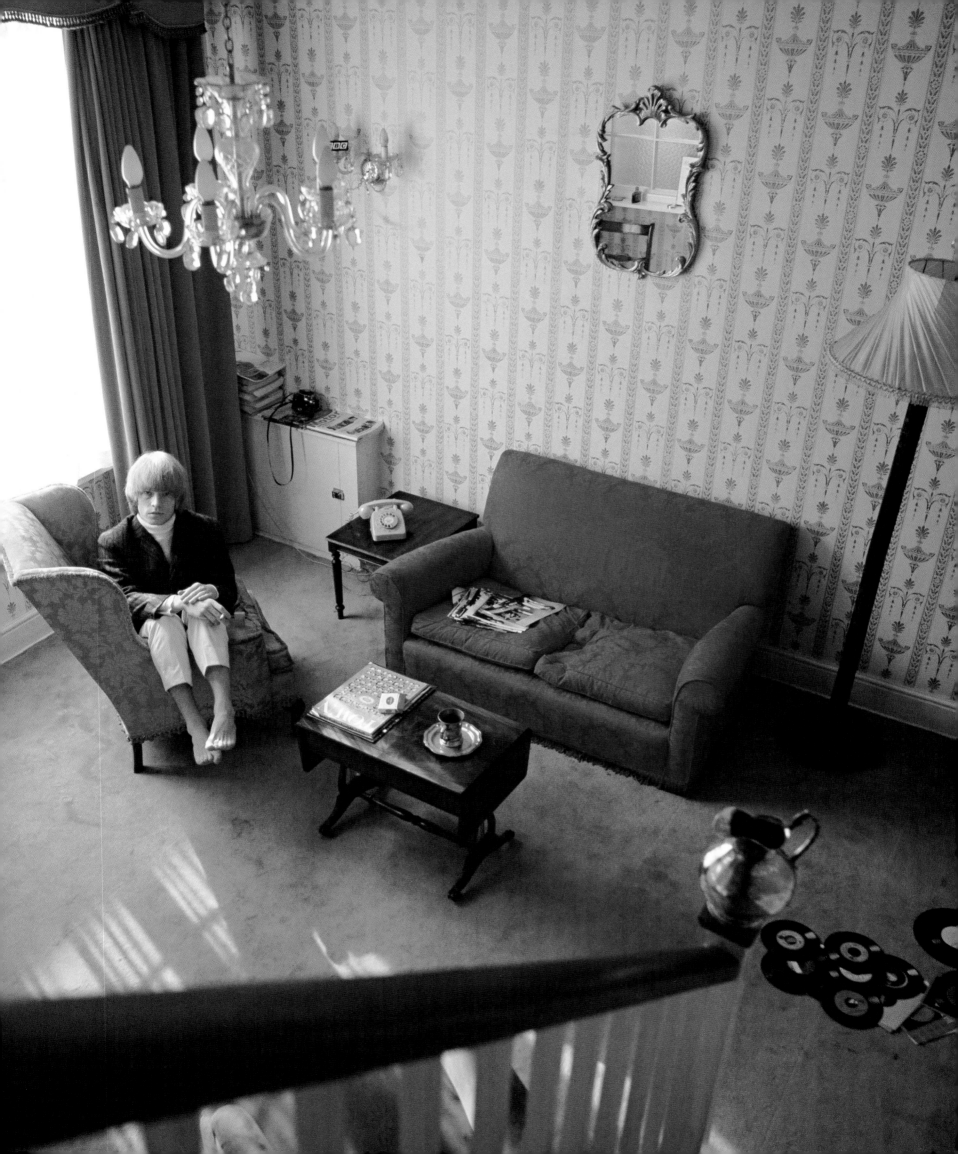

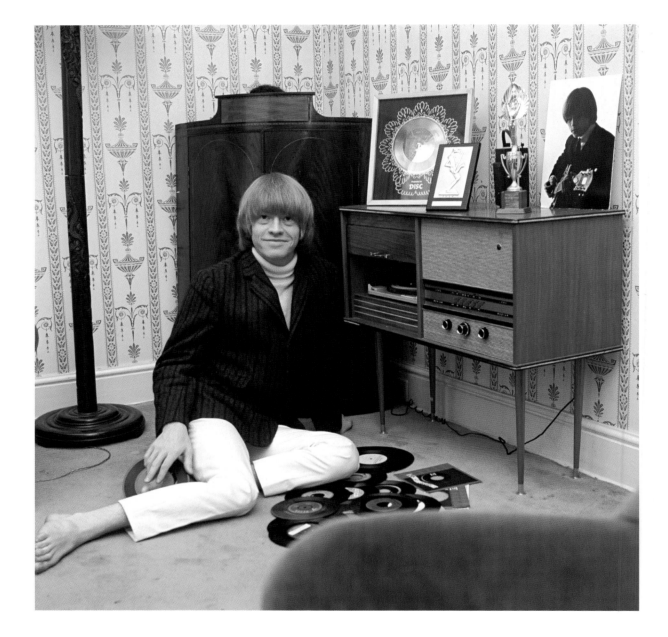

"About the only piece of furniture in the house that belonged to Brian was the radiogram, on top of which were several of the awards that Brian had won. I remember at the time that three of Brian's favourite records were **Baby Please Don't Go** by Them, Nina Simone's **Don't Let Me Be Misunderstood**, Dylan's **Mr. Tambourine Man** by The Byrds, and Otis Redding, who he played all the time." BR

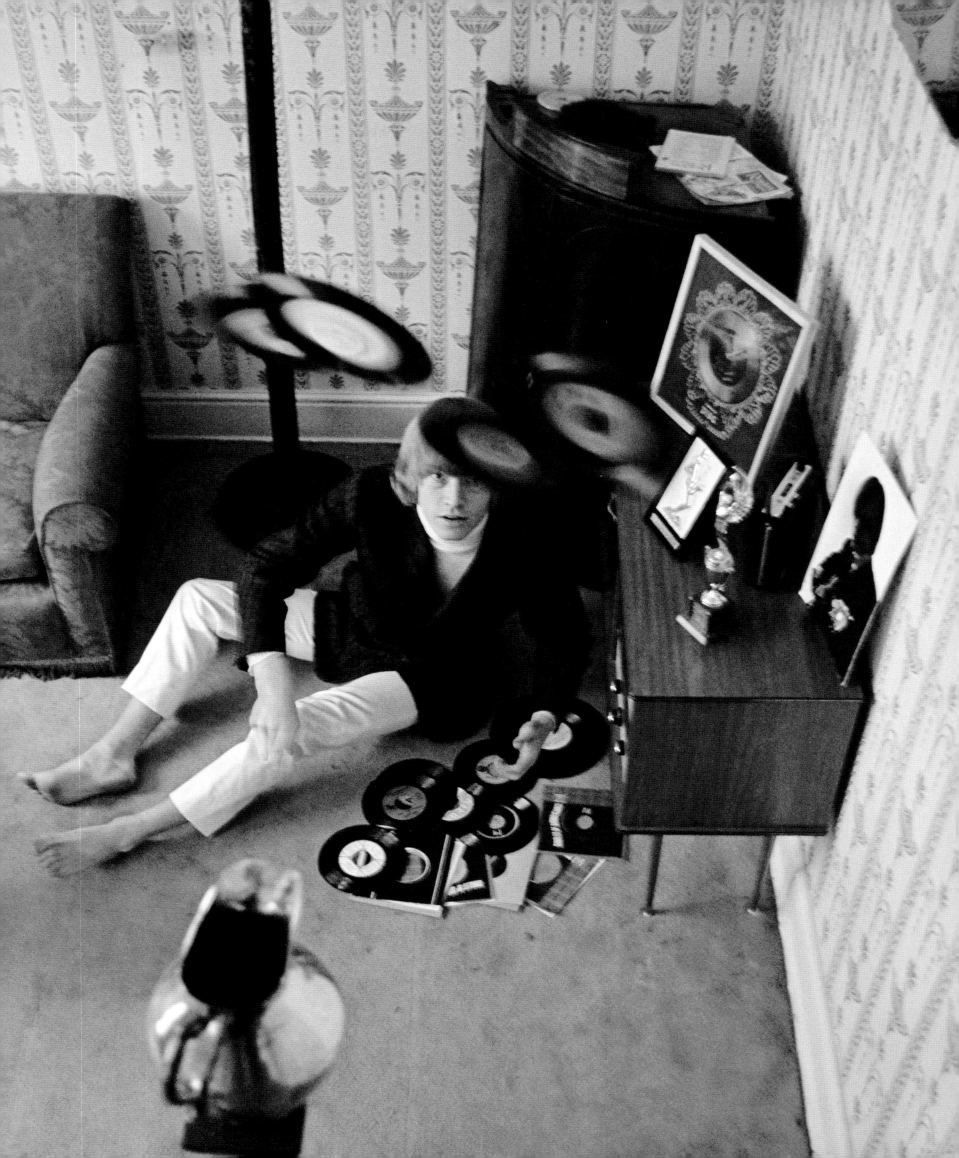

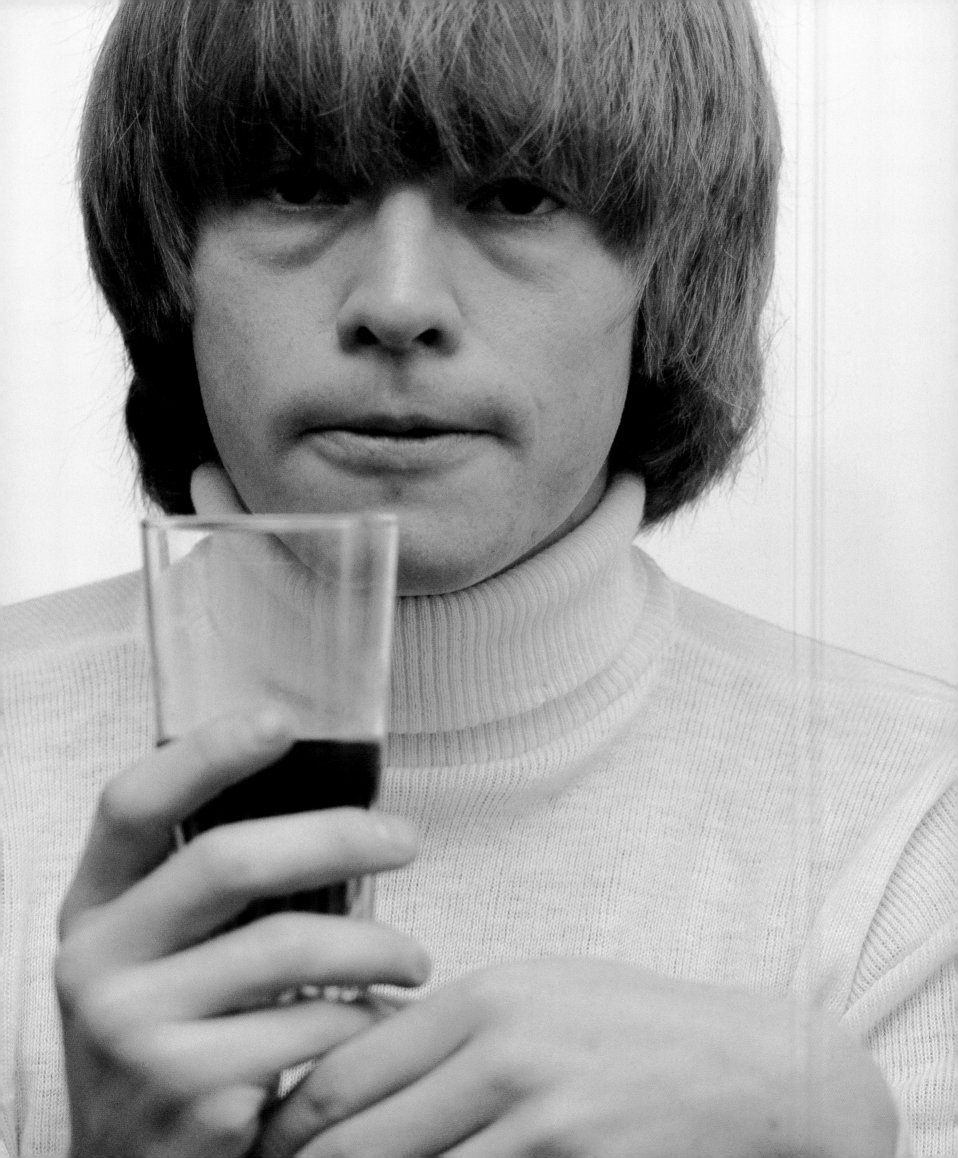

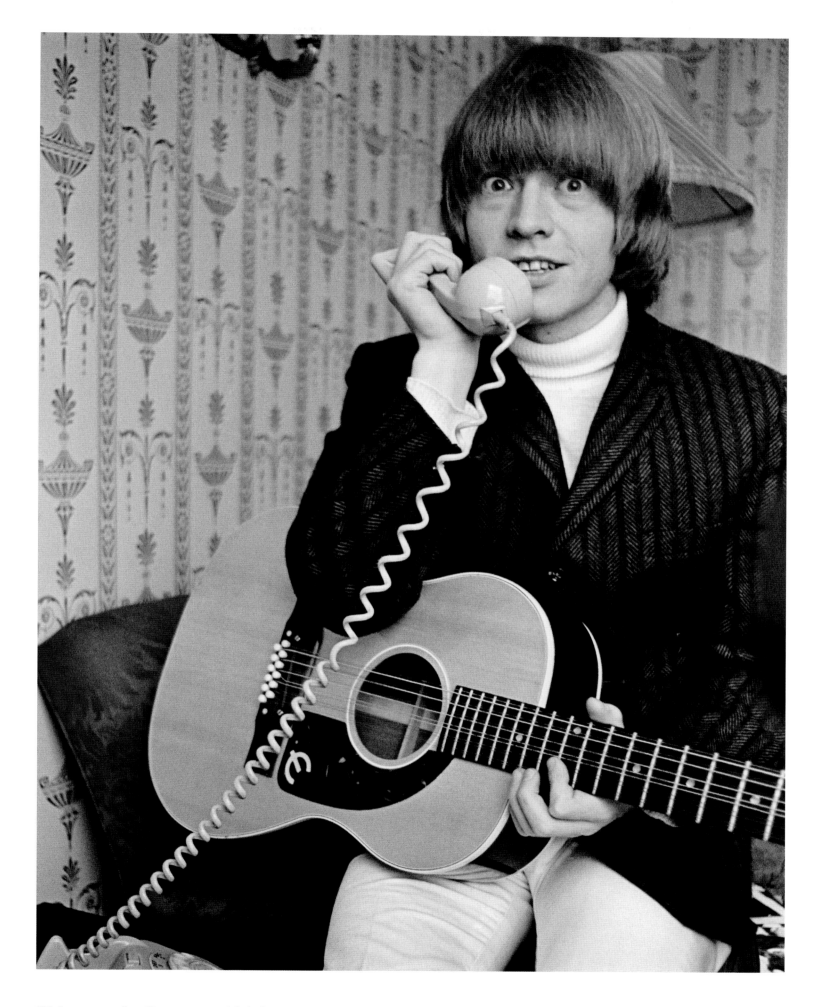

"Brian was the Stone on which just about every American band at the time seemed to model themselves. Look at pictures of The Byrds at this time and every one of them looks like a clone of Brian." BILL

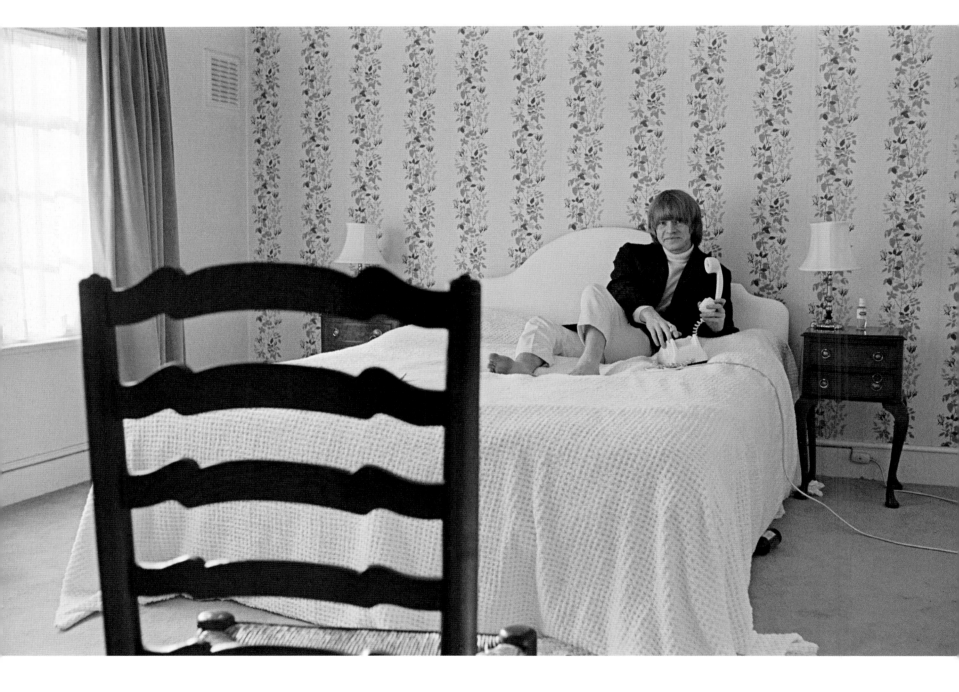

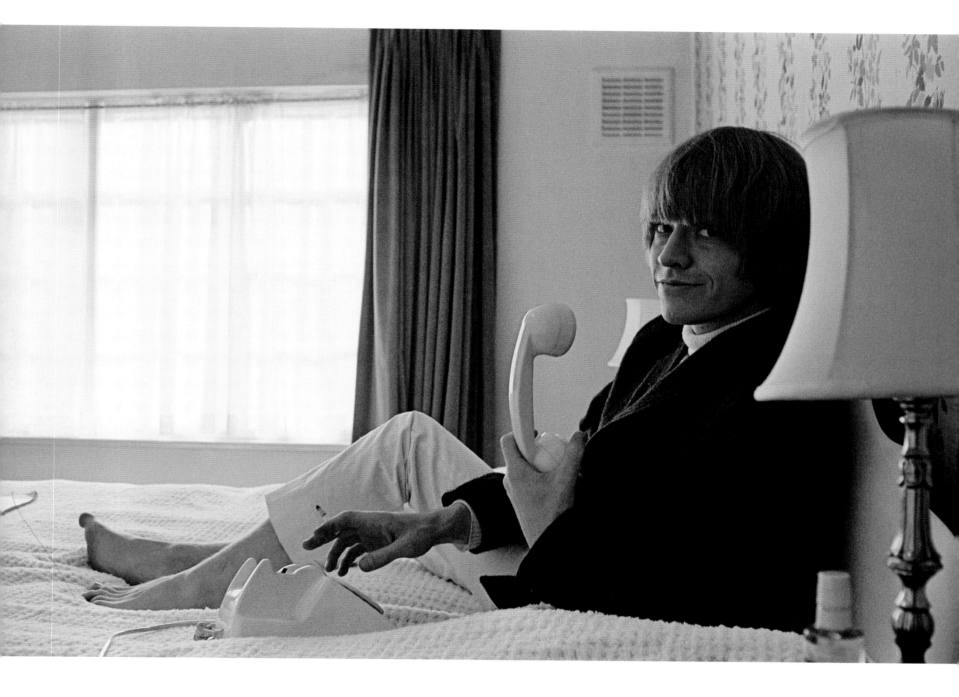

"When he feels that life is hell he shuts himself in his bedroom, makes phone calls or turns the TV on and he can remain there for anything up to ten hours. For preference he chooses gangster films or westerns which are so soothingly trivial that their noise fails to disturb him." BR MAY 1965

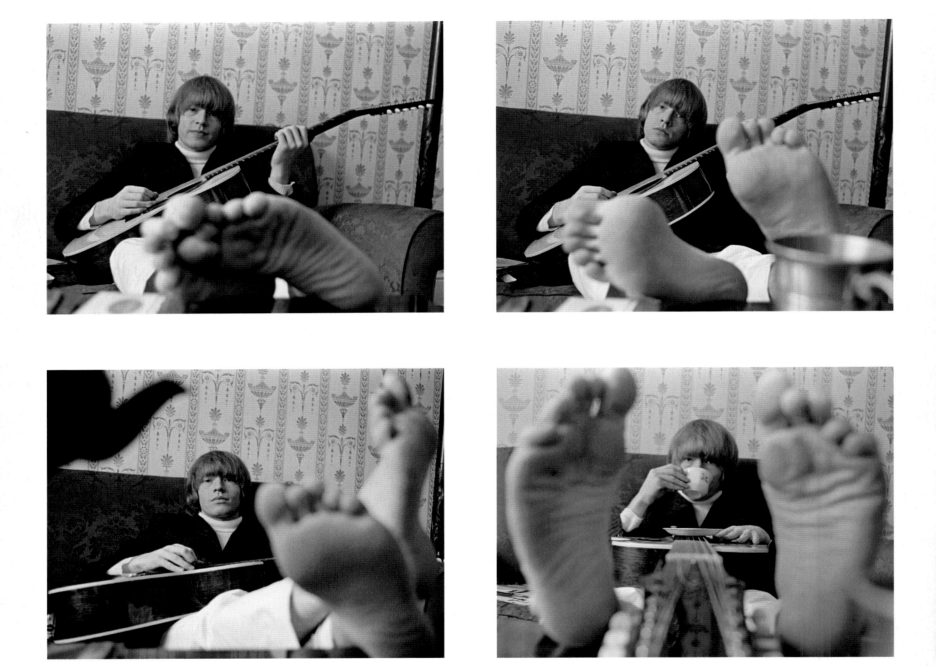

"This was probably Brian's happiest time. He was relaxed, his band was doing better than ever and there seemed no limits to the heights they could climb. Brian almost always went around barefooted at home, it was not something specially posed for these photographs. During this time we drank a lot of tea." BR

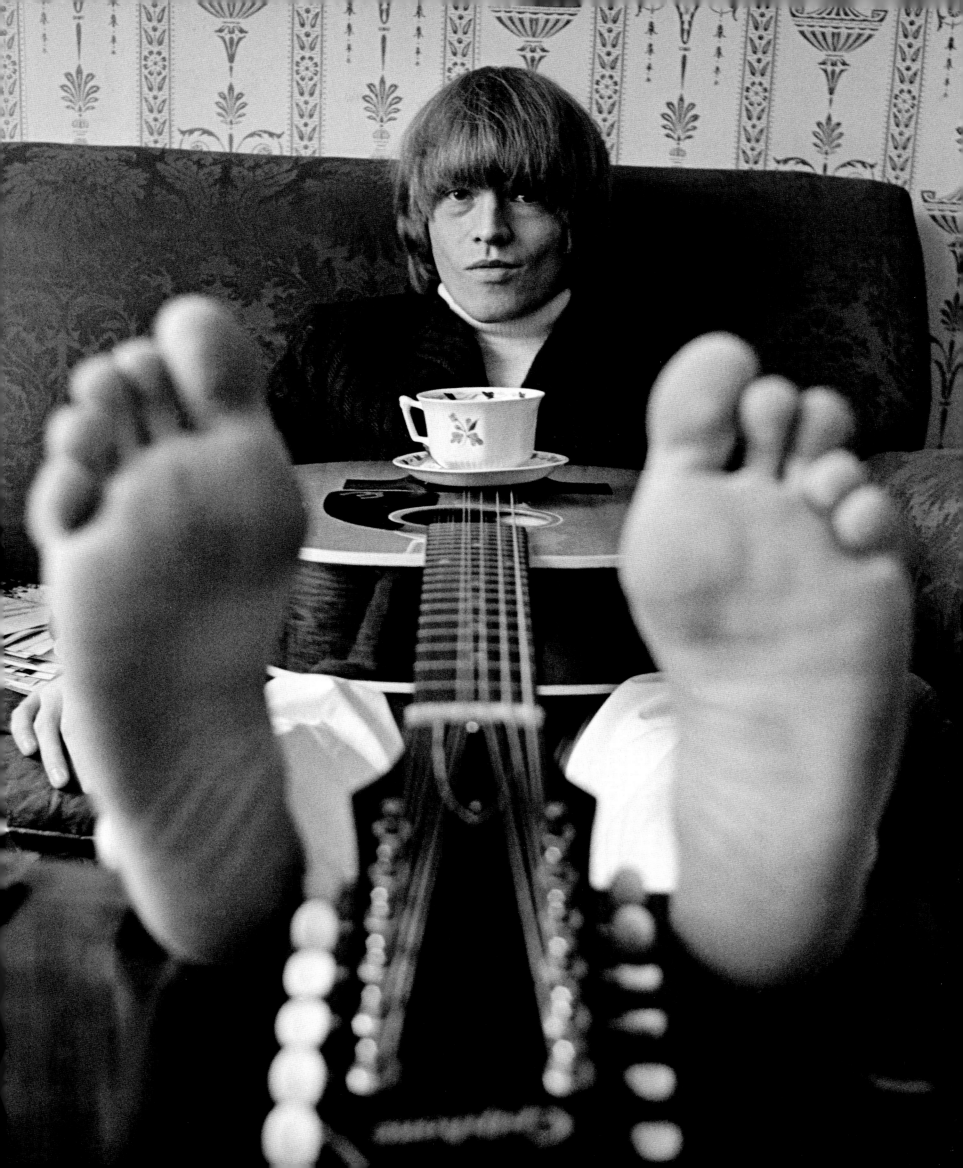

"Of course, Brian is different from the myth. I had the opportunity of observing this for myself when my wife and I stayed with him at his small rented terrace house on one of Chelsea's unobtrusive streets. Our friendship with Brian is the outcome of many encounters with him in Scandinavia, including the fortnight he stayed at our home in Copenhagen after the Stones tour.

"Brian is a restless wanderer, and if I ever thought the man was blasé (it would not be remarkable if he were, would it?) my visit convinced me of the opposite. Brian is 'interested' in the broadest sense of the word, interested in what he does, interested in what is going on around him, interested in people. It is obvious that he has not settled down yet. That's why he loves the life he is leading as a member of one of the world's most popular Beat groups. He loves travelling; he loves not knowing what tomorrow has in store.

"When he's at home with nothing particular to do, he walks round in his bare feet like a lion in a cage — ill-at-ease and restless. He seizes the guitar, plucks a chord or two, throws it down, picks it up again, sits down, gets up, before making an offhand remark without expecting an answer.

"Brian is the easiest to connect with of the five Stones, but I think he's the last one you get to know. When he has overcome the shyness (which he himself admits is one of the heaviest crosses he has to bear), when he suppresses the distrust he has for people, he begins to open up. In spite of his position, his fame, and his money, he feels fundamentally uncertain about himself. 'I never express my real self except when I'm playing. A good concert bucks me up for days on end; a poor one knocks me out. I'm really living when I play; I believe in myself.' Once he starts, he can talk about himself for hours; about his lack of faith in his ability, about his fear for the future; money has nothing to do with it; his doubts concern the man in him. What he will be doing, with whom he will be living.

"But the truth about Brian Jones is not all depressing. Now and then the self-assured Brian comes to the surface. One day, after about ten hours of concentrated TV rehearsals, he came home with a smile all over his face. He looked at us and said, 'Come on, folks, let's cut loose'. He borrowed the keys of my car (having no car of his own) and took us on a highly instructive round of all the worthwhile bars and clubs in London." BR MAY 1965

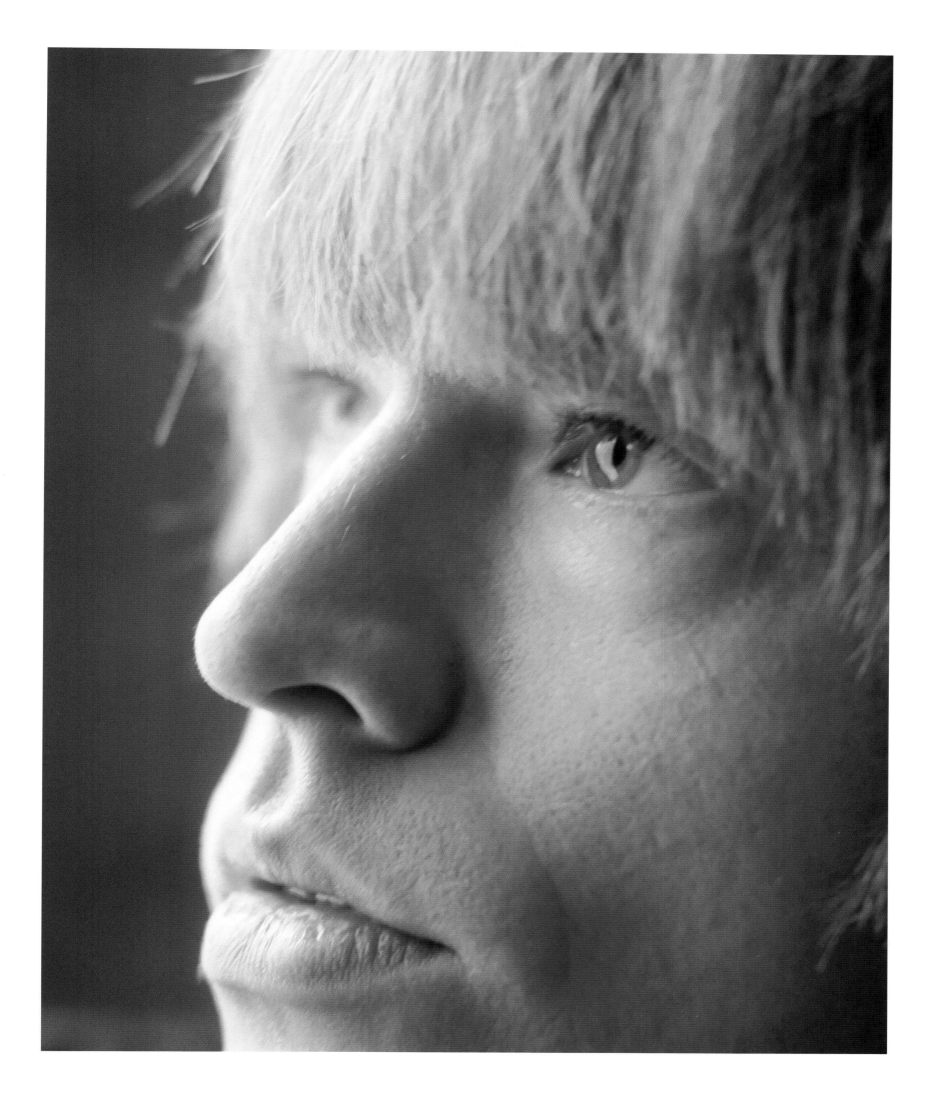

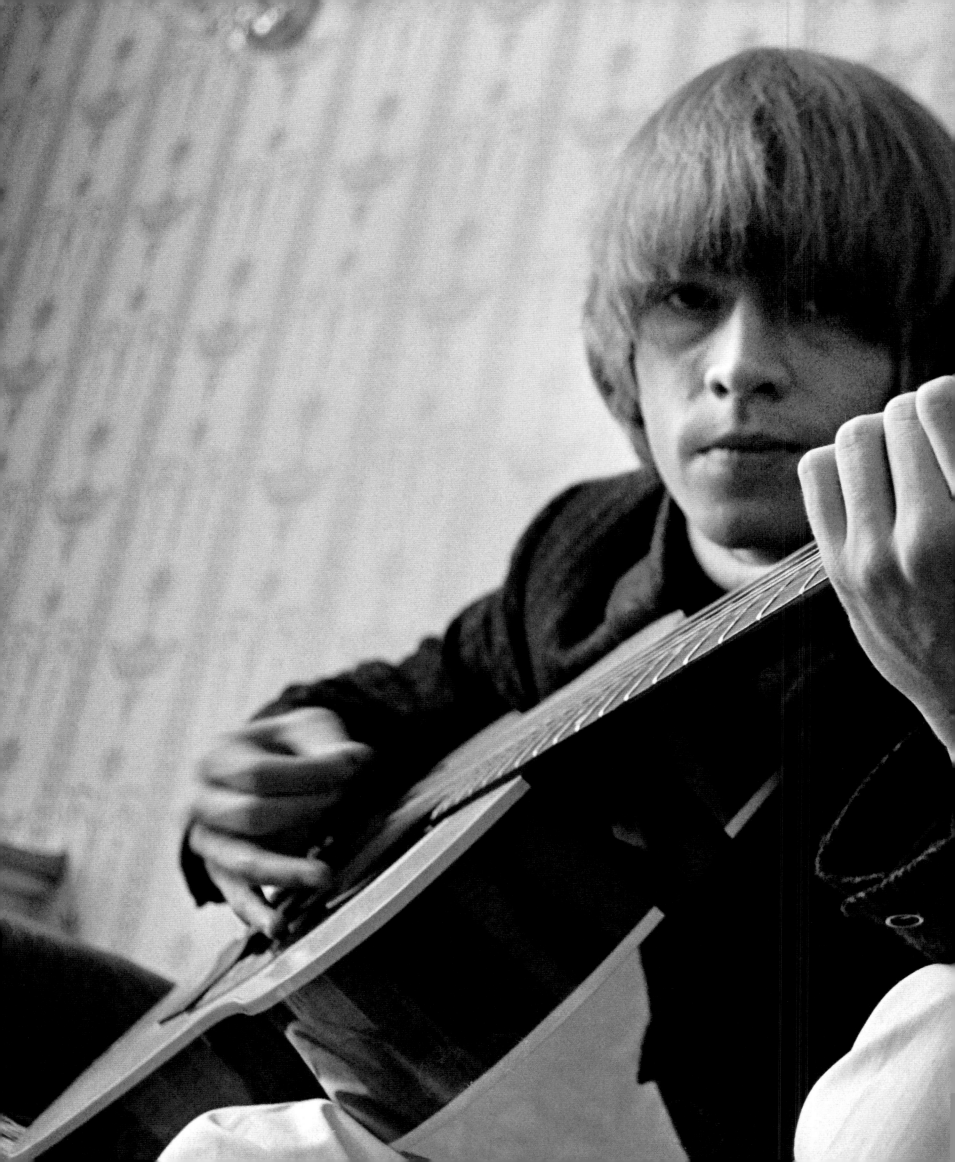

ON THE ROAD

Just before the Stones went to Scandinavia, to begin their first tour in Europe, they completed a two-week package tour of the UK with The Hollies, Goldie and the Gingerbreads, and Dave Berry and the Cruisers in support. Their first Danish date at Odense was eight days after the last Hollies dates. In between, the Stones had been reported for using a garage forecourt as a lavatory, appeared on TV's Thank Your Lucky Stars, and Keith had appeared in court on three motoring offences — he had been caught driving without L-plates, which had been stolen off his car.

Three weeks after finishing the Scandinavian tour they began their third North American tour; it was, to this point in their career, their most prolonged spell away from home. On this tour they were beset by problems: hassles with hotels, trouble with fans, an unsympathetic press, worries back home, and arguments among themselves — the first signs of a serious divide in the band. Brian was beginning to feel like he was on the outside. They played 21 different venues by the time the tour had ended, with most of their gigs on either the West Coast or the East Coast. According to Bill at the time, they were nearly killed after a concert in Long Beach, California. "We were told to make for an exit, but it was too narrow for the limousine to get through. We backed up, and made for another exit. Too narrow again, and by this time 6,000 kids tore down on the car. We have been in some awful crushes and jams, but this was the worst ever. I thought we would all be crushed and suffocated. There must have been 100 teenagers on the roof of the car, and more piling on to them, like a rugby scrum. The car was surrounded, and bodies were jammed against the sides and windows. Girls looked terrified and fought for breath. In the car we all stood up and pushed on the roof with all our strength to keep it from coming in on us. The car was battered and dented. The police started swinging their long batons, hitting at everything, as they tried to restore order. There were several casualties. One girl lost fingers on one hand, and another had her foot crushed. It was horrible."

Home from America at the end of May they did a short tour of Scotland starting in mid-June before they headed back to Scandinavia for four more dates. In mid-July there was a six-date UK mini-tour that included two shows at the London Palladium at which Bill played his new Wyman Vox bass for the first time. After a break in August they were back in Germany for a troubled tour in September.

Home from Germany there was barely time to catch their breath before beginning a 24-date British tour with The Moody Blues and The Spencer Davis Group as the support on some of the dates. Twelve days after finishing the UK tour on 17 October they began a huge US tour that went from coast to coast and had the band appearing at 37 venues in 38 days. There were concerts in 20 different states, along with Washington DC and three cities in Canada. They played matinées and evening shows on six different days, which still only gave them seven days off in seven and half weeks away from home.

The band then had a decent break until 11 February when they left Heathrow to fly to New York en route for Australia. By the time the Stones arrived in Sydney on 16 February to begin their second tour of Australia and New Zealand it had been their longest break from performing since January 1963. In Australia their popularity was assured as Decca had released thirteen singles, six EPs, and four LPs; supporting the Stones throughout the short tour were The Searchers. According to Frank Allen of The Searchers: "We traversed Australia with The Rolling Stones, a combination as weird as teaming up Vlad The Impaler with Mother Theresa."

When the Stones returned from down under they did so via Los Angeles where they did some recording. Their first shows of a short European tour were in Holland, Belgium, and France and finished in Denmark and Sweden. Following the release of the **Big Hits (High Tide and Green Grass)** album the Stones began another tour of North America, and midway through it they released the US version of **Aftermath**. It had been more than six months, during which three singles made the top ten of the Hot 100, between the Stones' fourth and this, their fifth North American tour. Once again they visited twenty states, Washington DC, and Canada and on this tour they played in Virginia, Missouri, Oregon, Utah, and Hawaii for the first time. Although the band played fewer shows than on their fourth tour, they grossed almost three-quarters of a million dollars.

According to the Oregon Journal: "Whether or not you dig the Stones' sounds in the world of modern music, they're what's happening, baby." This was the beginning of the Rock era — the Stones as a touring monolith. Having said that, they wouldn't tour America again until late 1969.

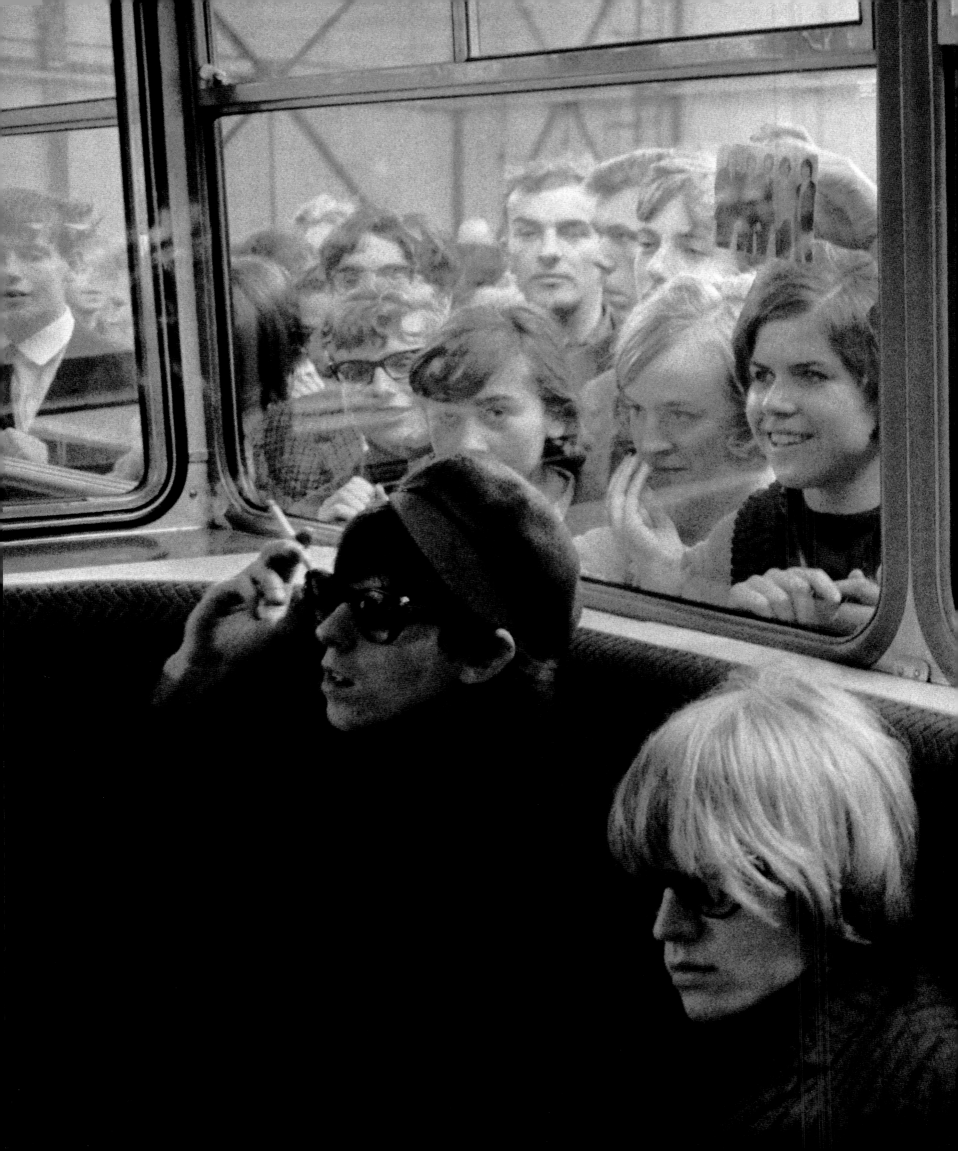

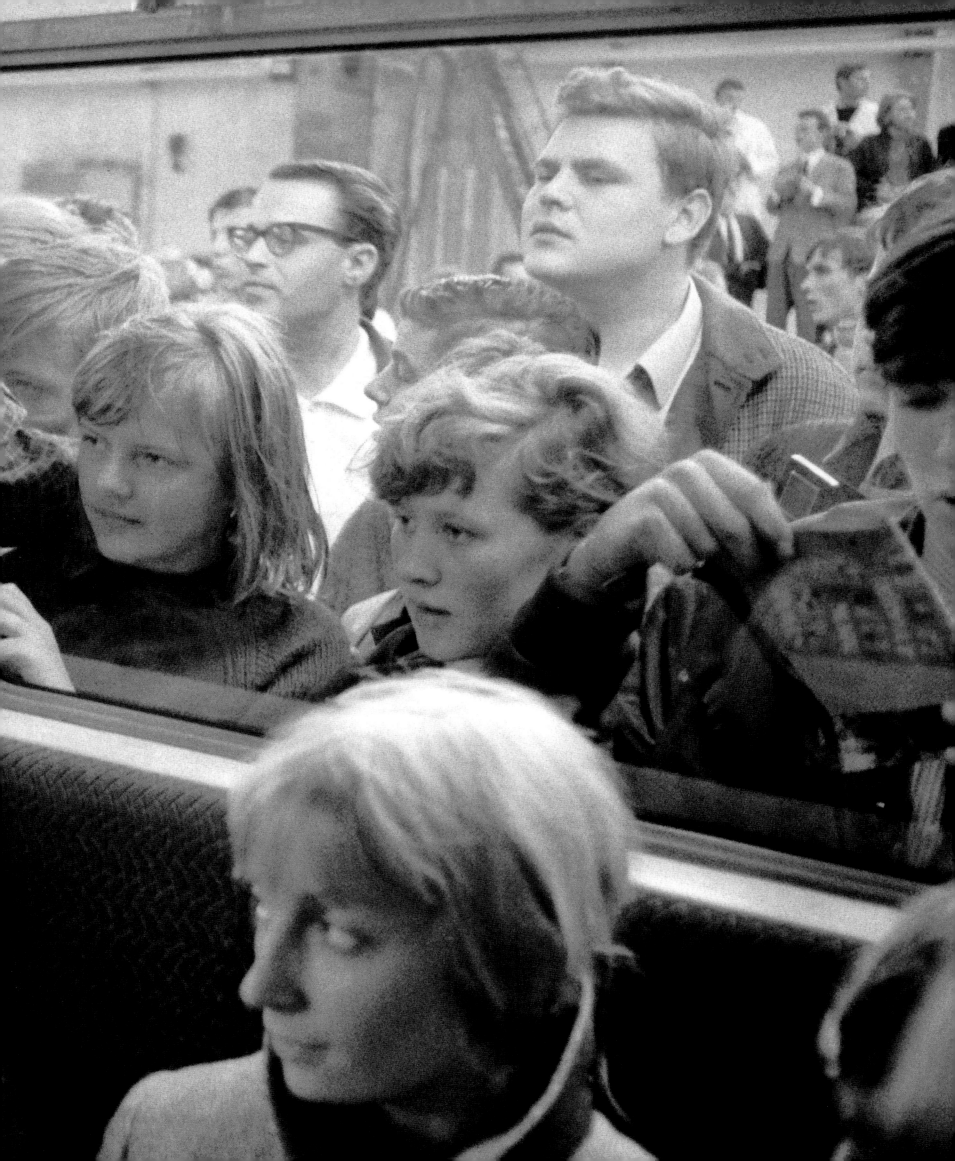

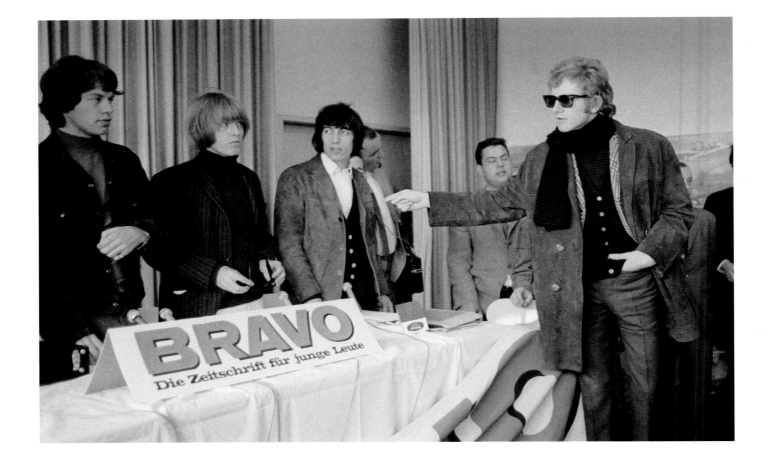

"It was on this tour of Germany that I first met Andrew Loog Oldham. When the Stones arrived at Düsseldorf airport they were taken straight to the airport cinema for a press conference which started at 12.15pm. The first fifteen minutes were reserved for the photographers and then it was left to the journalists to ask questions. After a dramatic interruption from rioting fans the press conference had to be cut short and we left for the hotel in Essen by Mercedes limos. Afterwards the Stones went to another press conference at the offices of Bild Zeitung, the parent company of Bravo, the music magazine and sponsor of the tour." BR

"Everybody had a hand in the practical jokes – here promoter Knud Torbjornsen played his part." BR

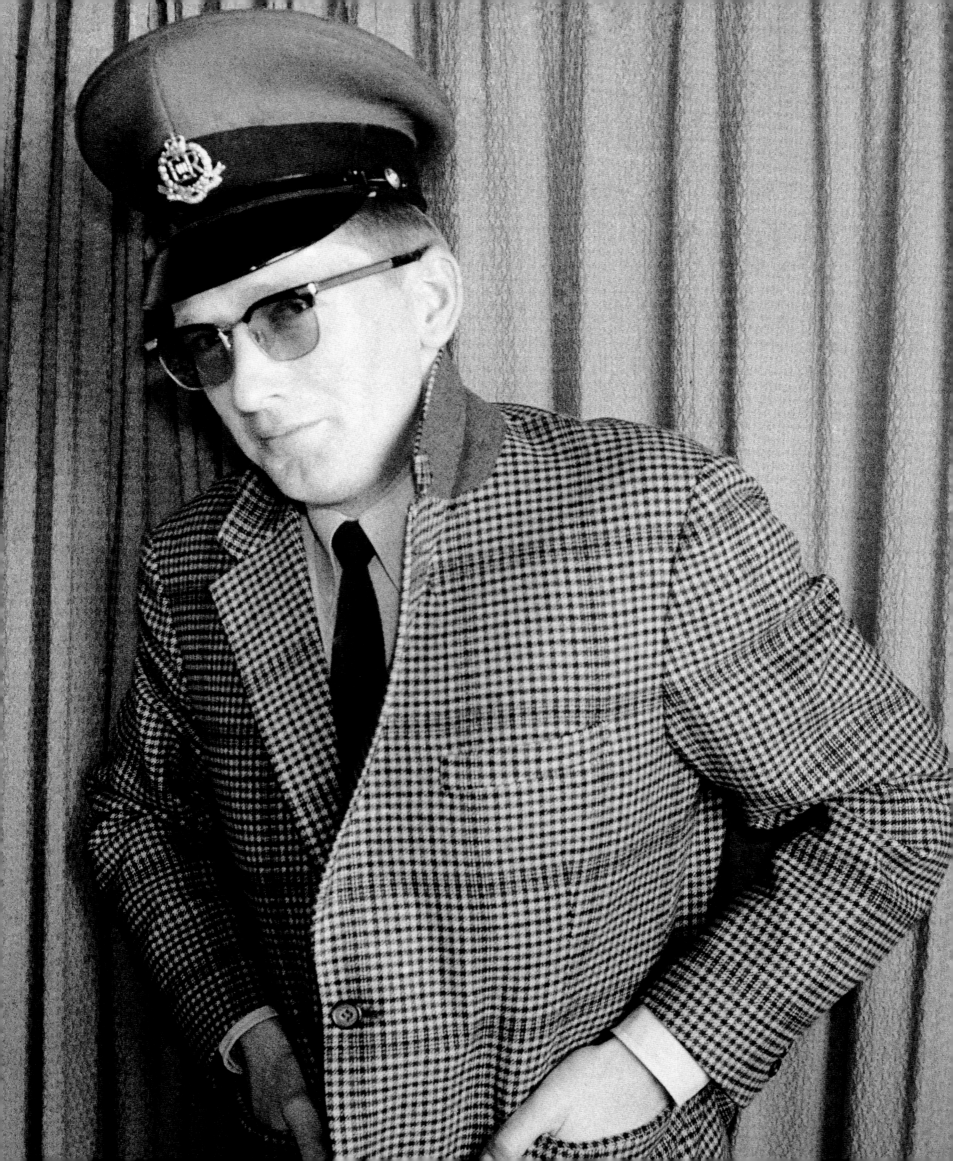

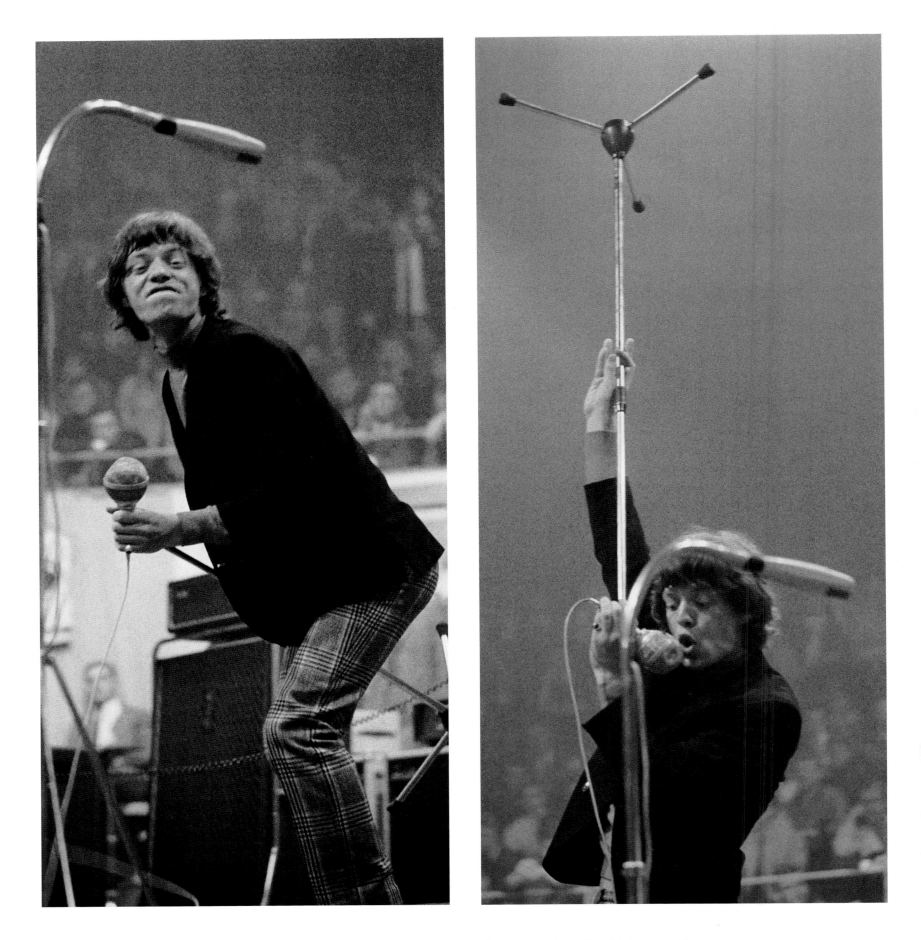

One newspaper referred to Mick as the "Hexenmeister", which roughly translates as "Master Magician".

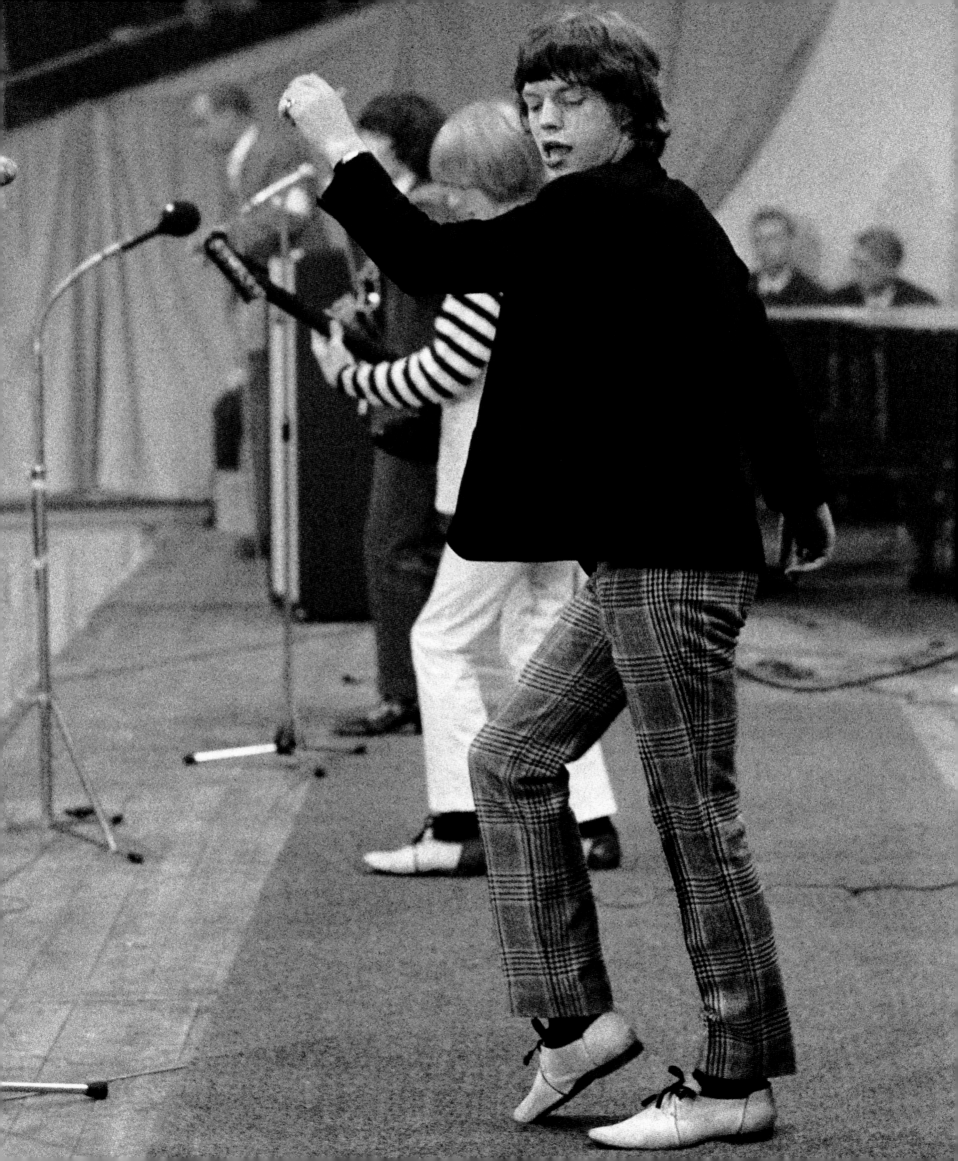

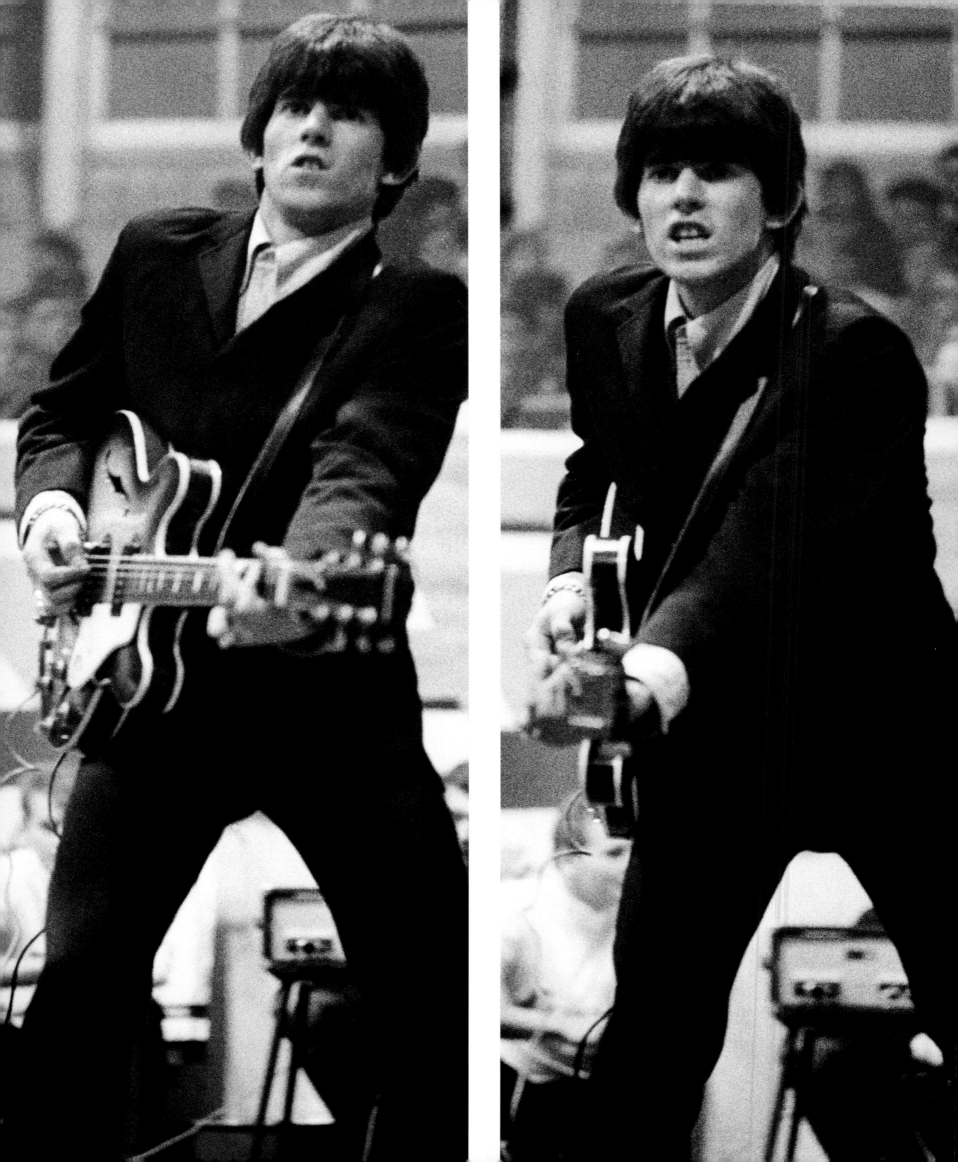

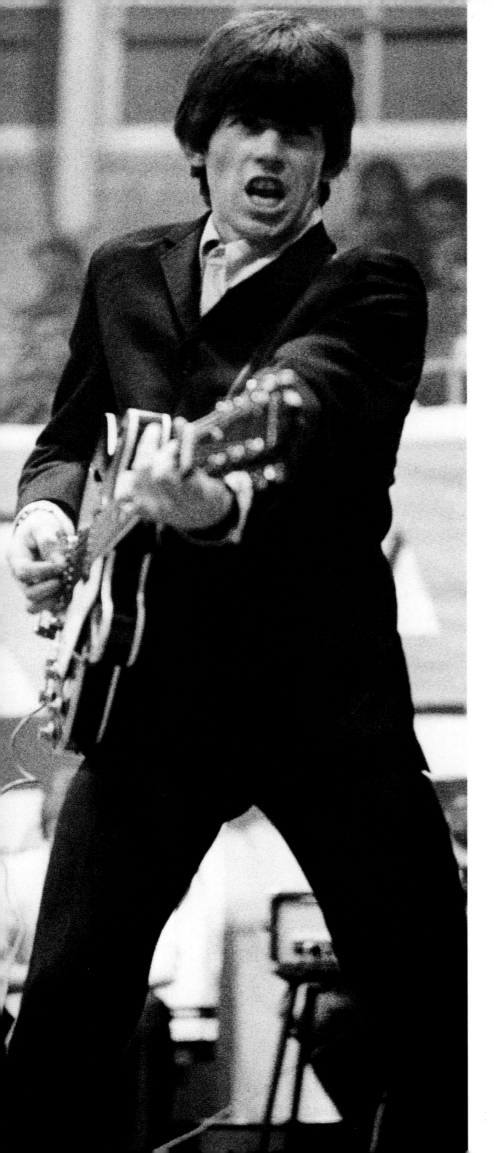

"This is Keith playing the Chuck Berry number, **Around and Around**, judging by his movements." BILL

"According to one local newspaper reporter the Stones were overwhelming. 'I've been close to bombs exploding, next to big guns being fired, close to jet aircraft taking off, but all these are nothing when compared to what I experienced at the Münsterland Halle. I have Stones in my ears and I've had trouble hearing since the concert finished.' In another paper Mick was reported to have said that the fans sang so loudly that it gave the band a headache, and they all had to have a pill before going to bed." BR

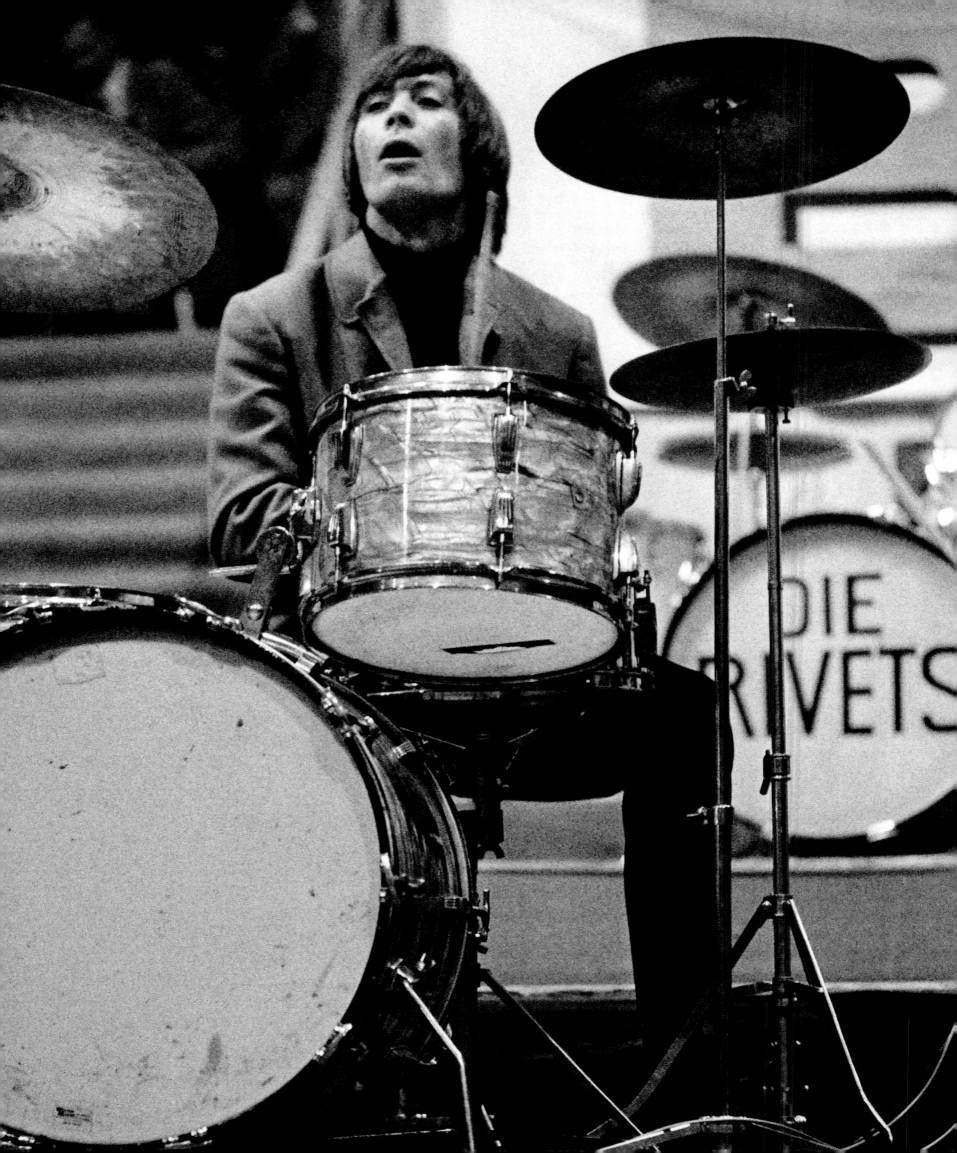

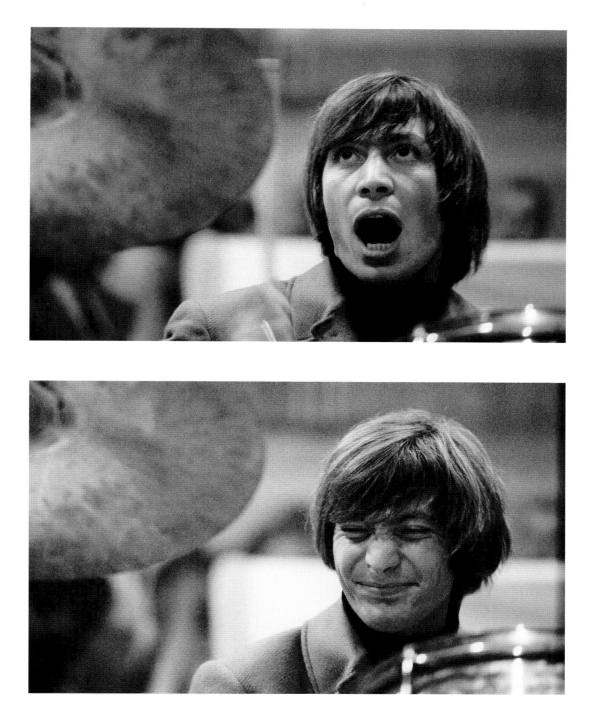

"Wow! See those scandalous teenagers and their nasty pop records with the unmentionable (if unintelligible) lyrics. Why, they're almost as bad as all those clean-living, high-principled, and pure-of-heart grown-ups who dig Lenny Bruce, devour 'Fanny Hill' and frequent those havens of good old-fashioned morality, the Playboy Clubs." KATHIE HARACZ - NEWSWEEK MAGAZINE, 13 SEPTEMBER 1965.

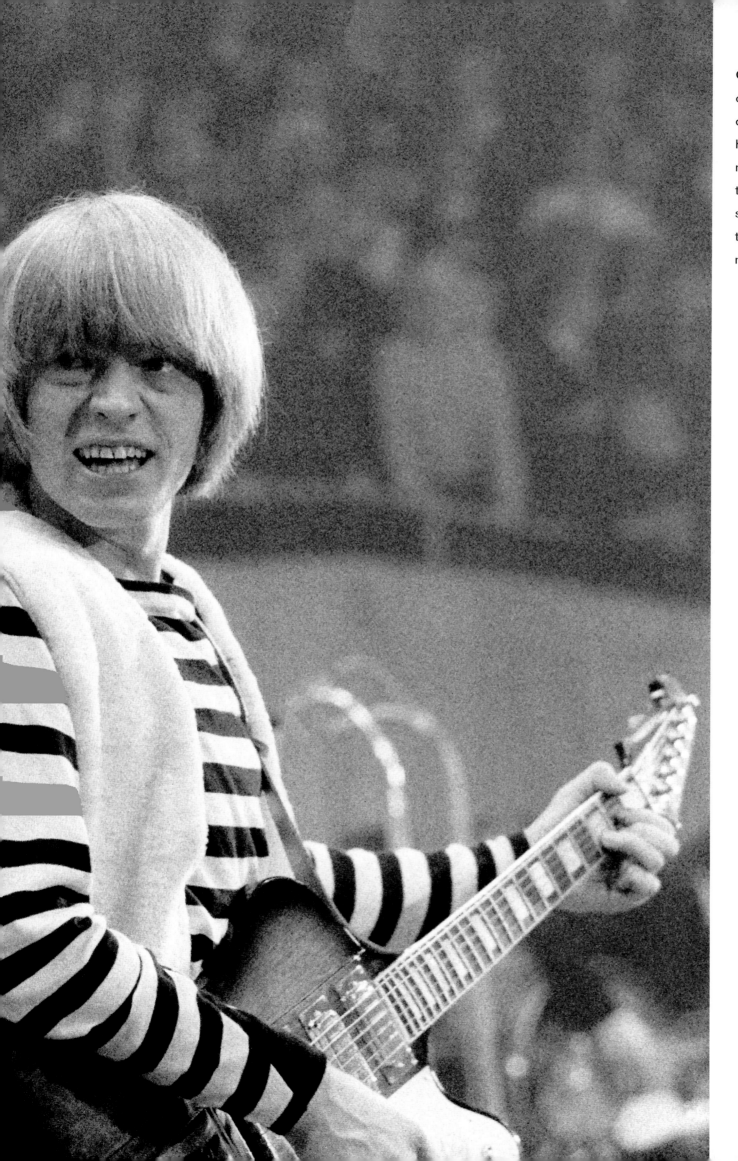

Communication onstage was very difficult. The band had no stage monitors, and often the crowd was screaming so loudly that it drowned the music completely.

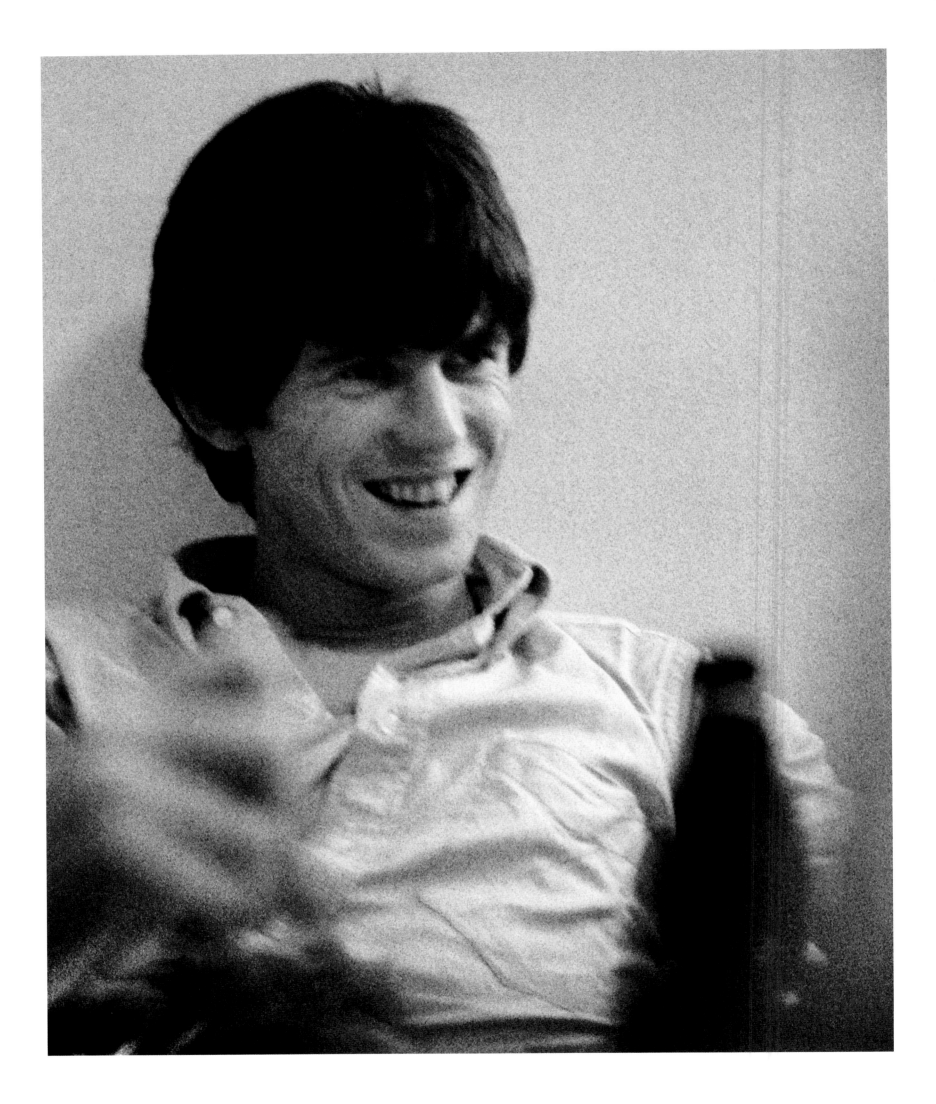

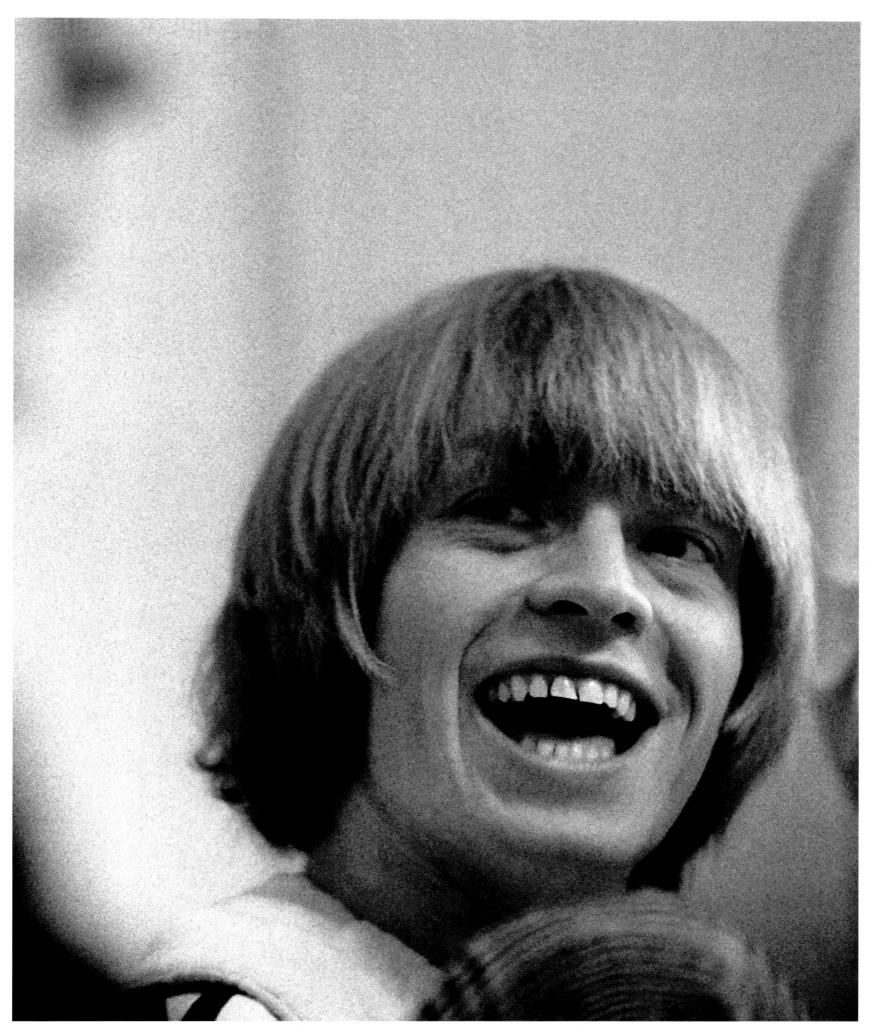

According to one German newspaper, when The Rolling Stones arrived
in Germany they "unleashed a typhoon of destruction".

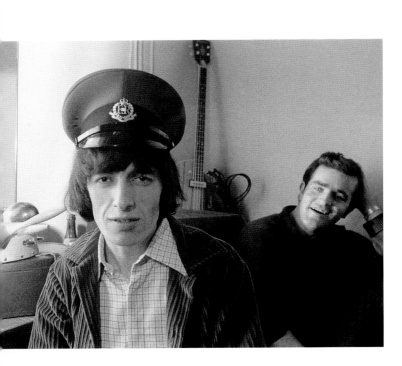

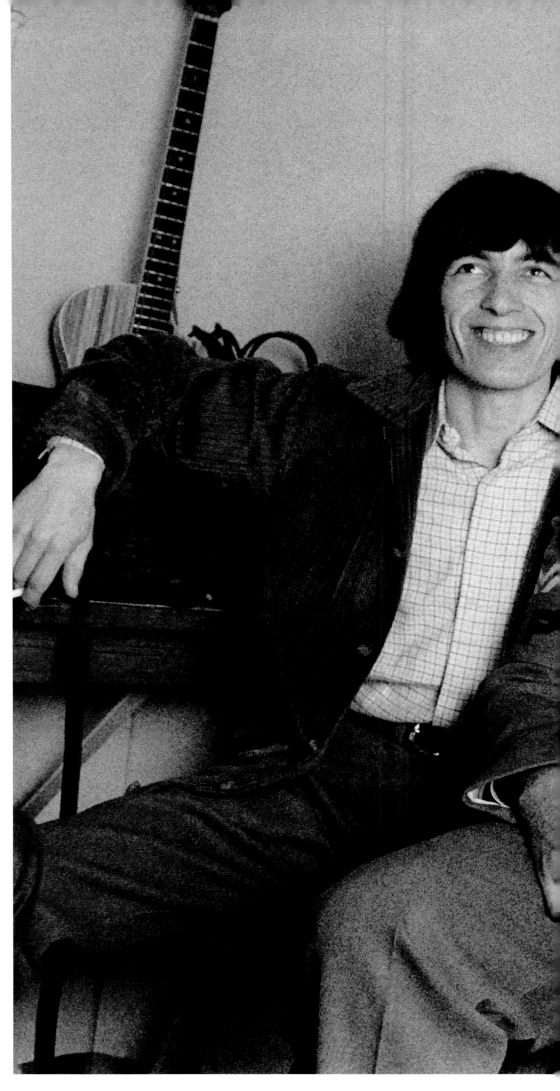

"Twenty years after the end of World War II and British military personnel, like other Allied troops, were very much in evidence throughout West Germany. Bill (who had served in the RAF and was stationed in Germany during the 1950s) and Charlie invited the soldier into the dressing room and talked with him." BR

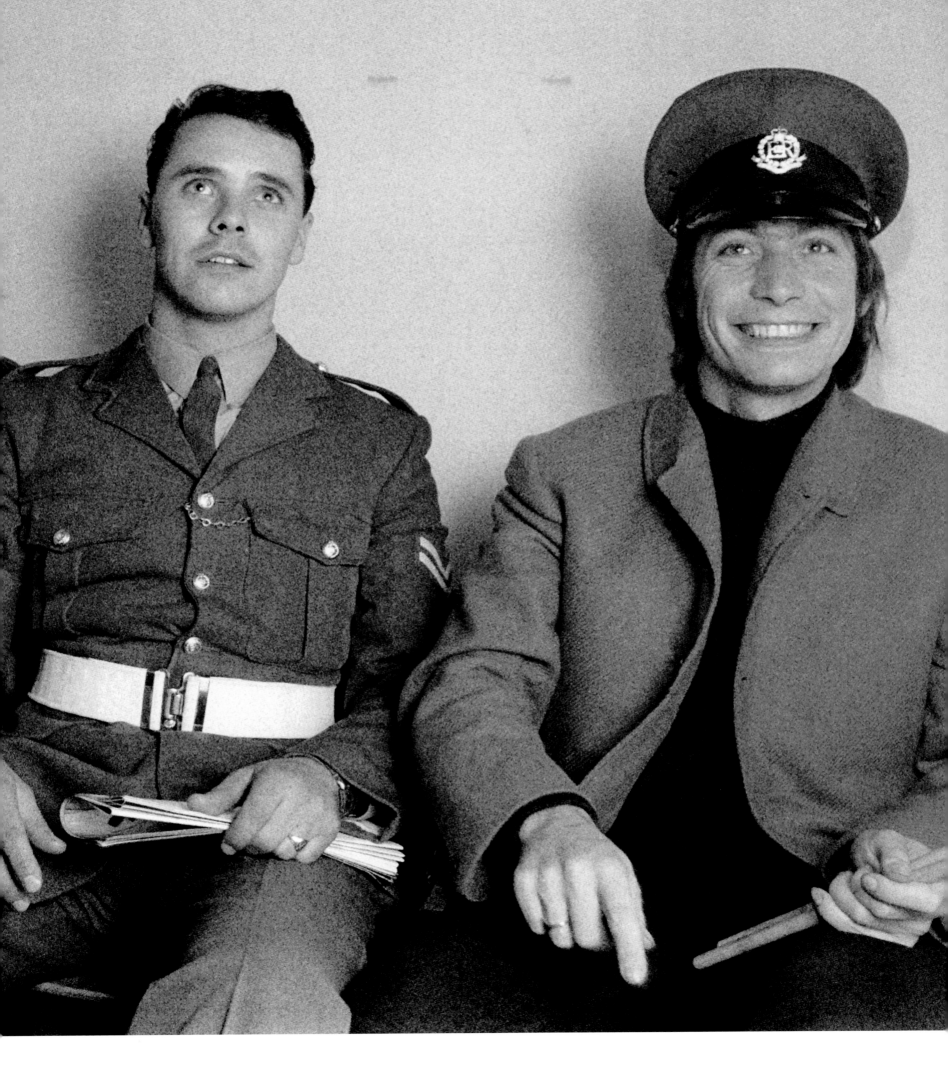

CHANGING TIMES

When Bob Dylan sang **The Times They Are A-Changin'** they certainly were. In many ways the events of 1965–66 formed a pivotal point in the development of post-war culture.

JANUARY 1965 Britain decides to continue with the Anglo-French Concorde supersonic airliner despite mounting costs • 24 JANUARY 1965 Winston Churchill dies • 8 MARCH 1965 President Lyndon B Johnson sends the first US troops into South Vietnam. The 3,500 marines are the first American ground troops to fight in Vietnam. Their role was to be "purely defensive" but by the time the war ended there would be 45,000 Americans dead. The Vietnam War played a significant part in the history of Rock music • 28 MARCH 1965 Dr Martin Luther King leads 25,000 in a Civil Rights march in Alabama • 1 APRIL 1965 Che Guevara leaves Cuba • 10 APRIL 1965 Future American President Richard Nixon visits Moscow • 18 APRIL 1965 Fifty-six Mods and Rockers are arrested in Brighton as fights break out between the rival gangs • Late APRIL 1965 There are signs in Europe of the growing anger at the US involvement in Vietnam. This includes violent demonstrations in Paris outside the US Embassy in which demonstrators chant "US assassins" • JUNE 1965 US troops go into battle for the first time in Vietnam • 11 JUNE 1965 The award of MBEs to The Beatles in the Queen's Birthday Honours list angers many traditionalists • JULY 1965 More troops are sent to Vietnam with President Johnson predicting that the situation will get worse • JULY 1965 The House of Lords votes to abolish hanging for an experimental five-year period • 27 JULY 1965 Edward Heath becomes the first Grammar-school boy to become the leader of the Conservative party • AUGUST 1965 In Watts, an area of Los Angeles, race riots create an unprecedented level of US domestic troop deployment when 20,000 soldiers and National Guardsmen are put onto the streets of the city. More than 1,000 fires are started, over 2,000 looters arrested, and damage is estimated at $175 million. Twenty-eight people were killed and almost 700 wounded • 1 AUGUST 1965 Cigarette advertising is banned on British TV • 7 AUGUST 1965 **(I Can't Get No) Satisfaction** by the Stones is knocked off the top of the US Hot 100 by Herman's Hermits with **I'm Henry the Eighth I Am** • 12 AUGUST 1965 The first female High Court Judge is appointed in England • 15 AUGUST 1965 The Beatles' concert in New York's Shea Stadium draws 55,000 fans • SEPTEMBER 1965 According to a poll, 94 per

cent of British people belong to a church • 25 SEPTEMBER 1965
Tears by Ken Dodd replaces The Rolling Stones' **(I Can't Get No)**
Satisfaction at the top of the UK singles chart • OCTOBER 1965
Radio Luxembourg boosts the power on its transmitter that broadcasts
to Britain • OCTOBER 1965 A map seems to prove that the Vikings
discovered America • NOVEMBER 1965 Mary Whitehouse starts
a campaign against the amount of sex and violence on British TV11
NOVEMBER 1965 Rhodesia decides on the Unilateral Declaration of
Independence from Britain • 27 NOVEMBER 1965 Ken Kesey and
the Merry Pranksters hold the first public Acid Test in San Francisco with
musical accompaniment from the Grateful Dead • JANUARY 1966 A
breath test is introduced in Britain to determine whether or not drivers are
fit to drive after the consumption of alcohol • JANUARY 1966 It is
announced that Motown Records outsold all other labels in America for
singles • 15 MARCH 1966 At the Grammy awards the Record of the
Year for 1965 is announced as **A Taste of Honey** by Herb Alpert and the
Tijuana Brass; the Best Contemporary Rock and Roll Group Performance is
judged to be The Statler Brothers and **Flowers on the Wall** • MARCH
1966 Freddie Laker forms an airline with the objective of bringing low fares
to the airline business • APRIL 1966 Figures show that the number of
illegitimate children born in England and Wales has doubled in the past ten
years • MAY 1966 Eight thousand anti-war protestors encircle the
White House in Washington for two hours • MAY 1966 A sixteen-year-
old named Bruce Springsteen and his band, The Castilles, record their first
and only single – it is not released • 4 JUNE 1966 Frank Sinatra's
Strangers in the Night takes over the UK No.1 spot from **Paint it,**
Black by The Rolling Stones; three weeks later **Paperback Writer** by The
Beatles knocks Frank Sinatra from the top spot • 2 JUNE 1966 An
unmanned American space ship lands on the moon • JUNE 1966
A US Air Force pilot admits shooting down two South Vietnamese planes
while under the influence of drugs • 29 JUNE 1966 The Barclaycard,
Britain's first credit card, is introduced by Barclay's Bank • JULY 1966
More race riots break out across America – Chicago, New York, and
Cleveland see death on the streets • JULY 1966 The British
government imposes a wage freeze in an attempt to resolve a worsening
economic crisis • 30 JULY 1966 England beat Germany in the final of
the World Cup • August 1966 Mao Tse-tung's Little Red Book
published; beginning of the Cultural Revolution in China.

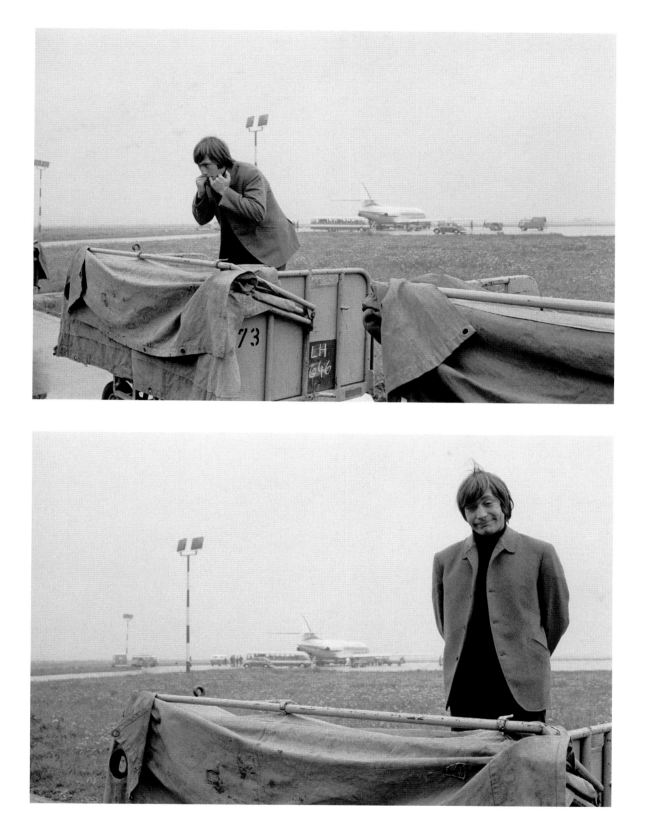

"On Monday, 13 September we flew from Düsseldorf to Hamburg. Unlike today, when airport security is paramount, things were a lot more relaxed then, allowing Brian and Charlie the chance to fool around, enabling me to get some different shots." BR

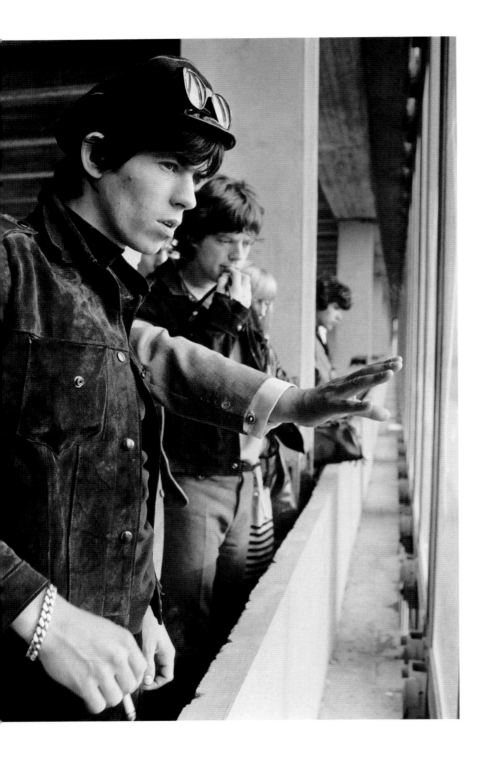

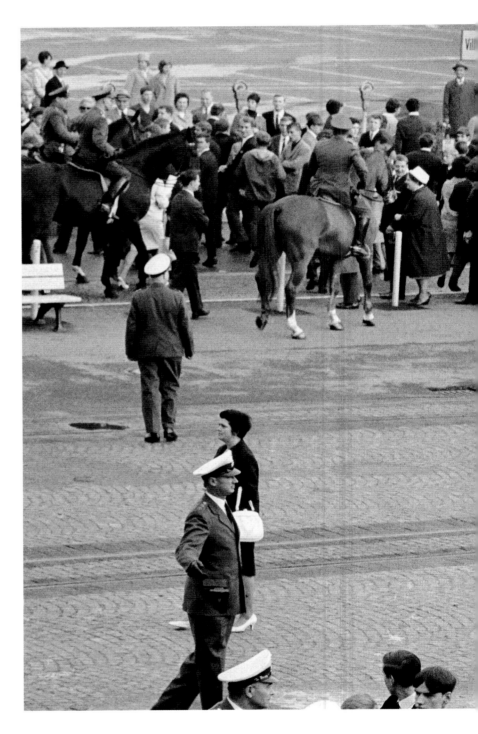

"Ordnung muss sein!"

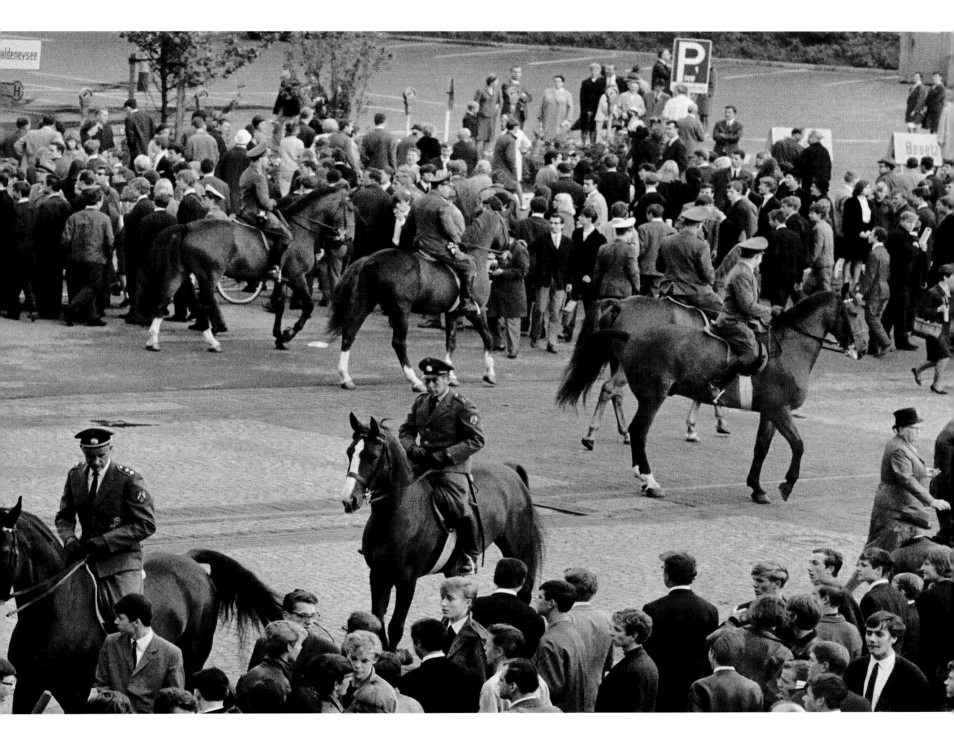

The band played the Grugs Halle, Essen, and even before they went onstage there was trouble for the mounted police to deal with. Unlike in Britain and America, a far higher proportion of the Stones' audiences were male — in some places as many as 70 per cent to 80 per cent were men.

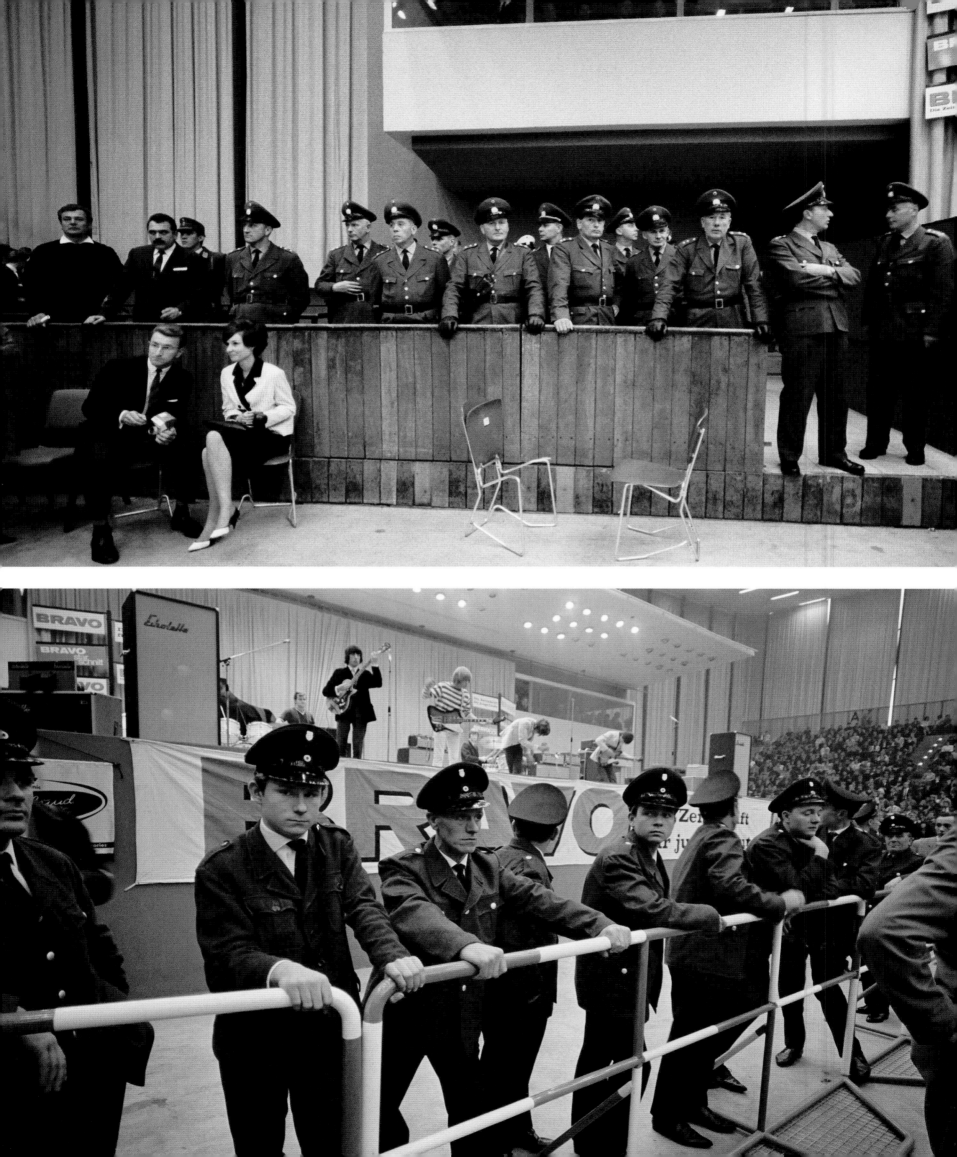

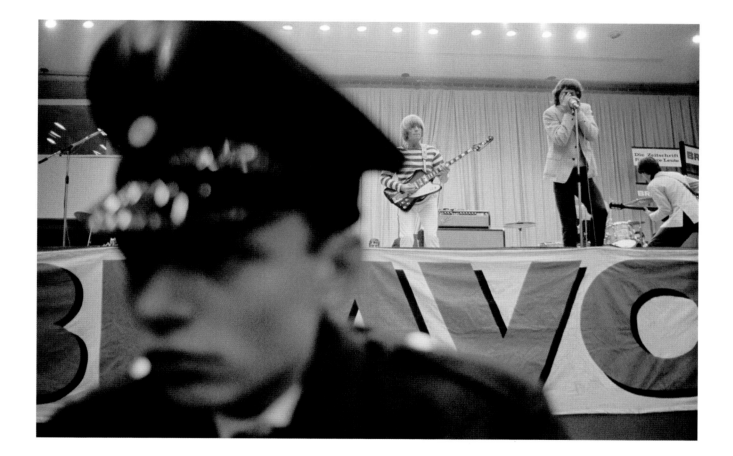

"The Stones performed behind steel crash-barriers erected around the stage. Twenty policemen with guns and truncheons waited. More than 12,000 [sic — there were only 8,000] youngsters surged towards the stage. Youngsters unable to get in broke through the police lines. Mounted police charged the 2,000 teenagers..." DAILY MAIL, 13TH SEPTEMBER 1965

"I've seen nothing like this...

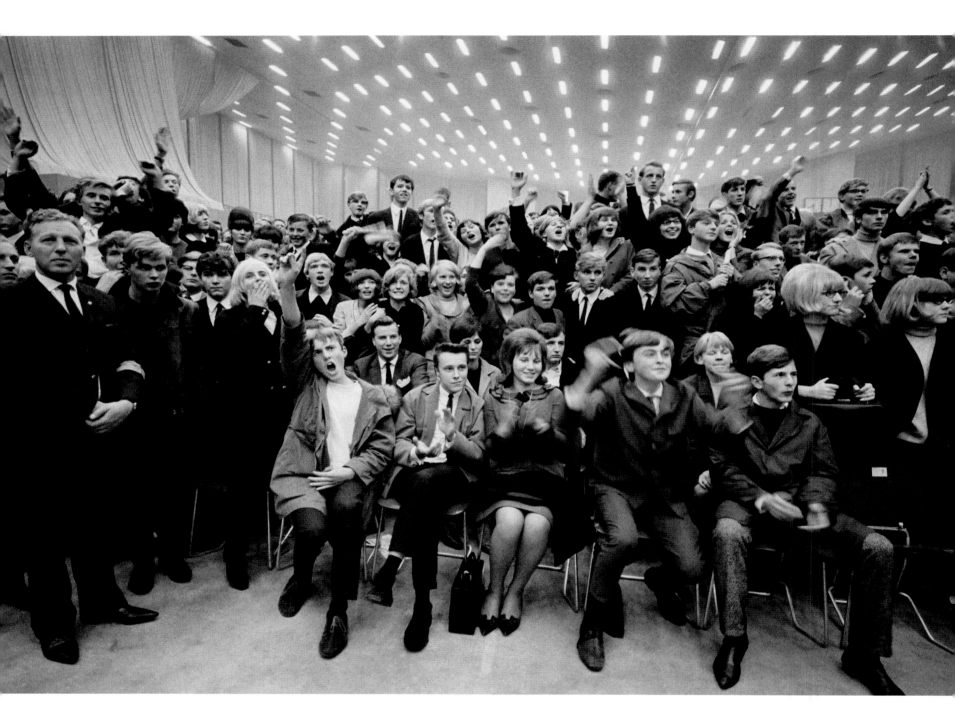

... since the old days
of a Nazi or Communist rally."

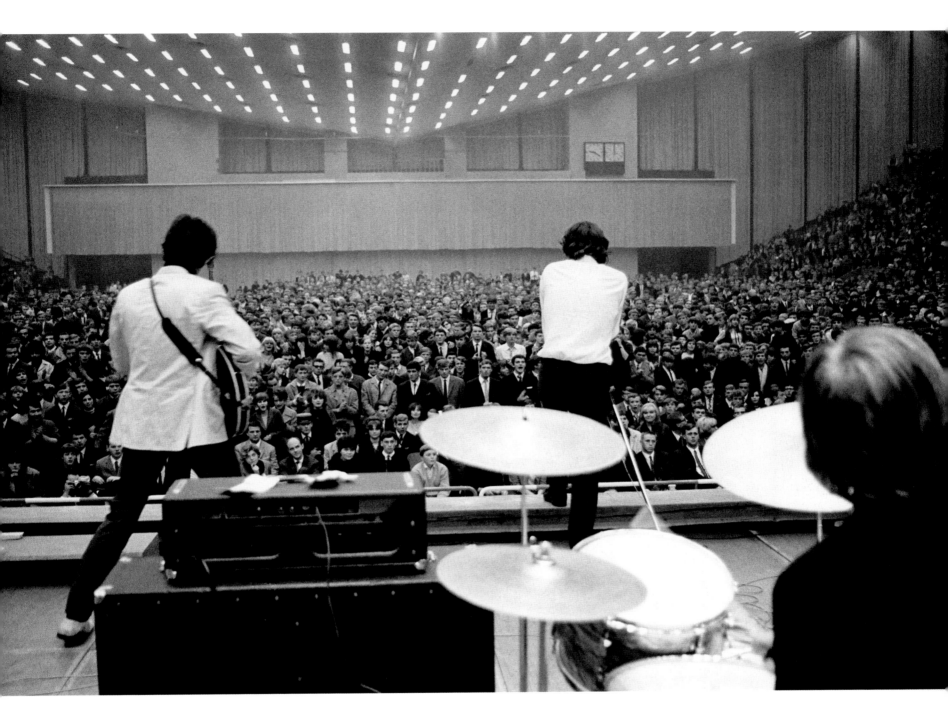

"While the Stones whipped up a musical storm inside the Grugs Halle, fans without tickets continued battling outside with the police. They stormed the barricades in an attempt to gain entry using eggs, tin cans, tomatoes, and even a dead rat as missiles against the police. The fans inside hurled toilet rolls towards the stage." BR

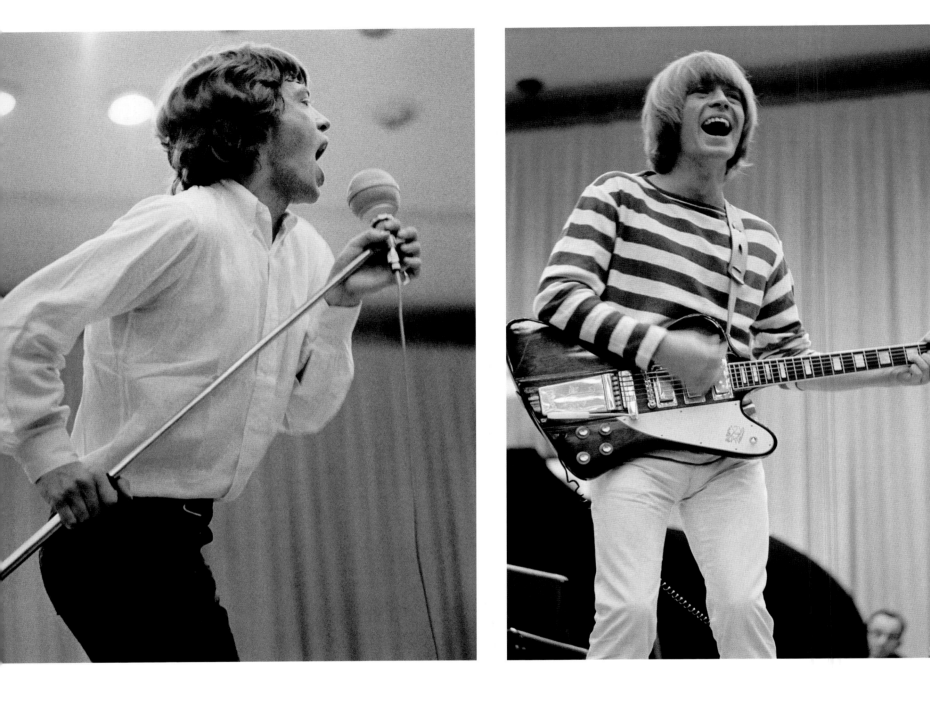

"The phenomenon of Beat music has hit the land of Beethoven and Bach with a crescendo. They stood on seats, stamped their feet, shook their bodies and howled. They threw toilet rolls across the hall and unbolted the tubular chairs to wave in the air. At one point they lost all self-control and

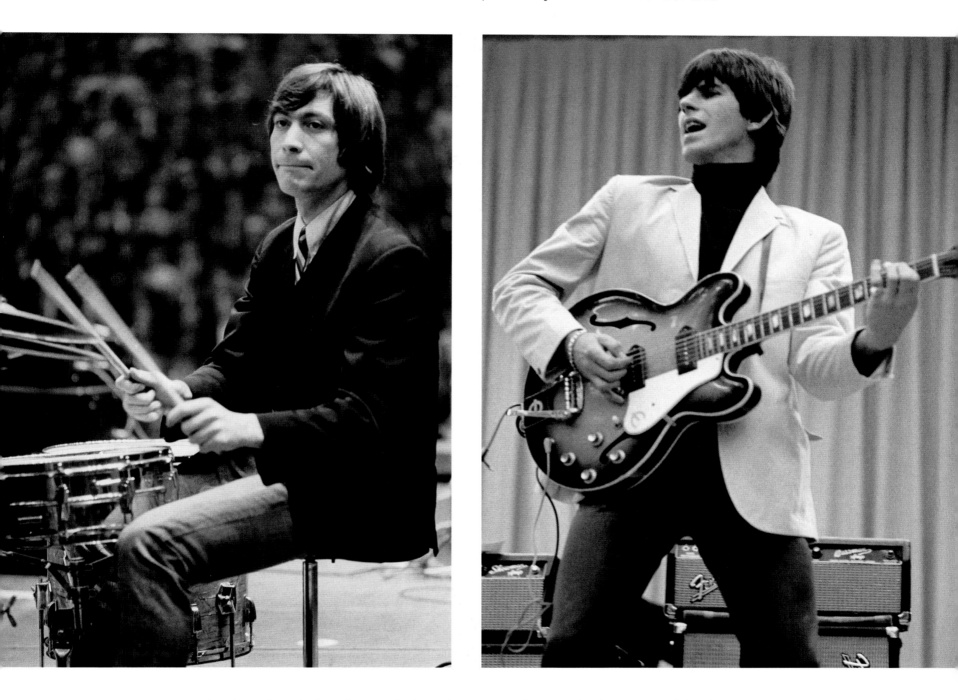

chanting, hand-clapping and stamping, surged towards the stage. A burly attendant picked up two boys and tossed them over the barriers.

These were the wildest audiences the group has played to outside America. In the police charge two boys with Beatle haircuts fell and lost their wigs. Young Germans, catching up late with The Beatles rave, have not yet had time to grow their own hair long enough. Mick Jagger said: 'I prefer the girls. They only scream. Here all these boys stand up and yell at the top of their voices. You can't hear yourself for the din they make.'" DAILY MAIL, 13 SEPTEMBER 1965

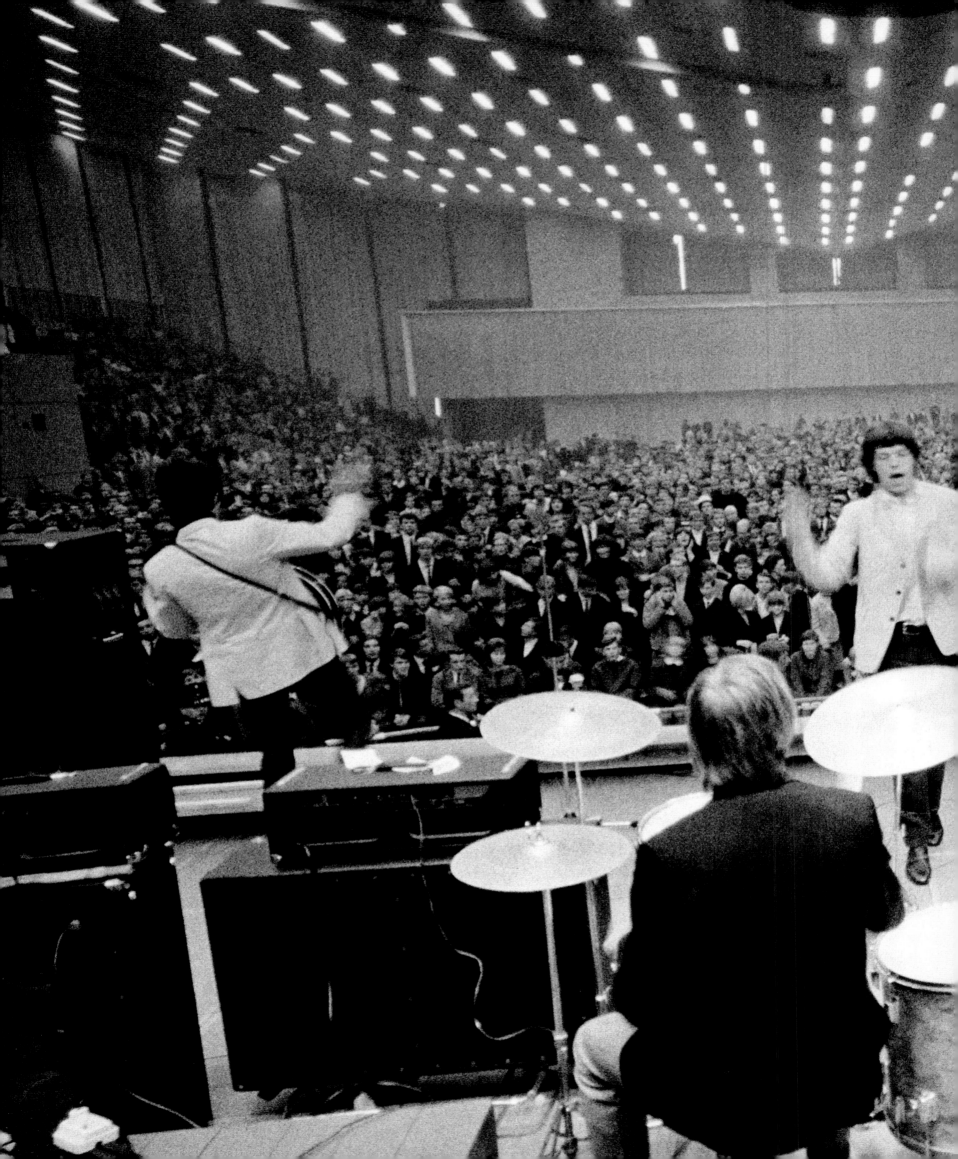

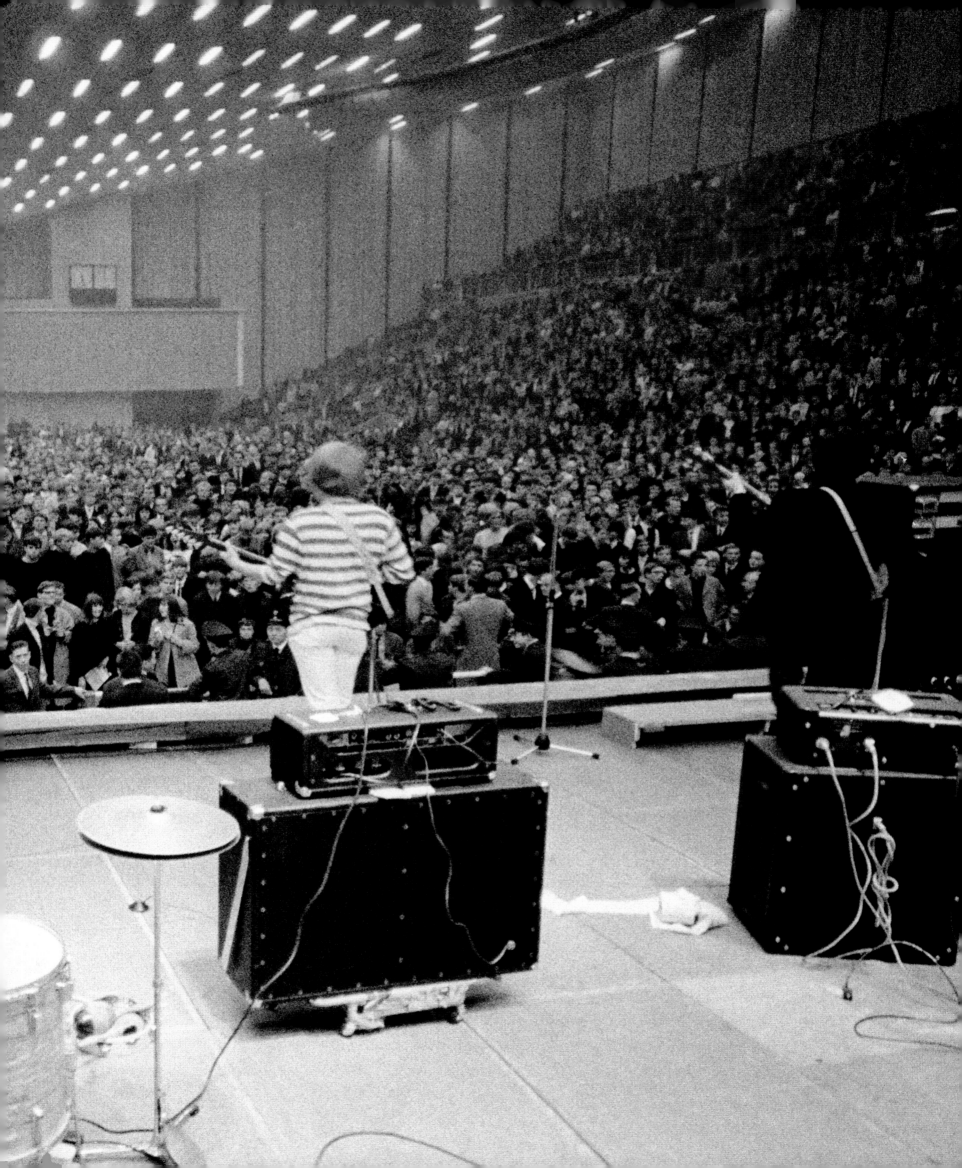

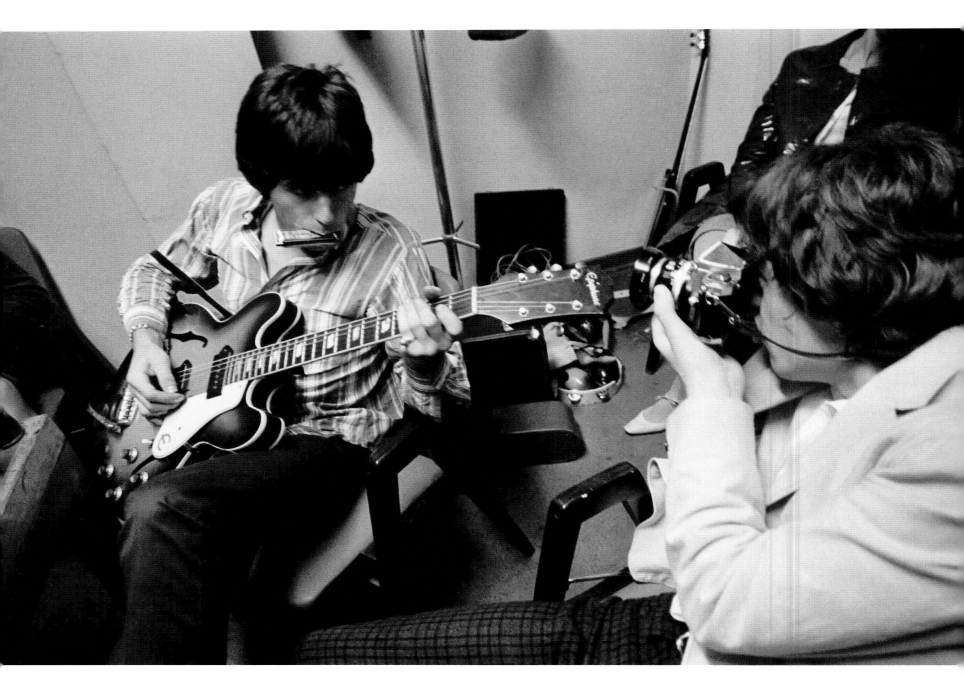

"Backstage between shows Mick turned photographer using one of my Nikons. Keith as usual played his guitar and his mouth organ. Because the Stones played two shows at most of their gigs during this period there was plenty of time to hang around backstage, which had them looking for ways to amuse themselves." BR

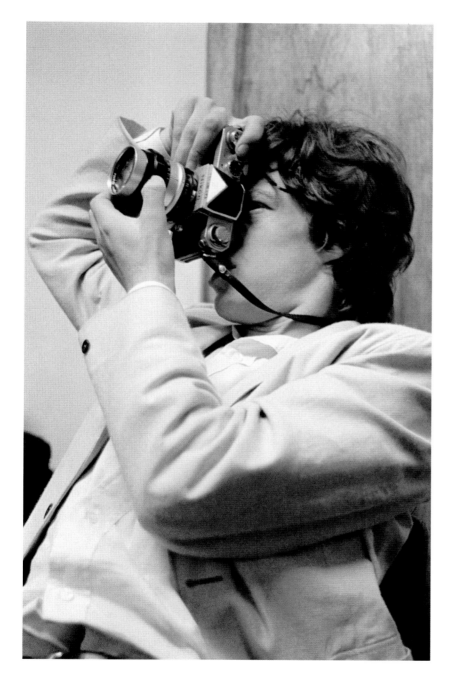

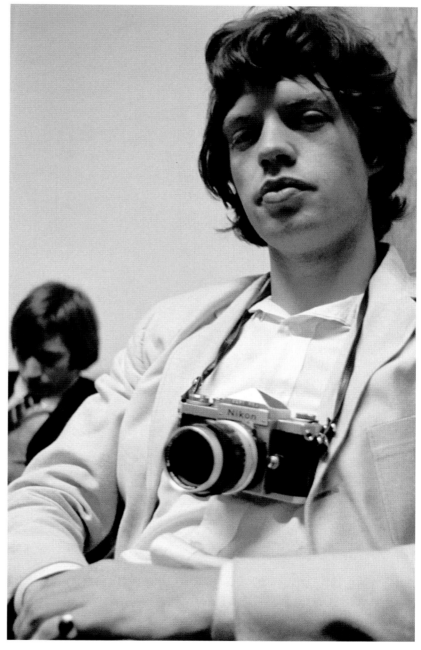

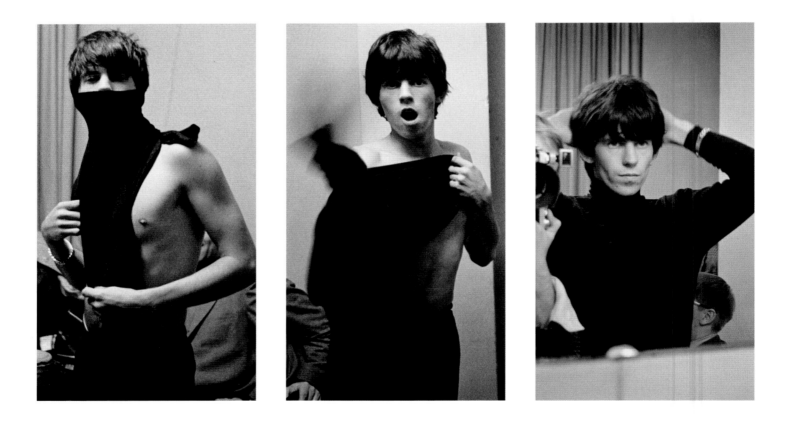

Today we are very used to seeing pictures of Keith posing for the camera, his skull and crossbone ring to the fore. Keith is a man who always seems aware of the camera and uses it to his advantage. However, prior to 1965, photographs of Keith obviously posing were much less common, and so it seems unusual to see such an early example of an image-conscious Keith.

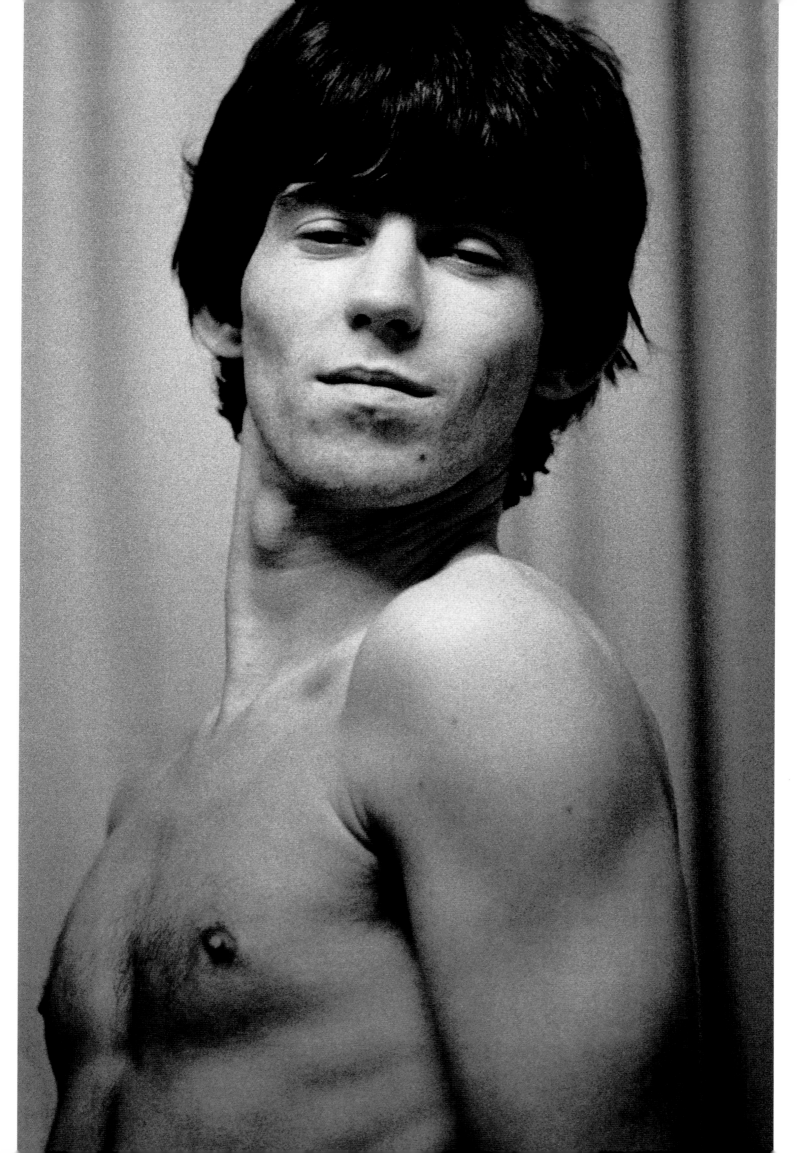

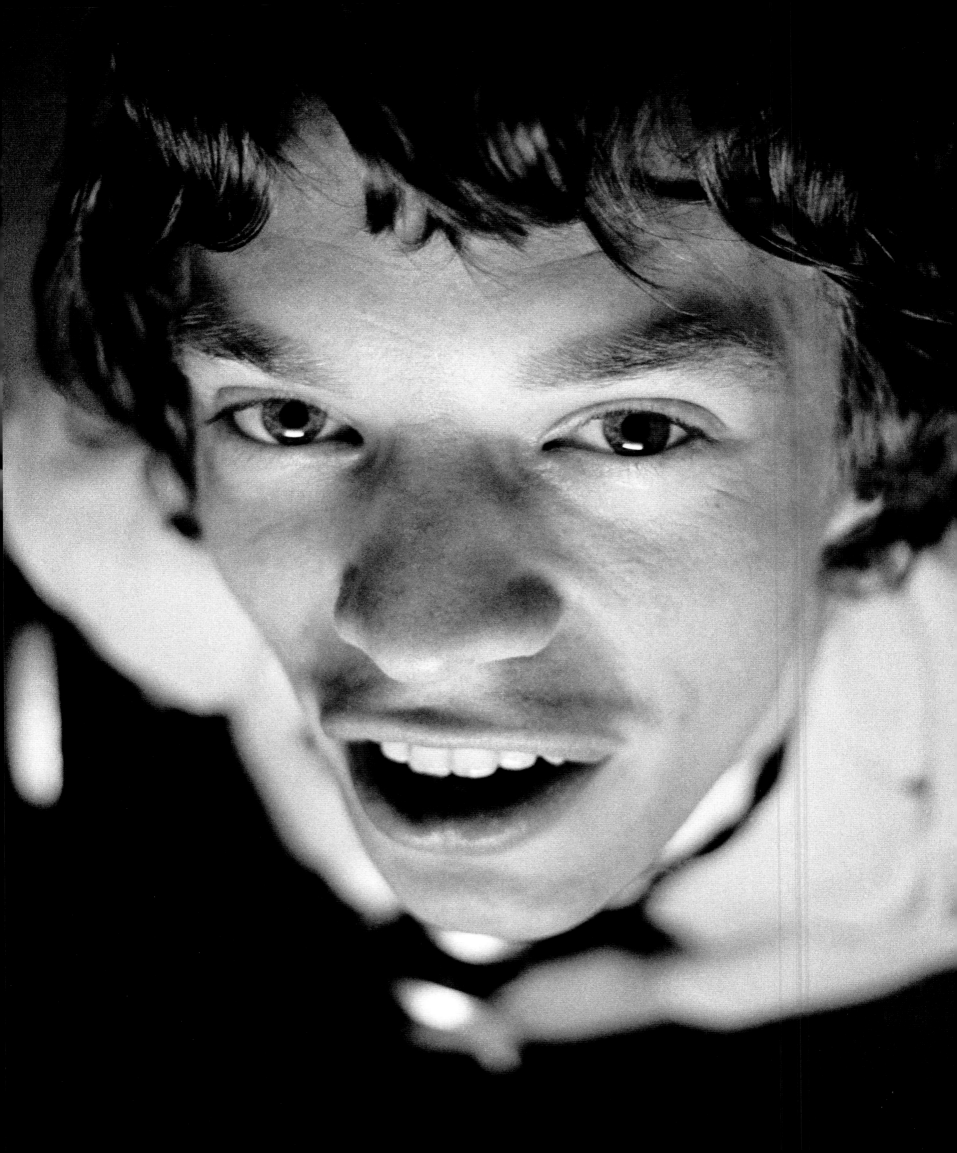

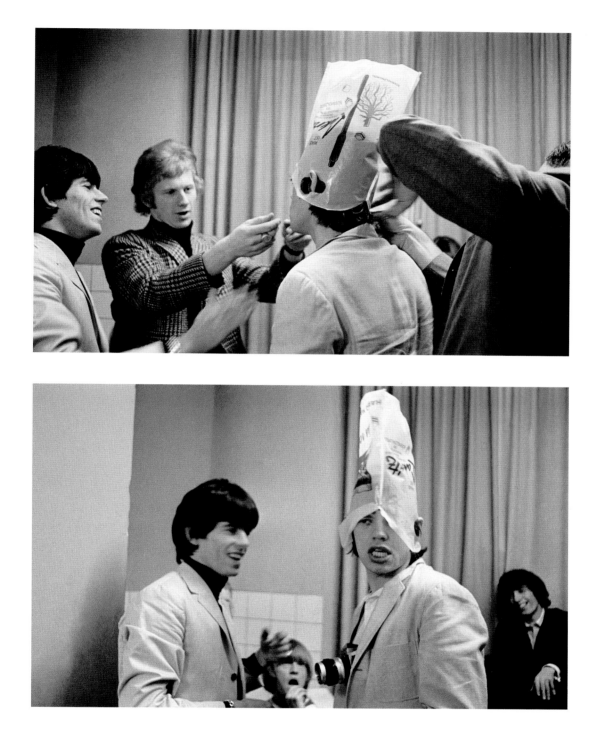

"To kill the time before we went onstage we would end up fooling around in the dressing room; Andrew, when he was around, almost always joined in. You can tell it's before we went on stage because we still had our jackets on. I have no idea what the idea of the headdress was, but I know it was, despite appearances, nothing to do with the Ku Klux Klan." BILL

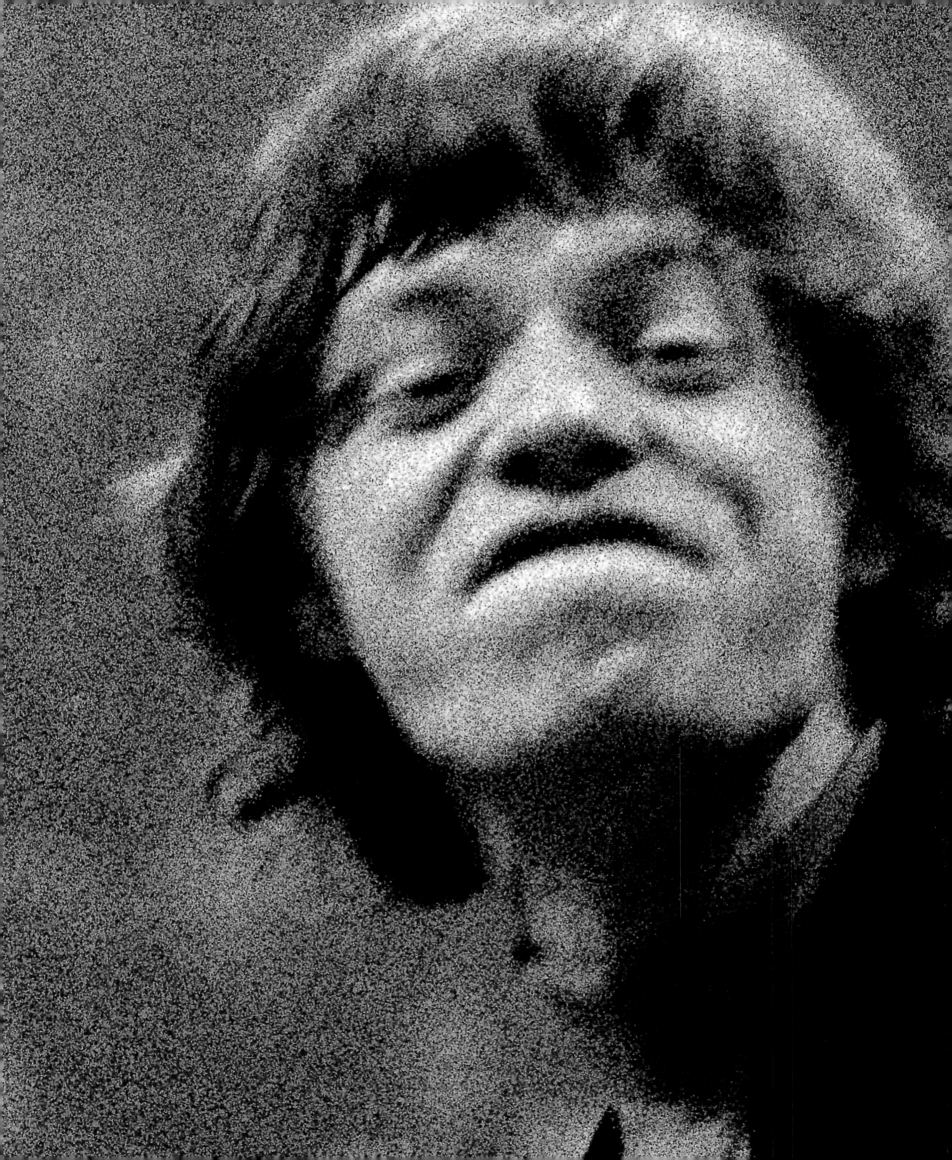

mick jagger

MICHAEL PHILIP JAGGER

Michael Philip Jagger was born on 26 July 1943 in Dartford, Kent. Mick's mother, Eva, had been born in Australia, but she and her family moved to England when she was four years old. Mick's father, Basil, was born in Lancashire. Known as "Joe", he came from a strict, non-drinking, Baptist family; he married Eva, a hairdresser, in Dartford in December 1940.

In 1947 Mick started school in Dartford, in the year his brother Christopher Edward was born. A fellow pupil at Mick's primary school was one Keith Richards. Mick's father became director of Physical Education at a large college, and also worked with the British Sports Council, helping to develop the British Basketball movement. The family moved to a detached house in Wilmington, a move that defined their middle-class status. Mick passed his 11-Plus examination in 1954 and went to Dartford Grammar School. "We called him Mike. He hated the name Mick," said his brother. Mick began taking basketball seriously, he even had real American basketball boots — everyone else had plimsolls. According to his father, "He could have been a great athlete. He was excellent at basketball and cricket."

In March 1958 Mick and another boy from his school went to see Buddy Holly in Woolwich. The following year Mick passed seven O-Levels and went into the Sixth Form to study A-level English, History, and French; he also became a school prefect. Mick and some other friends began playing Rock and Roll together at Dartford Church Hall. Mick sang Holly's **It Doesn't Matter Anymore**, and died a death. He also worked part-time selling ice creams from a tricycle outside the public library in Dartford, which is where he once again met Keith. In July 1961 Mick passed three A-Levels and won a scholarship to the London School of Economics (LSE), signing a declaration to complete his Economics and Political Science course.

Just after starting at the LSE, Mick met Keith on Dartford railway station; it was a friendship that rekindled quickly and soon they were playing together in a band called Little Boy Blue and The Blue Boys. The activities were more sporadic than serious but in April 1962, Mick, Keith, Dick Taylor, and another friend went to the recently established Ealing Blues Club where they saw a guy sitting in with Alexis Korner's Blues Incorporated. Afterwards they chatted with the guy, whose name was Brian Jones; he mentioned he was forming a band and before long Mick, Keith, and Dick were part of it.

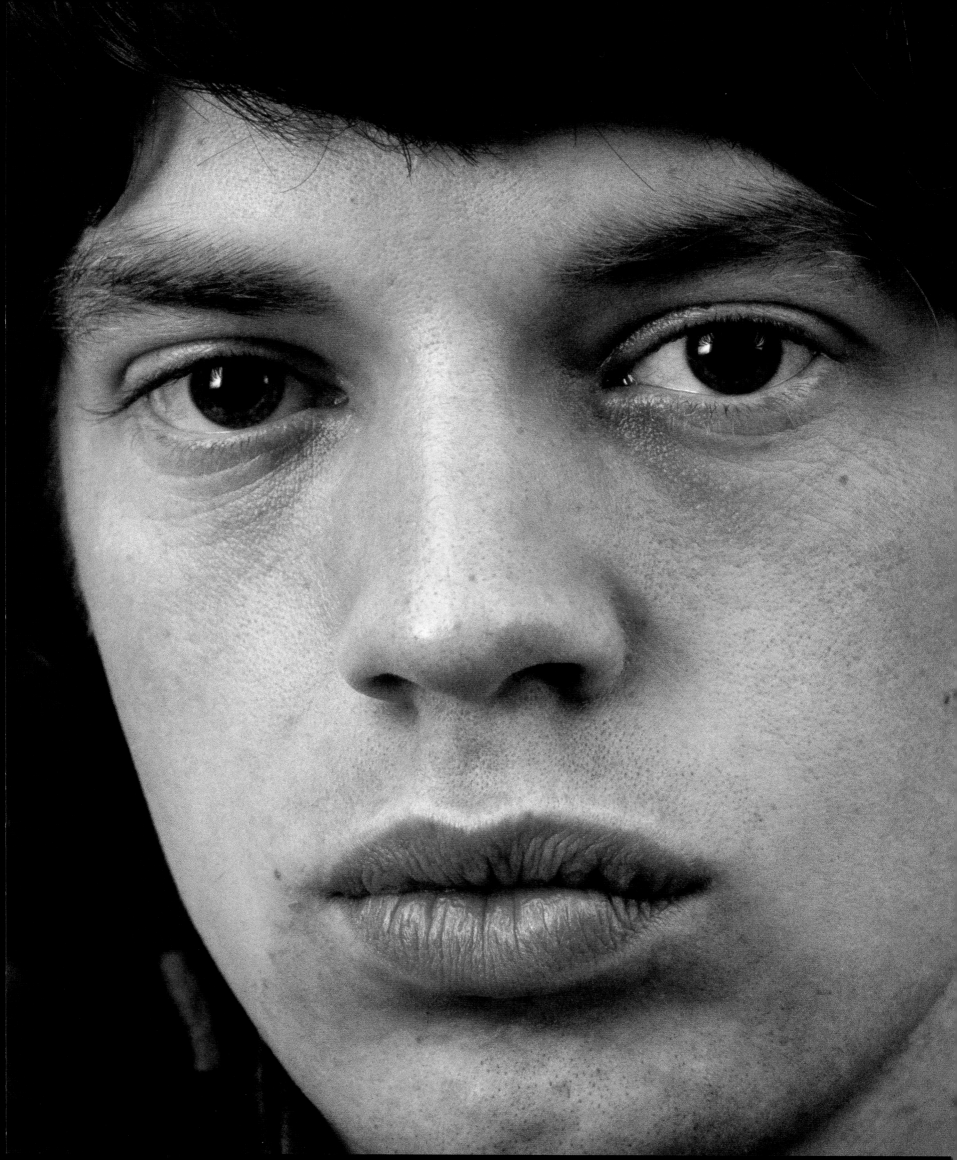

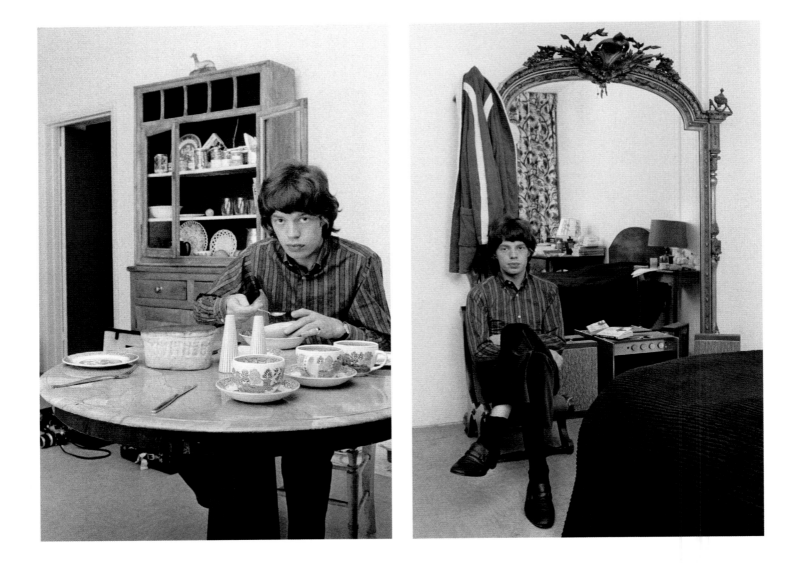

"Mick had moved into a basement flat near Oxford Street in June 1965. He had been staying at David Bailey's house for a while but moved into 13a Bryanston Mews East, London W1, which was fitted out with the latest G-plan furniture and, of course, two telephones. 'Chrissie [Shrimpton] can chat on the telephone for hours,' Mick said, 'so we have to have two telephones in each room for I might have to make a call too.'" BR

"I've always thought it amusing that Mick moved into 'Bryan Stone' Mews." BILL

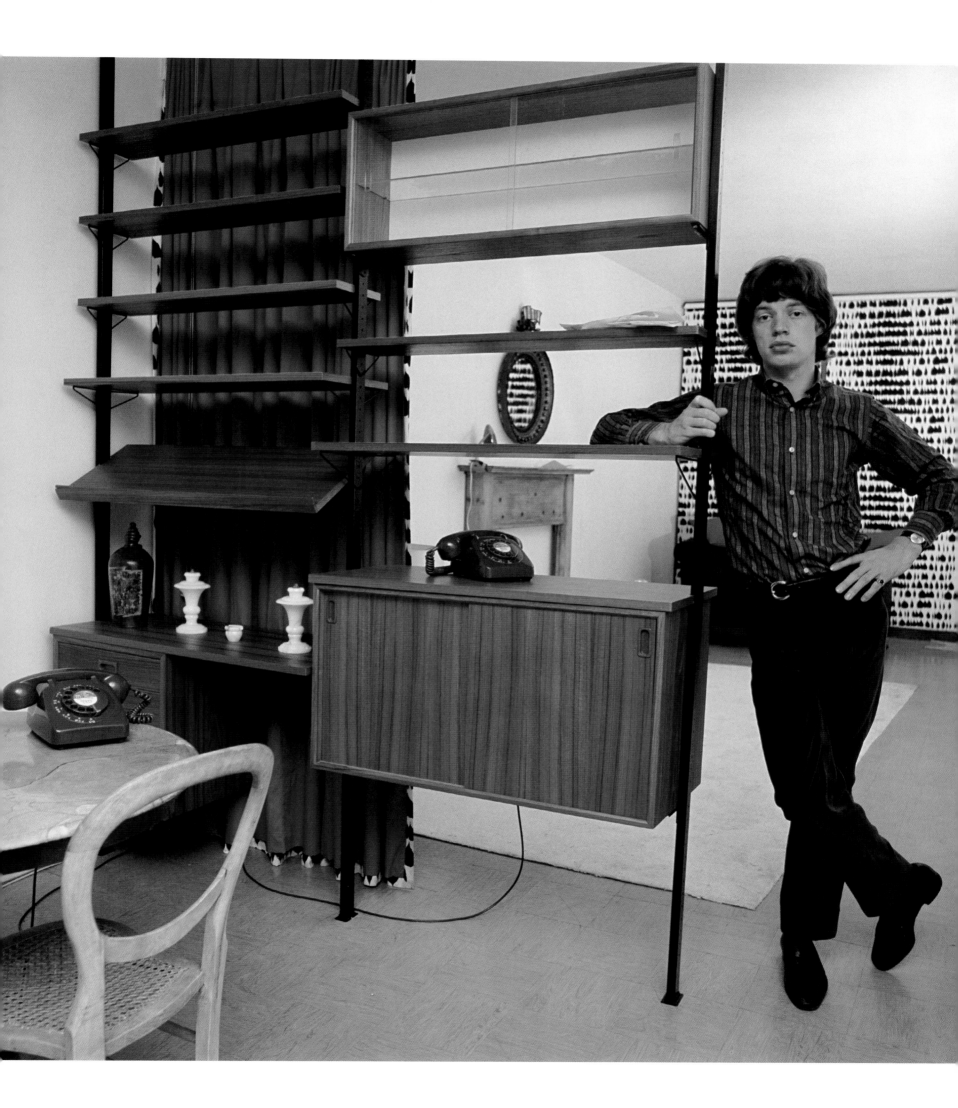

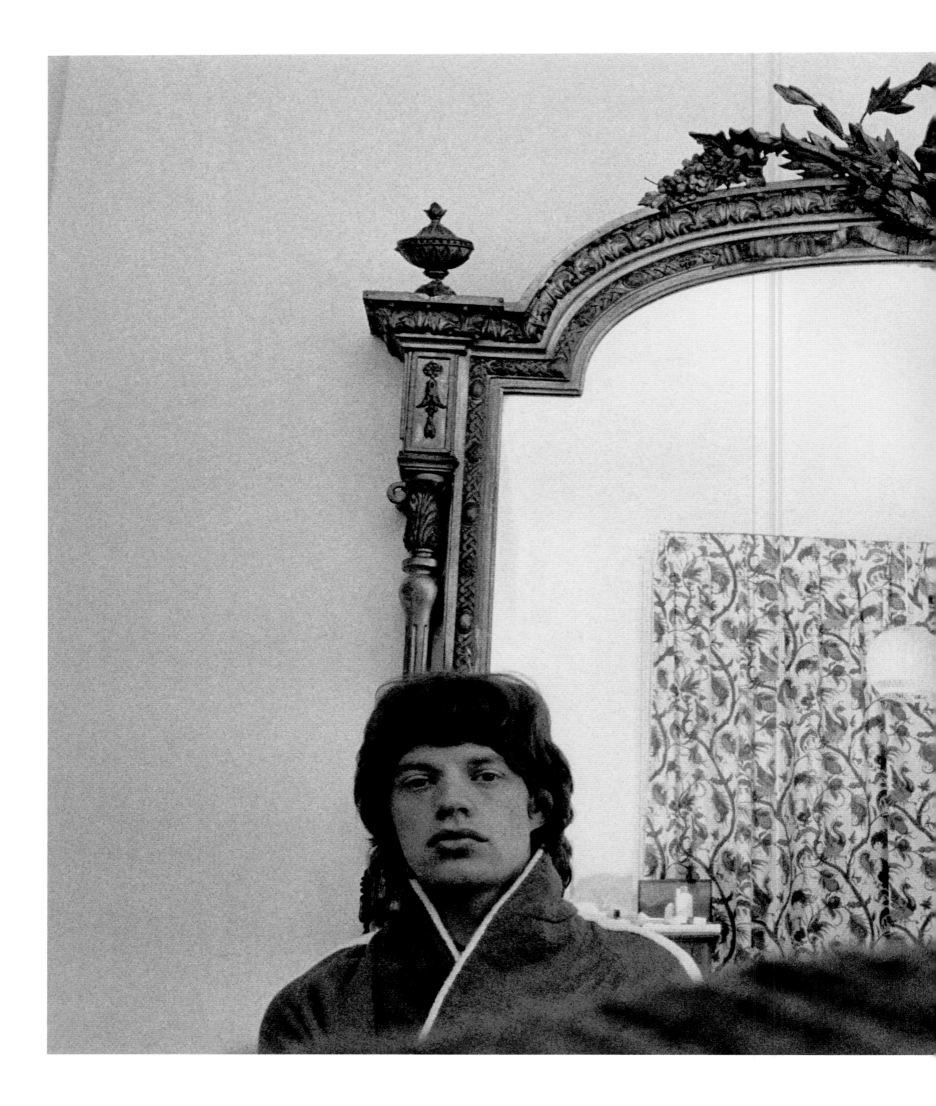

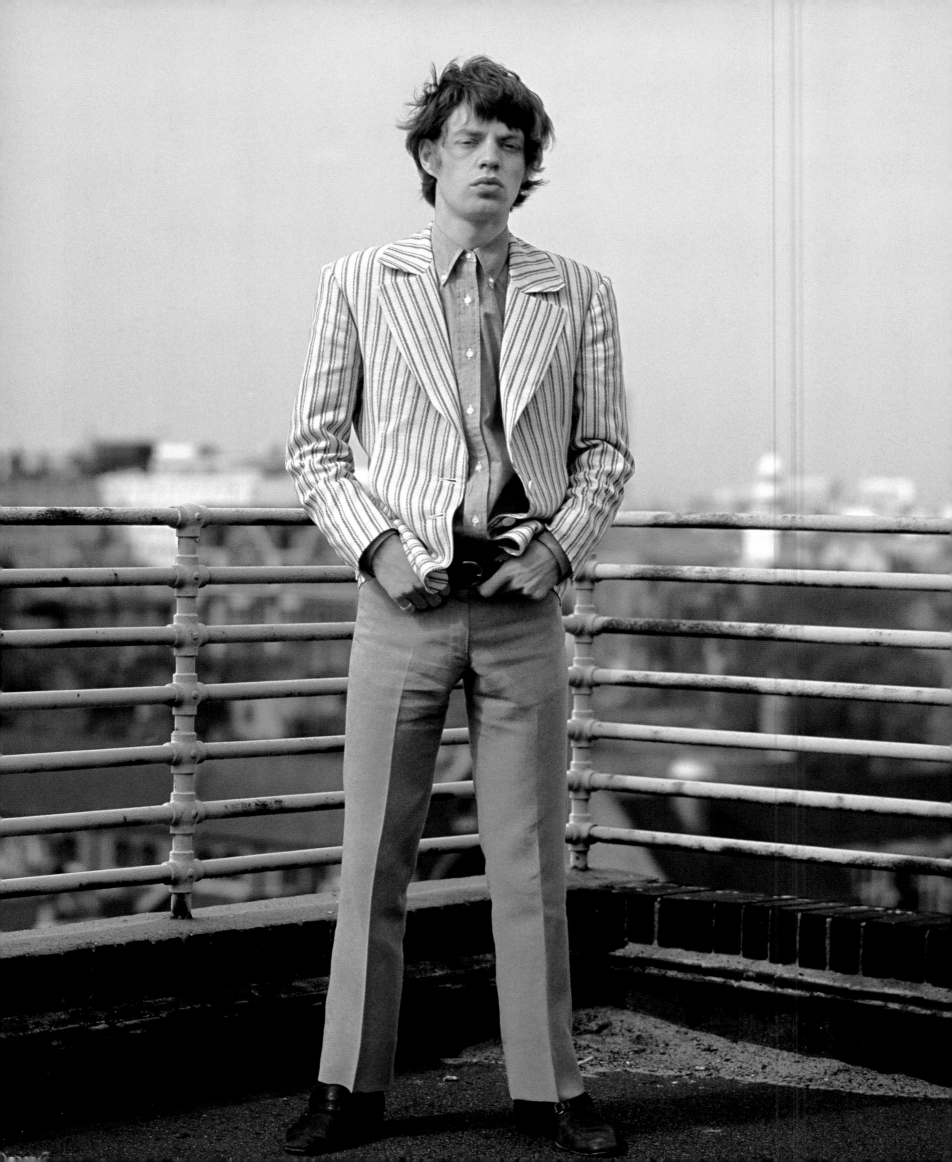

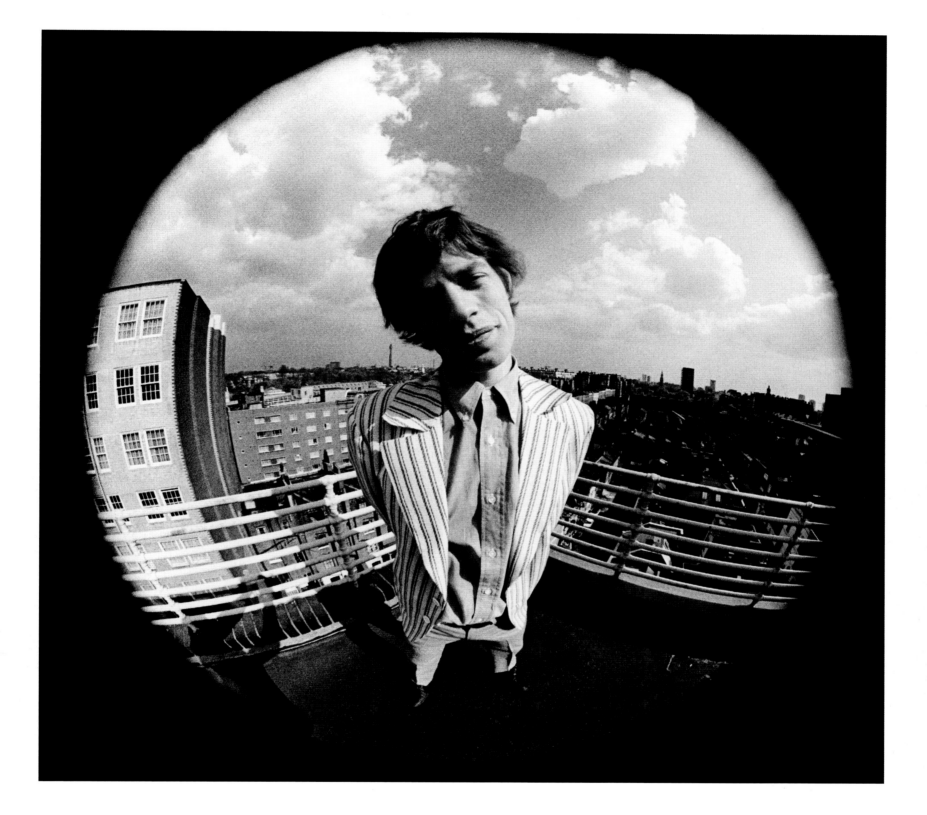

"I photographed Mick on the roof of his rented mews apartment. Mick was the last one of the Stones who agreed to me photographing him in his home. I needed him to do it because without him the feature I was doing for a magazine really didn't work. It gave me an opportunity to play around with my new fish-eye lens." BR

"Mick Jagger lives in a basement flat near Oxford Street. You have to know those parts well to find the house. Down the main street, down a narrow street, a little to the right in an alley and then behind three small houses. And still you have to ask the street sweeper which door to knock at. Mick isn't exactly the hospitable type, and I understood that as soon as the door was opened. He looked awfully sour. Later we're told why: a sick cat and a sour Chrissie Shrimpton. A real domestic scene in fact. He did smile while I photographed him but only because of our private friendship and because all the other Stones had been through the same thing.

"Mick's home has no hall. You go from the street right into his sitting room; the sitting room and kitchen are in the same room. There is no wall dividing the two rooms, just the bookshelves, which Mick leans against in the pictures. He reminds me somewhat of a fox, and like all foxes he has two exits. The other one is in the bedroom, through a basement shaft, and onto the parallel street. There is not much furniture. A sofa, a couple of easy chairs, a white carpet, and an artificial fire-place. And then, of course, there are the rather empty bookshelves with a vase and three candlesticks. The bedroom seems to be the room where he and Chrissie spend most of their time. It is brimful with cupboards, mirrors, weekly magazines, record-player, cosmetics (mostly Chrissie's), and radios.

"The very moment I stepped in the front door Chrissie slipped out the back door. 'My girl is to be left in peace,' Mick said sourly. She is not going to be photographed except for her professional fashion work. There were still cups and plates on the kitchen table, they just had their breakfast — it was 3pm." BR OCTOBER 1965

"Just because Keith and I aren't sharing this flat, everyone thinks we've had a bust-up. I'd like two bedrooms, a large double one and a smaller one, a very large living room-come-dining room, a kitchen, and a bathroom. You know the type of place I mean — old-fashioned furniture, fur rugs and big thick curtains, and a woman who can cook for me. That's a necessity. I'm a bit hopeless when it comes to the old bacon and eggs. I definitely won't be throwing parties. I don't mind going to other people's parties, but I'd rather do without the mess. Of course, I'll have the rest of the Stones round, and my other friends will be very welcome." MICK - NME, 24TH JULY 1965

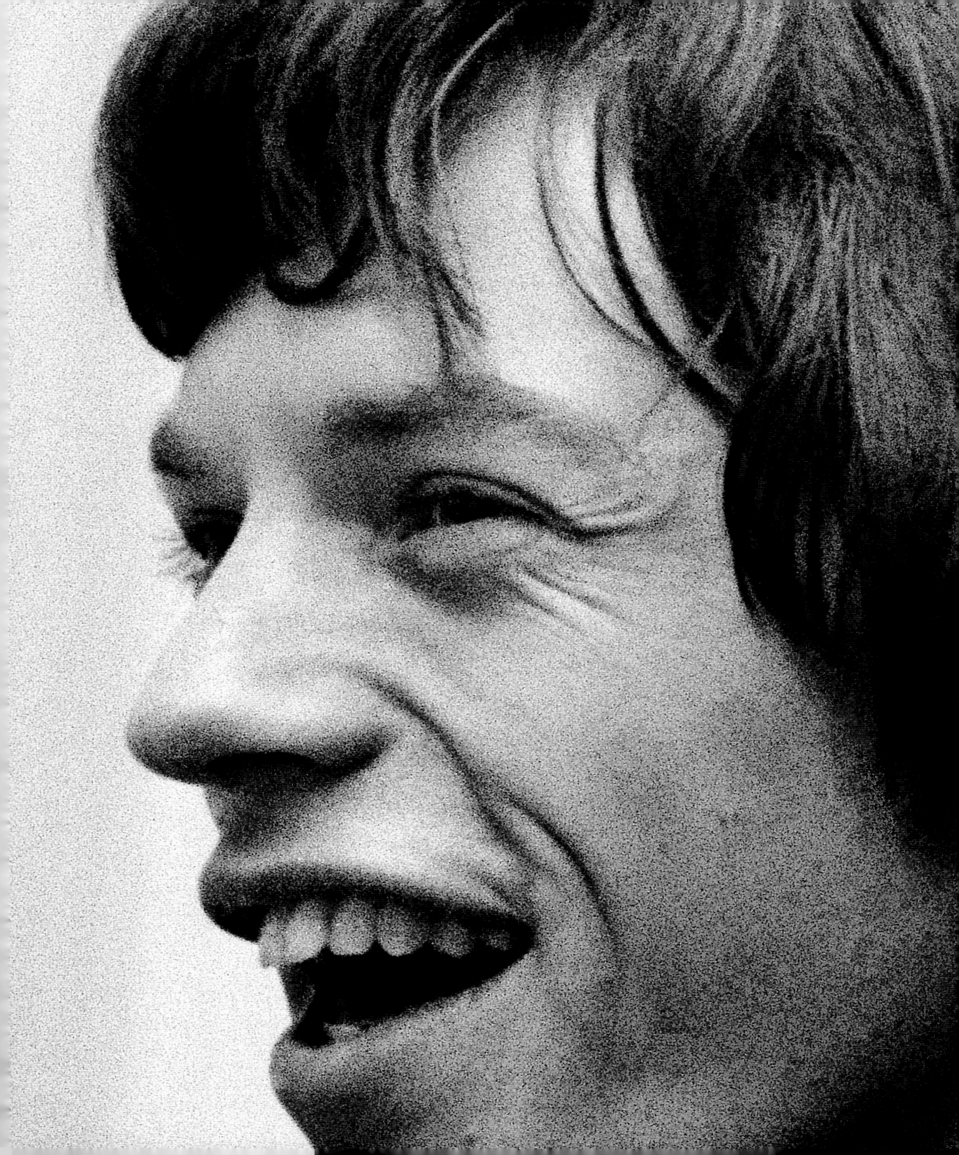

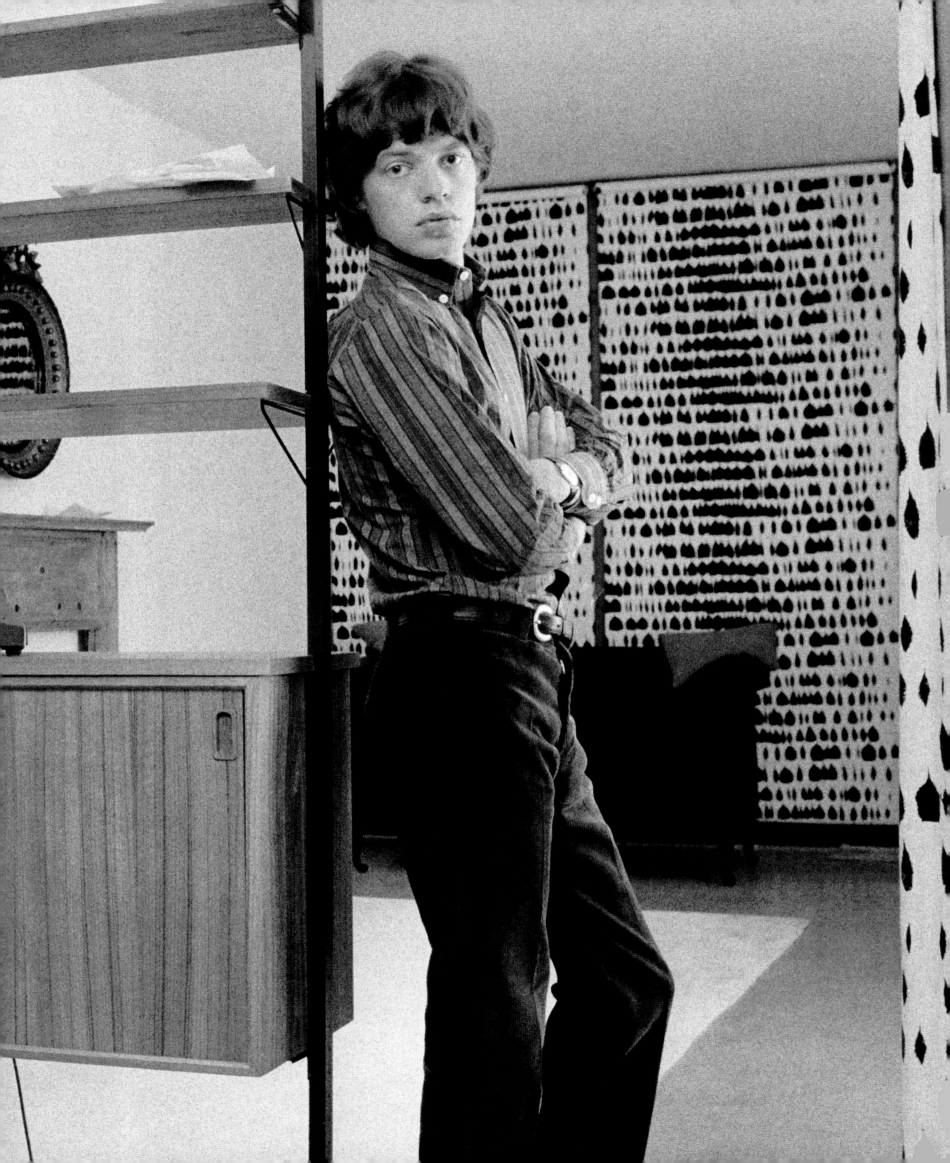

A YEAR OF SATISFACTION

On 18 January 1965 the Stones were in RCA's studio in Hollywood recording the backing track for **The Last Time**. They had stopped off in Los Angeles for a couple of days en route to Australia and New Zealand for their first tour down under. Mick and Keith went home via Los Angeles and recorded the vocals for what became the band's sixth UK single release and the first A side to be written by Jagger and Richards. Released in the last week of February **The Last Time** became the band's third No.1 in a row when it topped the charts for the first of its three weeks at the top spot on 20 March; five days later the Stones flew from London to Copenhagen to begin their first European tour.

A couple of weeks after finishing the Scandinavian tour the band were again back in America for their third American tour. While they were staying in Clearwater, Florida, Keith woke up in the middle of the night with a riff in his head, and fortunately he put it down on tape. In the morning Mick wrote words for the riff that would become one of their most famous songs. A few days later the band went to Chess Studios in Chicago and among the tracks they cut was **(I Can't Get No) Satisfaction**; the recording featured a harmonica played by Brian, but overall this version lacked something. A couple of days later back at RCA in Hollywood with engineer Dave Hassinger they did another version of the song. This time Charlie put down a different tempo, and Keith added a fuzz-box on his guitar sound that gave the recording a whole different feeling. After the band listened to the recording they discussed whether it should be the next single. Andrew Oldham and Dave Hassinger were very positive that it should be, so they put it to the vote. Andrew, Dave, Stu, Brian, Charlie, and Bill voted "yes", while Mick and Keith voted "no".

Released in the USA in early June and in the UK on 20 August, the record, with what is possibly the most famous intro in Rock music, became the first Stones' single to top the charts on both sides of the Atlantic.

Before **Satisfaction** came out in Britain, an EP recorded on the band's UK tour of March was released. It was called **Got Live If You Want It**. Apart from **I'm Alright**, a group composition under the infamous Nanker, Phelge alias, it was made up of covers, the other tracks being **Everybody Needs Somebody to Love**, **Pain in My Heart**, **Route 66**, and **I'm Moving On**. There was actually one other track on the record, entitled **We Want the Stones**, which was also credited to Nanker, Phelge. The track consisted only of fans chanting and, by crediting themselves as the composers, the Stones would have collected royalties. This EP with its attendant faults and limitations of recording is as close as you can get to experiencing what the Stones sounded like at the time.

At the end of July, **Out of Our Heads**, the band's fourth US album was released – the first to be dominated by band originals, although only three of the tracks were Mick and Keith originals. Four of the songs were Nanker, Phelge compositions.

Two months later the UK version of **Out of Our Heads** came out and it was substantially different to the US version with six different tracks. While the US version made No.1 the British release only got to No.2.

The Stones' third single release of 1965 was **Get Off My Cloud** and it became the band's second single to top the charts in both America and Britain. In the UK it was the band's fifth No.1 in a row – a feat previously only achieved by The Beatles and Elvis. Just before the year was over, **As Tears Go By**, a version of the song Mick and Keith had originally written for Marianne Faithfull, became the band's ninth US single but could only manage to make No.6 in Britain. The same track was used as the B side for **19th Nervous Breakdown**, which had its release in February 1966. In the US, **Sad Day** was the B side, and the single made No.2 on both sides of the Atlantic, which broke the string of No.1s in Britain.

By April 1966 the Stones' success in America justified the release of a greatest hits album. Entitled **Big Hits, (High Tide and Green Grass)** it made No.3 on the Billboard charts. The British version came out seven months later and it got to No.4. Within a couple of weeks of the US release of **Big Hits** the band's fourth UK album, **Aftermath**, was released. It was a milestone in that all the tracks were Jagger/Richards originals. It topped the UK album chart, but when it came out in America with a slightly different, reduced track listing it made No.2.

Paint It, Black, the next single, was released in May a week apart on both sides of the Atlantic. It restored the Stones to the top spot on both charts. Such was the enthusiasm for the record in Britain, there were advance orders of 200,000 for the single. The single effectively marked the end of the band's career as a pop-orientated band – from here on in they were on their way to becoming one of the first – and best – modern Rock bands.

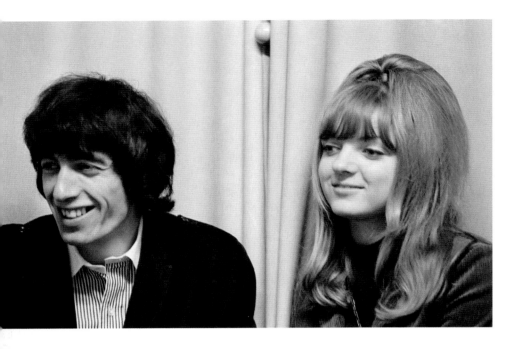

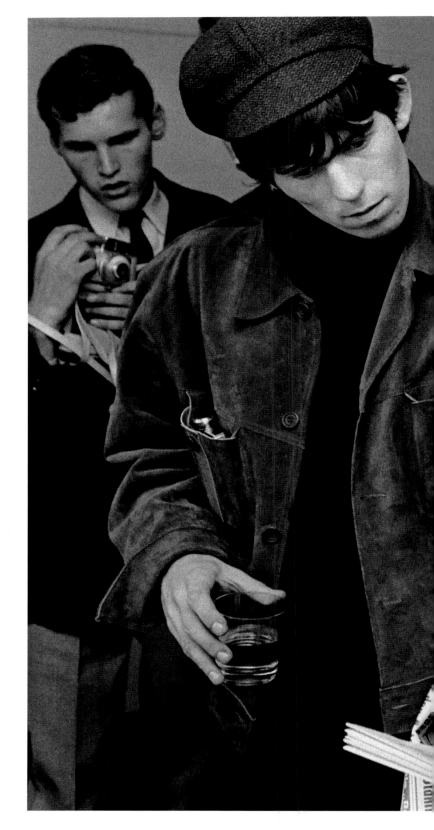

"Bill had a girlfriend from Copenhagen along with him on some of the German tour and this nearly created a huge problem for all the wrong reasons. The newspaper Bild Zeitung ran a story, which included a picture of her saying that she was in fact Mick's girlfriend Chrissie Shrimpton. Everyone, and particularly Mick, was upset by this and Andrew Loog Oldham forced the editor (pictured far right) to print a story retracting his newspaper's assertion in the next day's edition. The editor in fact had no choice: either he retract the story or the Stones would cancel the rest of the tour that was being sponsored by one of their publications, Bravo." BR

"My girlfriend did look a little like Chrissie Shrimpton in some photographs, although she was not as tall as Mick's girlfriend." BILL

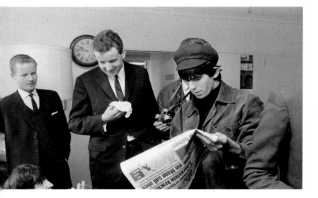

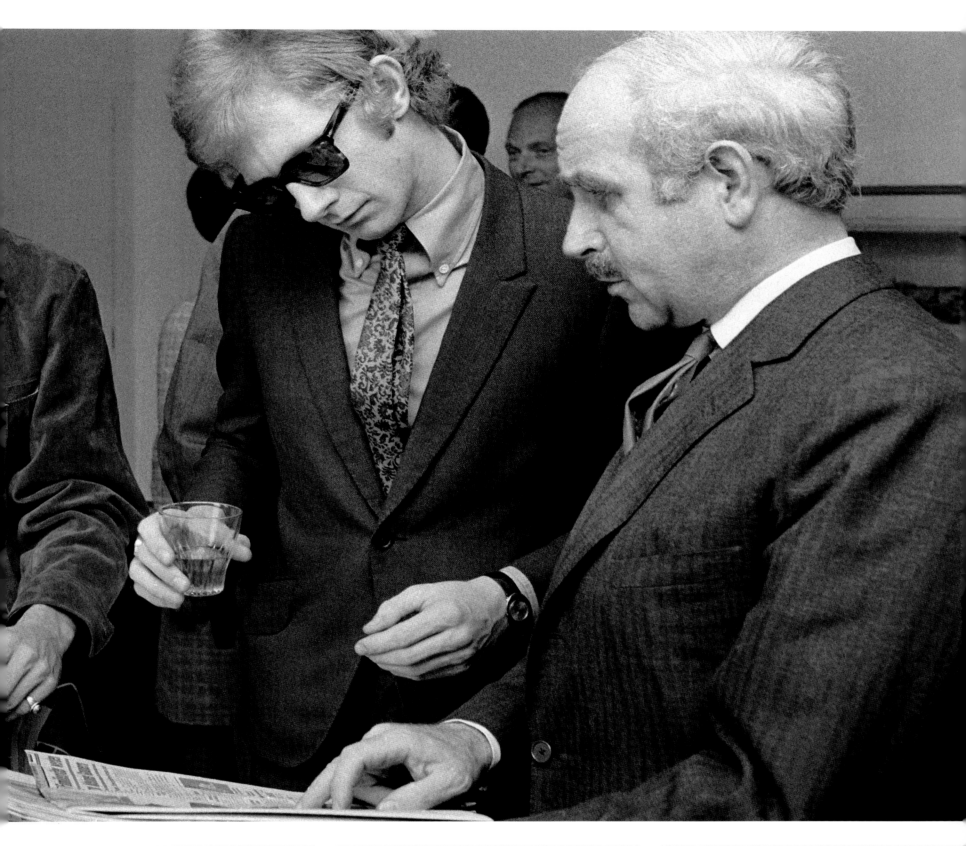

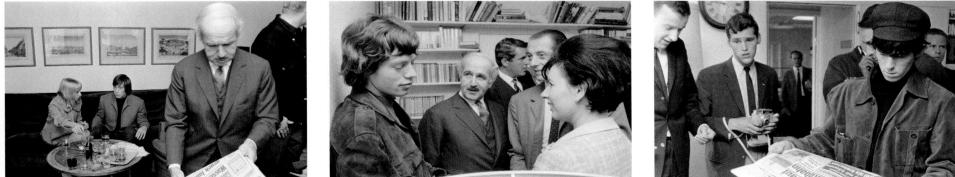

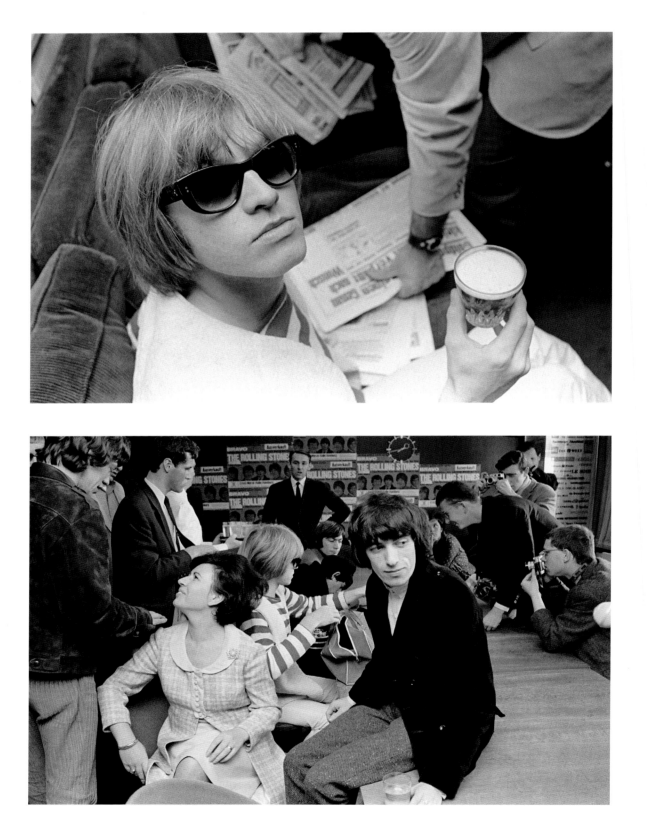

"Following the sticky situation over the picture, the paper produced some beers and some lunch, and before long the situation returned to normal and everything ended amicably." BR

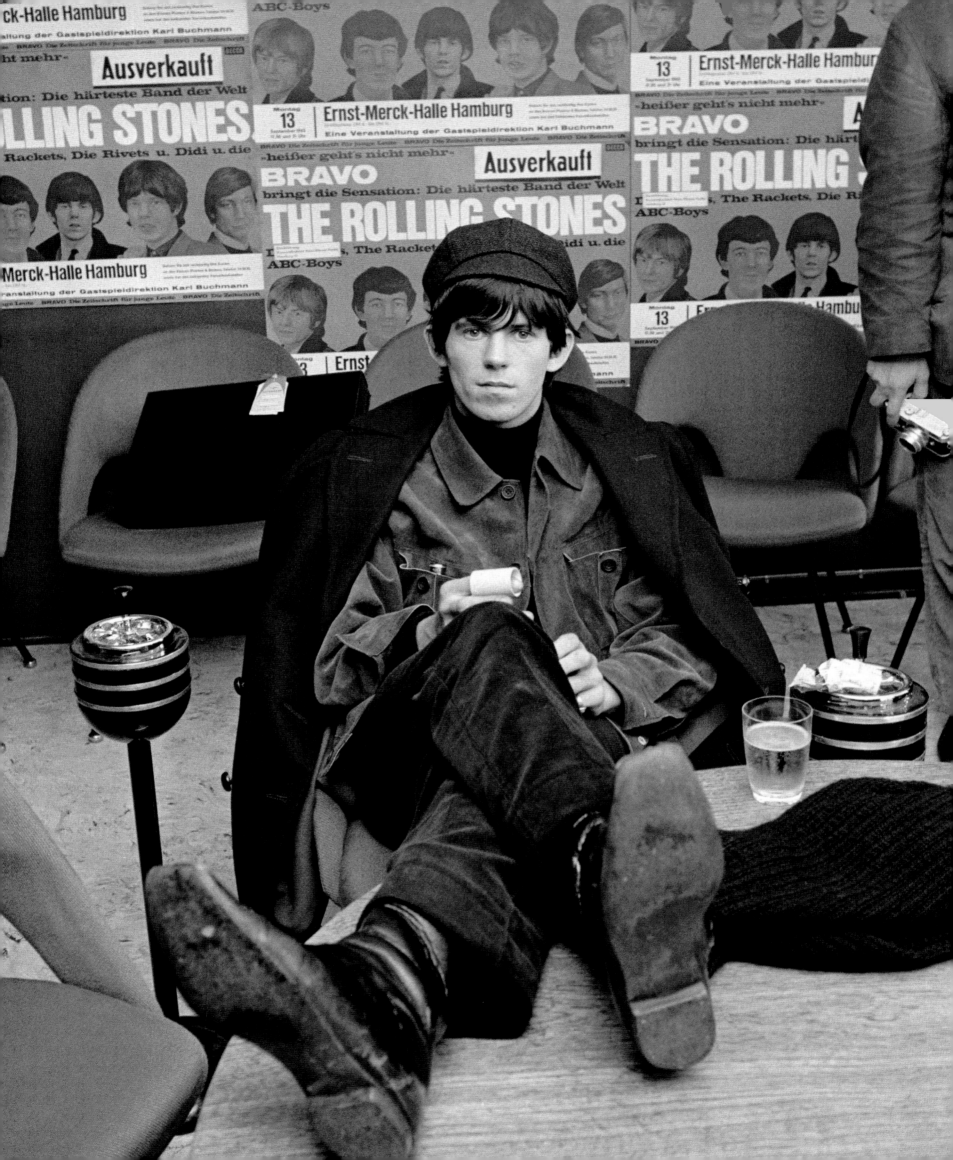

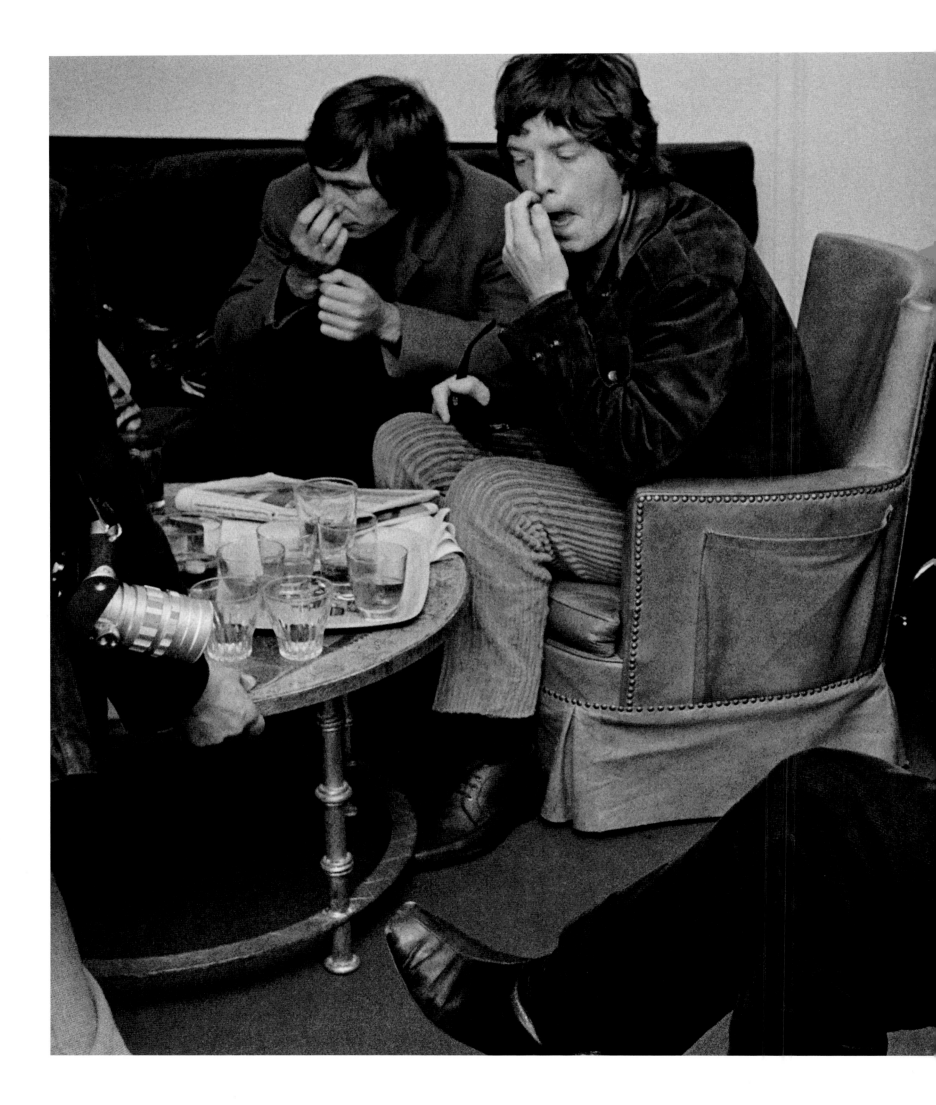

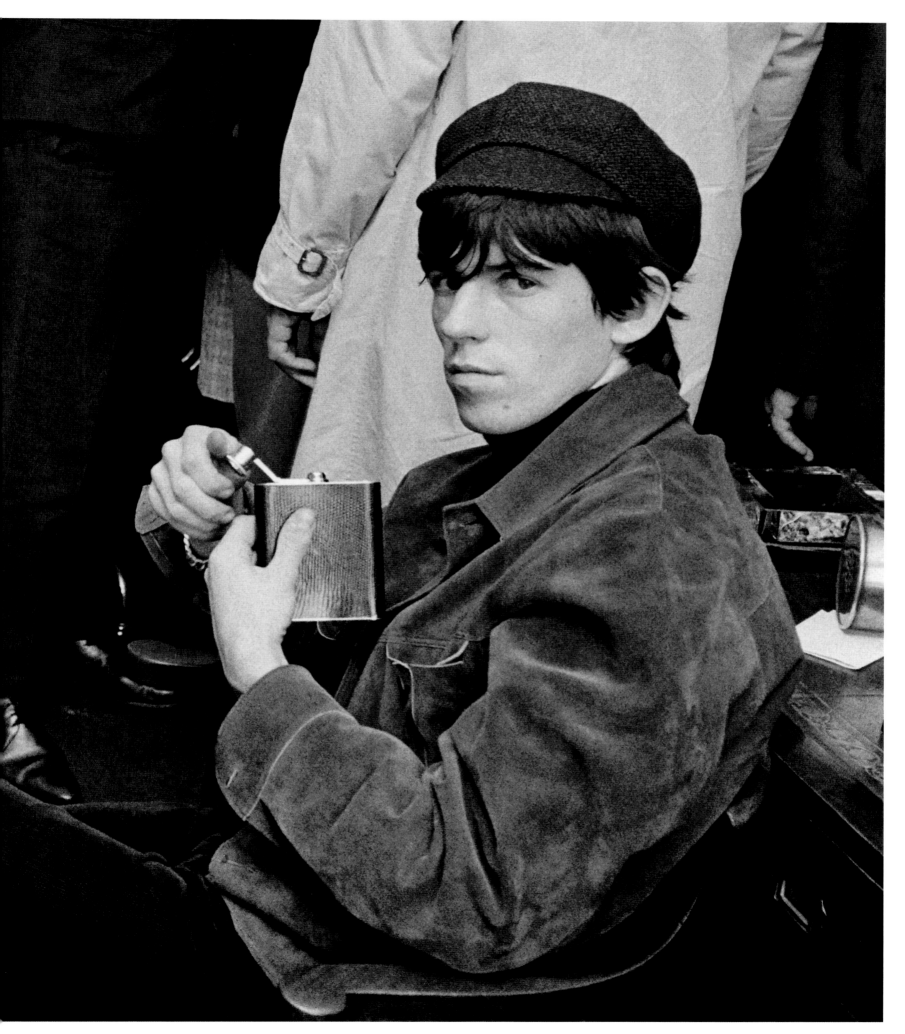

"Keith had his personal supply of drink in a hip flask, but I should mention that neither Mick nor Charlie were taking anything stronger." BR

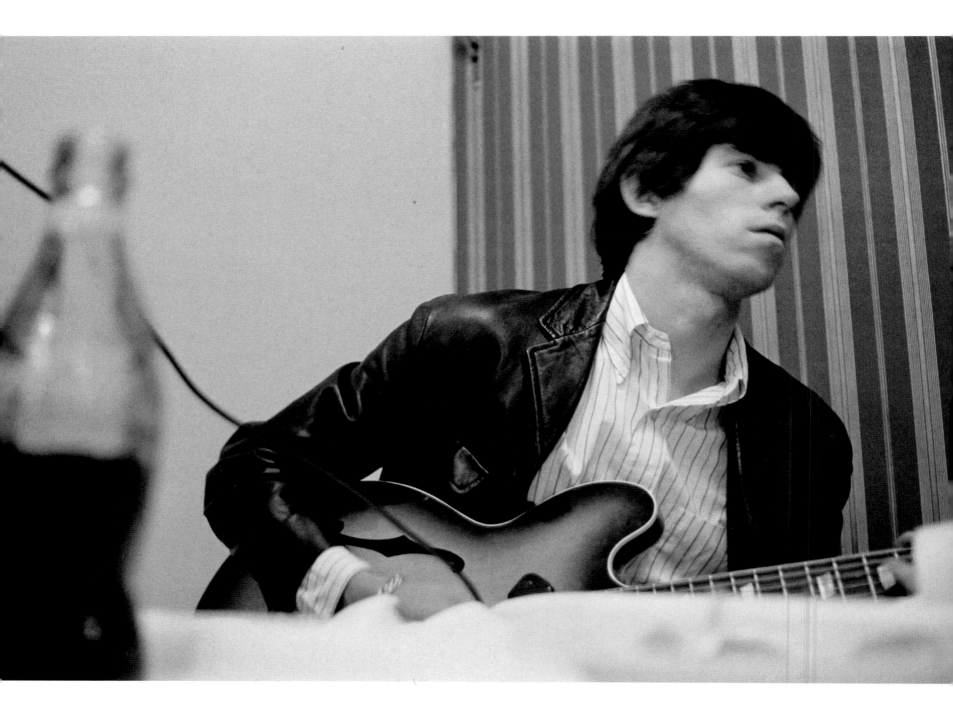

"Backstage at Hamburg's Ernst Merck Halle everything was relaxed and calm, as usual Keith was playing his guitar. The band were waiting for The Rackets, The Rivets, and Didi and The ABC Boys to finish their short sets. At the airport it had been anything but calm as there were 2,000 fans awaiting the arrival of the Stones." BR

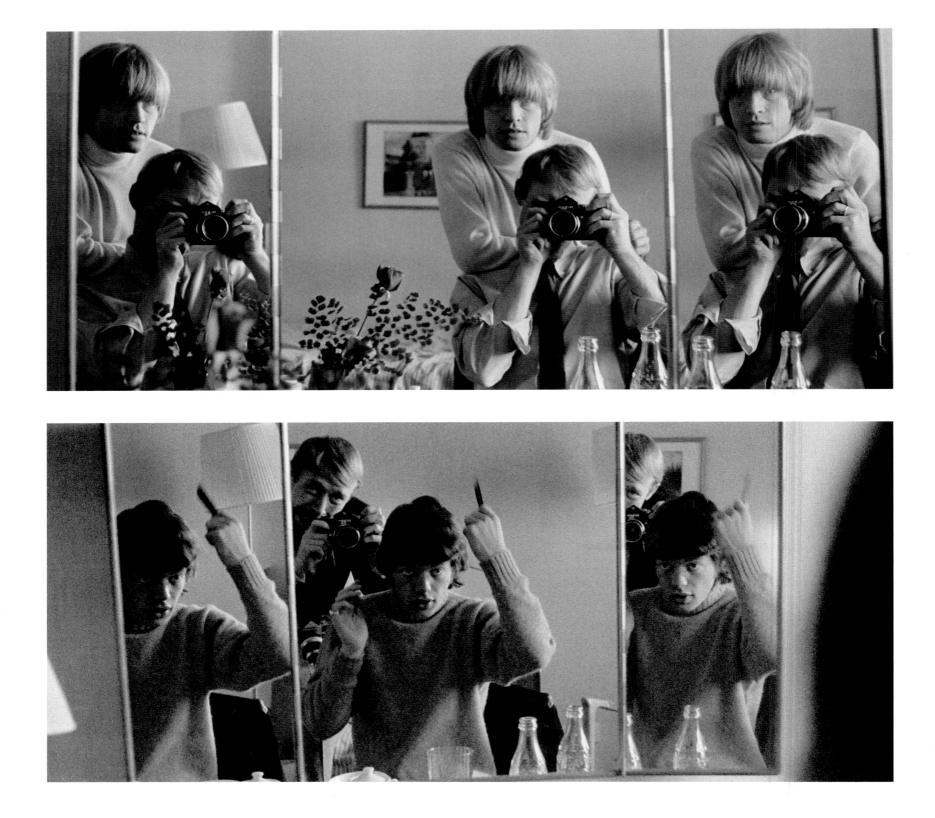

"Before the band went onstage Brian was the one who always seemed to be the one who was most conscious of his appearance. It gave me the opportunity to play around with my camera." BR

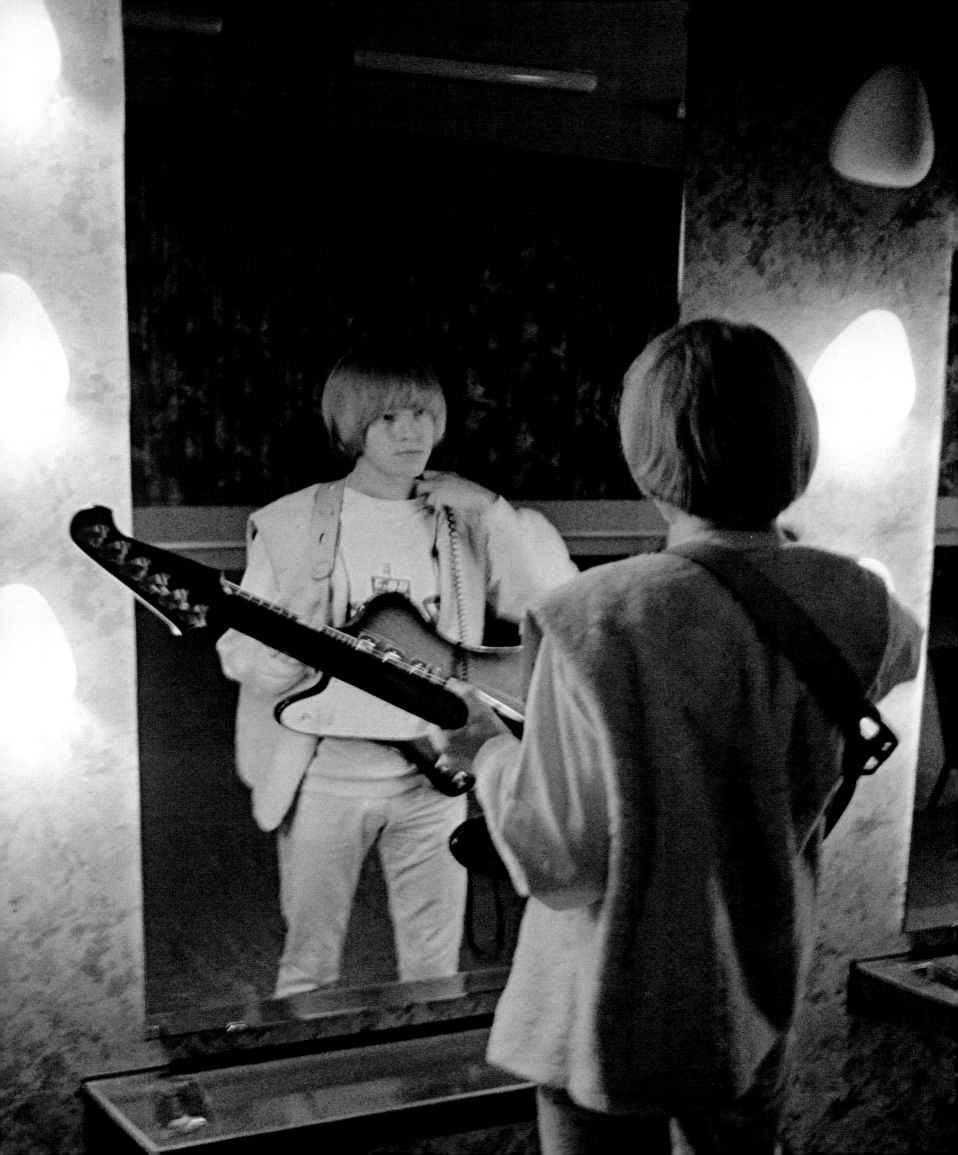

"Waiting to go onstage the band was unaware of what had been going on outside the venue. Police with batons fought with rioting fans and had to use water cannon to calm the situation." BR

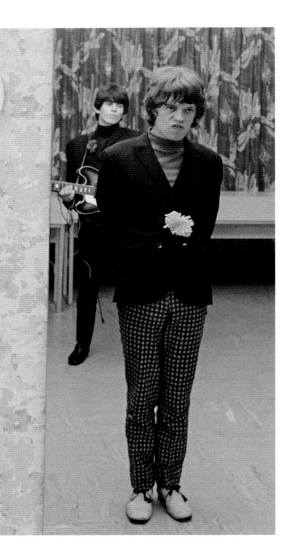

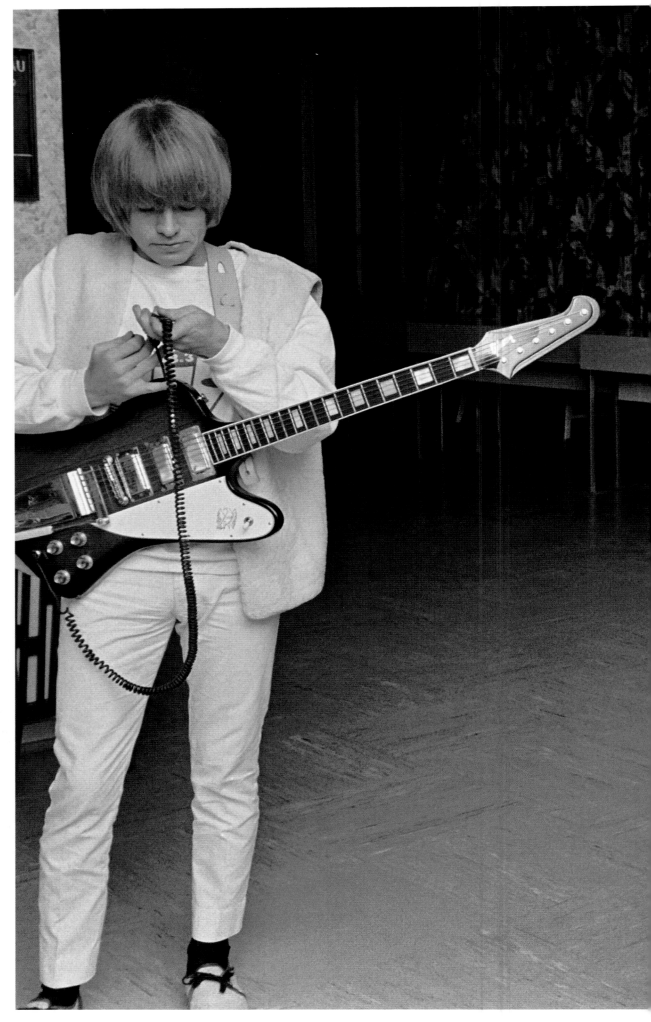

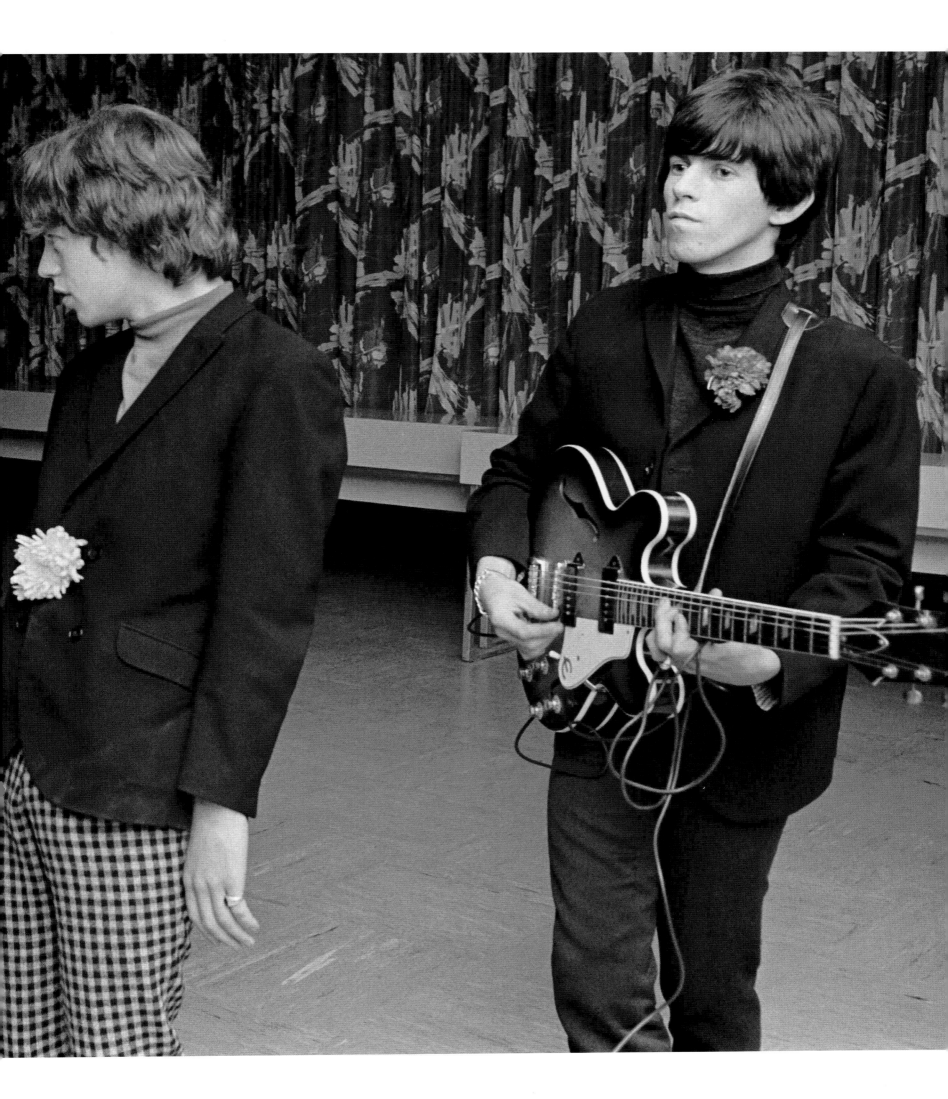

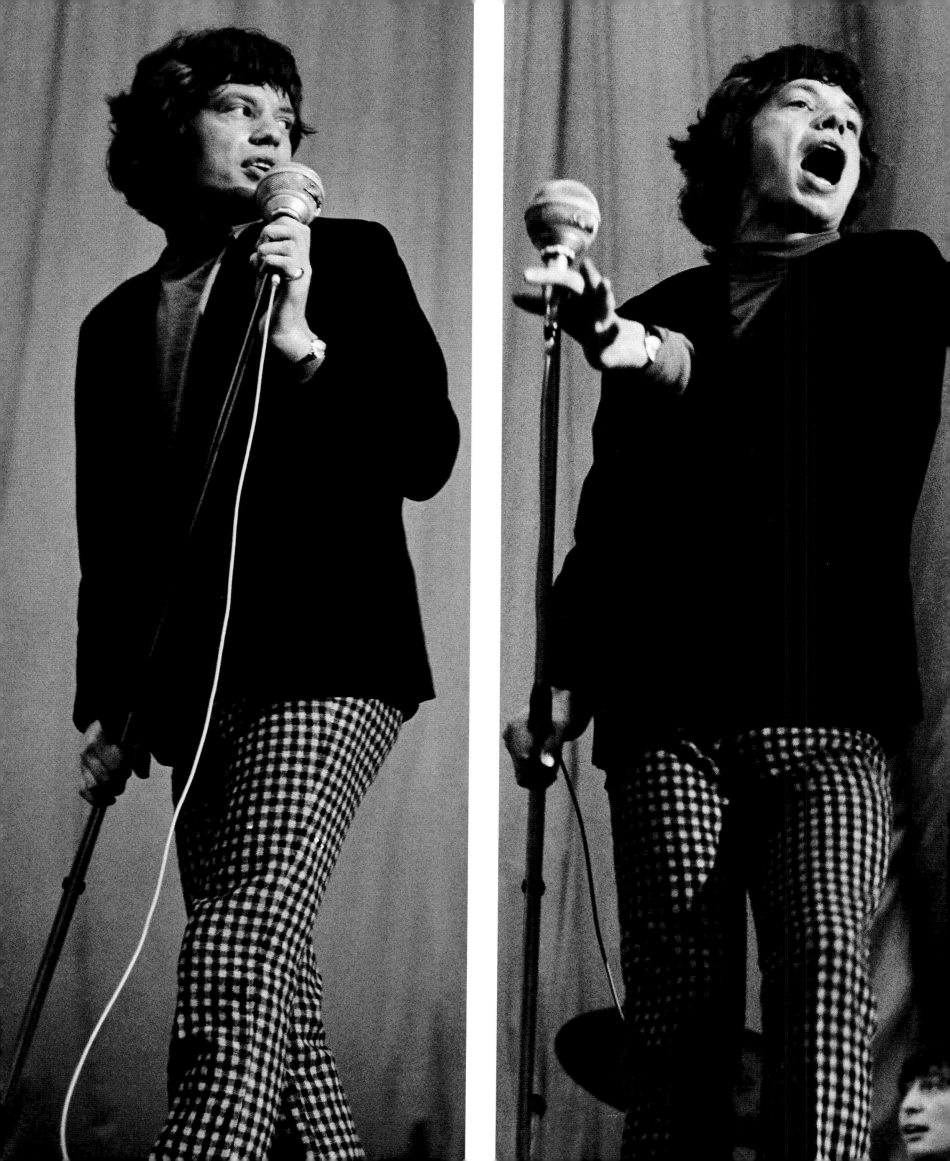

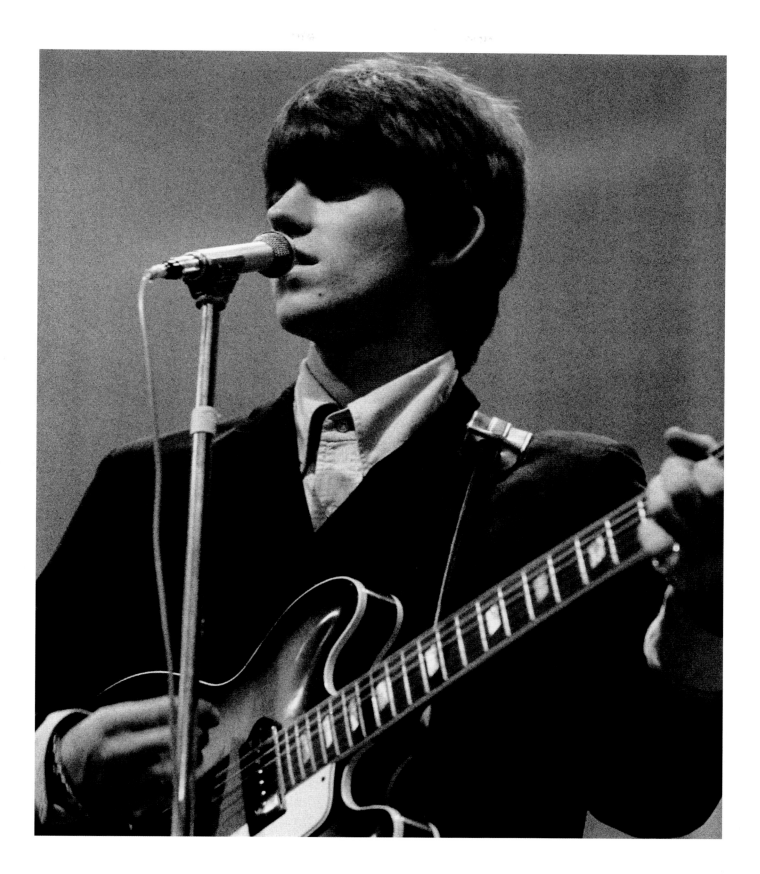

"The Stones played two shows to 7,000 fans at each performance; at both concerts the Stones gave everything. In actual fact there was not a performance I witnessed in my year photographing the band that wasn't 100 per cent entertainment." BR

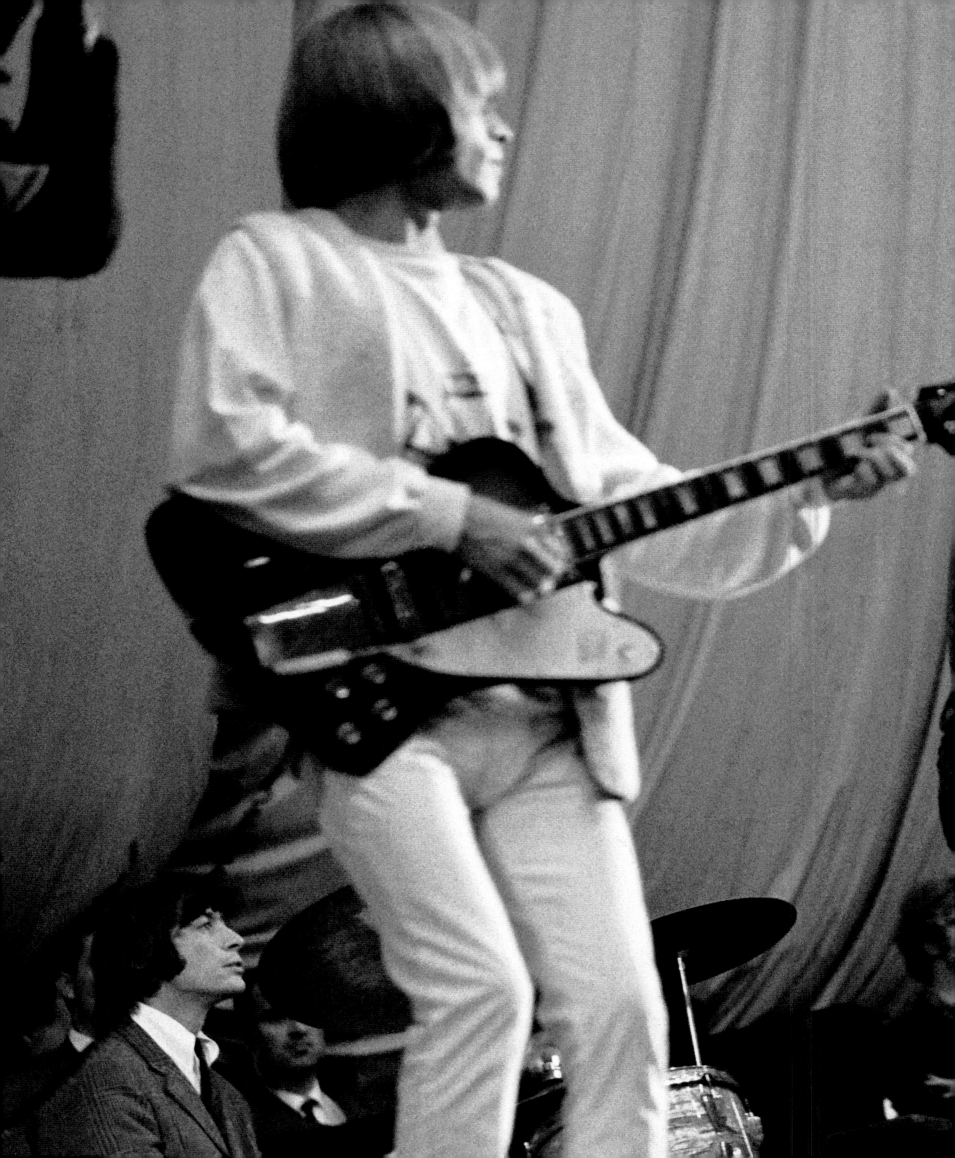

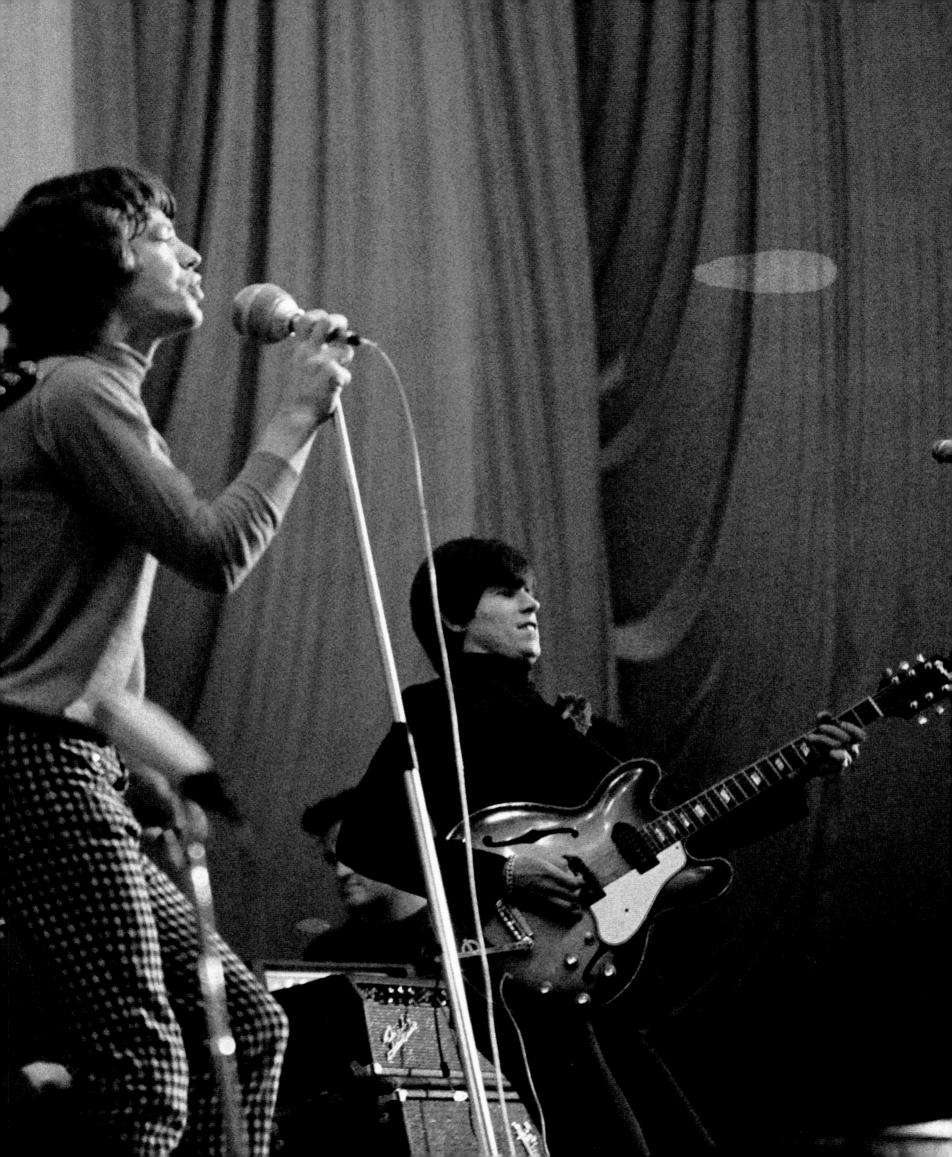

"Bild Zeitung had placed flowers in the band's dressing room while they were onstage for the first show as a kind of apology for what had happened over the picture story. By the time the Stones had finished with the dressing room it looked as though there had been a minor riot backstage. Outside the venue 700 police fought with the fans. Forty-seven fans were arrested and thirty-one were injured in the street fighting that lasted for around six hours. Cars were overturned and park seats were thrown into the road." BR

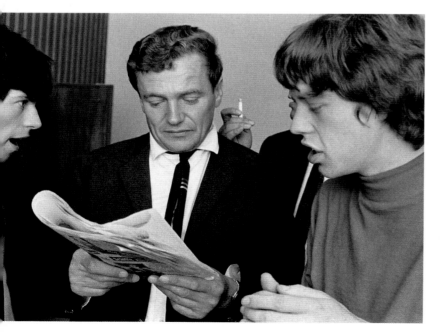

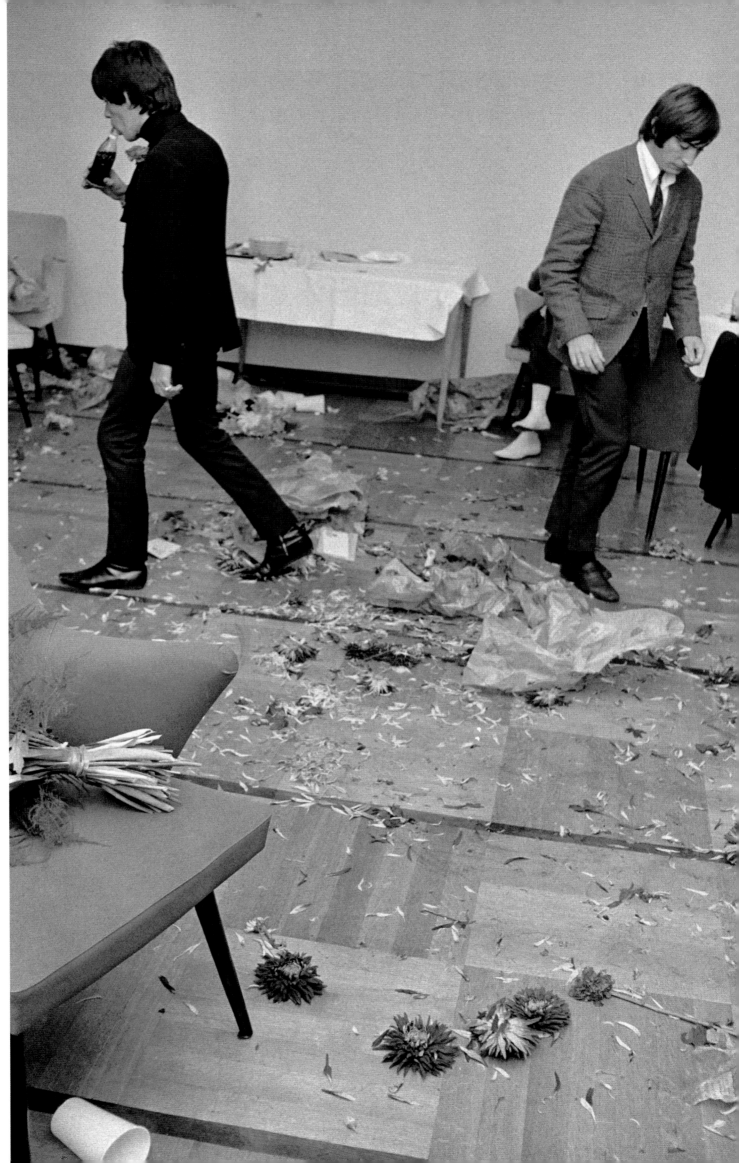

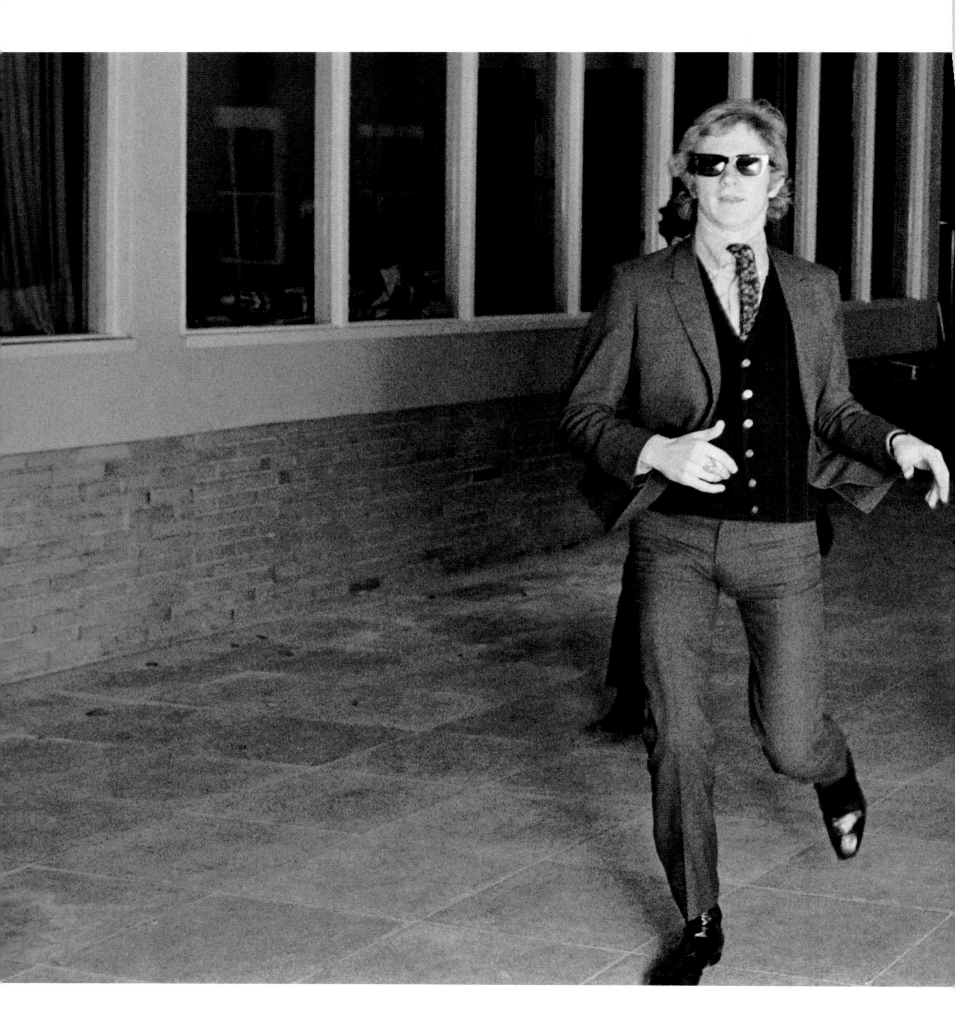

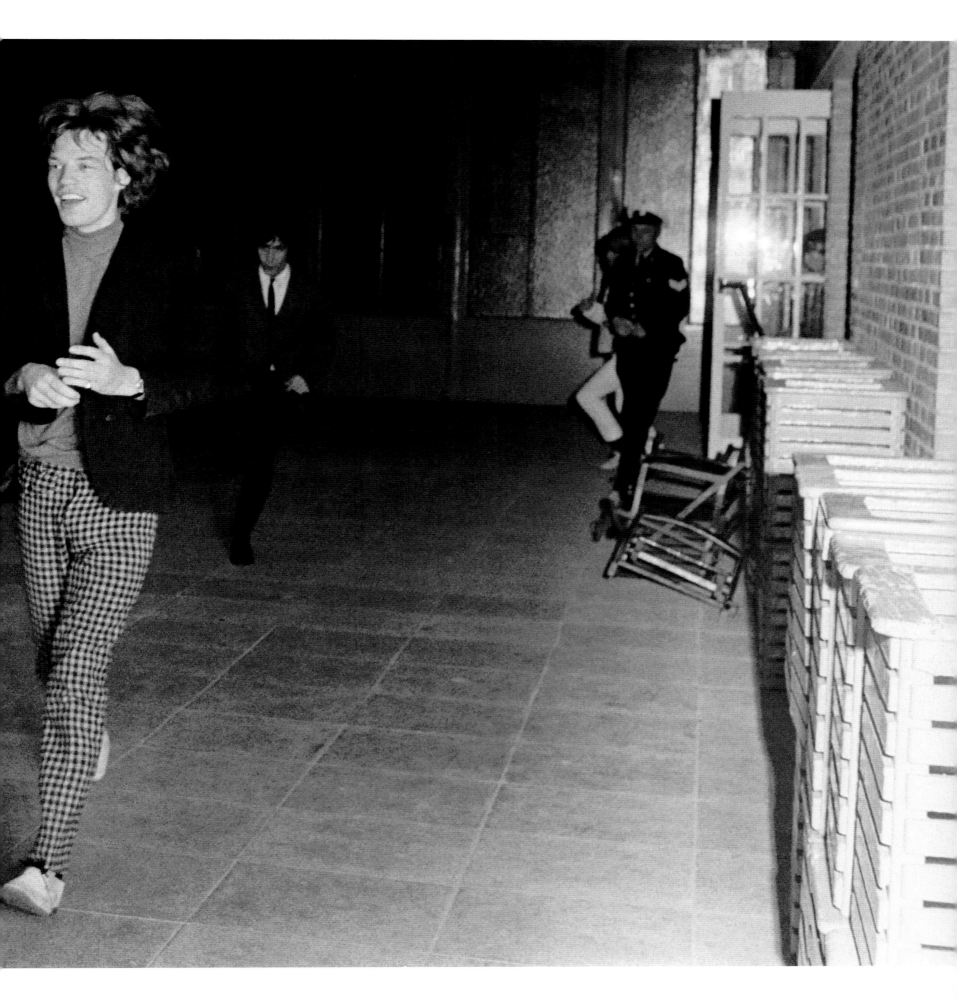

"Leaving a gig after the second show was always the same. It involved getting the band offstage as soon as the last song was finished, no time for an encore, then sprinting to the waiting cars to make a getaway before the fans could get out of the hall." BR

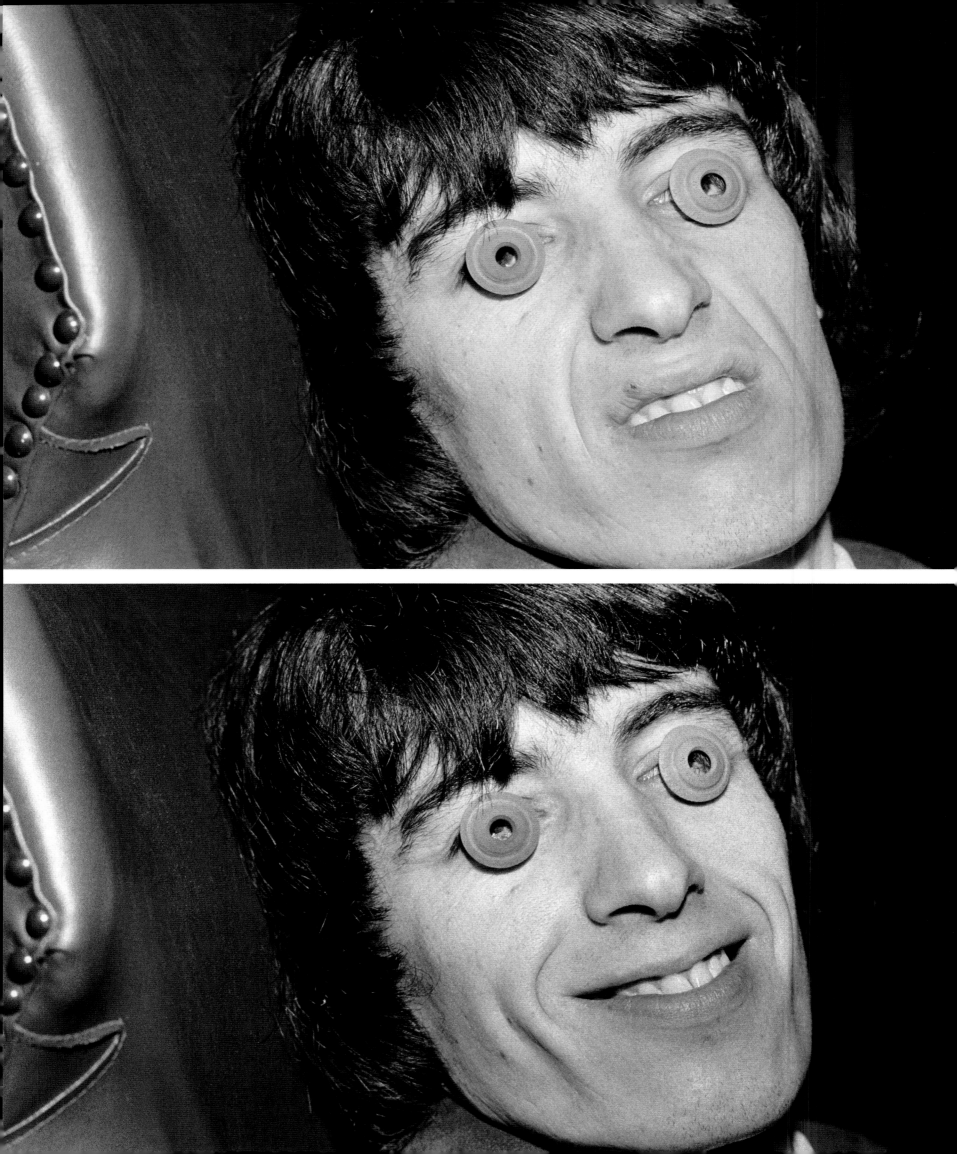

"In the dressing room I found some metal discs about the size of an old penny. I placed them in my eyes like monocles, and when someone asked me what they were I made up this crazy story that I used them onstage, to keep the lights out of my eyes. When they expressed some doubts, Keith backed me up, and we convinced them it was true." BILL

bill wyman

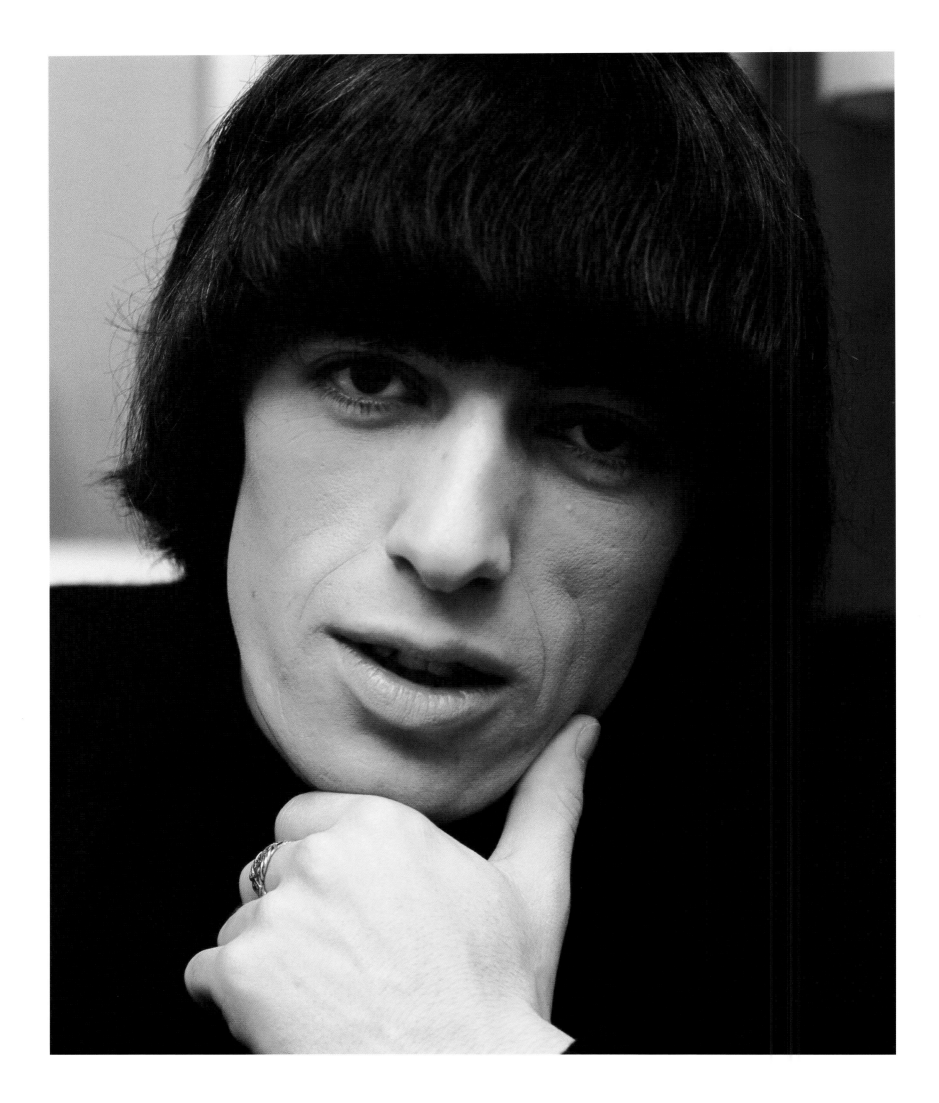

WILLIAM GEORGE WYMAN

William George Perks was born 24 October 1936 at Lewisham Hospital in south-east London, making him the oldest member of the band, although early biographies of the Stones had Charlie as the eldest. Bill's father, William George Perks, was one of ten children and his mother, Kathleen, was one of six. Bill, too, had five brothers and sisters, although one brother died in infancy. Bill's was a typical working-class family and they lived in a terraced house with no bathroom or hot running water. Bill was evacuated twice during the war but spent more time in London than elsewhere.

Much of Bill's early schooling was disrupted by the war but he did well enough to be one of only three from a class of 52 to pass his 11-Plus. He went to Beckenham and Penge Grammar School for Boys, but found he did not fit in. He was one of the only kids with a working-class accent, but even worse they made him play rugby not football! At school he took piano lessons, joined the choir, and played the clarinet. Eventually Bill's father insisted he leave school so he could pay his own way — the family were short of money. Bill ended up working in a bookmakers as a junior clerk.

Next for Bill came his National Service; he joined the RAF and was eventually posted to Germany. He signed on for an extra year and, when he came home in 1958, he worked at a meat importers before becoming a storekeeper at an engineering firm. A year later Bill married, and was the only one with a wife when the Stones started out.

In 1960, with some friends, Bill started a group. Initially called The Squires, the band was shortly after renamed The Cliftons. Bill's first public appearance was in January 1961. Bill eventually made his own homemade electric bass, which was fretless. He also bought some decent amplification and The Cliftons became a local attraction in the Penge area of south-east London. It was The Clifton's drummer who answered an advert and began playing with the earliest incarnation of The Rolling Stones. Through him, Bill got introduced to the band, who were very impressed with Bill's spare amp and his cigarettes — and his playing. Bill's first gig with the Stones was in December 1962, a matter of weeks before Charlie was persuaded to join the band, and the straightest rhythm section in rock was established. In August 1964 Bill, who had been calling himself Bill Wyman after a former RAF friend, legally changed his surname.

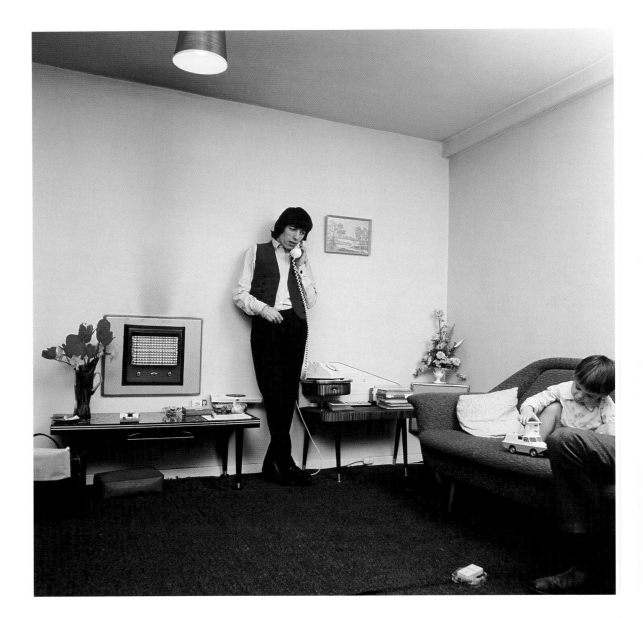

Bill and his first wife Diane had lived in several places in south-east London, in the area where Bill had grown up, before they moved to a flat at 8 Kenilworth Court in Penge in July 1964, which is where some of these pictures were taken in June 1965.

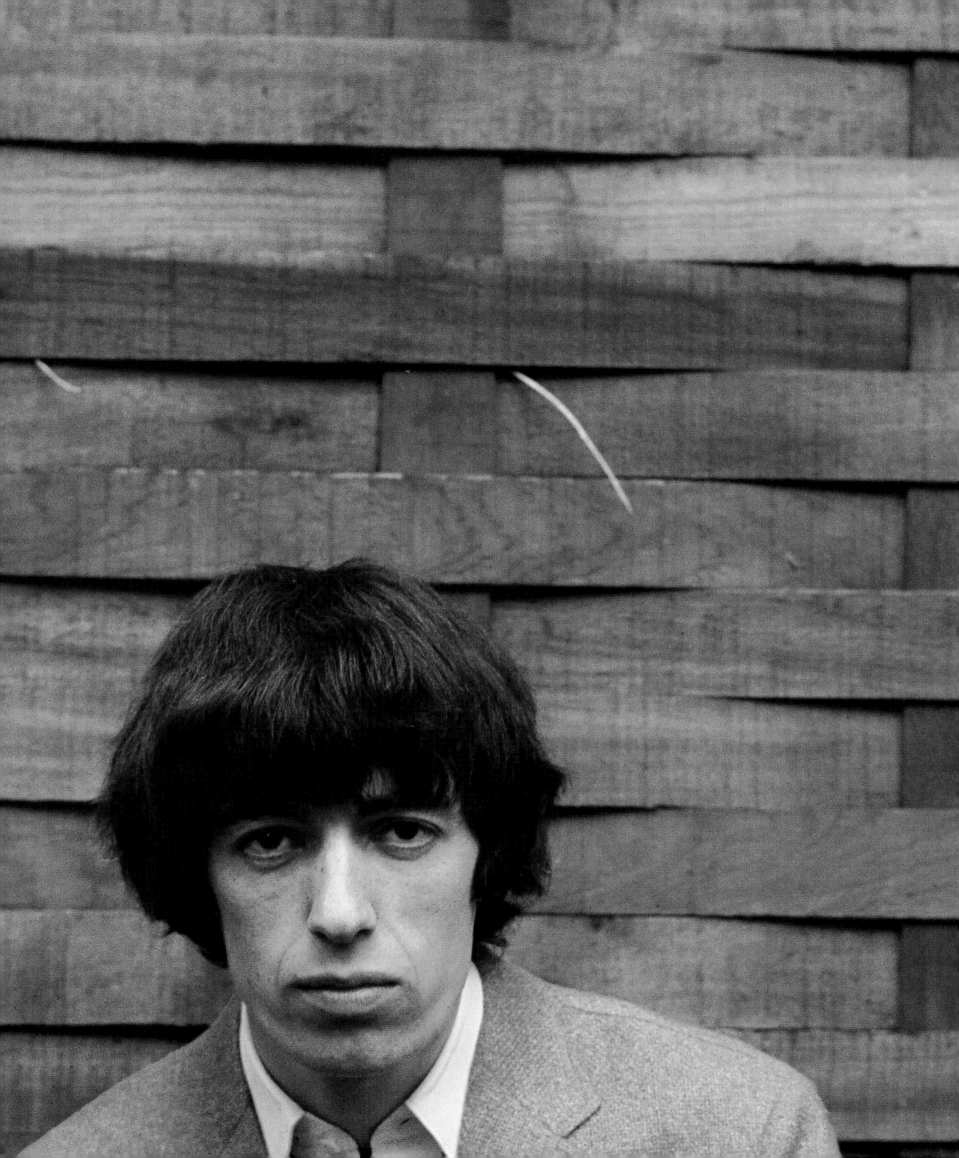

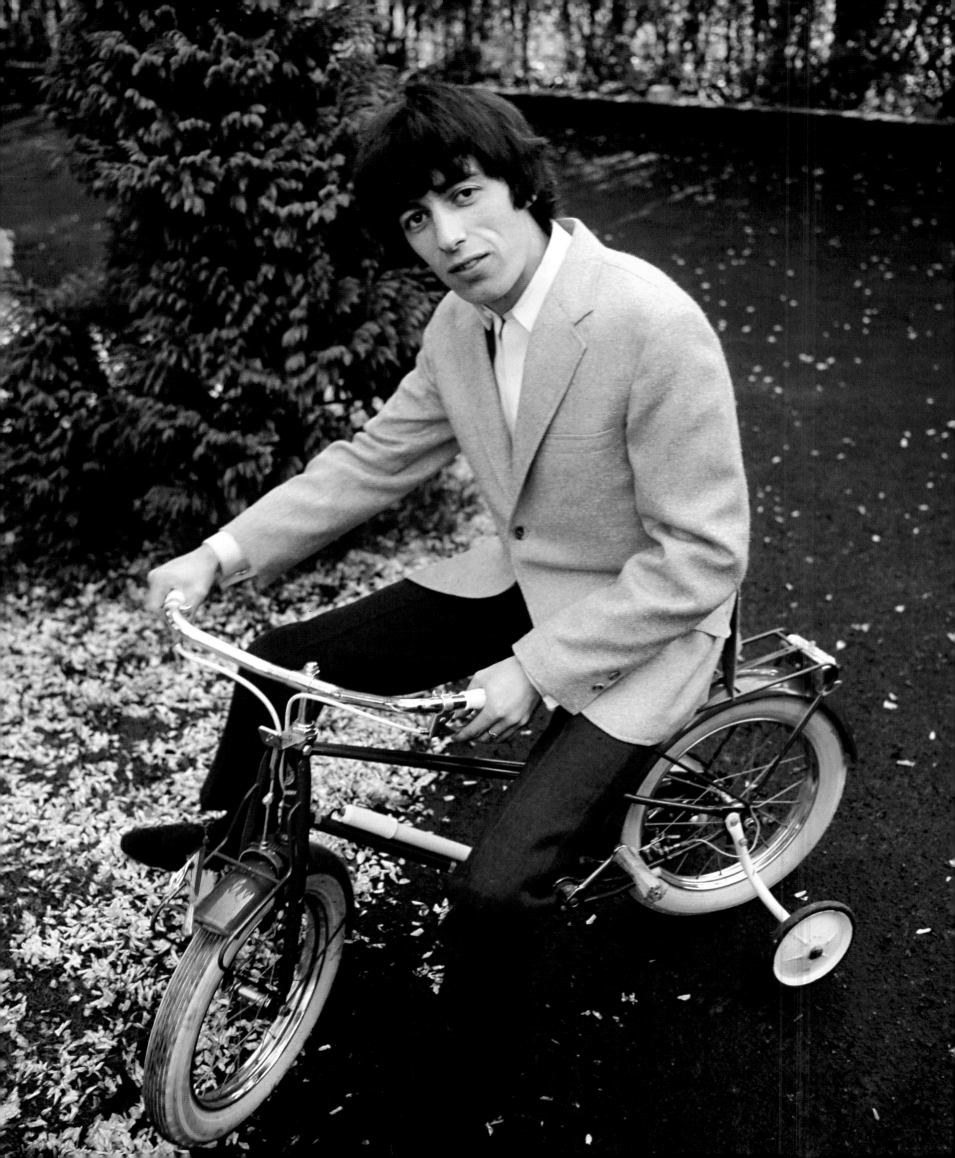

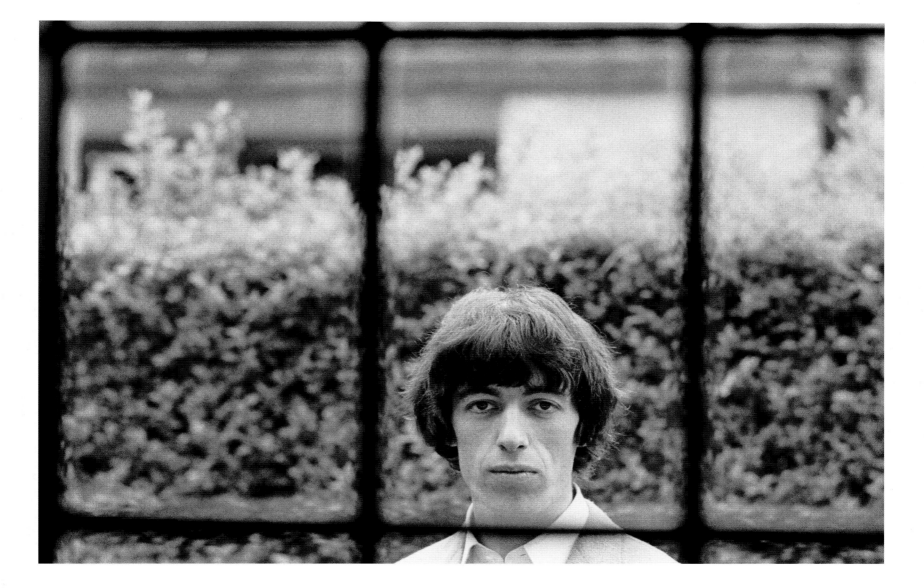

"These pictures were taken at my next home in Keston Park, near Biggin Hill in Kent. I moved to The Oaks, 15 Forest Drive on 21 January 1966 — it was a real step up from the flat over the garage at Kenilworth Court. Margaret Thatcher once owned a house in Keston. My house was just about half a mile from Biggin Hill aerodrome." BILL

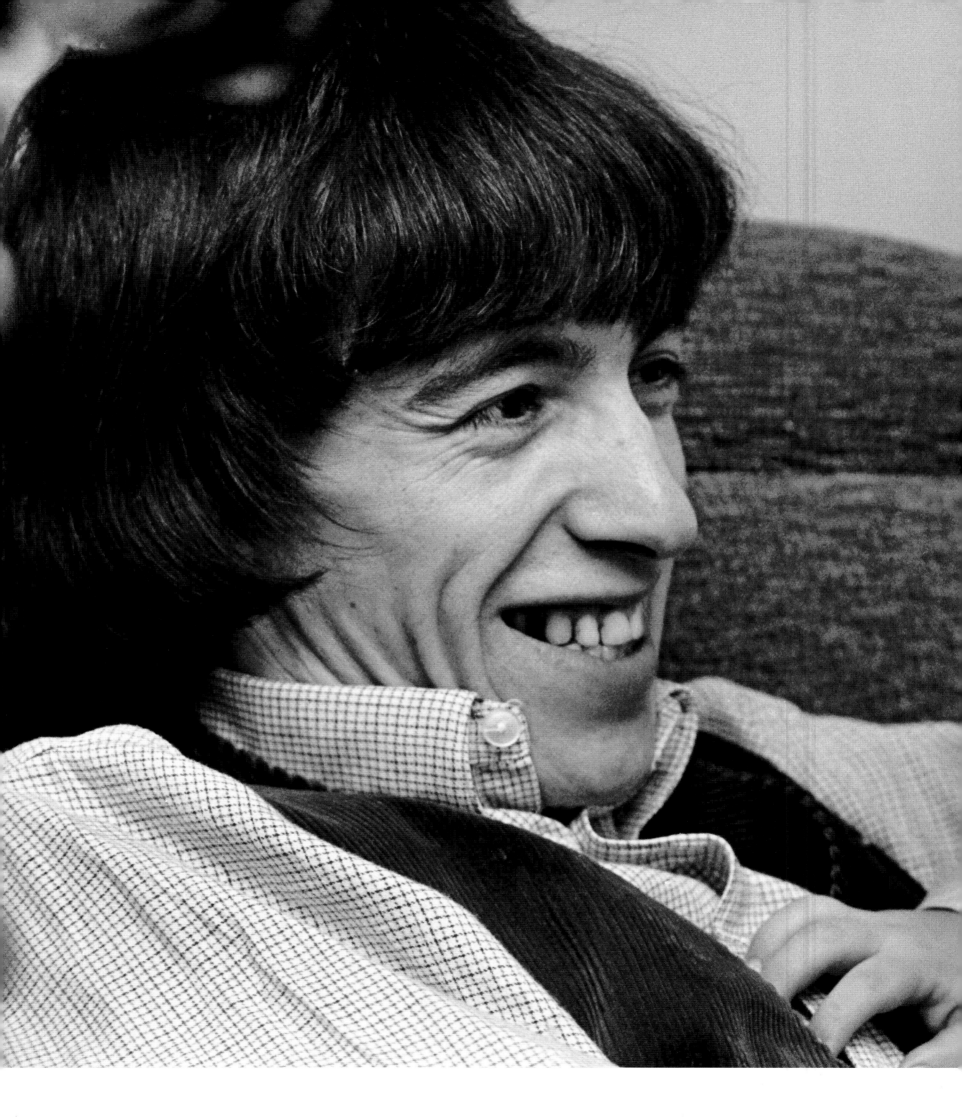

Bill's son Stephen had celebrated his third birthday in April 1965 — two months before this photograph was taken at Kenilworth Court.

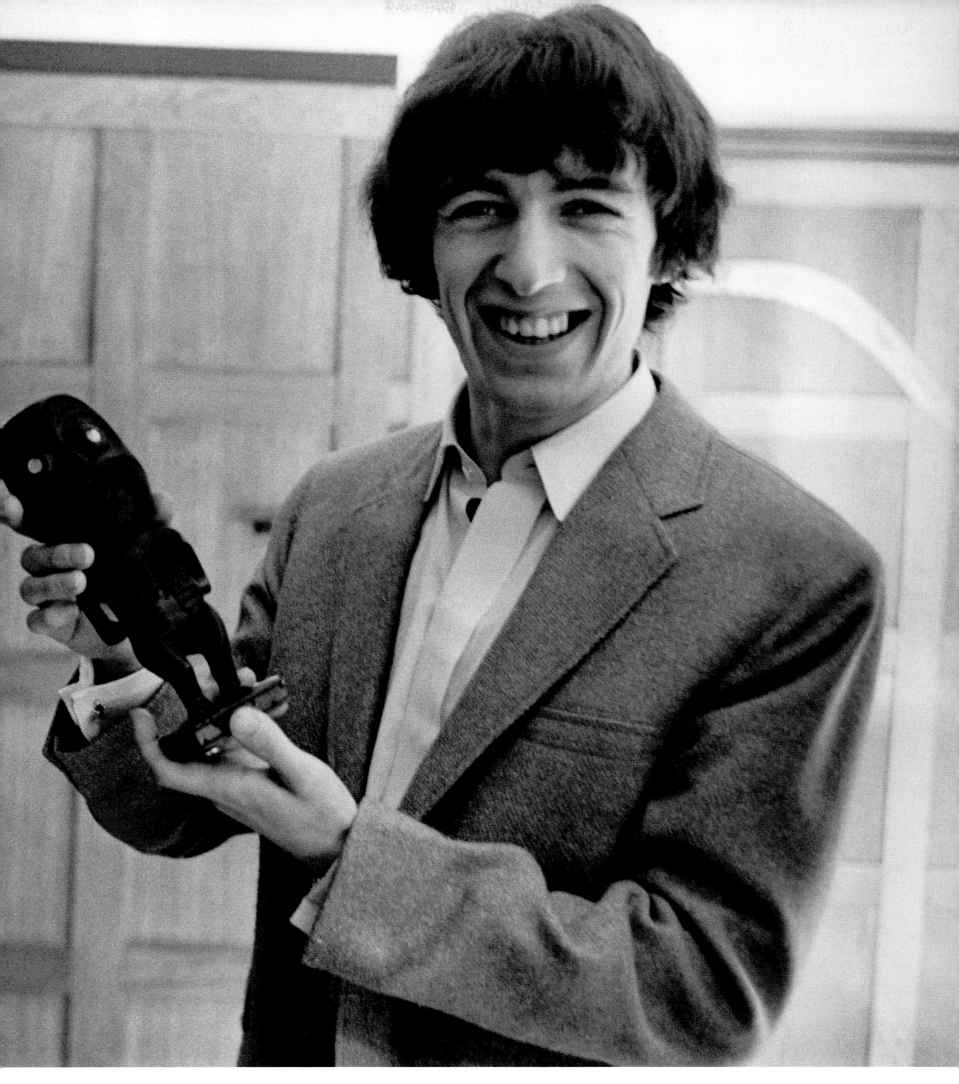

"Bill was always buying souvenirs on his travels and here he is showing one of them to me in his oak-panelled living room at The Oaks." BR

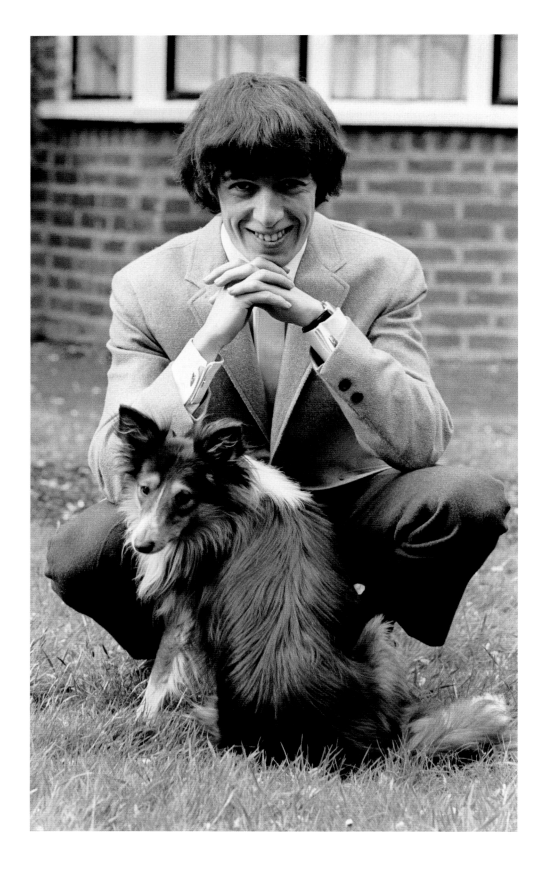

"My dog's name was Lucky, but he turned out to be far from it. One day he was run over by a car outside the house in Keston, where this was taken. Lucky survived for a few days but eventually died from his injuries." BILL

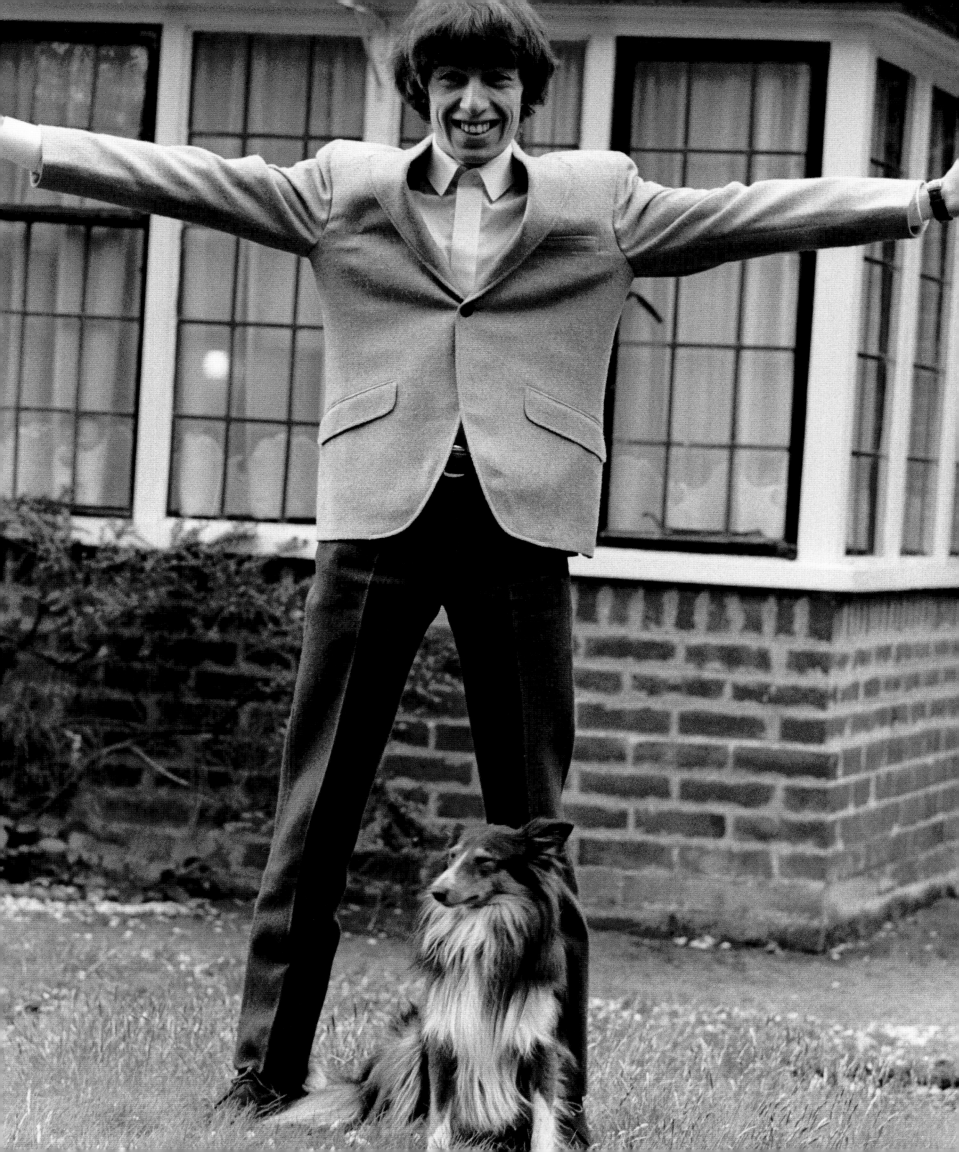

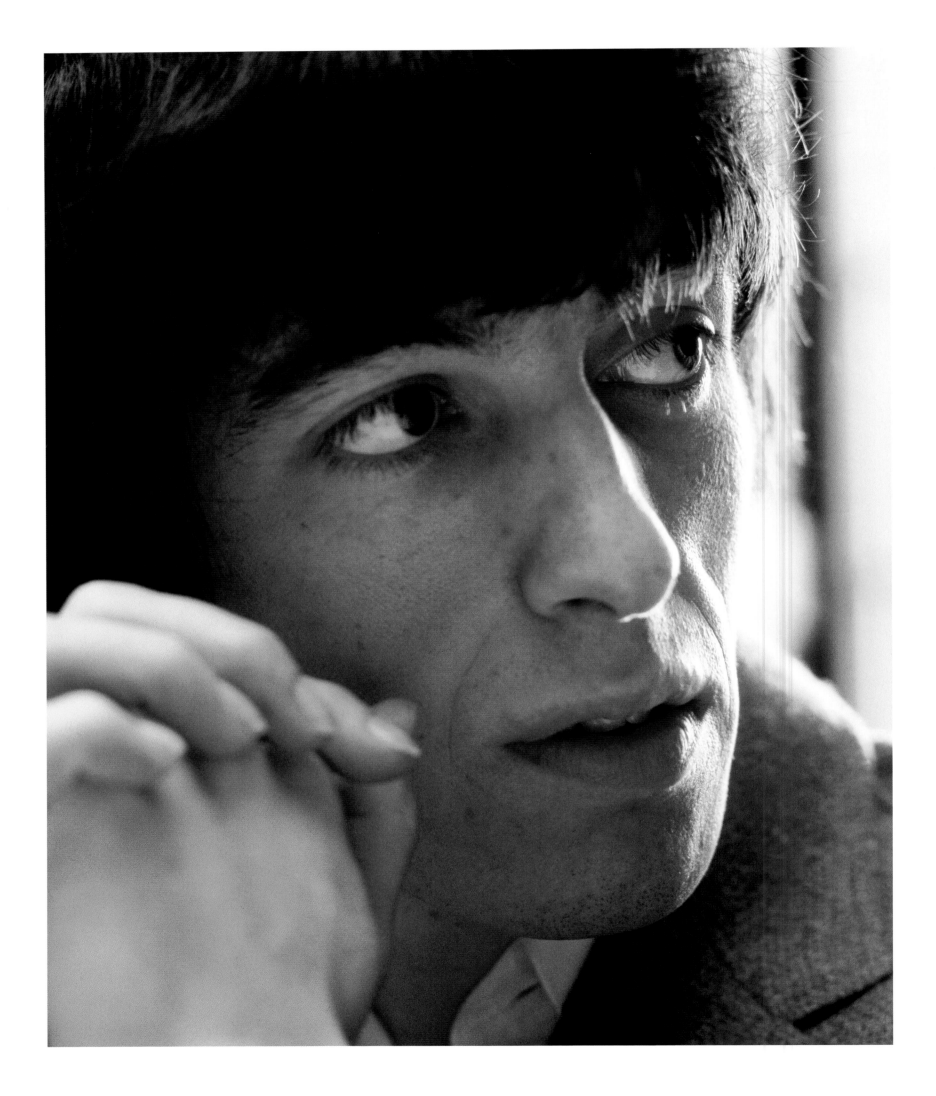

"Bill Wyman is a queer fish. He is the quietest of the five Stones and the least like a pop star. He rarely says a lot but when he does he shows an unusual sense of humour – bone dry and typically English.

"Bill, his wife, and their three-year-old son Stephen opened the door to their flat in a small suburban street in south-east London. They invite me in and ask if I would like a cup of coffee. I walk into the white painted hall where the stairs lead up to the first floor where there is a bedroom. Bill refused to let me see it because they were busy changing it. The guest room and bathroom are in a typically English style. The windows are open and Bill said they were even kept that way at night. 'My wife likes it that way so I have to put up with it,' Bill smiled. Both the furniture and the walls in the living room are a greenish shade. Their home is very ordinary.

"In the living room are a tape recorder and a record player. Bill tells me that he often sits at night while the family is sleeping, composing for several groups he has an agreement with. Bill is a member of the most famous Rhythm and Blues group in the world yet he prefers music of an altogether different style. Cole Porter is one who he admires. It is for this reason that his compositions are used by groups who haven't reconciled themselves to the R&B style.

"The living room hasn't got much furniture and Bill likes the space on the green carpet so he can play with Stephen and his toy cars, some of which he bought on the recent tour of Denmark. All in all, Bill is a typical English father who enjoys going shopping with his wife, and one who buys her things when he's away on his trips." BR MAY 1965

"When I was putting the book together I at first assumed I had taken all these pictures of Bill at his home at the same time. When Bill looked over the layout he immediately said, 'some of these were taken at my house at Keston.' He told me what a big step up for them it was at the time from living in the flat over the garage to a detached house in a very exclusive neighbourhood. It very much reflected the improving position in both the Stones' professional and personal bank accounts as 1965 became 1966." BR APRIL 2006

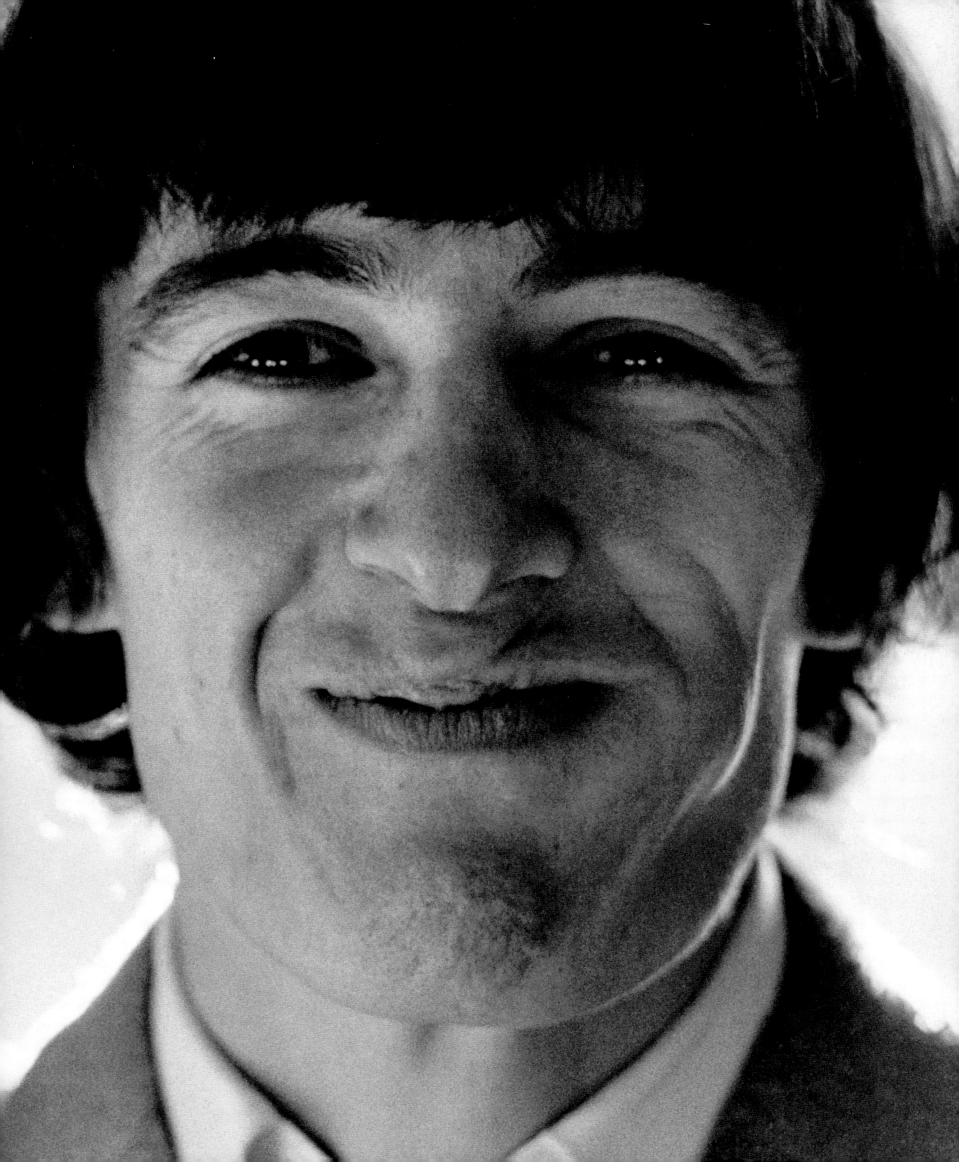

GOT LIVE IF YOU WANT IT

"It's the greatest of feelings to stand up there onstage with a big appreciative audience in front of you, and a tremendous powerful sound behind you." — KEITH, MARCH 1966

When the Stones were performing in clubs in Britain, before they had a record contract, they were very much a Blues band, playing extended versions of songs like Bo Diddley's **Crawdaddy**. By the time of their first package tour with the Everly Brothers, Bo Diddley, and Little Richard it was "three quick songs and off", as Bill always puts it. By the spring of 1965, at the start of their Scandinavian tour, their set was around twenty-five minutes long and had evolved into a more R&B feel.

Everybody Needs Somebody to Love had first appeared in their live shows in the autumn of 1964 and was the lead-off track on their second British album. **Tell Me** was the first Mick and Keith song to appear as a single when it came out in America in June 1964, and it became a regular in their live shows during the Autumn 1964 tour of America. **Around and Around** was recorded at Chess studios in June 1964 and the band began playing it onstage in September of the same year when they toured the UK with Inez and Charlie Foxx. **Time Is On My Side**, the band's fourth US single, was a cover of Irma Thomas's American 1964 hit. **It's All Over Now**, written by the Womacks, became the first Stones' single to top the charts in the summer of 1964. The Stones' cover of Howlin' Wolf's **Little Red Rooster** became their second UK No.1, but London, the band's US label, passed on releasing it. **Route 66** had been a staple of their live shows for a long time but this was the last time it featured until the Stones played Knebworth in 1976. **The Last Time** was their latest single and their third British No.1 in a row.

At a gig the band played in Paris in mid-April 1965 they had added the group's own composition **Off the Hook**, the B side of **Little Red Rooster**; they also played **I'm Alright** and **Not Fade Away** as an encore to their set. The American tour at the end of the month included these songs, as well as most of those they played in Scandinavia, but on several occasions they did John Lennon and Paul McCartney's **I Wanna Be Your Man**. The next burst of live shows was a short tour of Scotland followed by another in Scandinavia. Information as to what the Stones played live is sketchy but it was predominantly songs picked from those they had been playing for the last three or four months. What is unclear is whether or not they performed their new single, **Satisfaction**. They had played it live on the American TV show "Shindig" at the end of May and so it seems possible that it could have been played live on this tour for the first time.

In July the band did a short tour of UK cinemas that finished up at the Palladium. Supporting them were Tommy Quickly and The Remo Four, The Walker Brothers, The Steam Packet (with Long John Baldry, Brian Auger, Rod Stewart, and Julie Driscoll), and Elkie Brooks. By the time of the Palladium show the Walker Brothers had dropped out, tired of playing second fiddle to the Stones, and they were replaced by The Moody Blues. The band's set at the Palladium was **Everybody Needs Somebody to Love**, **Pain in My Heart**, **Around and Around**, **Time Is On My Side**, **I'm Moving On**, **Little Red Rooster**, **It's All Over Now**, **The Last Time**, and **I'm Alright**... but no **Satisfaction**!

On a short tour of Ireland prior to the riotous German tour in September the Stones definitely included **Satisfaction** as well as adding some different songs, mostly old favourites, to their set. These included **Mercy Mercy**, **Cry to Me**, **I'm Moving On**, **Bye Bye Johnny,** and **Bright Lights, Big City**; the latter was one of the songs they cut with Glyn Johns as a demo in March 1963. For the German tour it was back to a more traditional set. In Berlin they played **Everybody Needs Somebody to Love**, **Pain in My Heart**, **Around and Around**, **Time Is On My Side**, **I'm Moving On**, **The Last Time**, **Satisfaction,** and **I'm Alright**.

For their UK tour in September and October it was much the same set list and the US tour that followed was similar, although they had added their new single, **Get Off My Cloud**, to their shows. The tour of Australia and New Zealand in February and March had **19th Nervous Breakdown** included, following its release as a single in February. These two latest hit singles were added to the European tour in March and April 1966 while the rest of the set was made up of songs that had been a staple of the live shows over the last year. There was one exception, the group's own composition, **The Spider and The Fly** – the B side of **Satisfaction**.

"I can't see much in front of me because of the bright lights. I'm in a world of my own really. I don't look at my drums. I play by feel and put my head on one side to keep an eye on Keith. As far as sound goes, I can't hear much at all because I usually have to belt the drums as hard as I can to make my presence felt. The only thing I'm aware of is Bill's bass, that usually shakes the stage." – CHARLIE, MARCH 1966

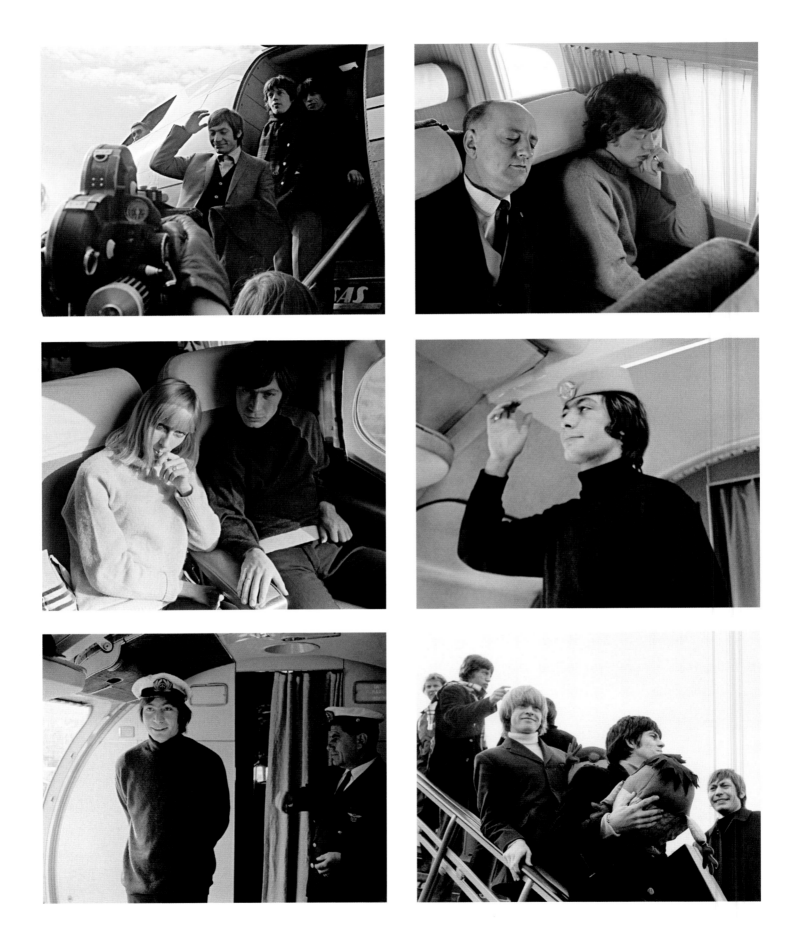

"Taking flights around Germany saved a good deal of time in the band's hectic touring schedule. Keith greeted Munich after he arrived onboard an Air France Caravelle from Hamburg." BR

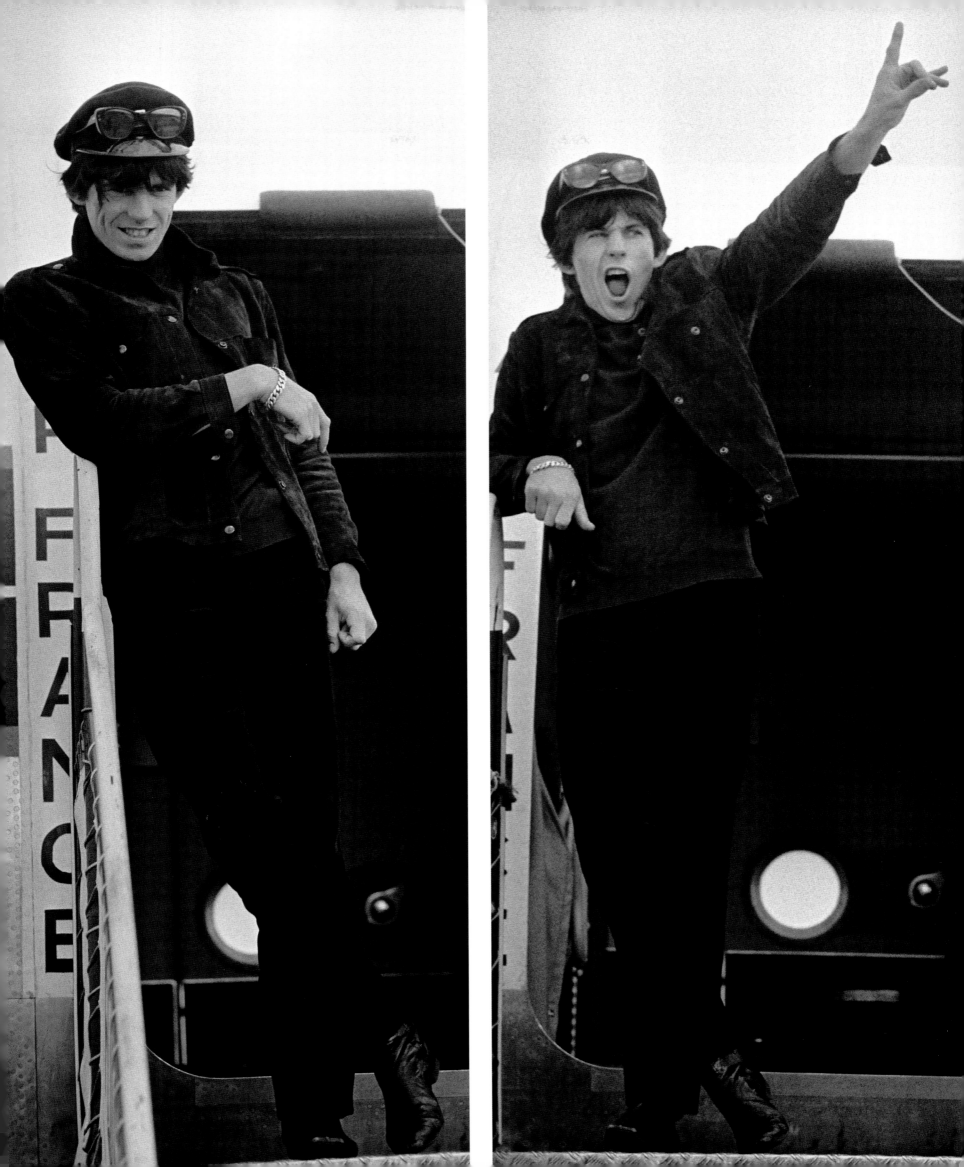

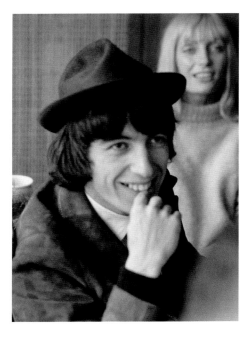

"When the band landed in Munich the police were out in force to meet them. About 160 police were at the airport but there were only about eighty fans that had made the journey in some very heavy rain. From the airport the band went to the Bravo office. Beneath the office in the basement they had their own Bierkeller where they entertained the band." BR

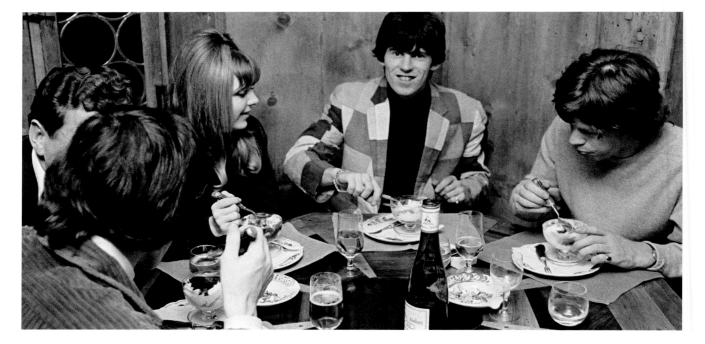

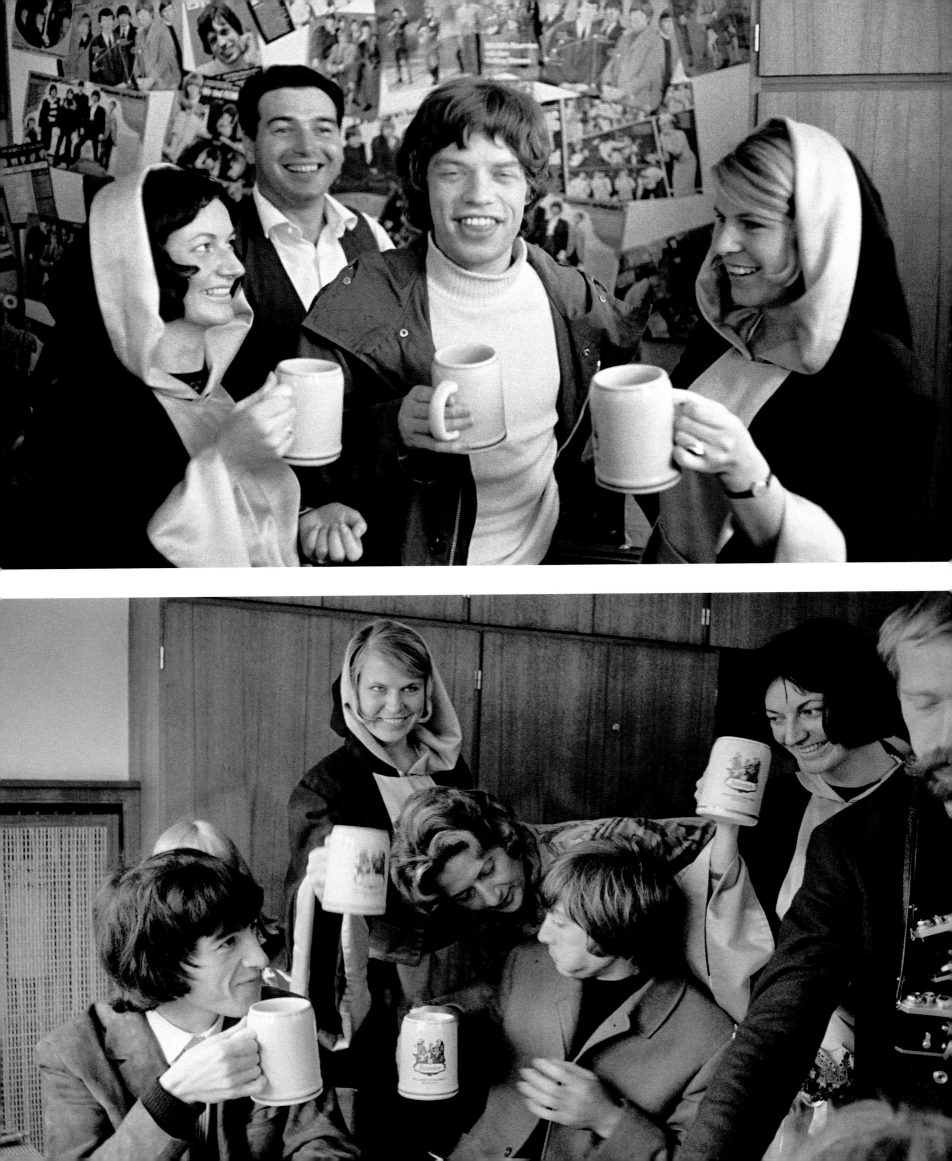

"No, it's not Mick's secret German girlfriend but Liselotte Krakauer, the editor-in-chief of Bravo, getting Mick's 'autograph'. The band and I had been enjoying German sausages and beers in the basement of their offices — maybe the beer had gone to their heads! Later that afternoon Brian and I went by taxi to the former Nazi concentration camp at Dachau, which had been turned into a museum. When we got there, the first thing we saw was the famous gate with the big inscription above saying, "Arbeit Macht Frei" — work brings freedom. I shot a whole roll of film around the camp, some of which included Brian in some not very pleasant situations. When we had finished having a good look around this depressing place, made more so by the fact that it was raining, we then went back to the hotel. I inadvertently put this film, along with a number of others that I shot in Germany at the concerts, in for processing at the lab; when the pictures were returned to me the whole roll of Dachau was missing." BR

The Lips

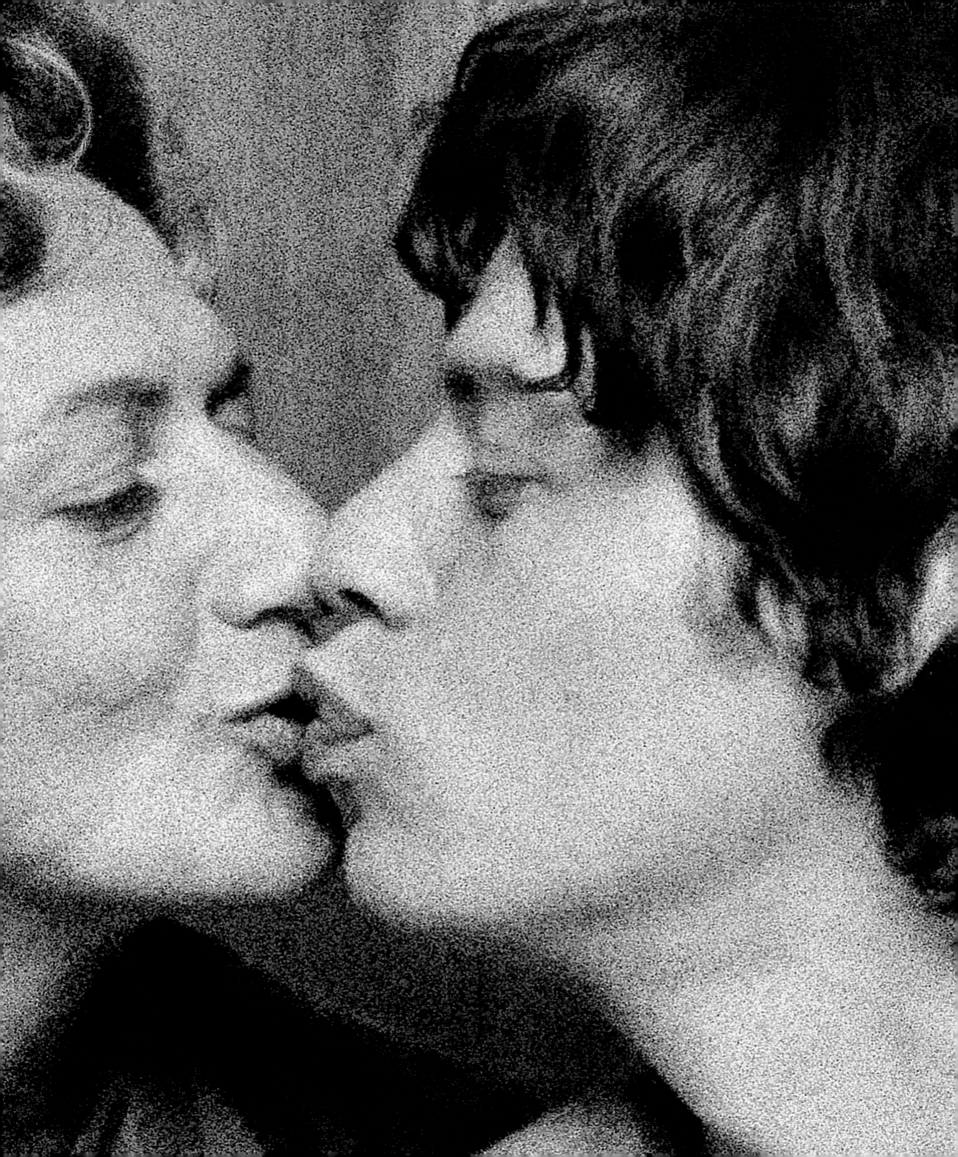

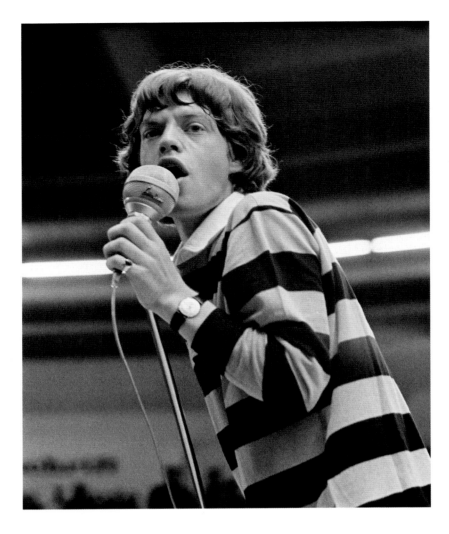
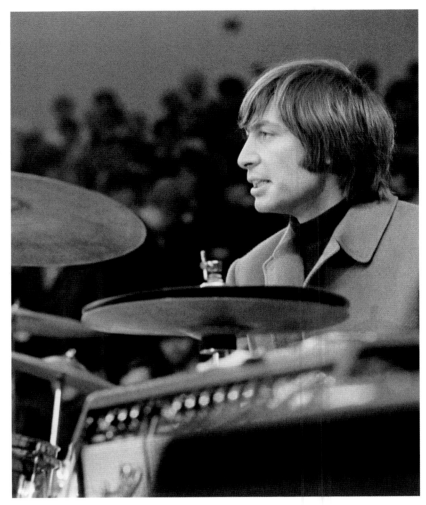
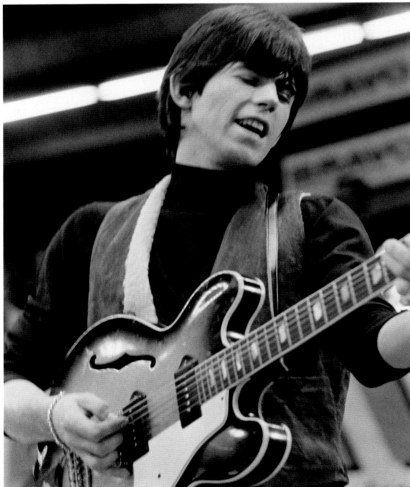
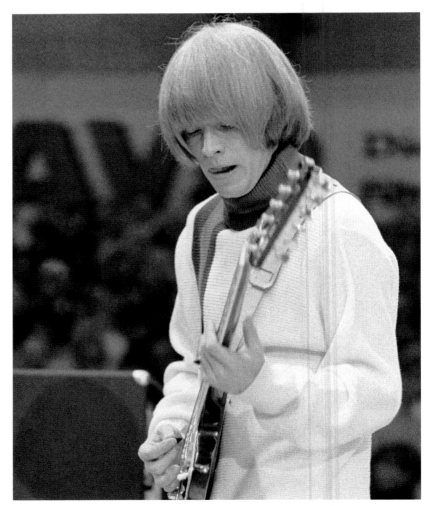

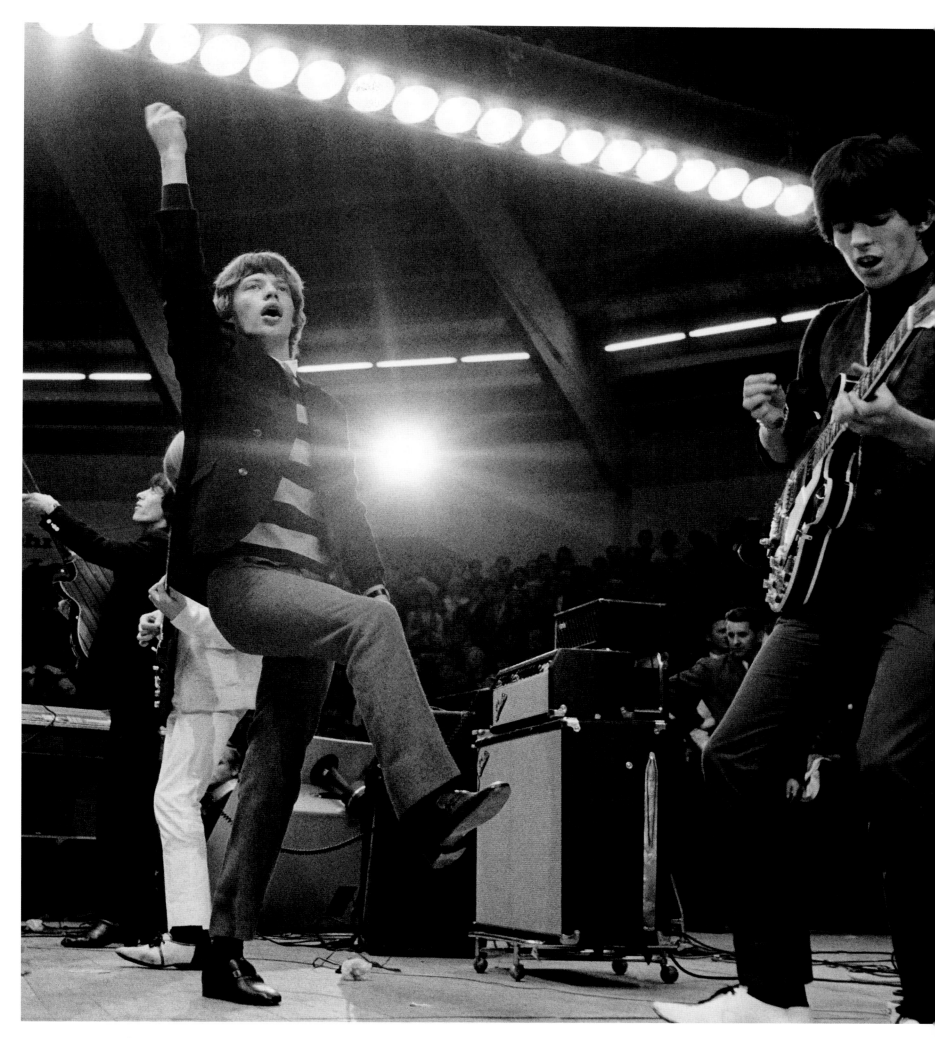

The Stones played two shows at the Circus Krone-Bau in Munich. At each show were 3,500 fans,
and both passed off without any repeat of the serious violence that occurred elsewhere in Germany.

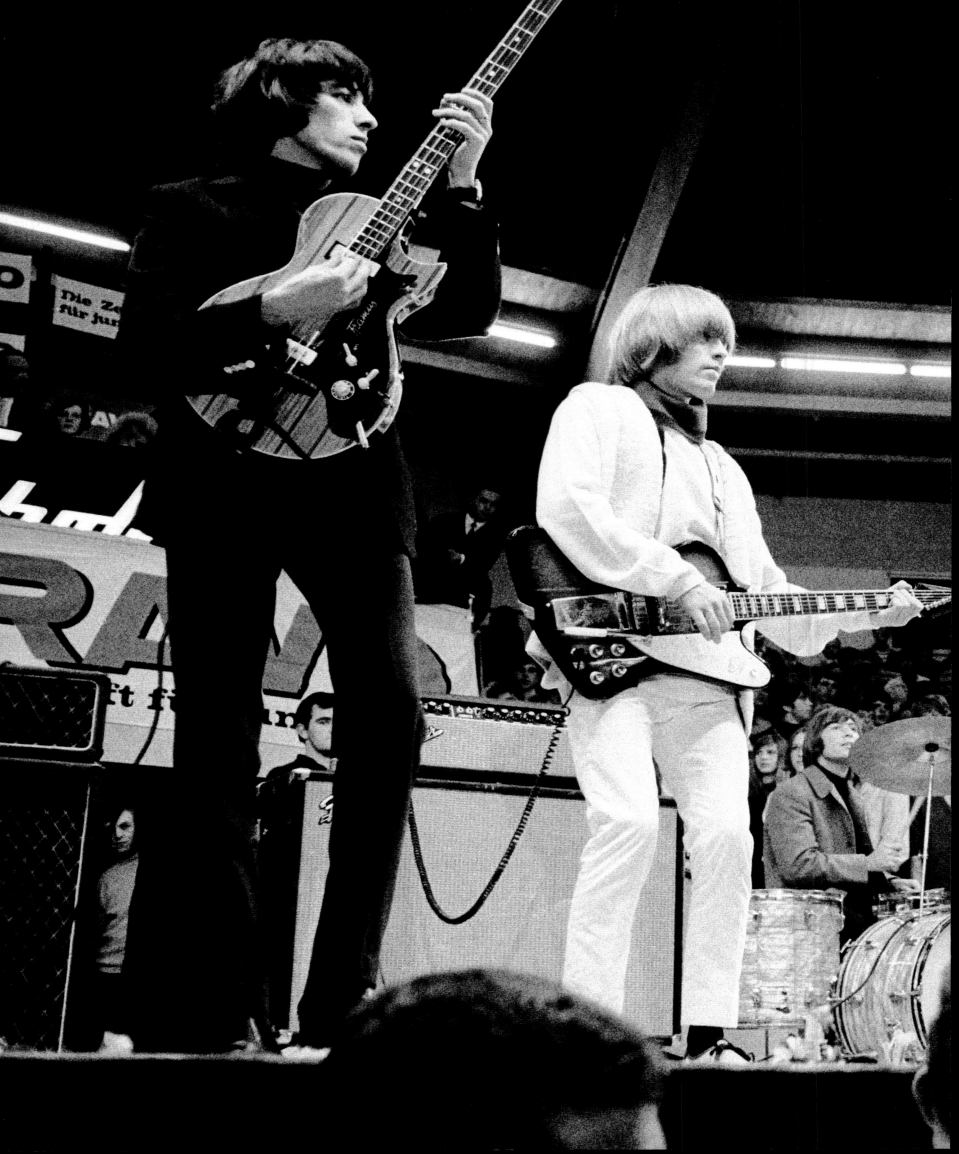

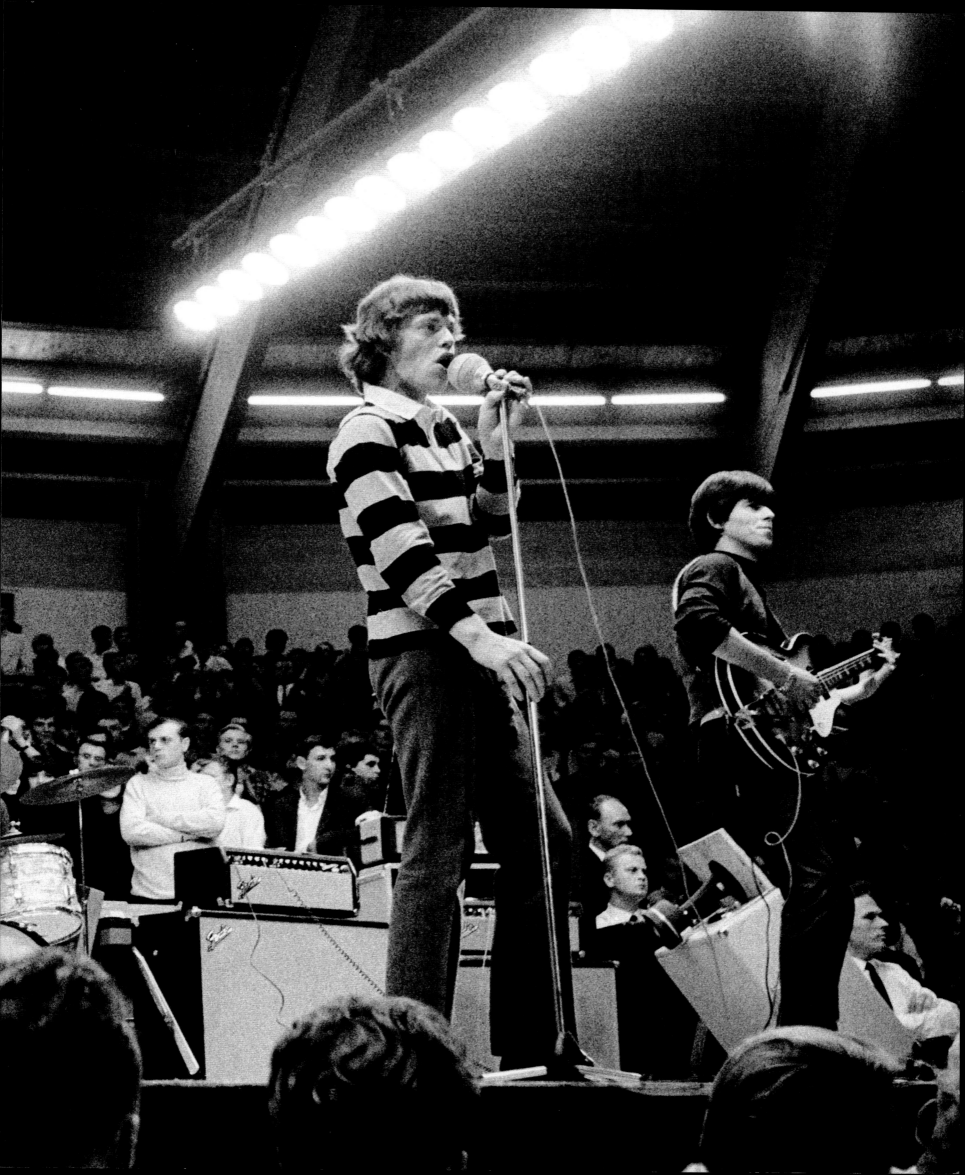

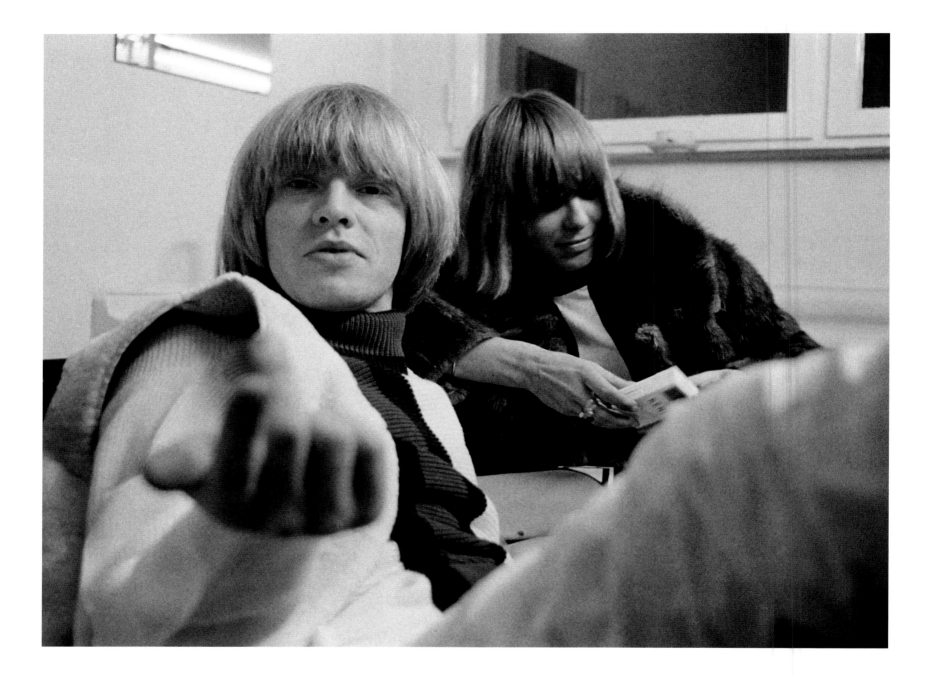

"I had been taking the photographs you have seen on the previous four pages and I was walking from the auditorium towards the backstage area when a girl came up to me and asked me to take her to meet the Stones. She was very pretty and so I had no hesitation — it was part of my job. Her name was Anita Pallenberg; and when she got backstage it was Brian who took over." BR

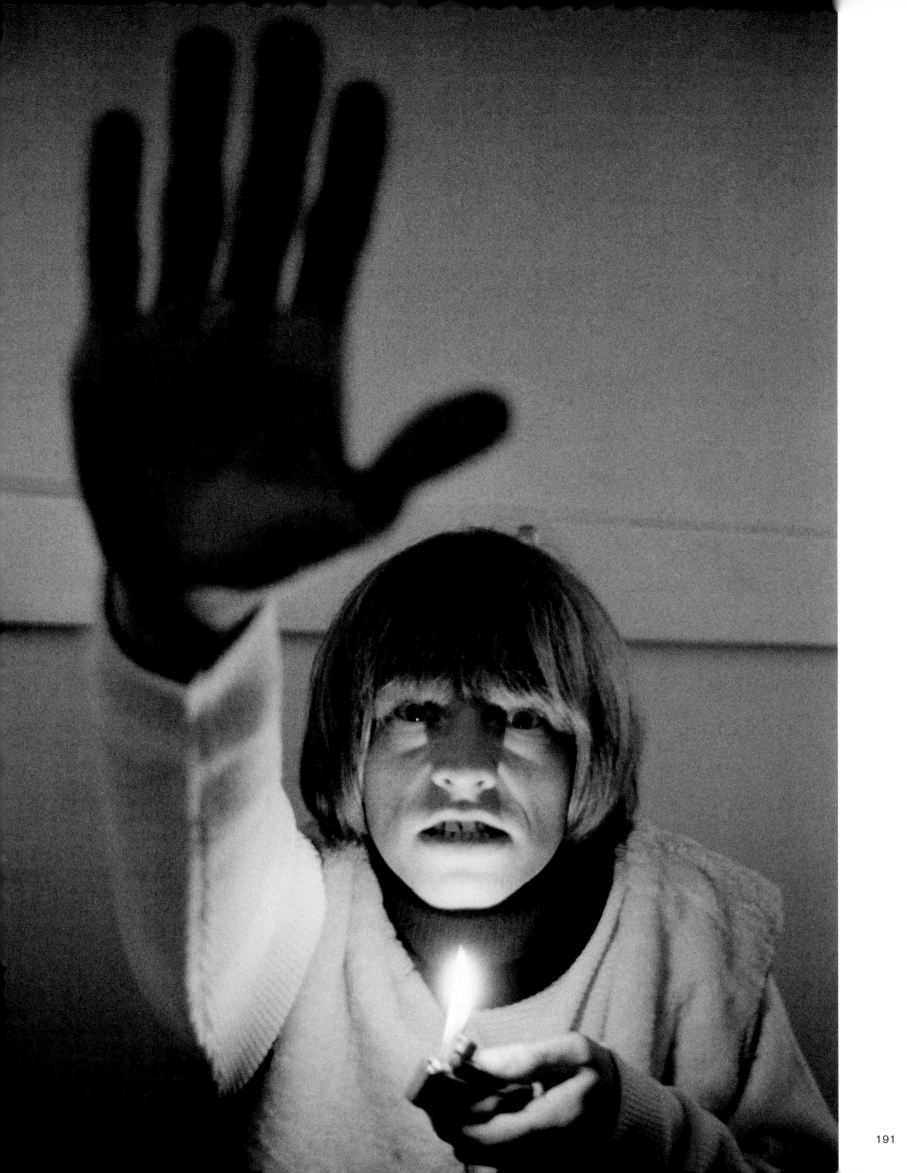

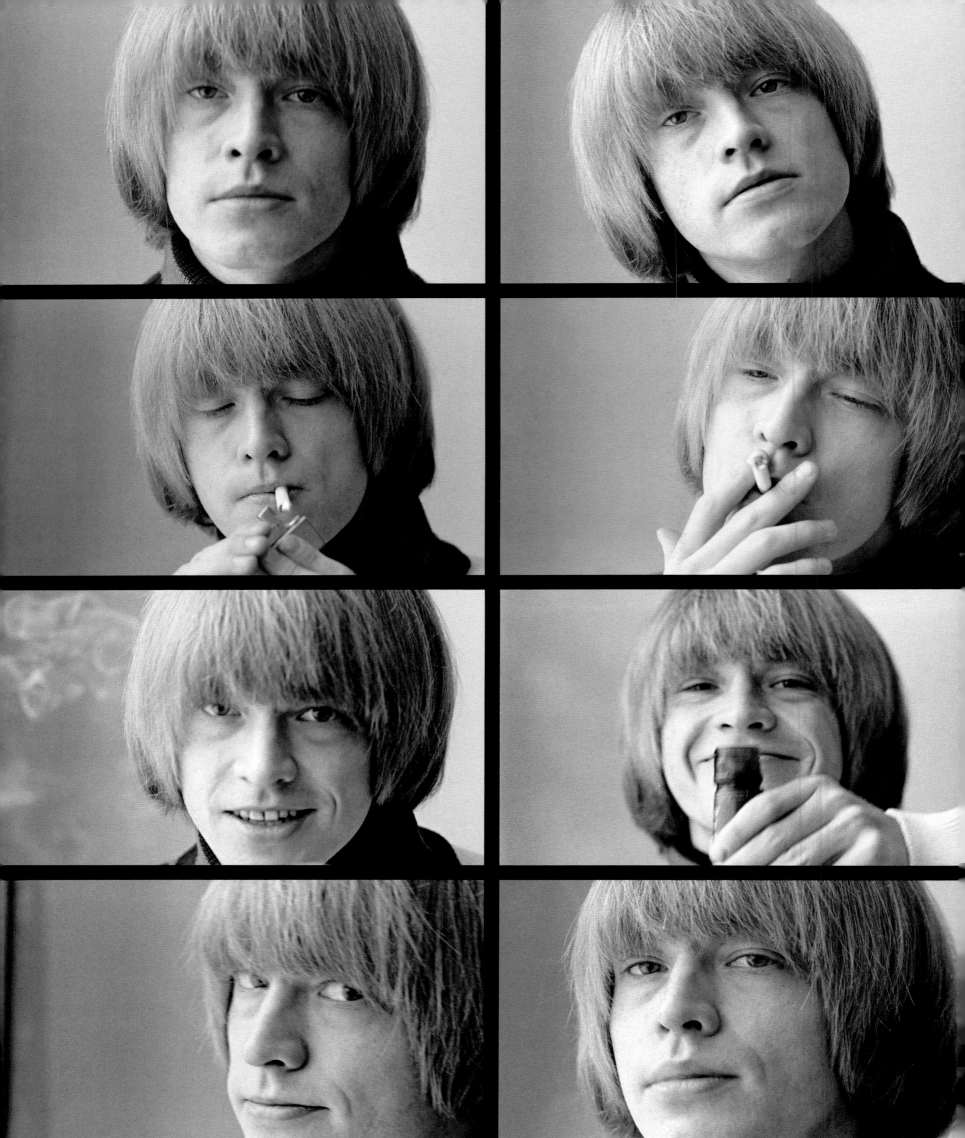

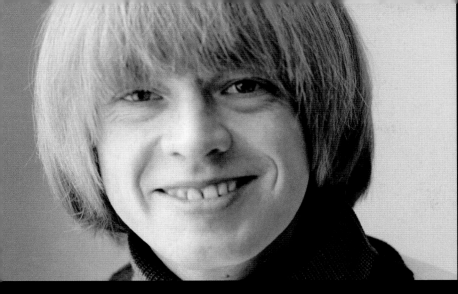
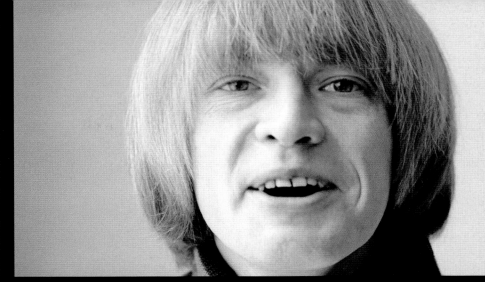
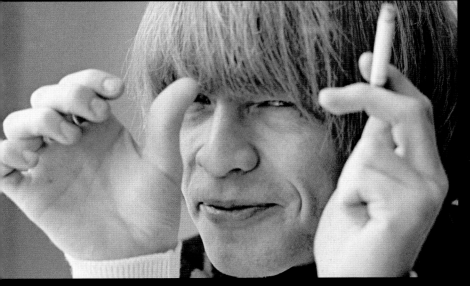
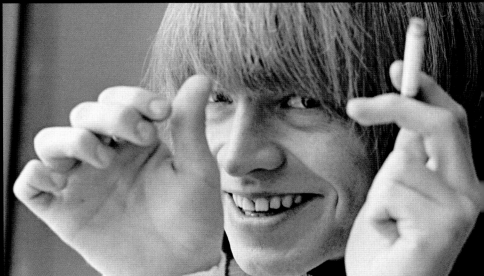
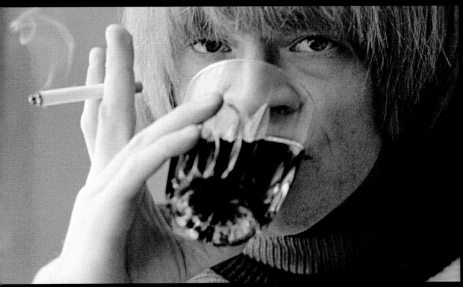
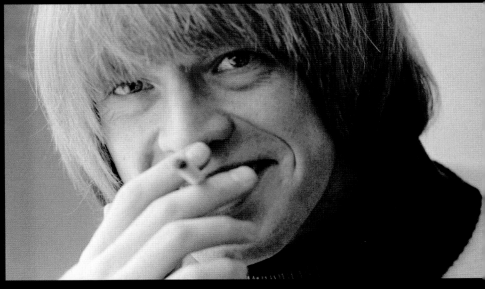
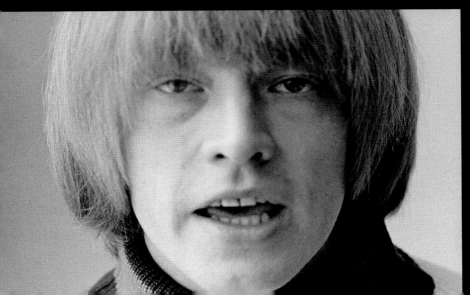
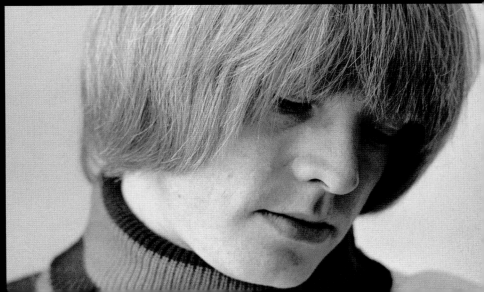

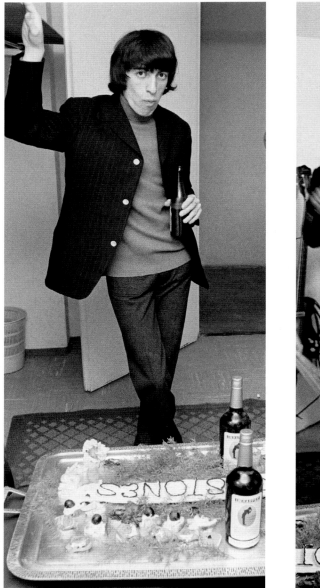 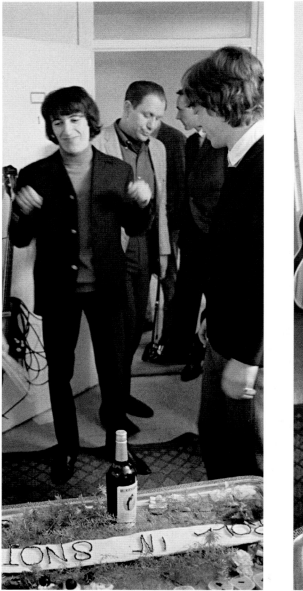 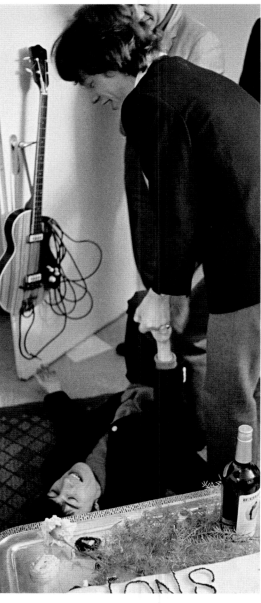

"Bravo made the band a cake on which it said 'Rolling Stones'. Much to everyone's amusement Bill rearranged the letters so that it said 'Roll in Snot'. Bill's punishment was a friendly beating from Mick." BR

"It's my small-body Framus bass hanging on the wall in the right-hand shot on this page." BILL

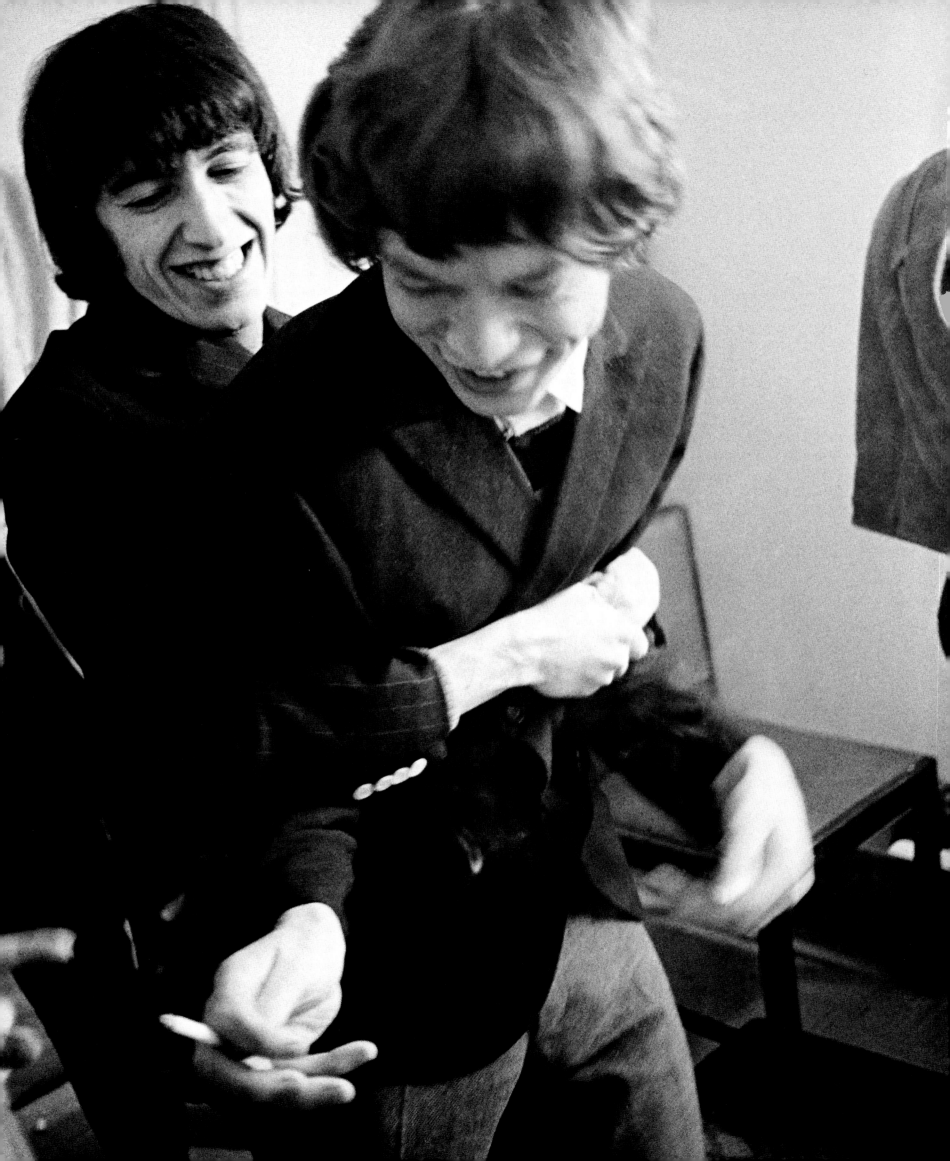

FROM MUNICH...

Looking back at the German newspapers from 1965 provides a fascinating insight into how things were viewed by the press. The language is stilted and strange, because for most of the reporters writing at the time, what was happening with the Stones was a totally new phenomenon.

The Munich papers reported the band's arrival as "quite calm, compared to other cities and this augured well for the Beat evening that was to follow." In fact the authorities were so certain that hoards of fans would turn up at Munich airport that they had made signs with large red lettering saying, "Arrival Rolling Stones – This Way." A loudspeaker car had been positioned to deal with the crowd and a water-cannon waited patiently in the rain for the opportunity to soak the fans some more. According to one paper: "The airport looked as though they were waiting for the arrival of a South American dictator and a threat had been received against his life."

The head of the Police was there personally to direct operations and he stood close to a TV surveillance car, which had nothing to do. It was more like a comedy than a riot. According to the police, the reason why there was no fan trouble was simple: "They are all in school and it's raining."

The Stones left the airport in a convoy of seven white limousines, leaving the handful of fans in their wake as they sped off to their hotel. According to the papers, all the fans saw was a glimpse of "a couple of shadows". After the band's reception at the Bravo offices they went to the Hotel Diplomat where "thirty fans waited for the five hairy boys". Here the Stones checked into their eleven staterooms that cost 45DM each. Once again, the police were taking no chances and eight of Munich's finest guarded the hotel.

According to one paper: "The Stones were disappointed with their reception, but happy with their show that evening." Another paper said that the fans would have heard more if they had stayed home and listened to their records – "You could tell they were singing because their lips moved." None of this stopped the fans from enjoying themselves as they danced "the shake and the monkey".

The only small hint of any trouble came after the doors were opened to let in the fans for the second show. Such was the rush that some people were trapped against some barriers and girls started screaming. This caused a nervous security man to let off his tear gas, which pleased no one. After this false alarm, the second show went off without a hitch.

Another day, another show...

...TO BERLIN

The Stones left their hotel in Munich at lunchtime to take the Air France Caravelle flight to Berlin at 2.20 in the afternoon. Landing at Berlin's Tegelhof Airport they were met not just by the press but military personnel from the four countries that shared the control of Berlin: there were Military Police from Great Britain, France, America, and Russia standing at the foot of the aircraft steps. It was, of course, just twenty years since the end of the Second World War and the Cold War was in full swing.

There were a thousand Stones fans at the airport who, because the aircraft was delayed, had apparently screamed themselves hoarse. The police took control of the situation by regularly broadcasting messages. "Dear Beat fans, The Rolling Stones will be fifteen minutes late." After they arrived they went straight to the offices of Bild Zeitung where there was a huge banner on the side of the building proclaiming – 'Welcome Rolling Stones to Berlin'. This naturally alerted the fans to the fact that the Stones may visit their favourite German music magazine, and they set about besieging the building. Police motorcyclists surrounded the office block and made a path for the Stones to enter the building.

One difficulty for the Stones was finding an hotel. The Berlin Hilton refused their booking outright and so they were booked at the Sachsenhof Hotel under false names. Once news of the Stones booking leaked out the police planned a sixty-strong cordon around the hotel. The fans began trying to get bookings for themselves; kids were phoning up and impersonating "international business men". The hotel was having to turn away regular bookings and the whole thing was getting out of hand. Eventually the management of the hotel told the band they could not stay, saying that their insurance company had refused them cover for the damage that the band would inflict on the hotel!

The solution for accommodating the Stones was found at the Gehrhaus Hotel, where Queen Elizabeth II had stayed on her state visit in May 1965. It was in fact a hotel regularly used by visiting dignitaries and VIPs and was located in its own grounds, which made it far more secure than a city centre property. The secret of where the Stones were staying was also kept from the fans, which ensured peace and quiet for everyone. The fact that a hundred fans kept up a constant vigil outside the Sachsenhof Hotel attests to the success of the ruse, despite the police continually telling them that the band were staying elsewhere.

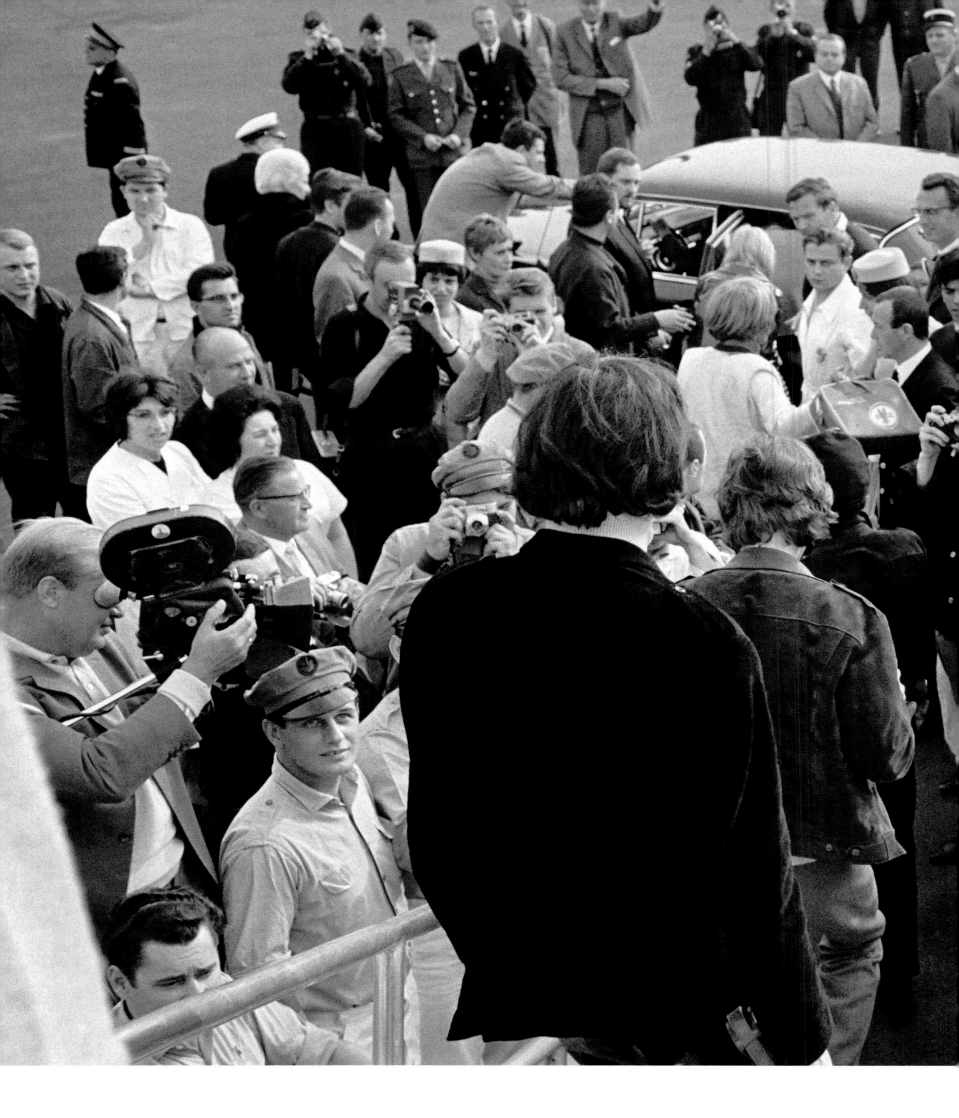

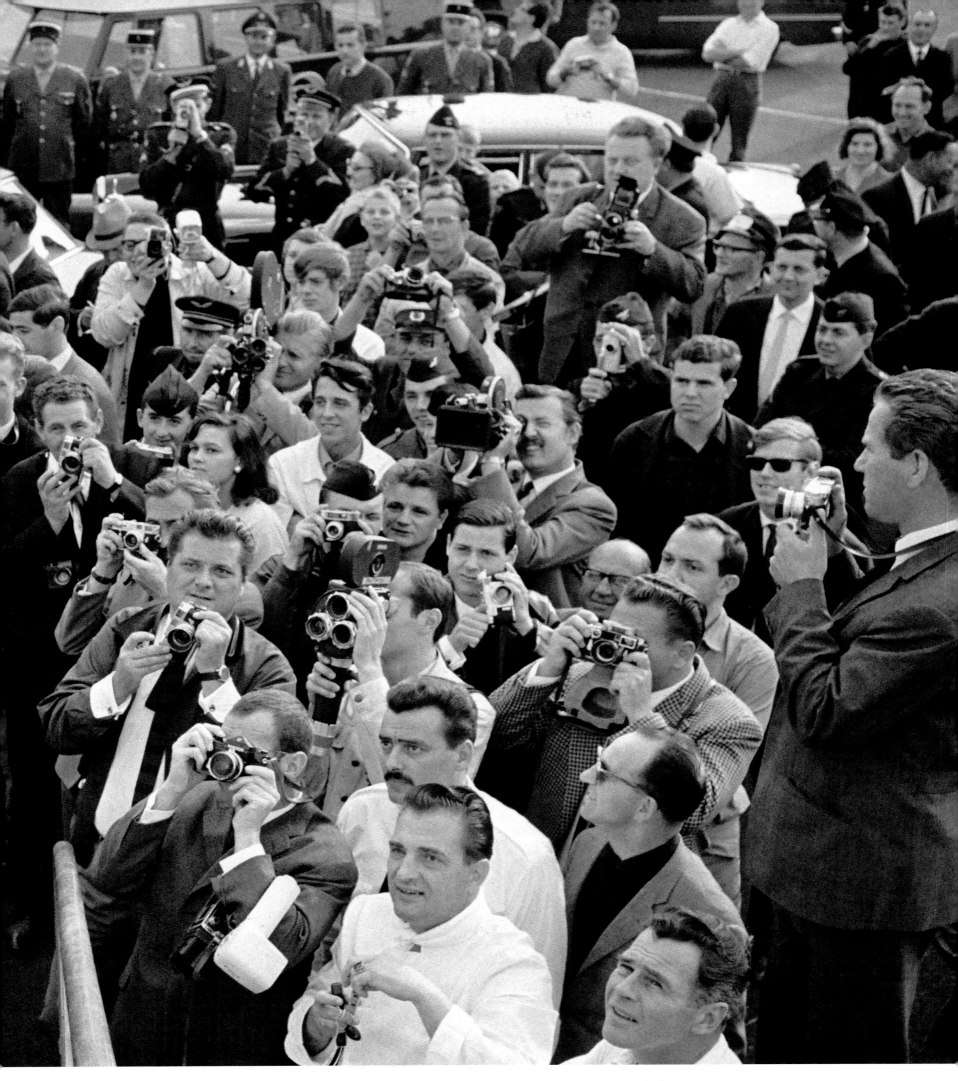

The band arrives at Berlin's Tegelhof Airport at 4.05pm where they are met by the city's press corps.

Bent's photograph is unique among Stones photographers in that he follows them out of the plane.

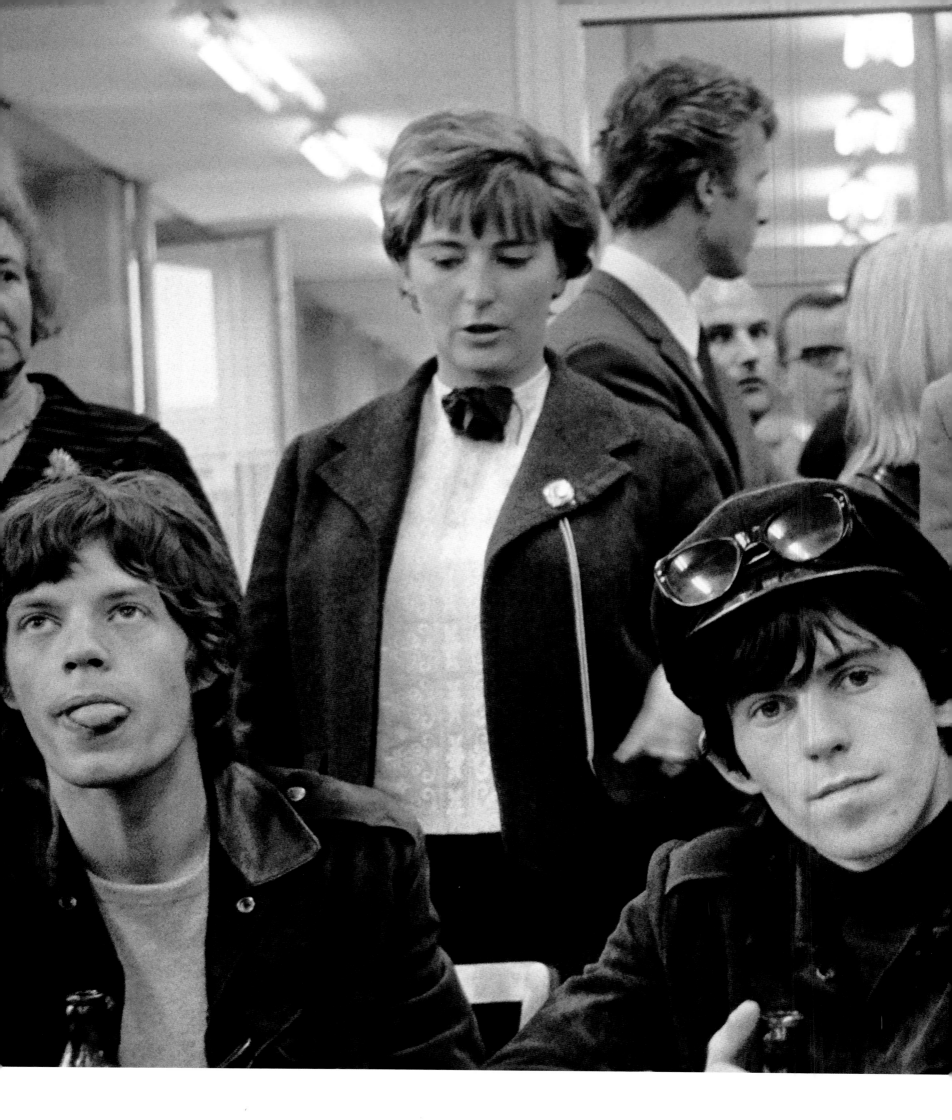

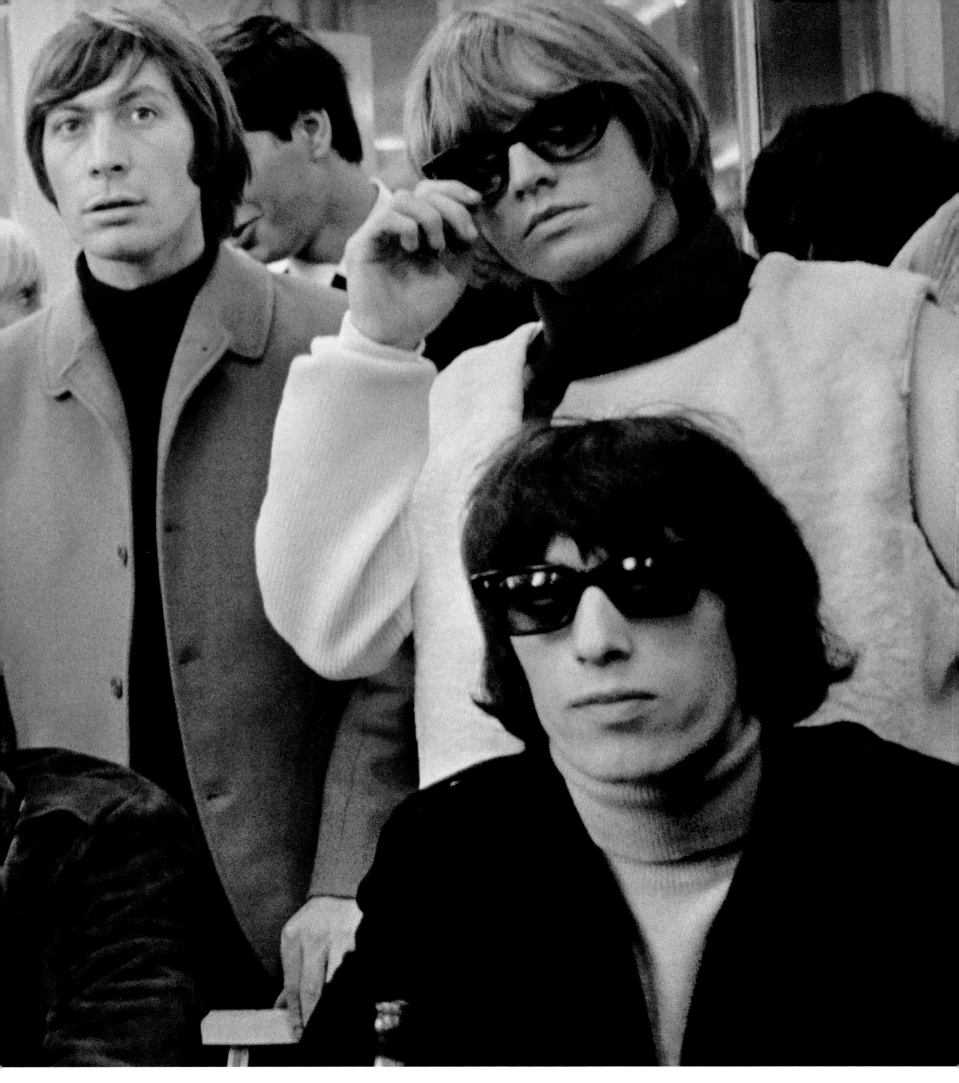

At a press conference at the Bild Zeitung office the Stones, as usual, did their best to look interested.

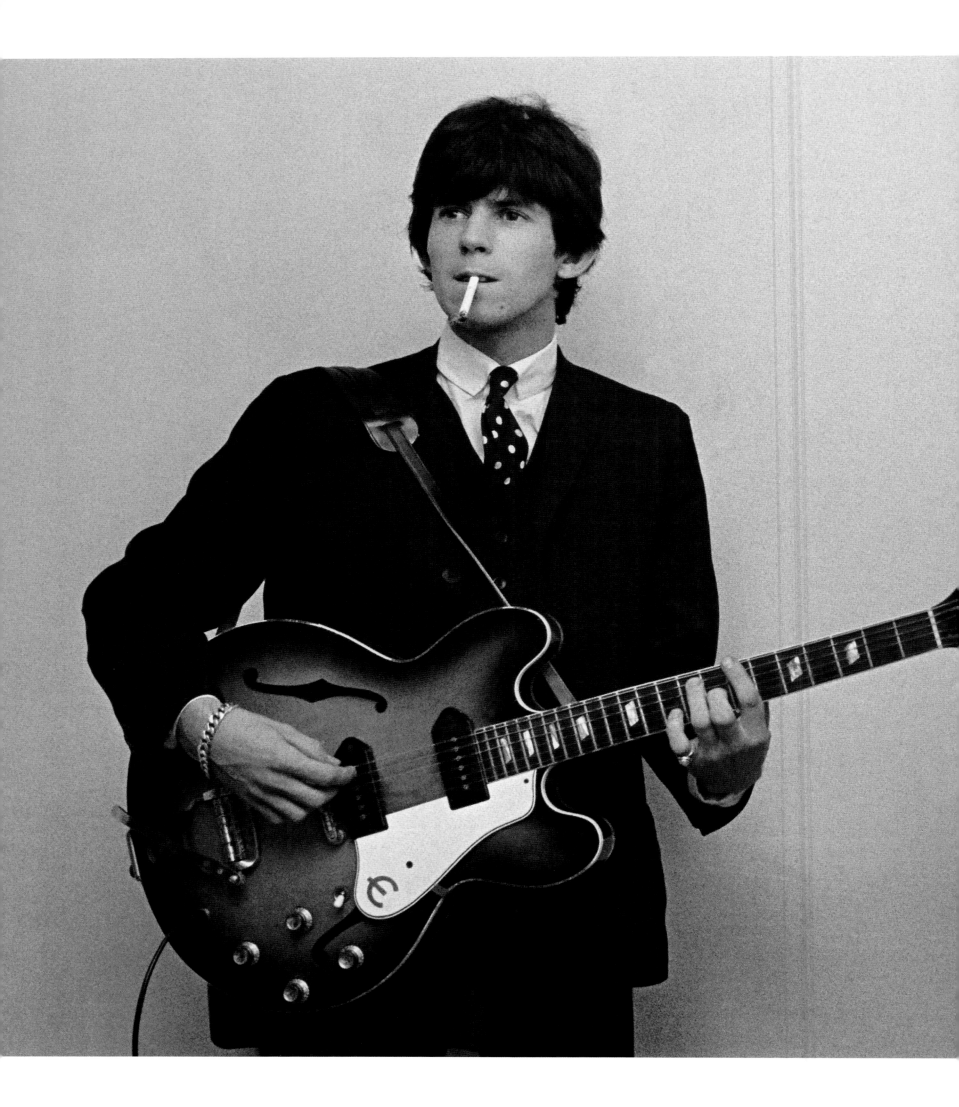

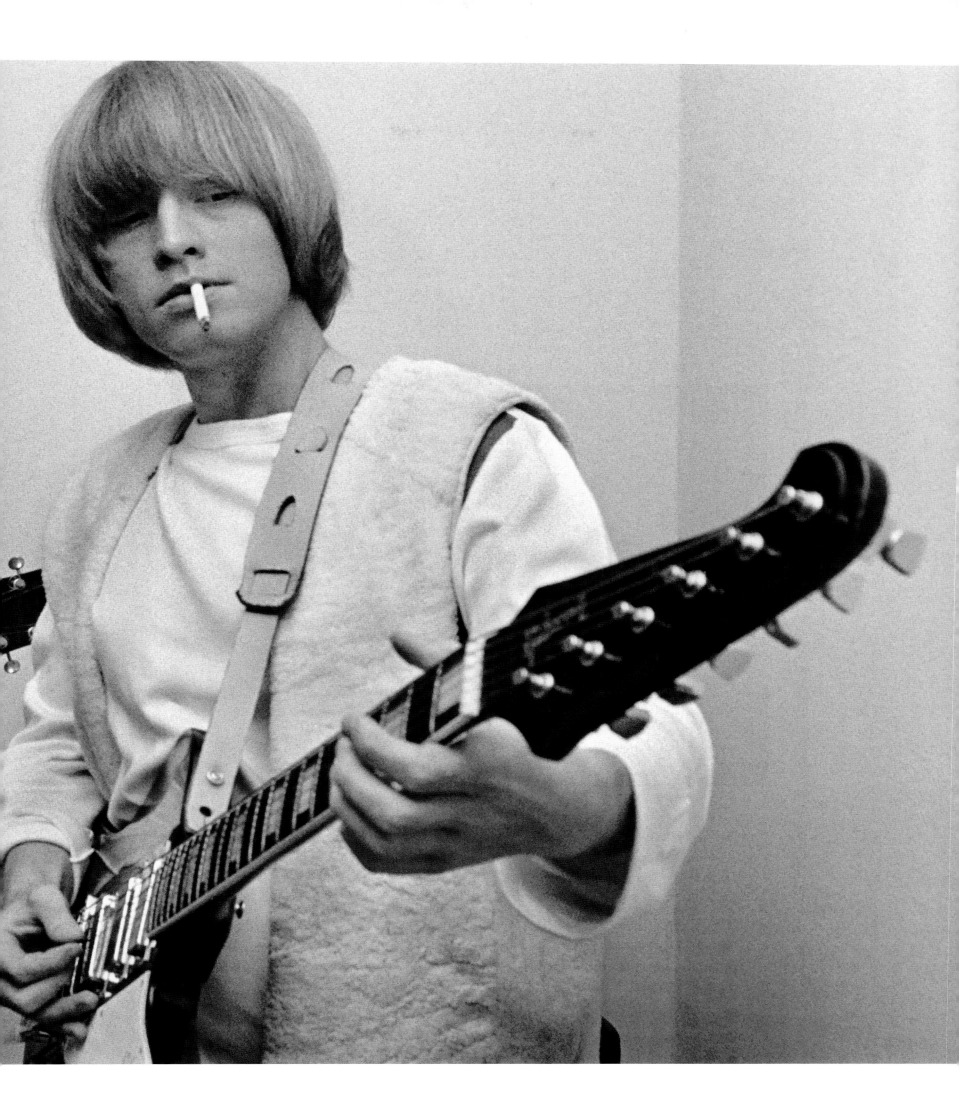

"Hi Bent, are you ready?"

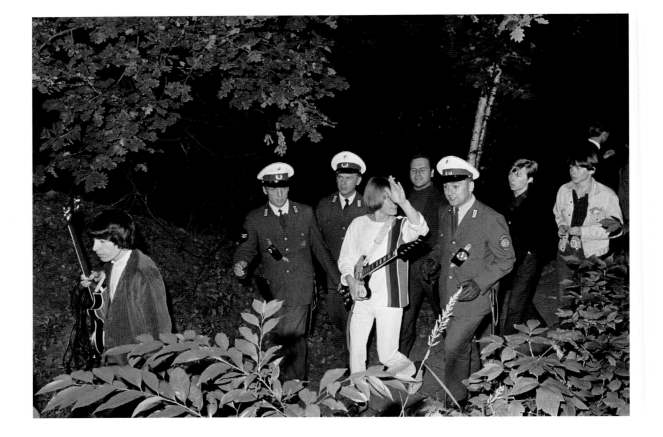

"The concert was being staged at the Waldbühne, where Hitler made some of his famous speeches. We had to walk for quite a way through the woods and underground bunkers to get to the stage. We'd agreed that on a given signal, Bent would take a photograph of Brian doing a Nazi salute with the police escort. Having got to the stage, we played just one number before we had to leave because the crowd was rioting. We went back into the bunkers and stayed there for twenty minutes or so while the police got things under control. We then went back on stage where we were able to complete our twenty-five minute set." BILL

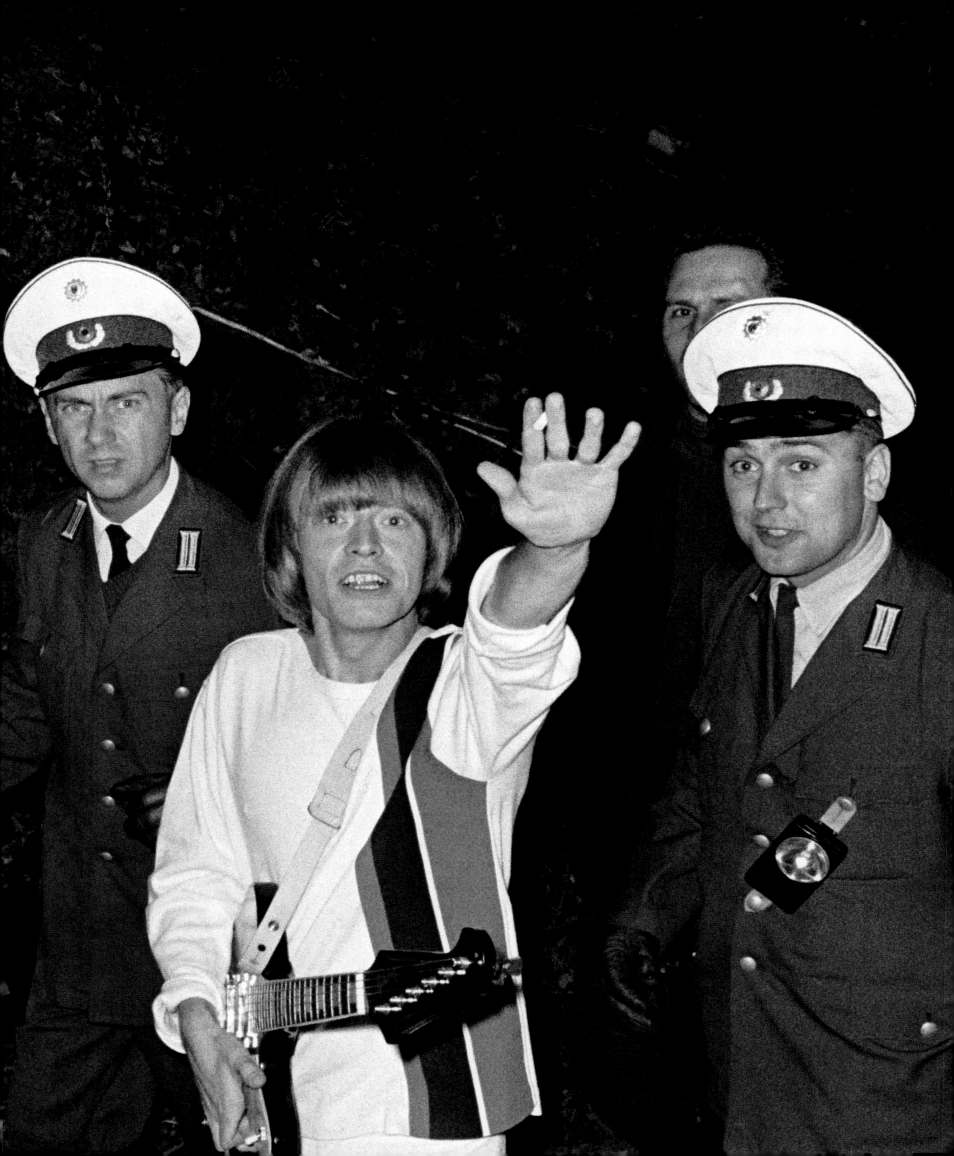

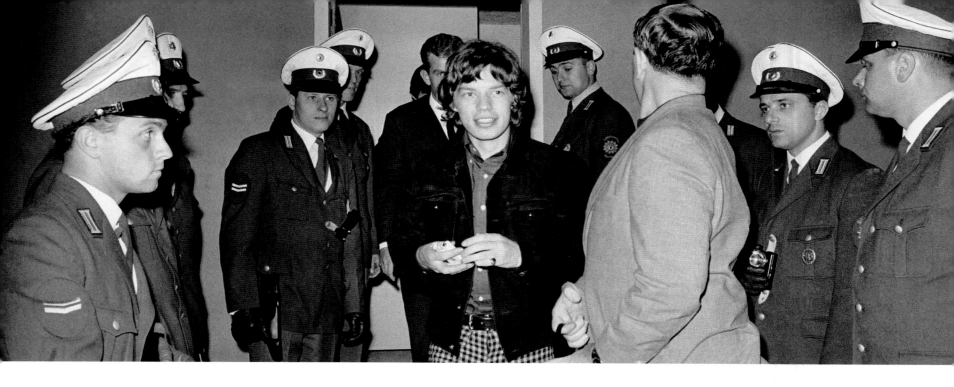

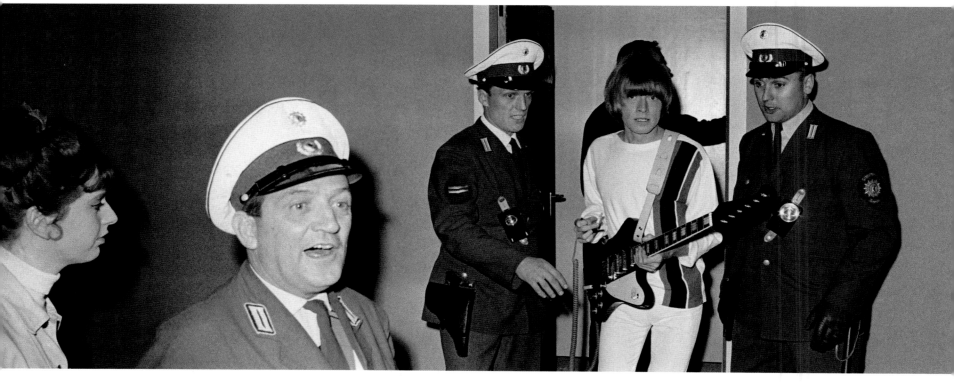

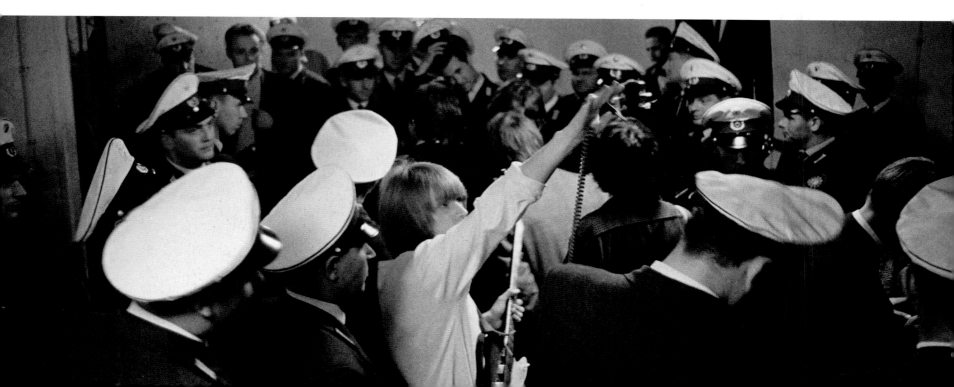

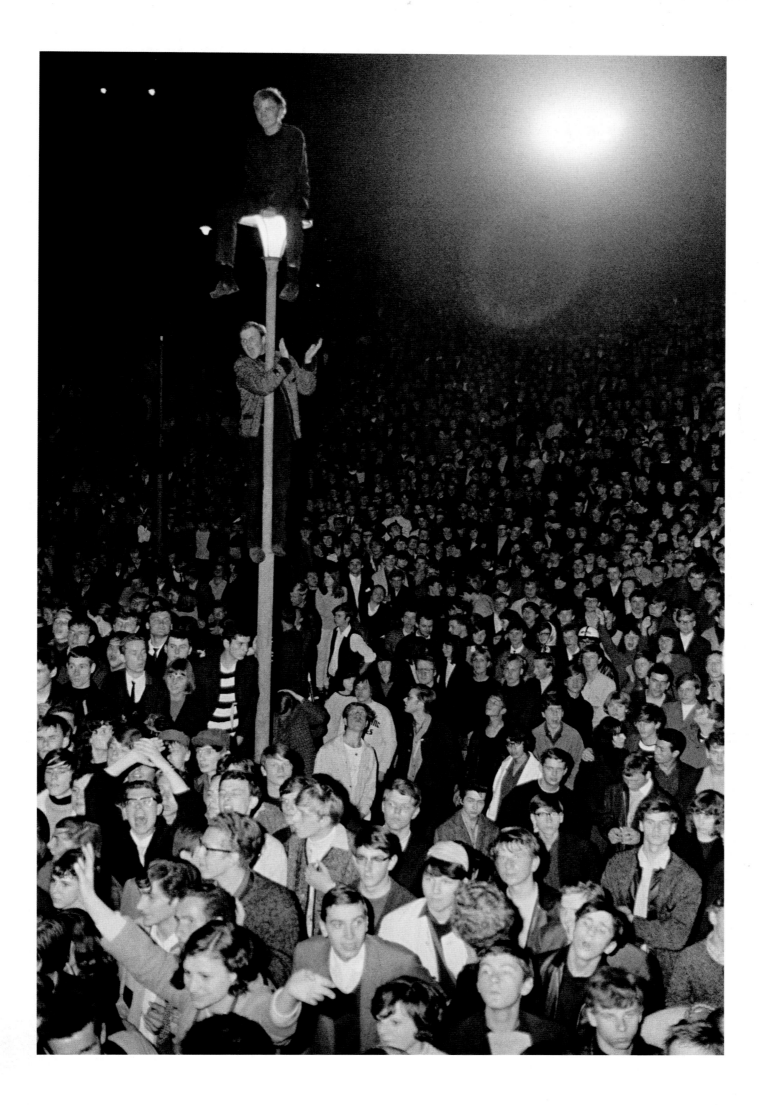

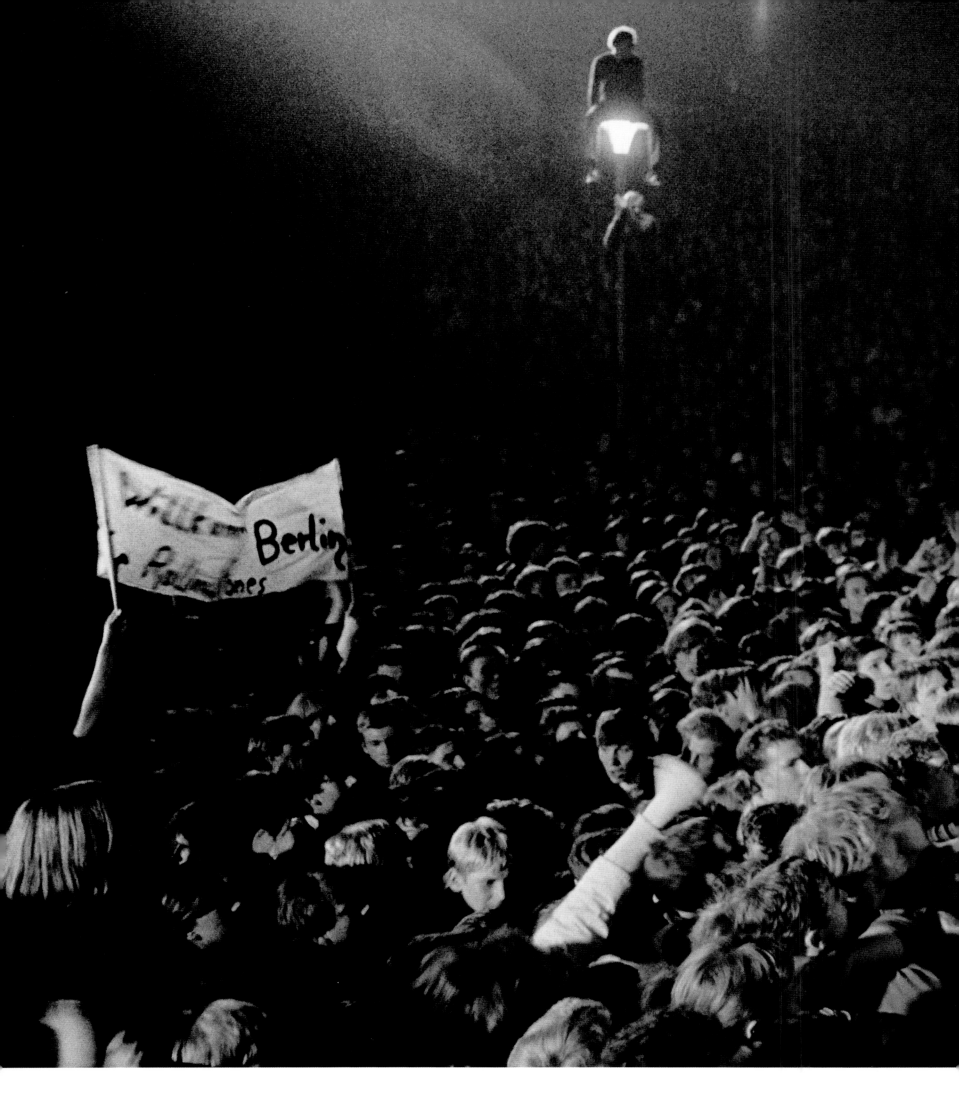

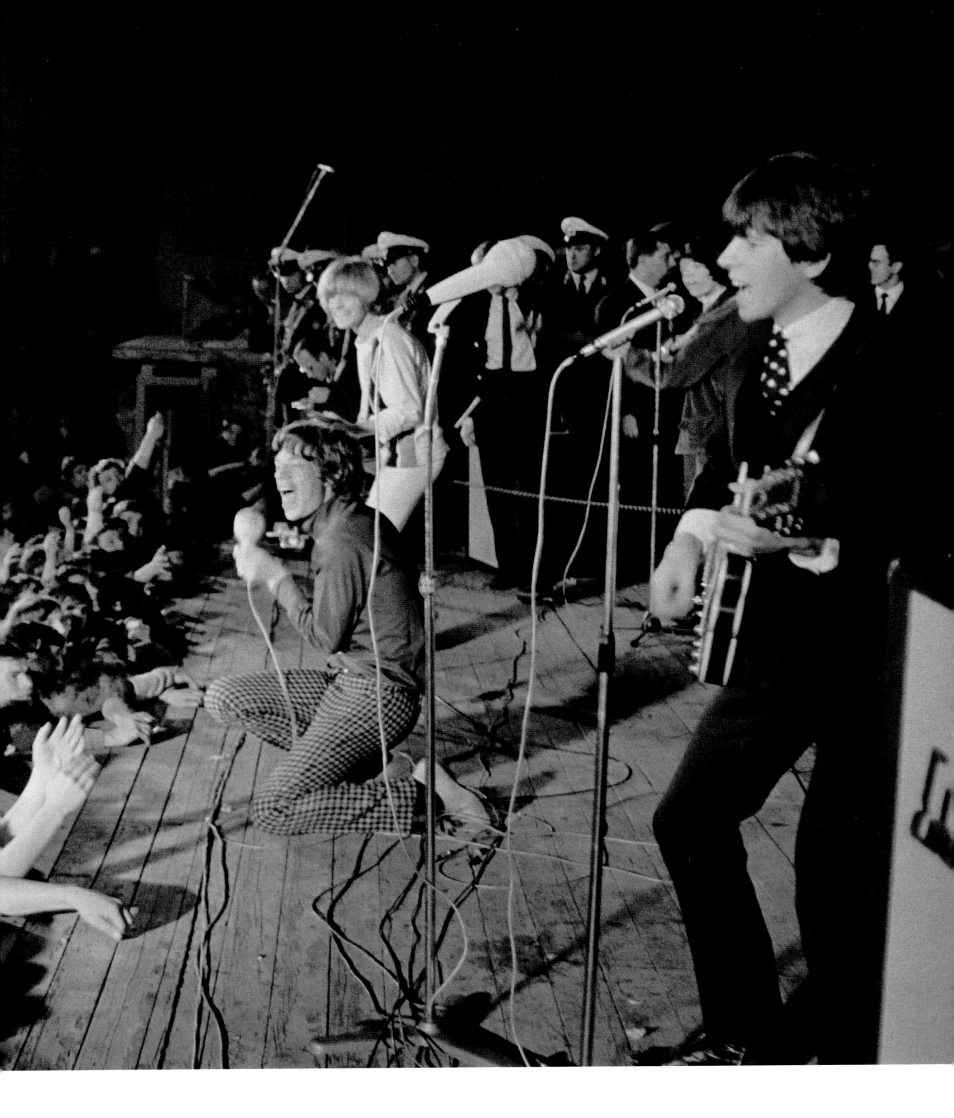

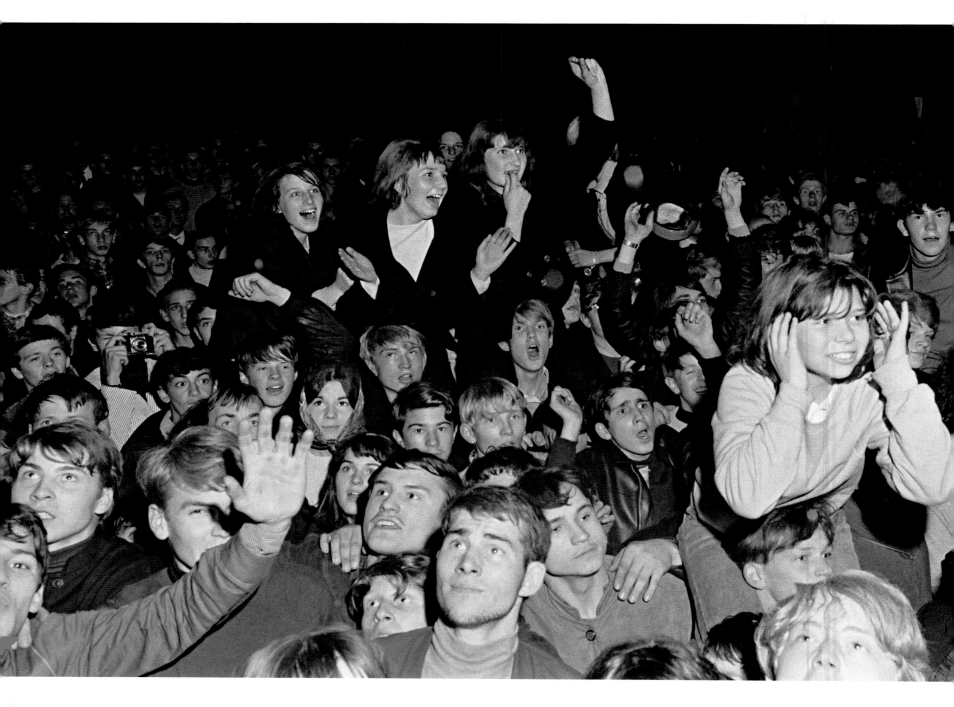

"There were wild scenes, but we missed most of it. A lot of it — such as the breaking up of seats — occurred after we'd gone. It was like a football crowd gone mad. I was a bit scared. They knew all our records and I believe that **Satisfaction** is now No.1 over there. We didn't see much of the country, though. The police wouldn't let us out most of the time."

MICK – MELODY MAKER, 25 SEPTEMBER 1965

Set list:

Everybody Needs Somebody to Love

Pain in My Heart

Around and Around

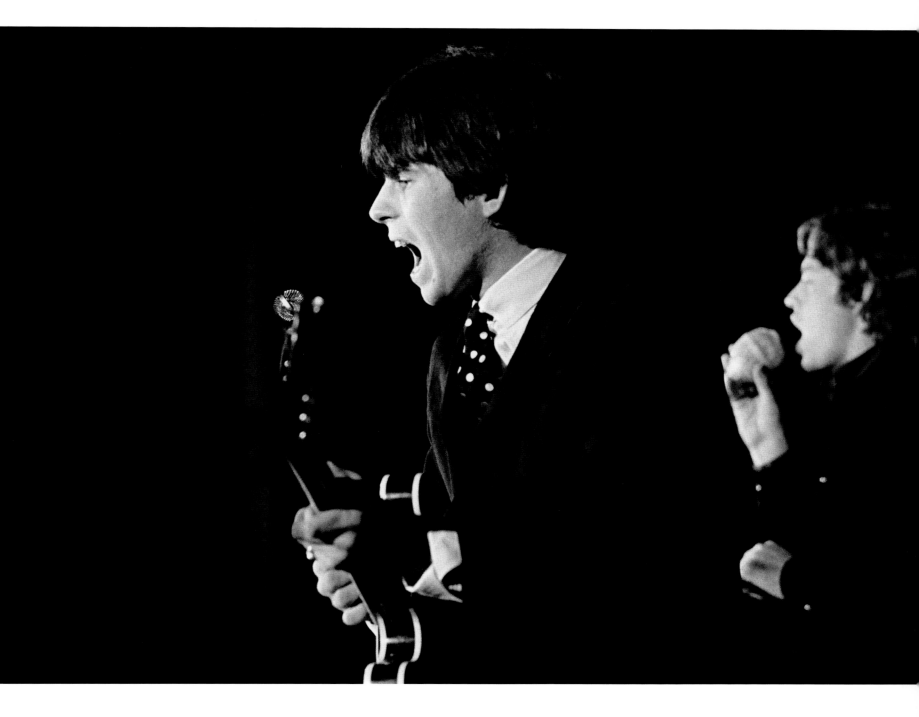

Time Is On My Side

I'm Moving On

The Last Time

Satisfaction

I'm Alright

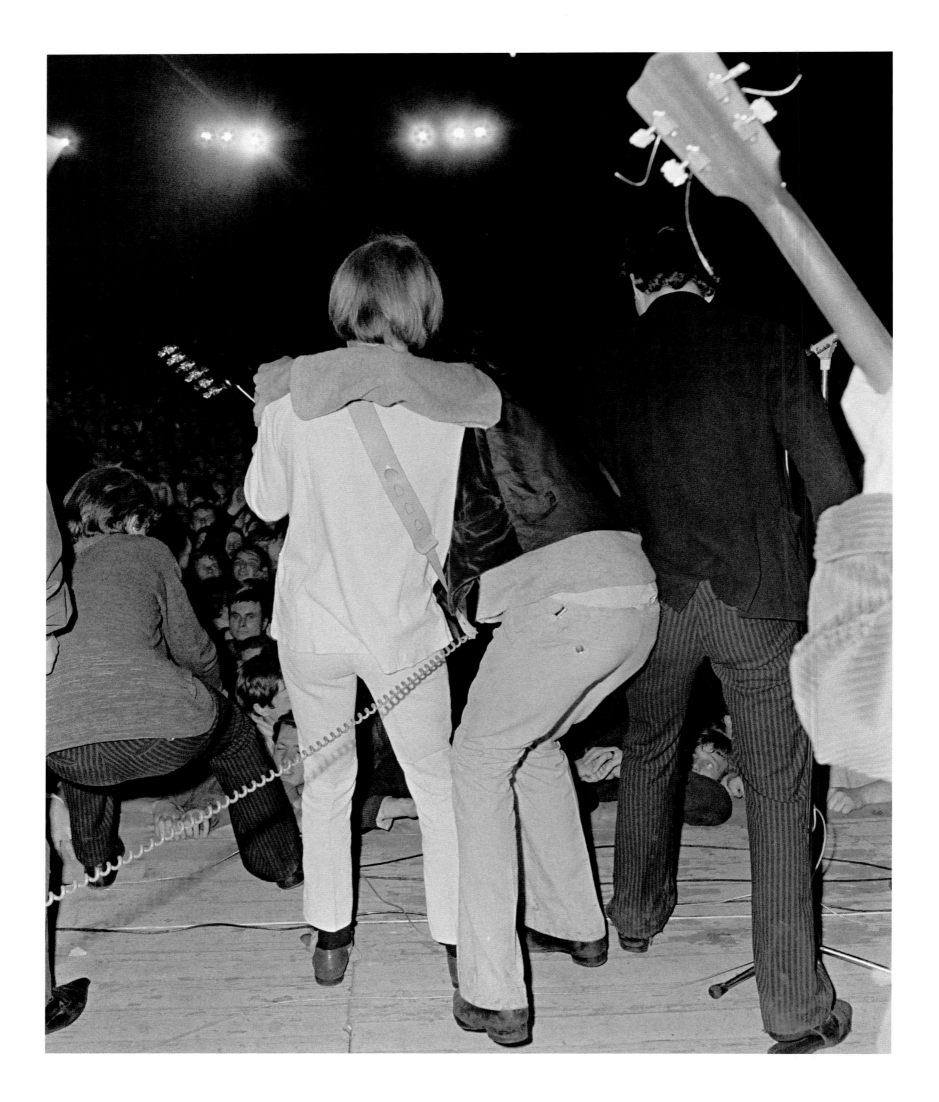

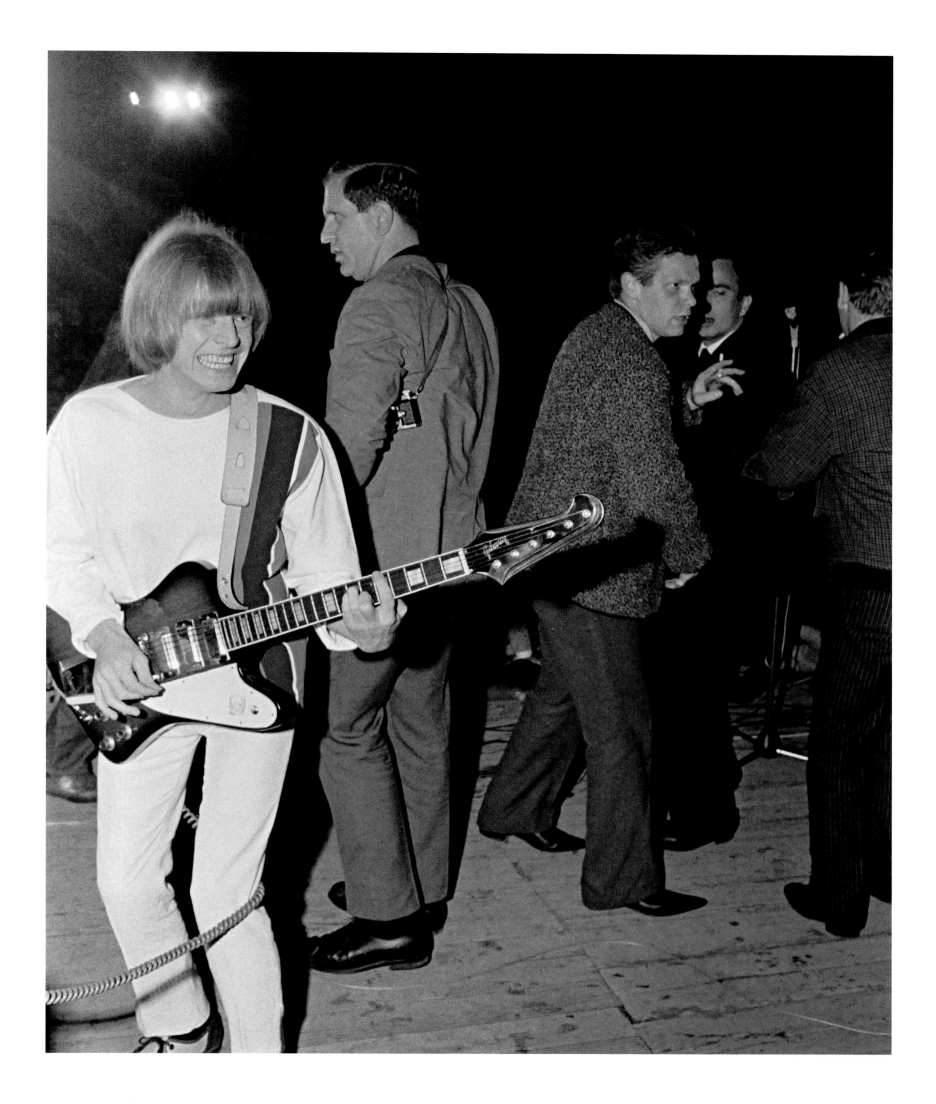

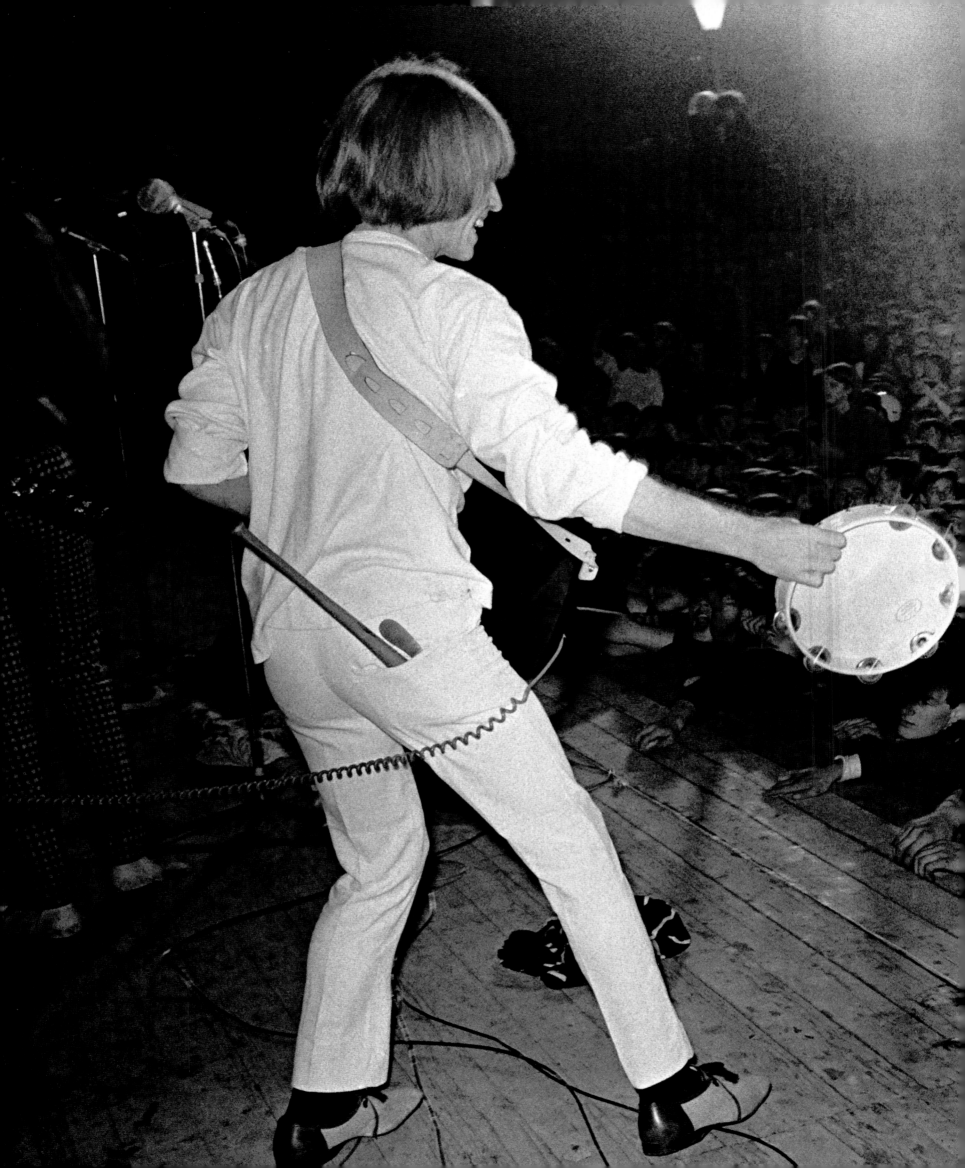

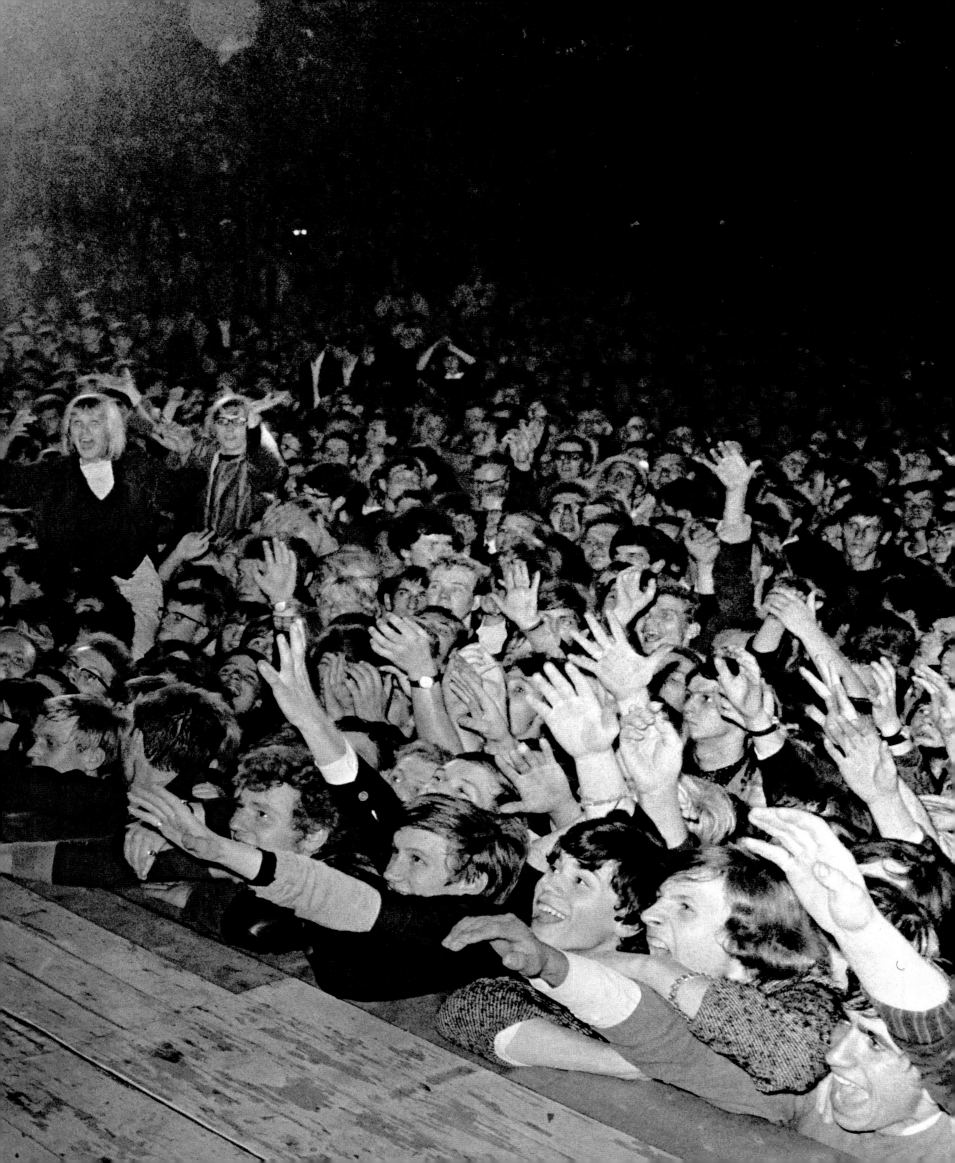

When the Stones had finished their thirty-minute concert Berlin police with their rubber truncheons drawn drove "21,000 Beat fans" out of the Waldbühne. It was not long before the huge open-air arena resembled something more like a battleground than a location for a "popular music concert". It was clear that no-one was prepared for what had happened, least of all the police. Their experience of handling such a large crowd of teenagers and young people was very limited and it was fortunate that things did not get more out of hand than they did.

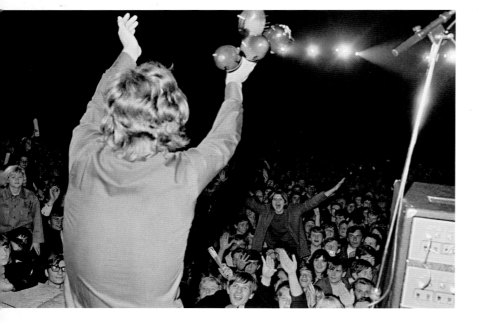

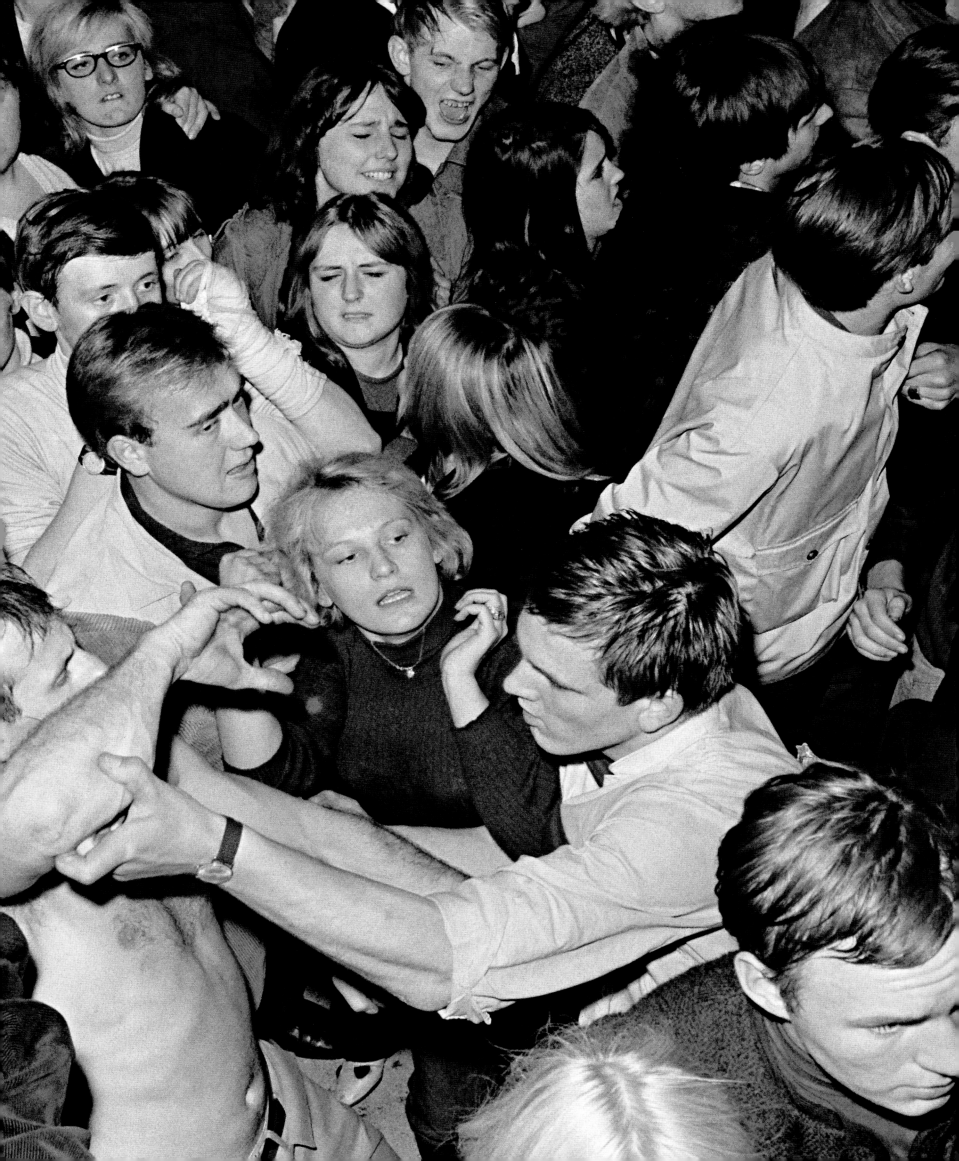

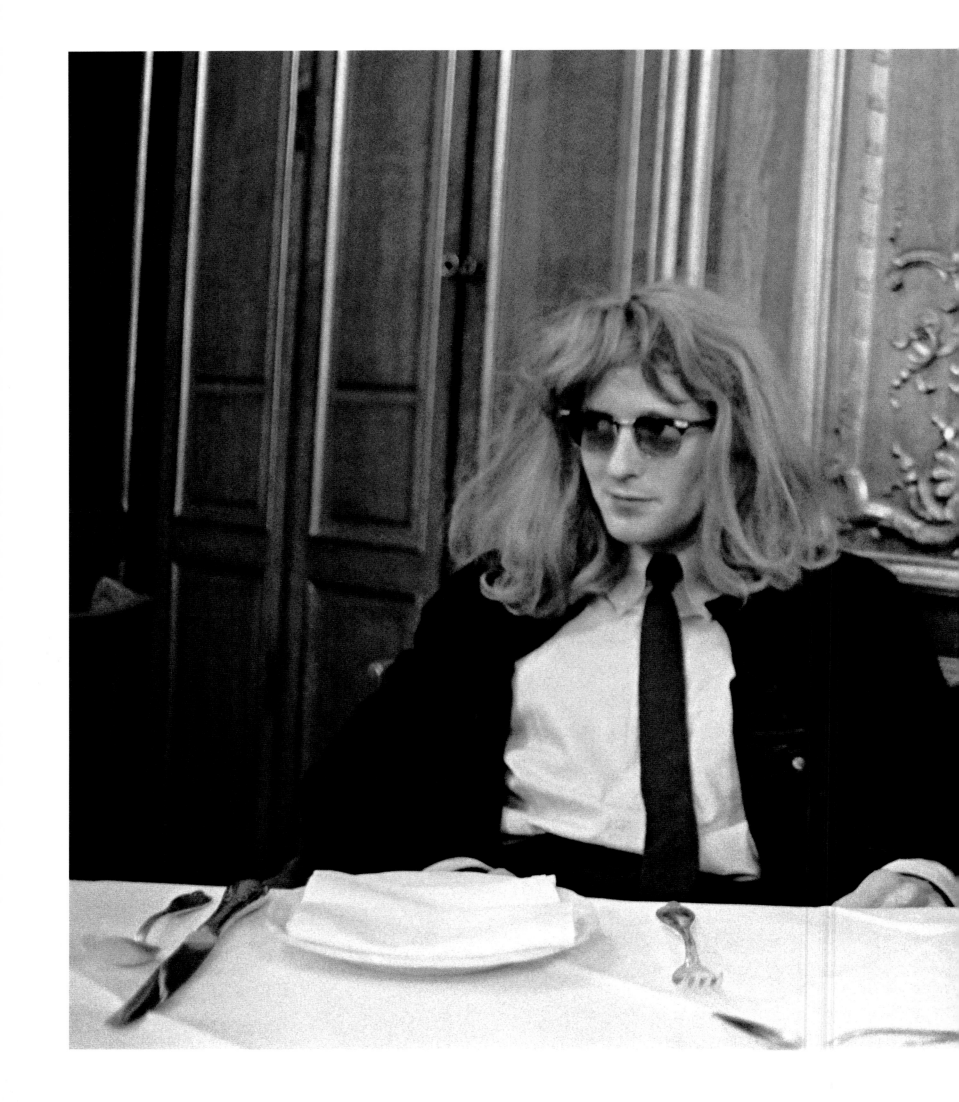

"Back at the Gehrhaus after the concert — we had had to take a police armoured vehicle from the venue to the hotel — everyone settled down to a quiet evening, to begin with unaware of what was happening back at the Waldbühne. For some reason Knud Thorbjornsen decided to wear a wig. Sitting next to him is another of the promoters named Anders. Before long we could hear the sounds of the rioting, which was several kilometres away. Brian decided to get a taxi and Niels Wenkens and him drove back into Berlin to see what was happening. Every time the taxi stopped Brian would wind down the window and give a Nazi salute." BR

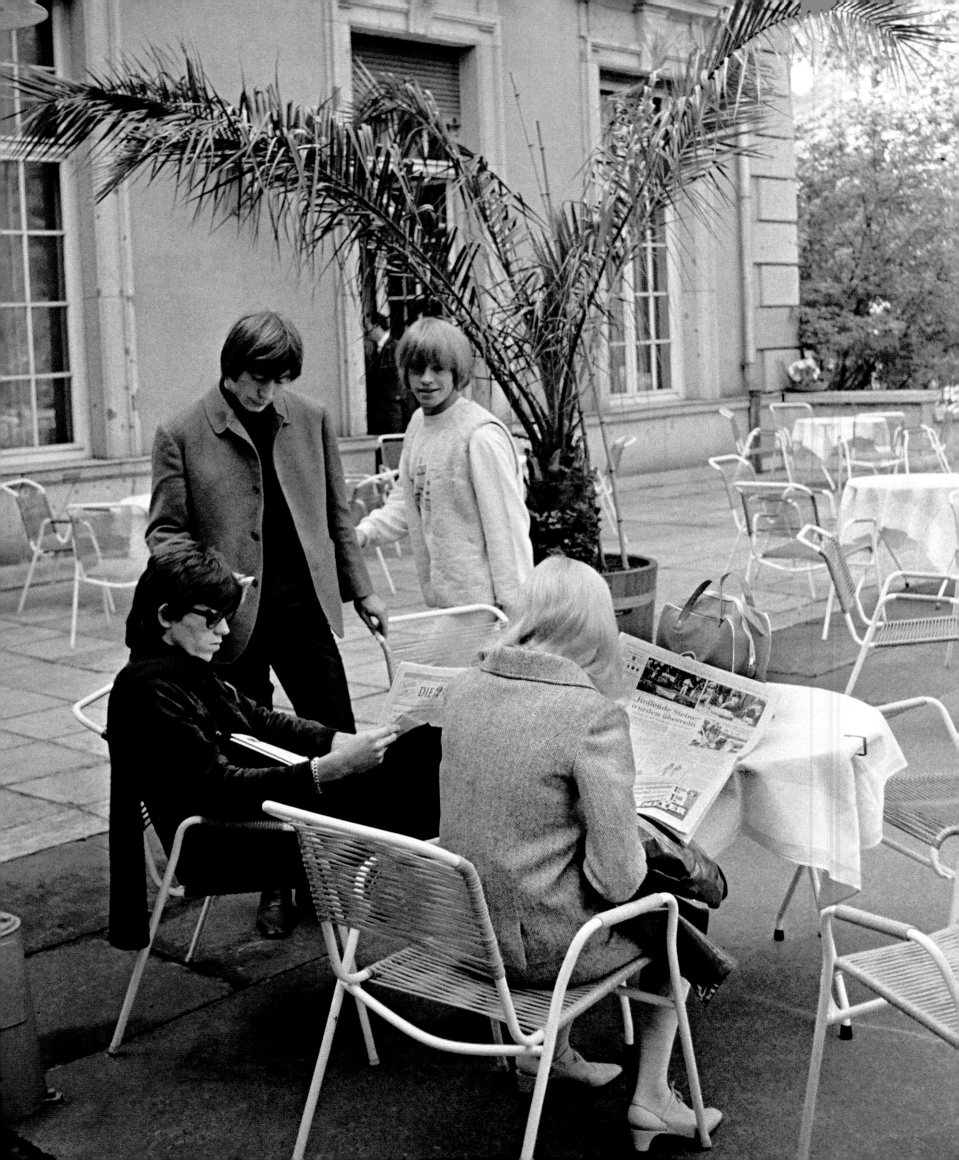

20,000 seats destroyed...

300 arrested...

28 fans and 6 policemen hospitalized...

train overturned...

44 cars smashed!

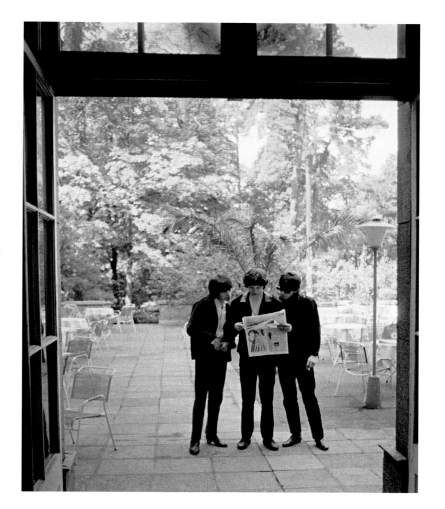

"The next morning before the band left, they spent some time reading through the newspapers and found it hard to believe the extent of the damage. While this wasn't the first time that The Rolling Stones had been involved in a riot situation, it was by far the biggest. Before the band left for the airport to take the flight to Vienna everyone tried to make out what the newspapers were saying — there were many pictures that helped to give a more graphic account than words could ever do." BR

BERLIN AFTERMATH

Even the British press gave full coverage to the events in Berlin.

"West Berlin is still counting the cost of The Rolling Stones' show in an open-air theatre on September 15, which ended in rioting. Ninety per cent of the seats, 50 per cent of the lamps, and 60 per cent of the fences were destroyed, and the bill is now estimated at £30,000. There were 21,000 young spectators in the theatre [sic] and about 4,000 of them are said to have rioted. The casualties: 77 people injured, 28 spectators, and six policemen taken to hospital. Four hundred policemen were in action in and around the theatre. Fifteen overhead railway trains [carriages] were badly damaged after the show." THE EVENING STANDARD

As in any situation like this, the question has to be asked: why did it happen? It would be too easy to blame the Stones, but music and even their full-on stage show could not cause such a riot. The fact was that there had never been this many teenagers in one place for a concert by a Beat band in Berlin. There was no question that as soon as the Stones went onstage that the audience reaction was incredible, the roar was said to be "deafening" as they stormed the stage. Fans climbed lighting gantries, pulling off their clothes to waive them wildly in the air. Neither does it seem likely that it was the police's fault. They, by all accounts, showed a lot of patience in trying to keep the crowd calm. However, once things got out of hand the police had little chance of maintaining order with only about 350 officers, although reports vary as to the precise number, to handle a crowd of 21,000 (again some reports suggest it was closer to 30,000).

According to Marianne Koch of Bild Zeitung, it was like nothing she had ever experienced. "Now I know what hell is like. My job has taught me to be brave but in the Waldbühne I learned what fear is like. It is a mob out of control, stampeding at the entrances. I was almost crushed. The air was filled with the yelling of the crowd and the hammering beat of the band. It was like a witch's cauldron and the whole place glowed with the atmosphere."

Others talked of it being the craziest show they had ever seen, with girls taking off their underwear so that they could throw them at the stage. They also spoke of the courage of the Stones, "to stand there amongst all the fury". The fact was that the German press was in shock. They had never experienced anything like it; compared to the Stones, The Beatles were like a Sunday-school outing.

The fall-out in the city, and for the promoters, was unprecedented. With questions being asked in the Berlin Senate, the future for concerts in the city was bleak. Heinrich Albertz, the Senator for Public Safety in Berlin, gave this reaction: "For at least a year, the government will not allow Beat shows with thousands of spectators in West Berlin. Shows with crowds of a few hundred will be allowed. We are not willing further to risk the lives of our policemen in such cases." Following this statement the city sent a bill to the promoter, Karl Buchmann, for the damage to the Waldbühne; it came to 271,571.50DM. They also asked for compensation of 23,000DM because a concert by the Budapest Opera Theatre had to be cancelled due to the huge amount of damage; so many seats had been burned that there was nowhere for people to sit. Buchmann's reaction was to send a letter to SBA, the Scandinavian promoter, asking them to pay the bill, but not before he had gone back to the Senate pleading that he had not made any money from the show.

And there was another problem for Karl Buchmann. According to the Daily Mirror: "The Stones have set a big poser in the music-loving city of Munich. The question being argued is, do they make music, or just noise? The city's tax authorities started the great controversy after the Stones gave a concert there. They said 'that's not music. It's just a noise', and handed concert organiser Karl Buchmann a £1,200 tax bill for amusement tax. This tax is levied on sport, circus and carnival shows, and dances. But NOT on music. Buchmann refused to pay up, and the Upper Bavarian authorities stepped in. They backed up the Munich authorities, saying that the Stones' music was amplified by electronic equipment to an extent 'that divests the music of its character in the usual sense and makes it appear simply as noise'. Buchmann says 'It's still music. You just have to get used to it'."

Forty years later and no one can remember or knows for certain the outcome of all the wrangling over the costs. Did Karl Buchmann pay the 271,000DM and the compensation to the Budapest Opera Theatre? It would be five more years before the Stones played Berlin, which was a year after another mini riot in the city that the Stones were kind of involved in. In October 1969, fifty youths were arrested by police after it was rumoured that the Stones were playing on the roof of a building owned by millionaire publisher Axel Springer, which overlooked the Berlin Wall. A riot erupted and police moved in to disperse crowds.

charlie watts

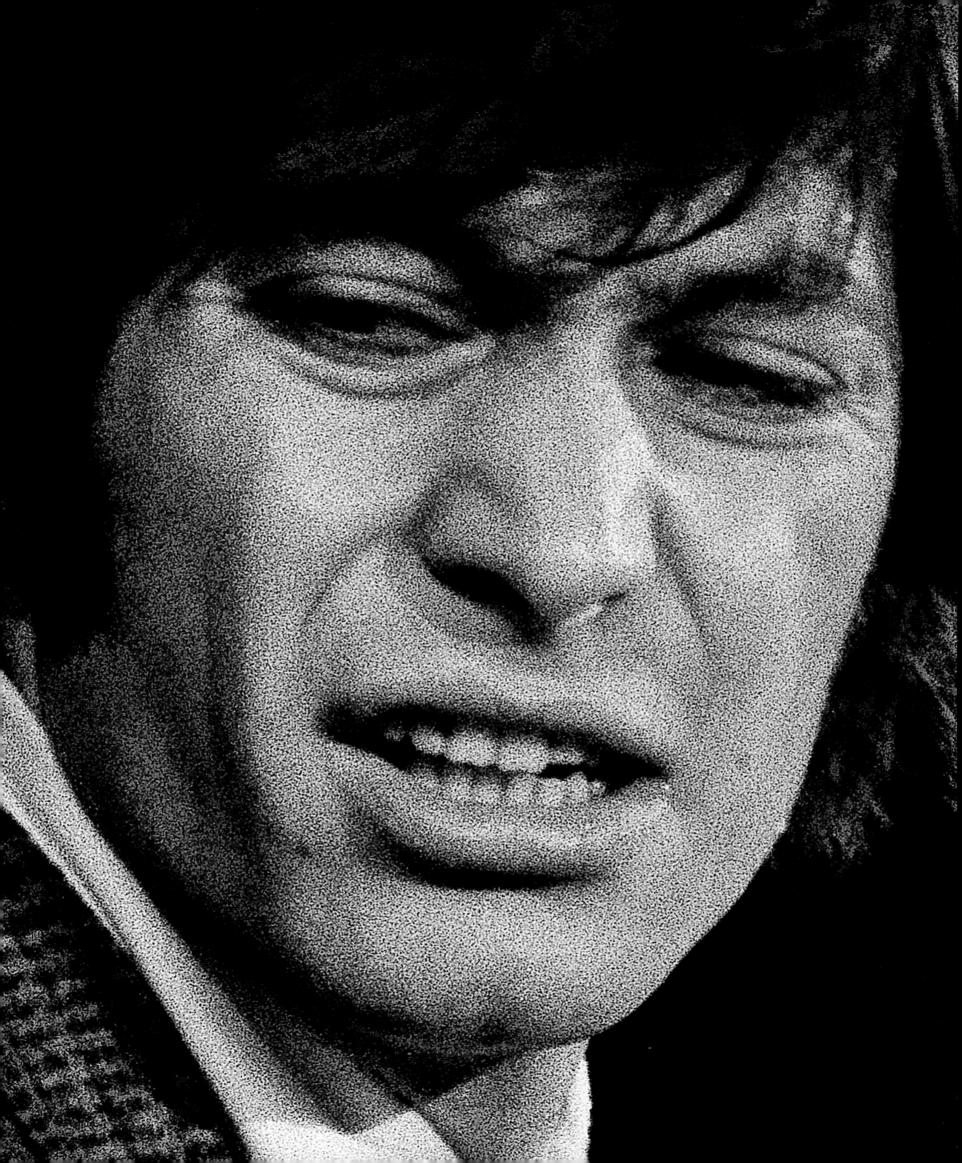

CHARLES ROBERT WATTS

Charles Robert Watts, the last man to join the original Rolling Stones, was born in London on 2 June 1941. His father, also named Charles, married Lillian in 1939. Baby Charlie lived for much of the war with his grandmother in King's Cross while Charles senior was serving in the RAF; Charlie has a sister who was born in 1944. After the war, Charlie's father began working as a driver with British Railways; he was still doing the job in 1964.

Charlie started school in Wembley in September 1948. He showed talent as a speedy right-winger and could have been a professional footballer; he also had a cricket trial for Middlesex. Lillian Watts said: "He was a big boy with strong legs. We often thought he would become a footballer."

Charlie first became interested in music when he was thirteen: "I can't claim that I came from a musical family. The only instrument anyone could play at home was a gramophone." Charlie bought himself a second-hand banjo. "I tried to learn the banjo, but I couldn't get the dots on the frets right. It drove me up the wall. I got pissed off with it and took the thing apart, made a stand for it out of wood and played on the round skin part with brushes." For Christmas 1955 Charlie's parents bought him a drum kit for £12. Any sort of jazz interested Charlie, so he taught himself by listening to other people's records and watching drummers.

Charlie was less academically inclined. He left school, aged 16, with an O-level pass in Art, but he did receive two cups for running, along with his three prizes for Art. In 1957 Charlie went to art school. "We wanted Charlie to go in for graphic art or draughtsmanship, and were very pleased when he went on to Harrow Art School," said his mother.

In July 1960 Charlie left art school, and became a tea boy at an advertising agency, earning £2 per week; he later became a visualizer, designing posters. In 1961 Charlie wrote a book on Charlie Parker called Ode To A High Flying Bird, which was eventually published in 1965. He played drums twice a week in a coffee bar, but by September 1961 he was playing with a band at the Troubadour Club in Chelsea. He met Alexis Korner who invited him to join his band, but Charlie declined – he was leaving London to work in Denmark. When he returned to London, Charlie heard a lot about the fledgeling Stones and was finally persuaded to join them in January 1963.

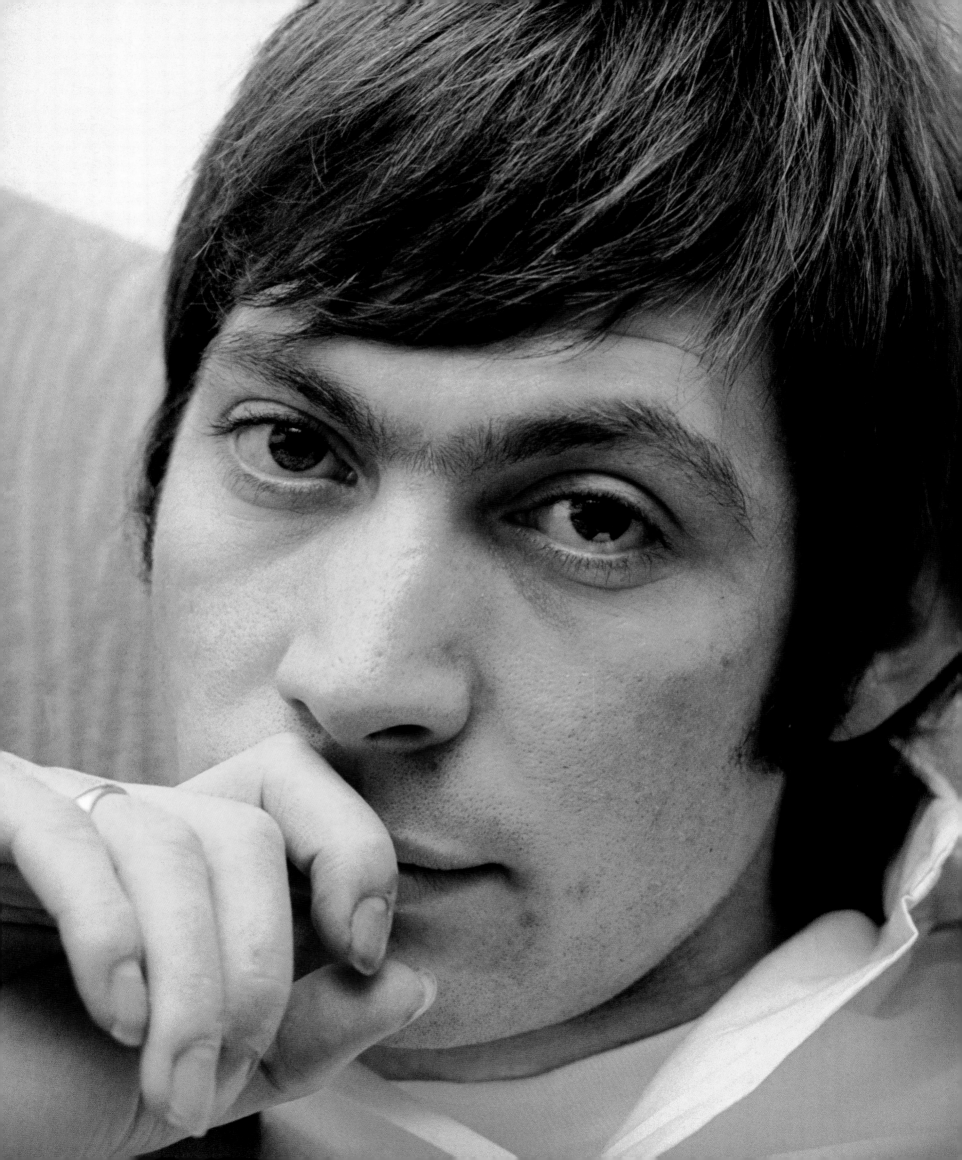

"Shirley Shepherd had studied sculpture at art college and, after she and Charlie had secretly married in October 1964, having first met at an Alexis Korner gig, she continued sculpting but ceased her formal studies. Their flat was very like an artist's studio, in part because of Charlie's interest in the subject." BR

"Charlie and Shirley's flat was at Ivor Court, in Gloucester Place and was above Andrew Loog Oldham's office. It was very small but comfortable, and of course stylish. Charlie was no cook but he could manage to make his guest a cup of tea." BR

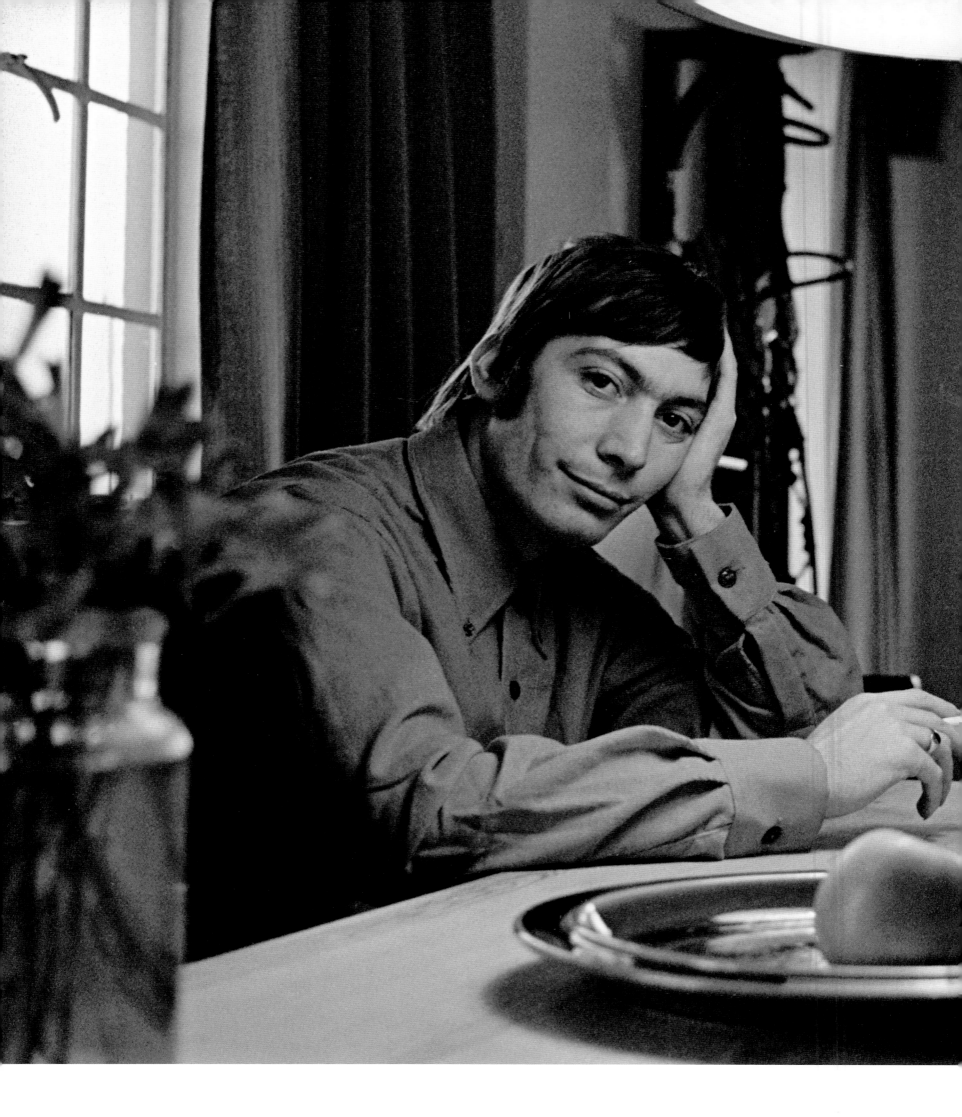

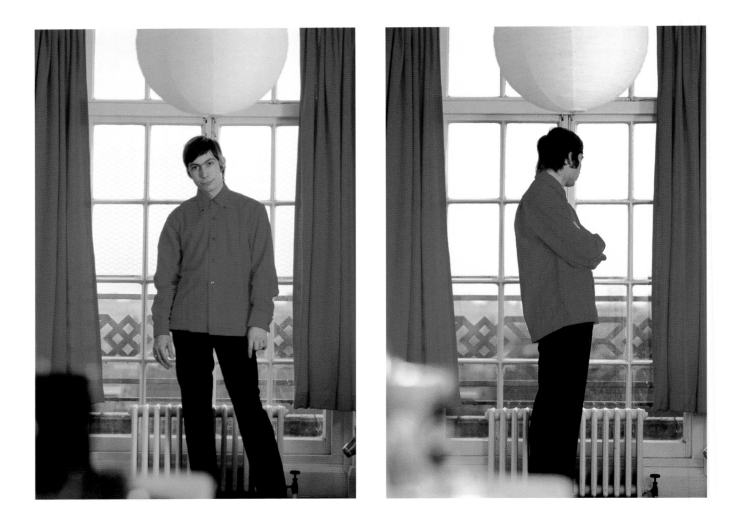

"Charlie went to live and work for an advertising agency in Denmark in October 1961. While he was there he played with a jazz group, the Don Byas Band, and also acquired a love for Danish pine furniture which he later bought to furnish his Ivor Court flat. I assume that he also loved red!" BR

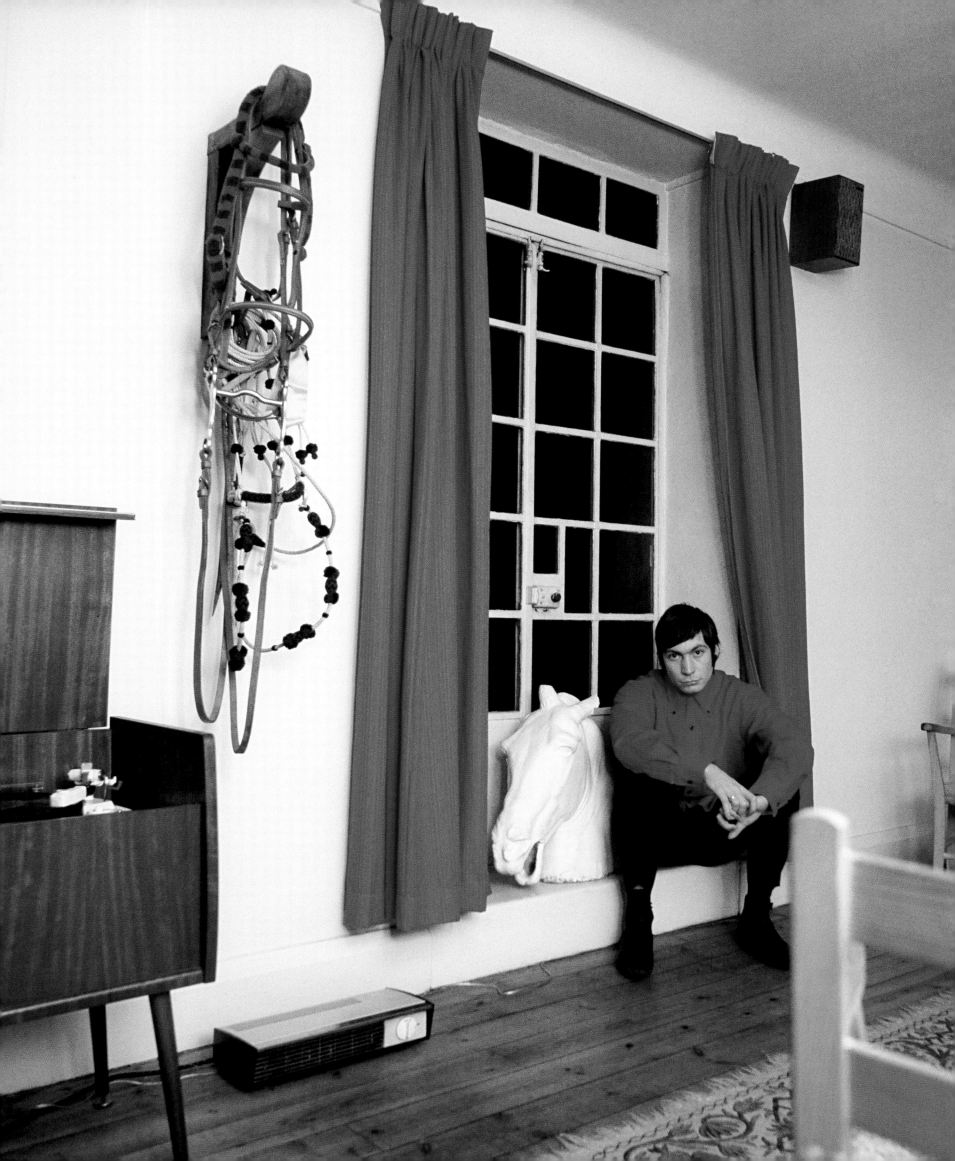

"On the day I took the photographs at Ivor Court in June 1965 I went with Charlie and Shirley to look at a house they were thinking of buying in the small town of Lewes in Sussex. The 16th-century Old Brewery House in Southover Street was just what they wanted. I think they put in an offer that day and then moved there in October 1965. The house once belonged to an archbishop of Canterbury and they bought it from the former Attorney-General in the Labour Government." BR

"Charlie is standing upright on one of Lewes's very hilly streets, which creates the illusion of him almost falling over." BR

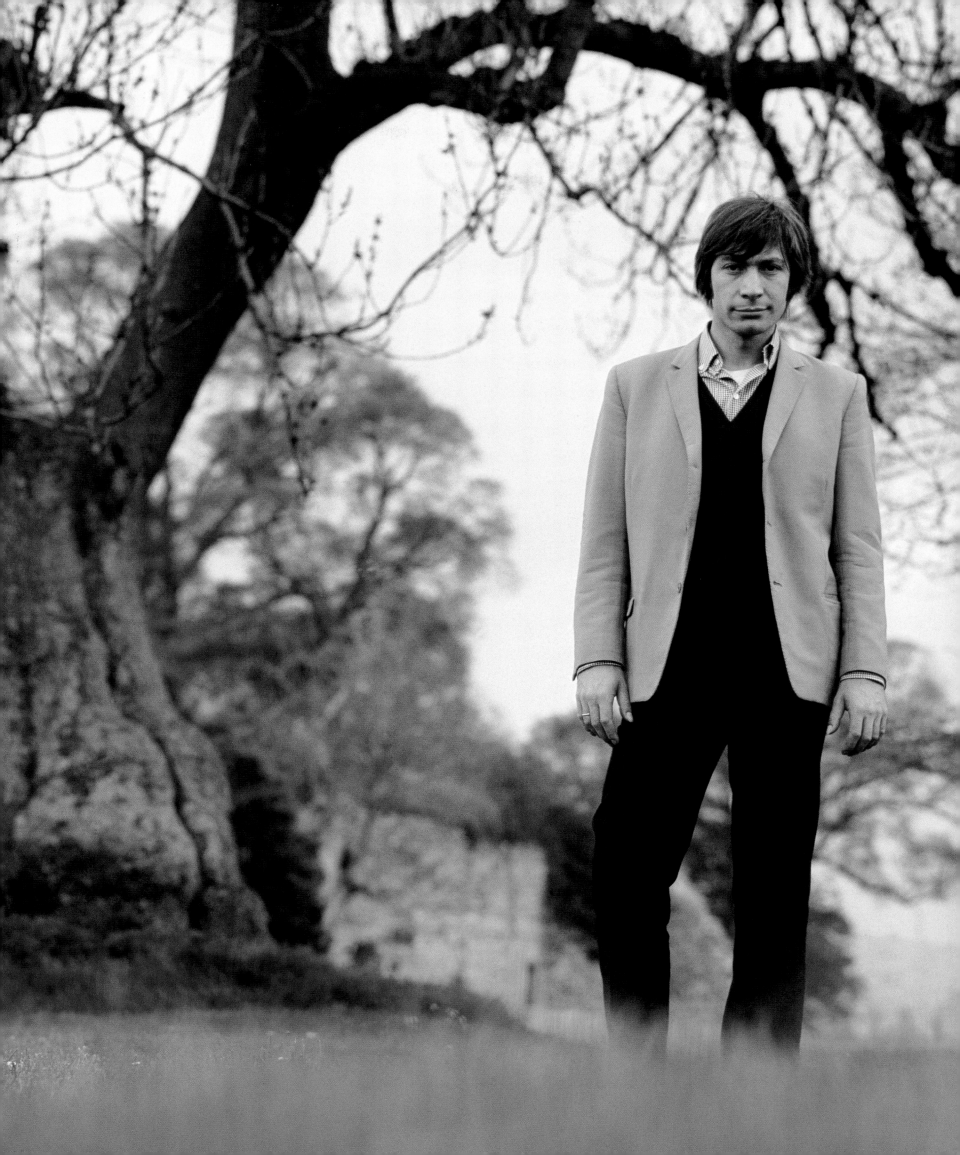

"Charlie Watts is 'half' Danish. Before he started his present career he used to work as a designer for a Danish advertising agency, and it shows in his and wife Shirley's four-room apartment on the eighth floor in the centre of London. Most of their furniture is Danish and what he didn't bring with him from his stay in Denmark he has bought on tours. Most of it is bright pine and the only things not Danish in the apartment are an English Chesterfield and some decorations on the walls – and even most of these are Scandinavian. Shirley and Charlie are very much in love, they confess. So much that she follows him around the world most of the time. That is also why you find four ready-packed trunks in one of the rooms. 'They are always ready for us', Charlie explains. 'When we are at home we can't waste the time packing and unpacking. We want to relax and enjoy being at home. We are always longing for London and what I look forward to most of all when we are touring is Shirley's cooking'. His favourite dishes are oriental and even if he is not much of a cook himself you will always find him with his nose in the pots when Shirley is preparing dinner. The only thing he does himself, whether at home or on the road, is the tea. This love for good food almost shows in the walls with paintings and decorations on them.

"The most important room of the apartment, however, is locked. It is a small room – 3 by 4 metres – which is filled with treasures. Here, in cupboards with glass doors, Charlie keeps his precious collection of fine, antique weapons, caps, uniforms, banners, and newspapers. Charlie's newspaper collection is a rarity that many a museum would pay a small fortune to get hold of. Here you will find some of the oldest examples of newspapers in the world.

"Whenever Charlie settles down with his records, Shirley settles down to her art. She will go into her studio to work on her sculpture. So far she hasn't tried to live from being a sculptress, all of her pieces of modern art go to friends and family – or stay at home. It's because they not only love each other, but they also love art." BR MAY 1965

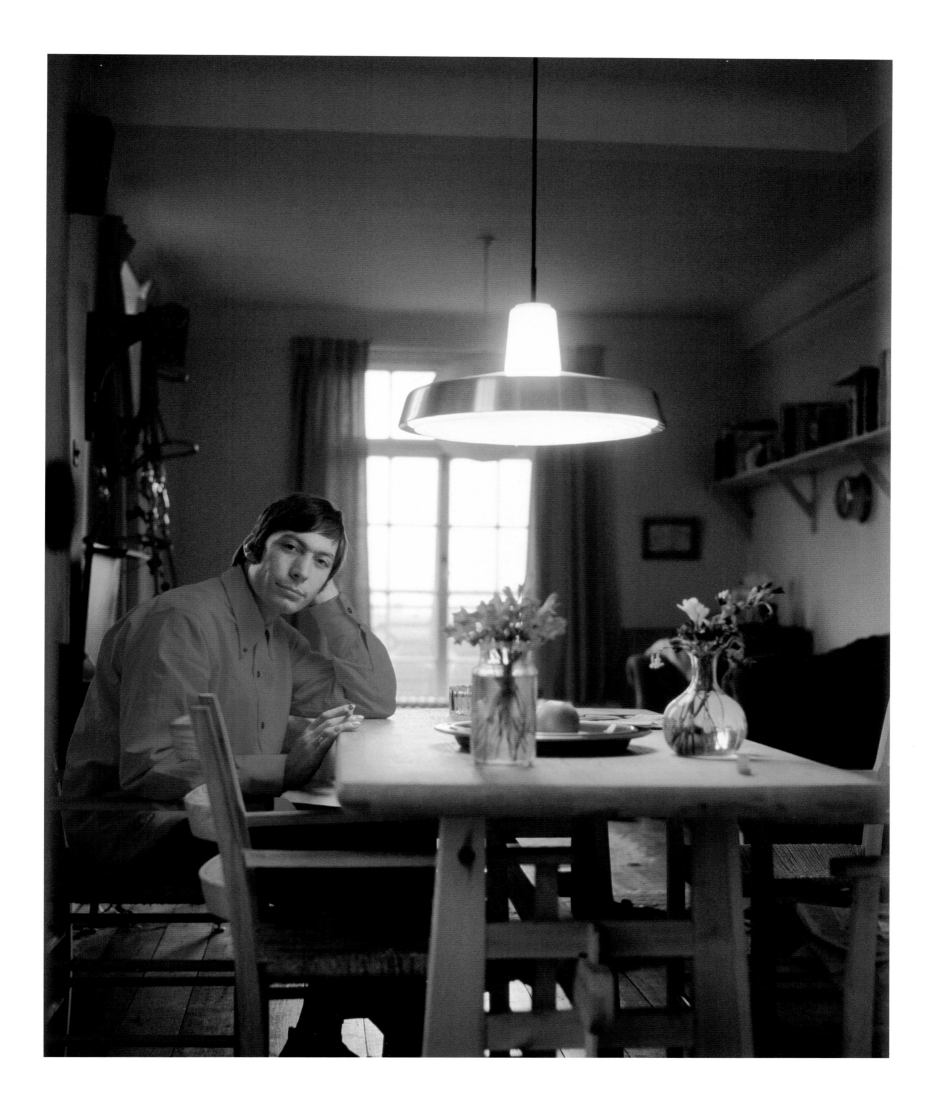

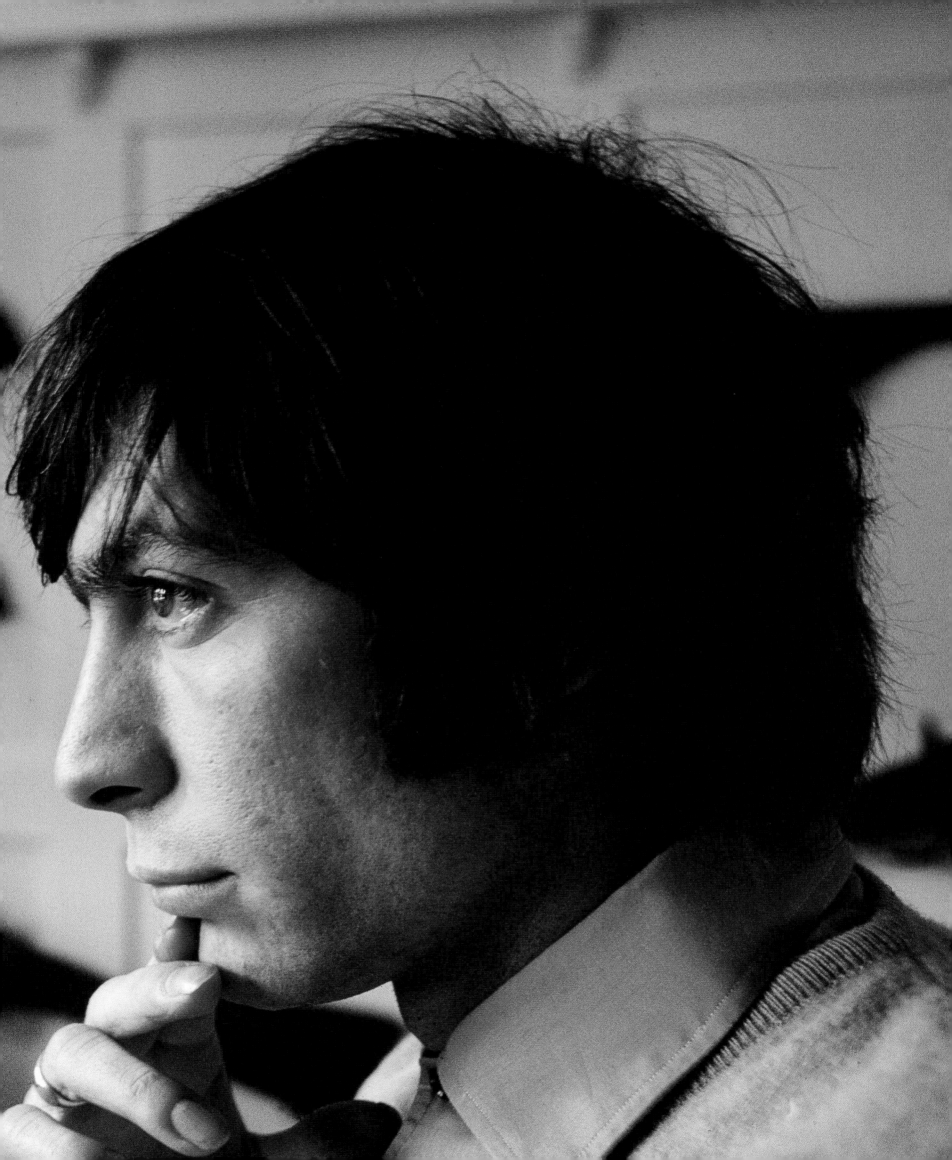

PAPER TALK 1965

"Police lost control of thousands of fans queuing for Stones tickets in Gothenburg, Sweden. Over 300 fans queued all night in bitterly cold weather, and were joined in the morning by thousands more. Police using horses and dogs, failed to control them and stopped sales after only 100 tickets had been sold." – Record Mirror, 6 MARCH • "I'm planning a German tour for the Stones. I have in mind, shows in Berlin, Munich and Hamburg, but soldiers over there have got a petition up, saying if we don't play Essen, they will boycott the boys." – Eric Easton, Record Mirror, 6 MARCH • "The Stones' stage clothes are always shockingly relaxed. Mick does the show in wrinkled jacket and grey cardigan. Bill in a tight leather jacket and dark glasses. All five hate ties." – Aftonbladet (Sweden), 22 MARCH • "It's now obvious that it's time for a period of Stonesmania." – Bild-Journalen (Sweden), 25 MARCH • "Hundreds upon hundreds of young people stood screaming at the airport, which called for more and more officials. It was on a par with visits of heads of state." – Ekstrabladet (Denmark), 26 MARCH • "I feel so strongly about the Stones getting thrown out of places. Do you know, in Switzerland, people looked at them as if they were SCUM! Another thing is people inferring that they're not clean." – Cathy McGowan, 17 APRIL • "The Stones would never have been booked, if we'd known ahead of time who they were. They were booked under individual names, and we didn't know until too late. Unfortunately, these groups encourage an unpleasant element among teenagers." – hotel manager Myles Craston, Ottawa Citizen, 26 APRIL • "They performed such apparent favourites as **The Last Time**, **I Wanna Be Your Man**, and **Not Fade Away**. They didn't exercise their pelvises as much as Elvis does, nor did they appear as content as The Beatles do. They strolled and shuffled about, twanging mightily, keeping up the same basic beat in almost every number, and grinning freely." – Albany Times Union, 30 APRIL • "What had been a comparatively peaceful show, now turned into a full-scale demand for puberty rights. Fresno could have been jolted by a score of sonic booms, and nobody in the stadium would have heard them. The girls screeched, wailed, moaned and cried. They pulled their hair, held tightly-clenched fists to their temples, waved and sagged to their knees." – Eli Setencich, Fresno Bee, 23 MAY • "Mick's hair flails like a hula skirt in a Force 8 gale. The wide, thick-lipped mouth spits out earthy words. The heavy, unsmiling features catch the spotlight. Neanderthal, primitive, ape-like, stone-age cult, unwashed rebels. When he tosses that shaggy mane the girls squeal." – Christine Fry, Today Magazine, JUNE • "I am surprised you go along and mix with the long-haired gentlemen called The Rolling Stones. What is the attraction for you? Complete morons like that. They wear their hair down to their shoulders, wear filthy clothes, and act like clowns. You buy a

ticket to see animals like that? You think if people come here with their banjos and hair down to their waist, you can smash windows?" – Magistrate James Langmuir, Evening Standard, 30 JUNE • "Charlie looked unutterably bored, Keith was quiet, and Brian less than cheerful. They dutifully posed for photographers when the award was made by Anita Harris. But when she kissed each of them, Charlie managed to remain completely grim-faced and wooden, bringing a shout of laughter from revelling journalists, who had emerged briefly from the bar." – Chris Welch, Melody Maker, 24 JULY • "To teenage followers, the Stones are glorious rebels. Adults see them as long-haired eccentrics or worse." – Judith Simons, Daily Express 4th AUGUST • "And for the sartorially-minded here is the fashion run down on the new-look Stones. Charlie Watts: Prince of Wales three-piece sports suit in grey tweed including button-down waistcoat. Mick Jagger: black serge two-button sports jacket worn with outrageous plaid slacks, predominant colour yellow. Brian Jones: white polo-necked sweater topped by white sheepskin lining from a car coat bought in Sweden. Bill Wyman: olive green corduroy casual jacket. Keith Richard: black sports jacket two years old with yellow corduroy slacks." – Ron Boyle, Daily Express, 30 SEPTEMBER • "70 rugby players will line up for their strangest 'fixture' – standing between The Rolling Stones and 5,000 fans. Their task will be to try to stop the girl fans from making a grab at their idols when the Stones appear at the Odeon Theatre, Leeds. The players, from local rugby teams, have been hired. Straight from their Saturday afternoon matches, the players will change into lounge suits and take up their positions in the theatre." – Daily Mirror, 8 OCTOBER • "Police in Rochester, New York, interrupted a performance by The Rolling Stones, then finally called the whole thing off when 3,000 teenagers threatened to storm the stage. But the Stones were furious. One of them yelled 'This is a hick town. They were twice as wild in Montreal'." – Daily Express, 3 NOVEMBER • "The cover of their brochure contains a picture of five petulant, semi-scowling faces, all dressed like boys. But if I had to take a guess, I'd say two of them were girls for sure, two probables, and the fifth has just got to be a horse dressed like a human being. A group long on hair and short on talent." – Les Horn, Pittsburgh Progress, 21 DECEMBER.

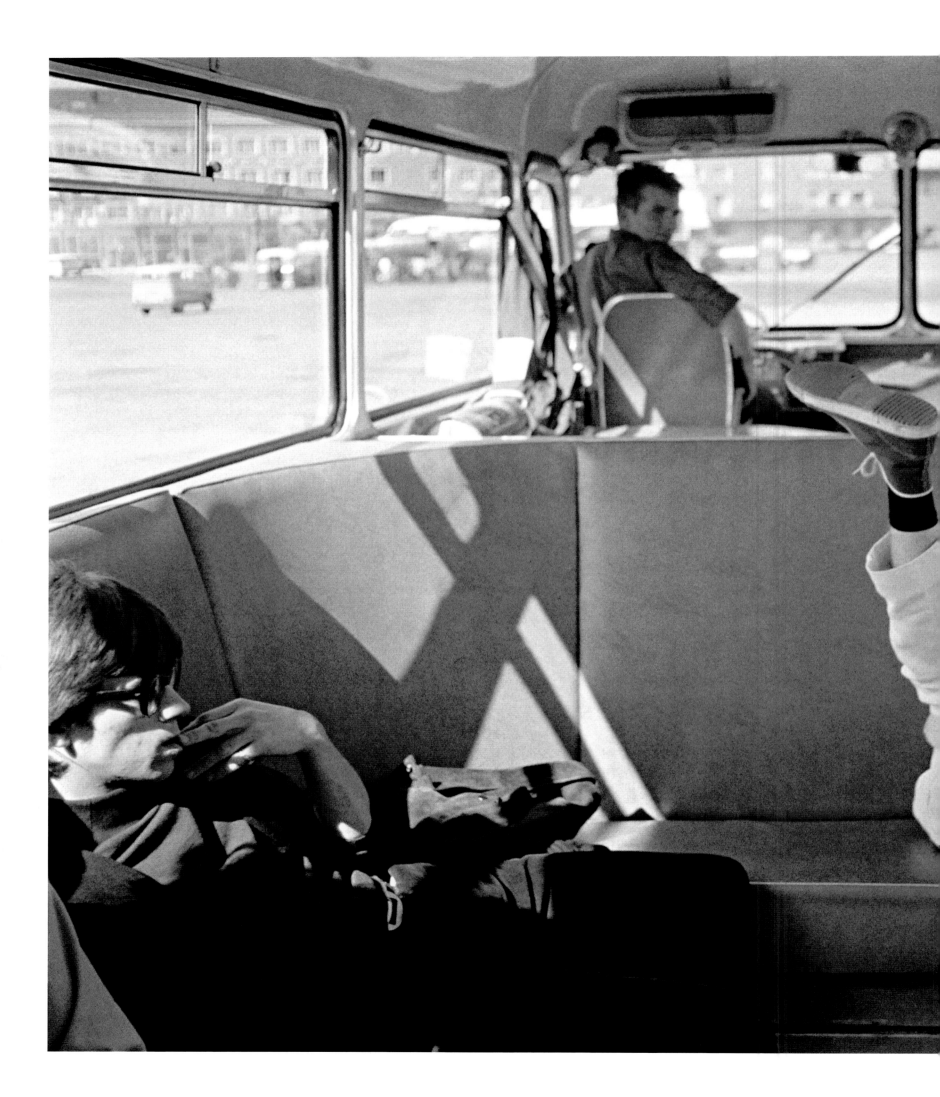

"After landing at Vienna airport a bus was on hand to take us to the terminal building. It was an opportunity for everyone, and especially Brian who 'pulled a nanker', to fool around. A fan got a little too close to our convoy and had to be rescued by a policeman." BR

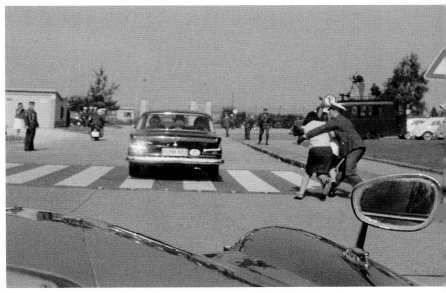

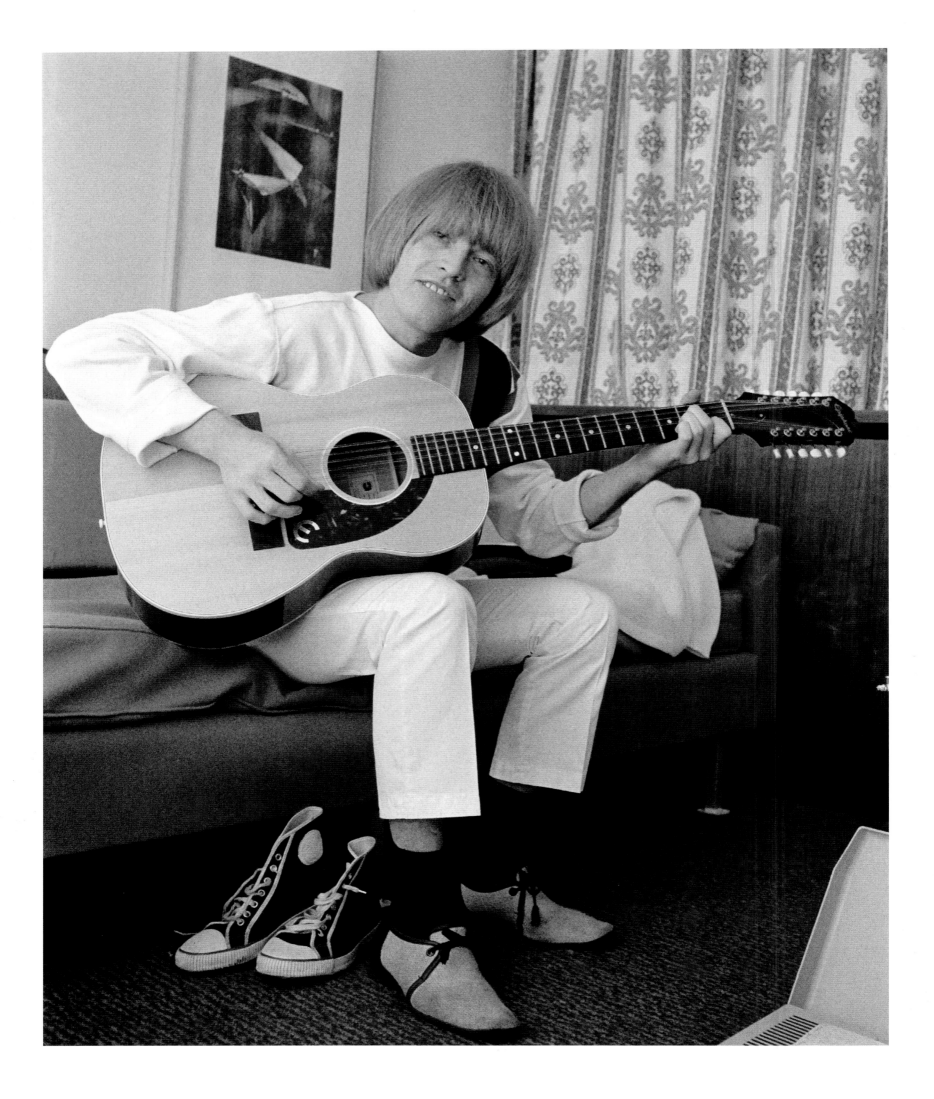

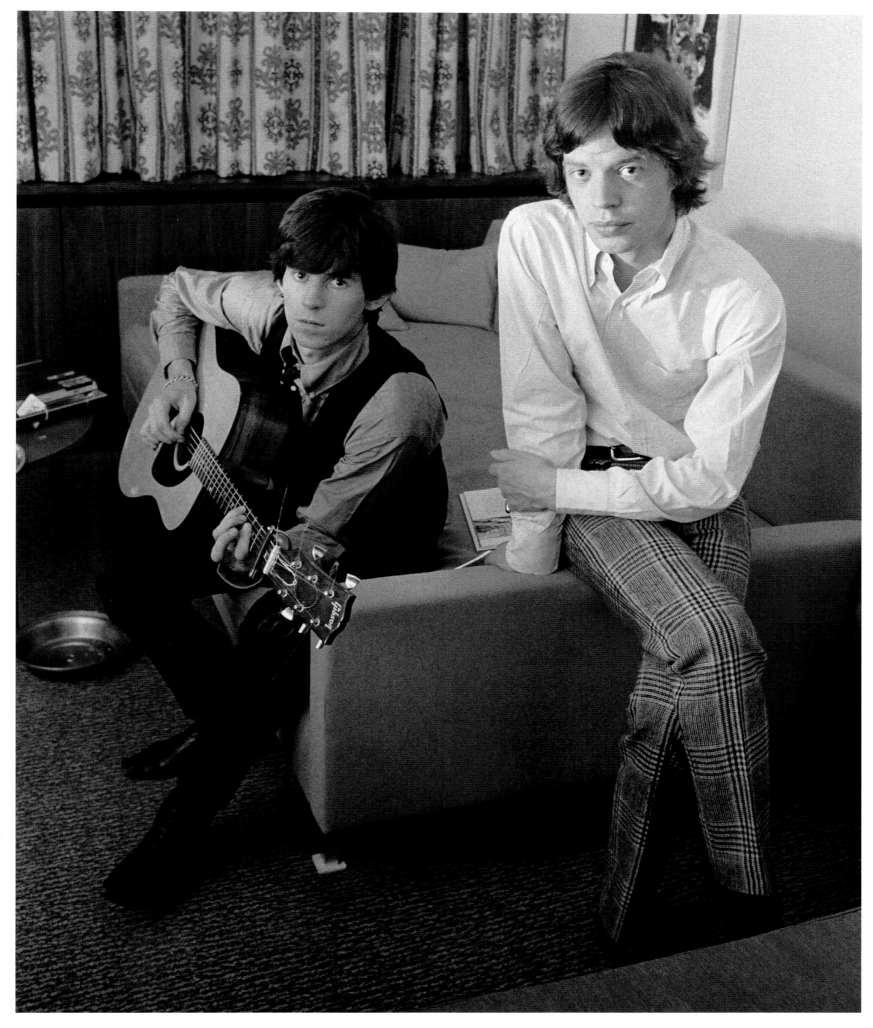

"An afternoon session at the Hotel Intercontinental in Vienna on 17 September 1965. I wish
I had had a tape recorder as well as my camera." BR

A photosession in Vienna Park
for a German magazine cover

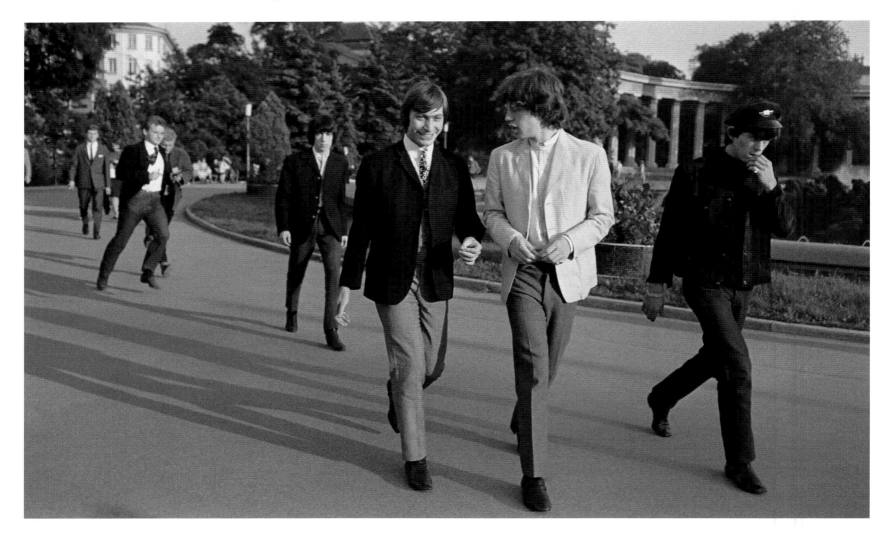

"I had been commissioned to take a photograph for a German record cover that was to be produced and sold by Hör Zu, the German radio and TV magazine. It's the cover that is featured on page 319. We did the shoot at around 4pm and then went back to the Intercontinental for a press conference at 5pm before the evening's concert." BR

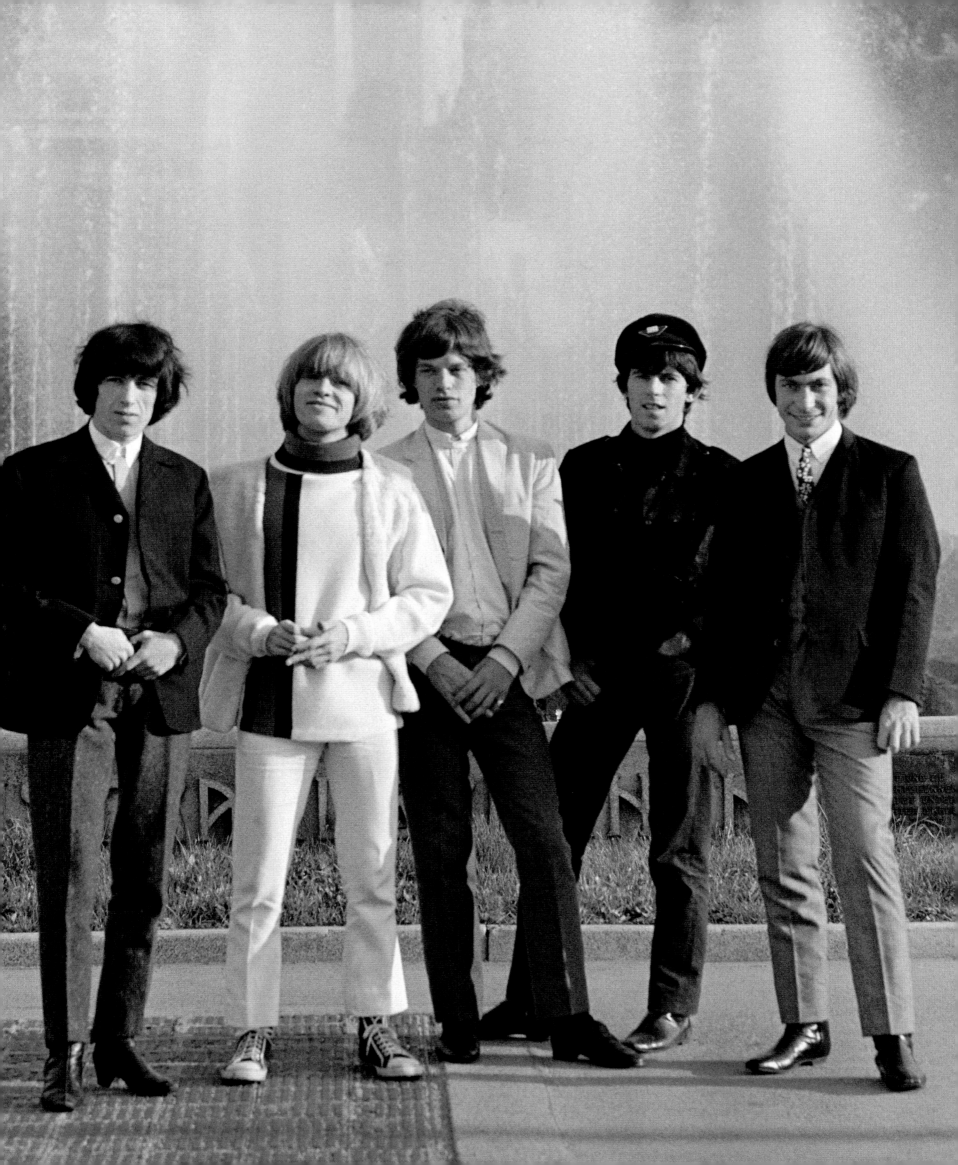

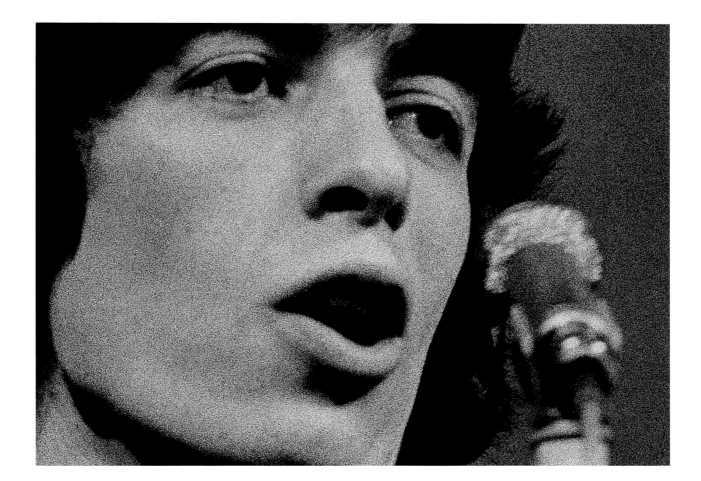

"Because the press were alive to whatever the band was doing when we were in a city, finding somewhere to eat that wouldn't be overrun by photographers was very difficult. The owner of a Vienna nightspot invited us to use his club. It was one of those clubs that was a bit like a Parisian club, with a floorshow that included some topless girls and a kind of cabaret. There were girls there who would sit with customers if they would buy an expensive bottle of champagne. We all had a good laugh and enjoyed the company but nothing else happened — honestly! It was our chance to take in a little 'local culture'. We would usually go back there each time we visited Vienna." BILL

Another day...

another city... and another show

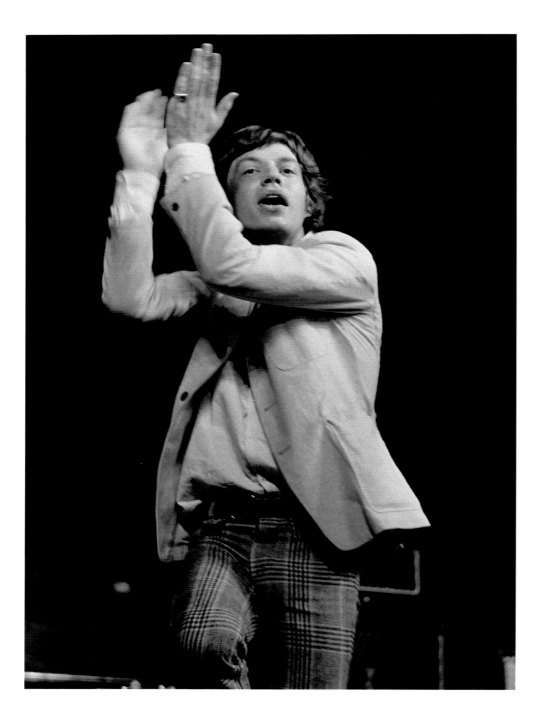

The Stones played just one show in Vienna, to 12,500 fans — and 800 policemen, who were there to keep the peace. Shortly before the show was due to start the police received a bomb threat that indicated a bomb would explode just before the band took to the stage. Of course nothing happened — it was just another day, another city, and another show.

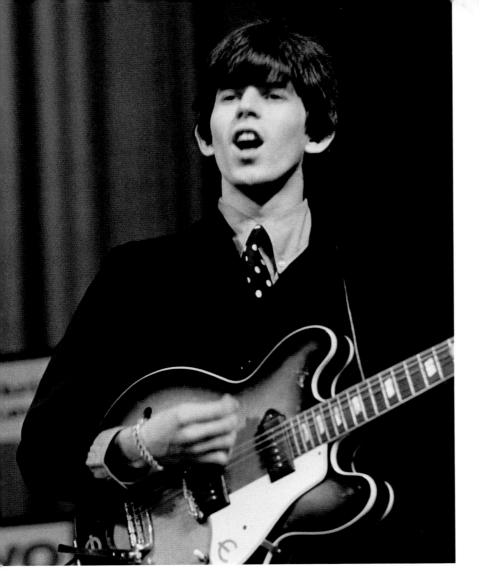
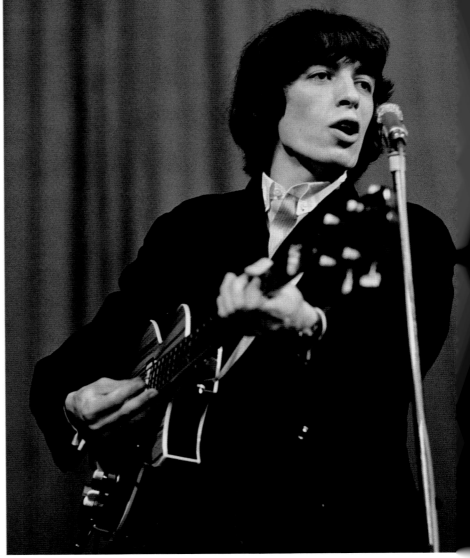
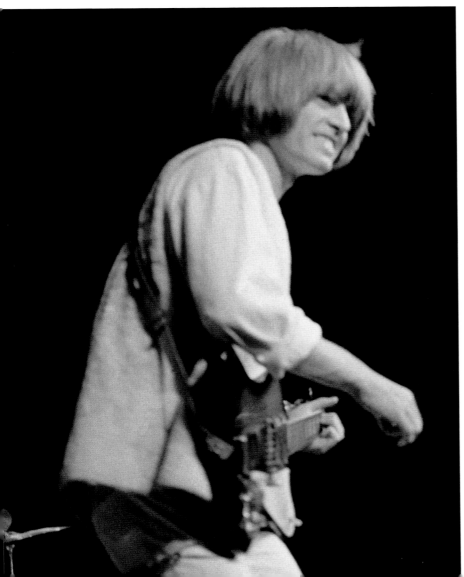
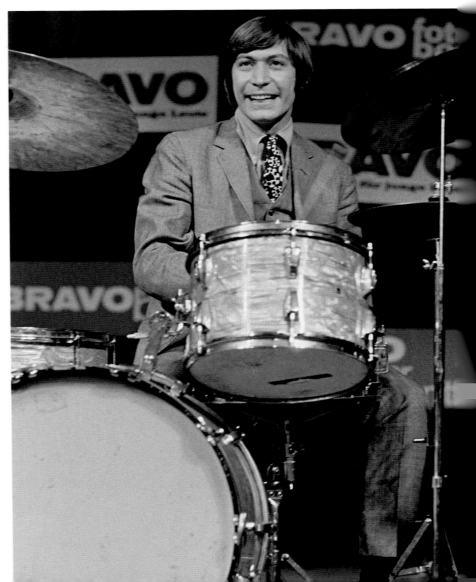

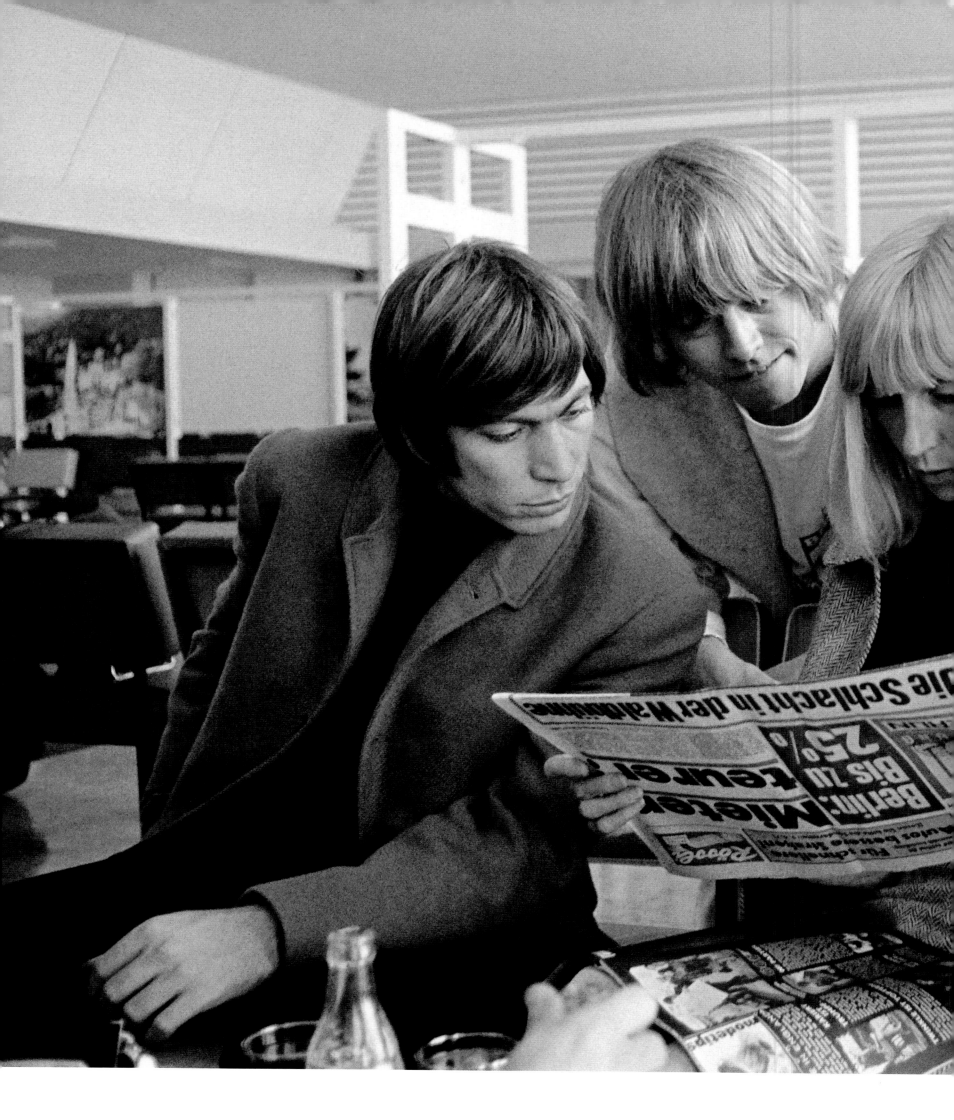

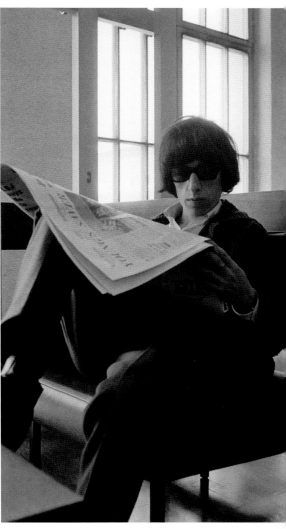

"Before the band flew back to London from Vienna they had a chance to look at the German newspaper coverage of the situation that had taken place in Berlin. 'Die Schlacht in der Waldbühne' translates as 'The Battle at the Waldbühne'. Charlie was anxious to get home as he was going to see The Count Basie Band that evening in London." BR

PAPER TALK 1966

"The Stones new album is going to be called Could YOU Walk On The Waters?" – Andrew Loog Oldham, NME, 5 JANUARY • "Everything in the Stones' garden is very nice at present. But despite their heights of appeal, they haven't got the staying power of The Beatles. Because of changes in taste in popular music, the Stones cannot hope for lasting popularity. The very nature of their music precludes drastic change. It's difficult to imagine them branching out as all-round entertainers, but their immediate future looks rosy enough. There is still a big metaphorical question mark hanging over them. It is difficult to see or discover which direction they are travelling in. Where do they go from here?" – Melody Maker, 8 JANUARY • "The Stones' publicity men in America protested that the group might have to set up a tent in Central Park, when they visit New York, because no hotel would accept a booking from them. It wasn't the Stones that the hotels objected to, but the destructive army of fans that follow them." – Daily Mirror, 7 FEBRUARY • "What more can my friend and I do to meet the Stones? About eight weeks ago we ran away from home to meet the Stones. We thumbed up to London on a Wednesday night, and arrived at one in the morning. We walked around all night. Thursday day-time we walked all around London, trying to find the Stones, but didn't succeed." – letter from Marie Van Tergouw in Rave Magazine, FEBRUARY. • "When The Beatles were here, seats were damaged. This was worse than The Beatles. Several seats were pierced by stiletto heels." – The Dominion (New Zealand), 1 MARCH • "The Stones are to make a film about a Britain controlled by teenagers. The Stones will be paid nearly £300,000 for their eight weeks work. Filming starts in August. Decca are financing the film, based on a book by Dave Wallis called 'Only Lovers Left Alive'. In the novel, the grown-ups commit suicide, and teenagers turn Britain into a Fascist jungle." – Alan Gordon, Daily Mirror, 11 MAY • "I've worked out that I'd be 50 in 1984 [sic]. I'd be dead! Horrible isn't it. Halfway to a hundred. Ugh! I can see myself coming onstage in my black, windowed invalid carriage with a stick. Then I turn round, wiggle my bottom at the audience and say something like 'Now here's an old song you might remember called **Satisfaction**.'" – Mick Jagger, Disc, 21 MAY • "The Stones are suing 14 of New York's top hotels for five million dollars (£1,750,850) because the hotels turned down their bookings. The Stones filed a damages suit, alleging that the hotels had injured their reputation. It is claimed that the Stones have suffered humiliation, ridicule and shame, because of the refusal. The Stones are also claiming that the refusal of bookings amounts to discrimination on account of

national origin, violating New York's civil rights laws. Each of the group's members is claiming one million dollars (£357,000) for alleged damage to reputation and $170 for the alleged civil rights violation." – Daily Mirror, 22 JUNE • "This was the most prolonged demand of physical endurance I have ever seen police confronted with, during my 33 years of service. Sixty police officers were hampered by the Stones themselves, who made offensive remarks and rude gestures at the police. Proportionately, the trouble was a lot worse than The Beatles show three years ago. A special meeting will be held at City Hall between myself and city license inspector Milt Harrell and others, to determine the future of such shows in Vancouver. The Stones in particular, would not be welcome in the city in the future. As soon as the R&R hits its tempo, the fans are 'gone'. The bumps and grinds are really what you would expect only an adult to be watching in a burlesque show. It is not only vulgar. It is disgusting. It's a tribal dance. Its purpose is to get the youngsters sexually excited." – City Police Inspector F C. Errington, Vancouver Sun, 20 JULY • "Brian seems to have disappeared from the public eye! He doesn't feature very much in the Stones' present image. Once, the rather weird, longhaired, almost mythical Brian, was the most talked-of and popular Stone, but nowadays people don't discuss him so much. We asked the Stones' office for an interview with him. Andrew Oldham said: 'No, you cannot see him, or phone him, and he cannot give you any quotes'." – Dawn James, Rave Magazine, AUGUST • "They looked like Edwardian 'Jack The Rippers' with their sullen faces. The piercing cries and pounding feet drowned them out, but by lip-reading, I made out the song **As Tears Go By**. Tears began to roll by on quite a few faces in the audience around me. Mick postured like a spastic elf. He sneered at us through half-closed eyes, and gave his heels a petulant flamenco dancer's stamp. There was more Oscar Wilde than Perry Como in his cultural heritage, but this dimmed no one's frenzy except my own. I sat calm in the eye of a hurricane, while around me, the others squealed, moaned or frugged. For their last number, the group sang **19th Nervous Breakdown**. This time, they were out in front of the curtains, so near, you could almost touch them, and the kids went wild. The screams were deafening. Girls stood up and held their hands over their ears, and at the same time, opening their mouths to shriek. When it was all over, we were exhausted by emotion, and by sheer exposure to sound. We left the hall listlessly, in a kind of torpor. This music is not for the ears alone; you must listen to it with the marrow of your bones. You must roll with it, be rocked by it." – Helen Eustis, McCalls Magazine, AUGUST.

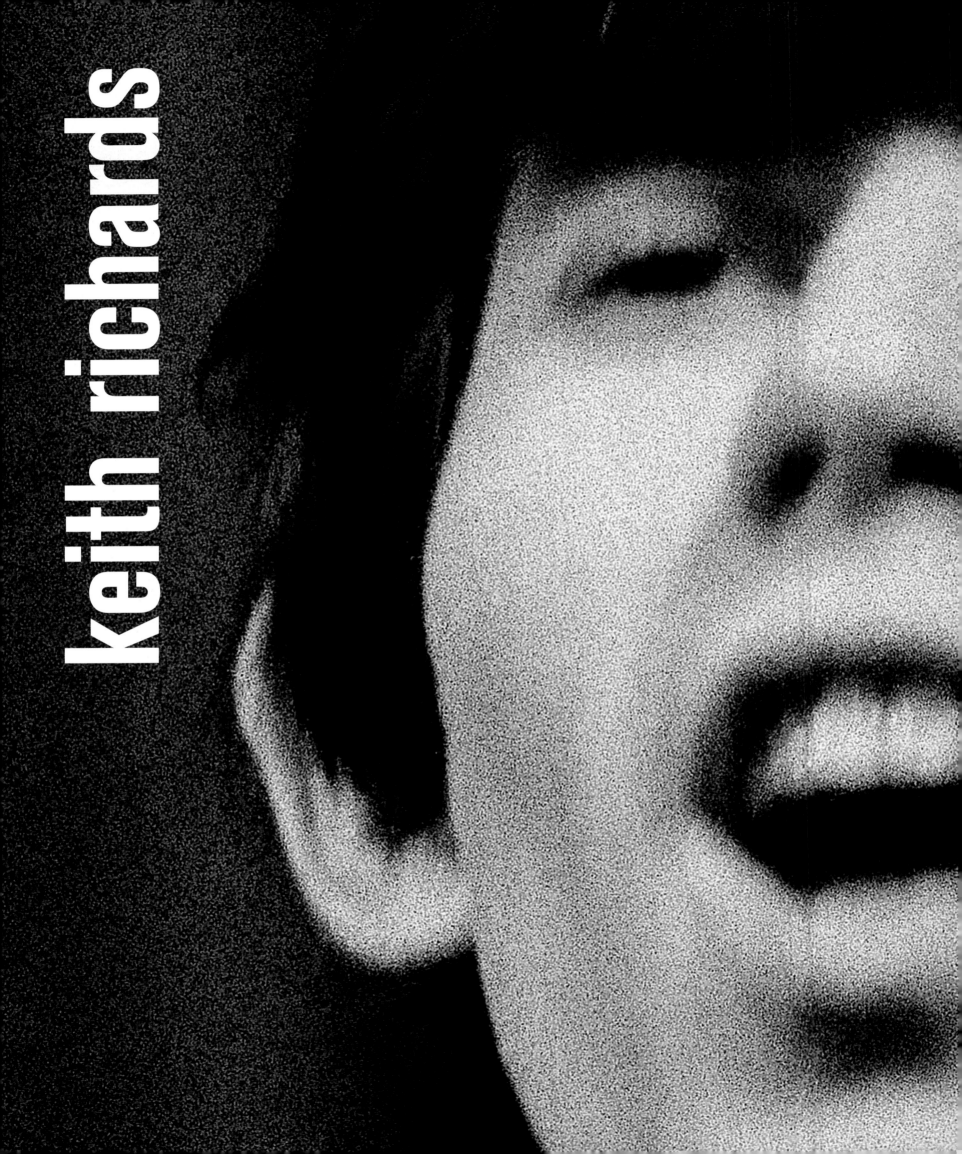

keith richards

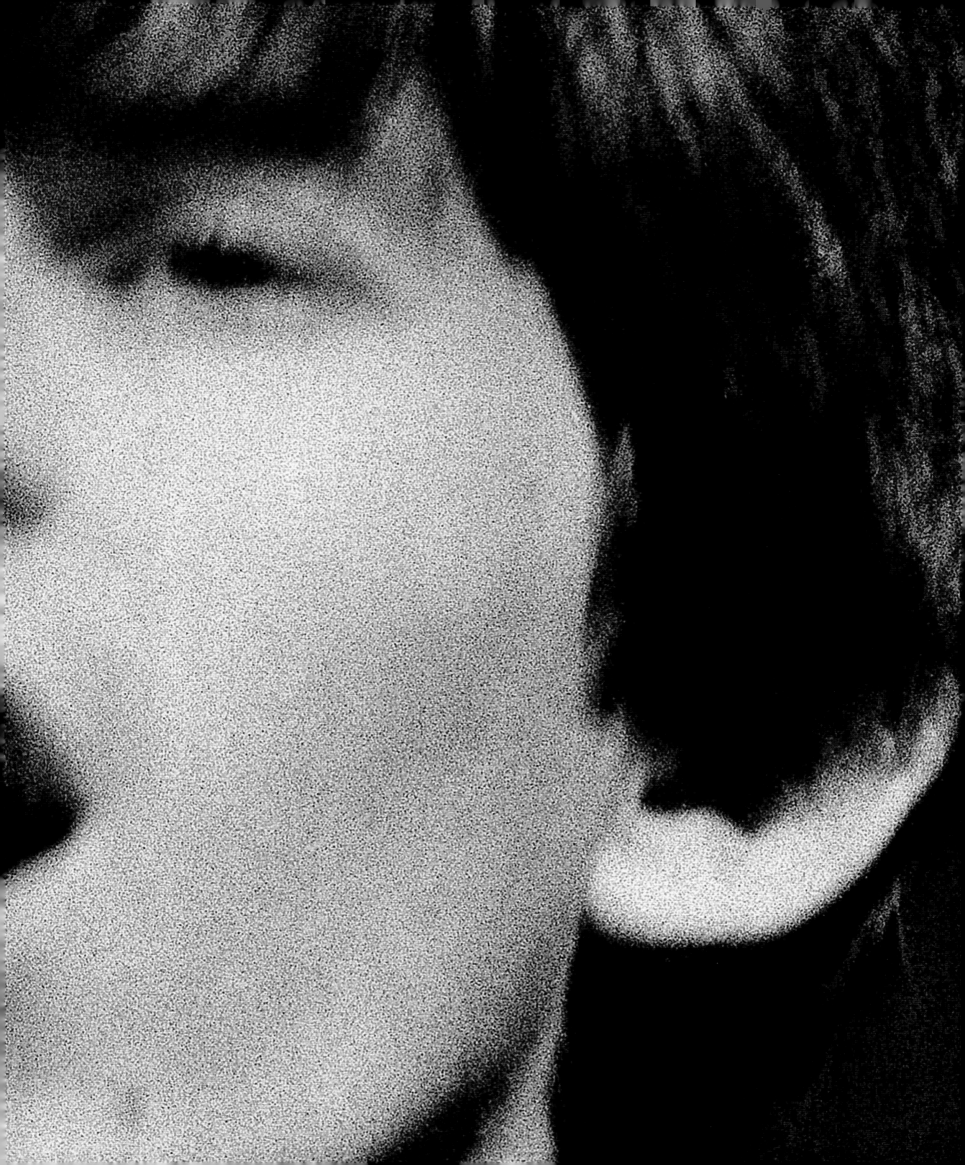

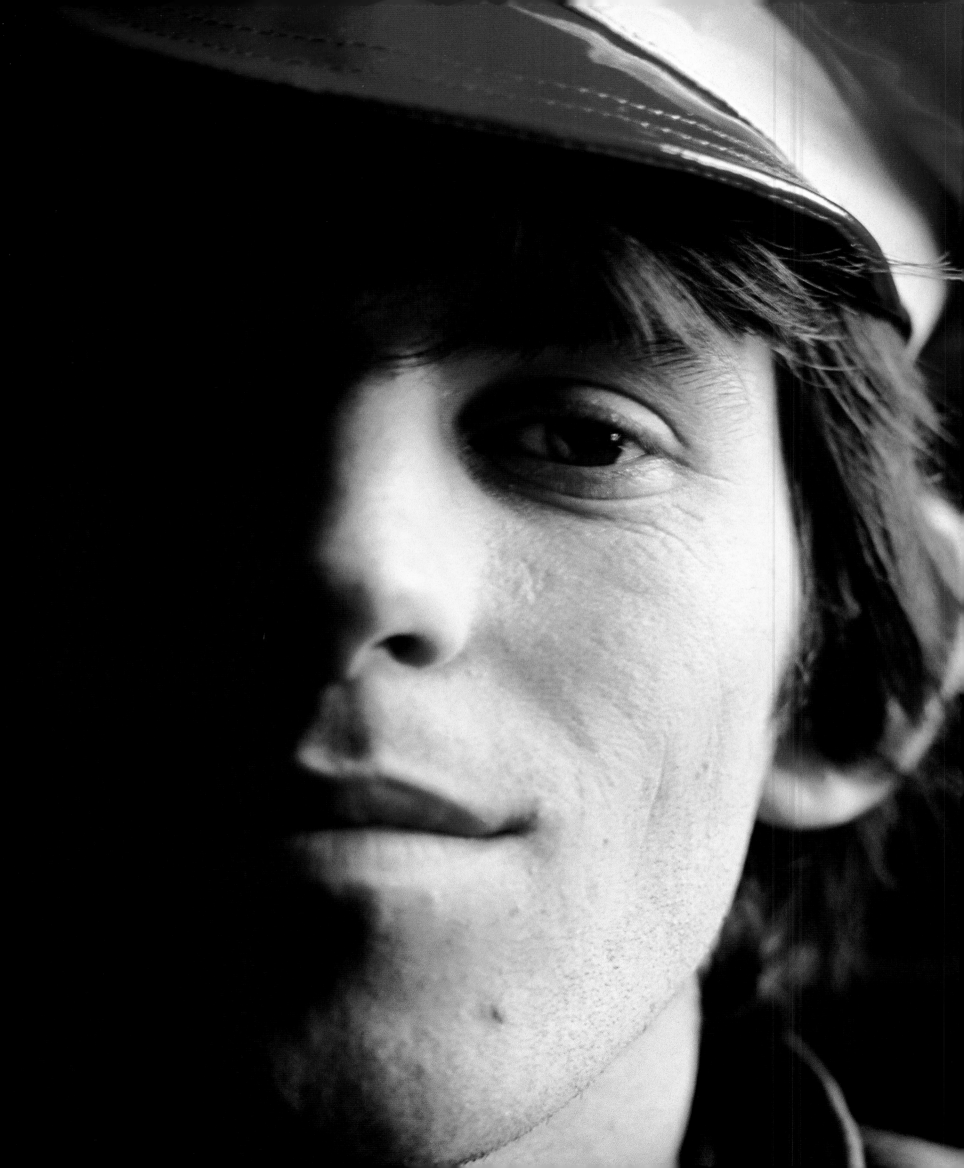

KEITH RICHARDS

Keith Richards was born on 18 December 1943 while his father was serving in the army. Keith's mother, Doris, lived in Dartford having married Bert in 1938 when he was working for General Electric. In 1944 Bert was wounded in the leg and sent to a hospital at Mansfield in Nottinghamshire. Doris and baby Keith moved there, and stayed for the rest of the War. Bert's family had moved from Wales to Walthamstow, East London, in the 1800s, and Keith's grandmother had become the Mayoress of Walthamstow during the Second World War. Keith's mother's family also had a Welsh background, although they originally hailed from the Channel Islands. Keith, unlike the rest of The Rolling Stones, was an only child.

Keith began school in Dartford in 1948, moving to Wentworth Juniors in 1951, where he met Mick. He would also go to Saturday morning cinema to watch his favourite cowboy star, Roy Rogers. Keith lost touch with Mick when he moved to the other side of Dartford and went to a different school having failed his 11-Plus. According to his mother, "I caught him smoking once, it made him ill." However, Keith must have grown to like cigarettes, as he later recalled: "In cross-country, I would start off with the main bunch, and as the others raced off I would hide myself behind a bush or tree. A quick fag made me feel as right as rain." But one thing Keith loved more than anything was music. His grandfather, Gus Dupree, who had a dance band in the 1930s, bought him a cheap acoustic guitar for his fifteenth birthday.

By 1959, Keith was frequently playing truant from school, and he became a bit of a Teddy Boy, sporting pink socks and drainpipe trousers. In April 1960, Keith was asked to leave Dartford Technical College because of his truancy. Luckily for Keith, the headmaster enrolled him into Sidcup Art School where he took a course in advertising and met Dick Taylor. According to Keith, "Dick Taylor was the first guy I played with. We played together on acoustic guitars." To earn money, Keith briefly did a bread round, but getting up early was never Keith's forte.

When Keith and Dick began playing music with Mick it was Keith's proficiency on the guitar that made Mick give up his aspirations on the instrument and switch to harmonica and vocals. As Mick and Keith started being credited as songwriters, Keith dropped the 's' off the end of his name, only re-adopting it a decade or so later.

When Keith talked of meeting Brian at Ealing he said: "He could have easily joined another group, but he wanted to form his own. The Rollin' Stones was Brian's baby".

Mick and Keith had lived, together with Brian, at Edith Grove in Chelsea before they moved to northwest London and shared a flat together at Mapesbury Road. They then moved the short distance to 10a Holly Hill, in Hampstead, in June 1964. They both left the Holly Hill flat in April 1965; Mick went to stay with David Bailey for a short while. Keith moved in with Brian for a few weeks before he found himself homeless. The solution for Keith was simply to move into a suite at the Hyde Park Hilton hotel.

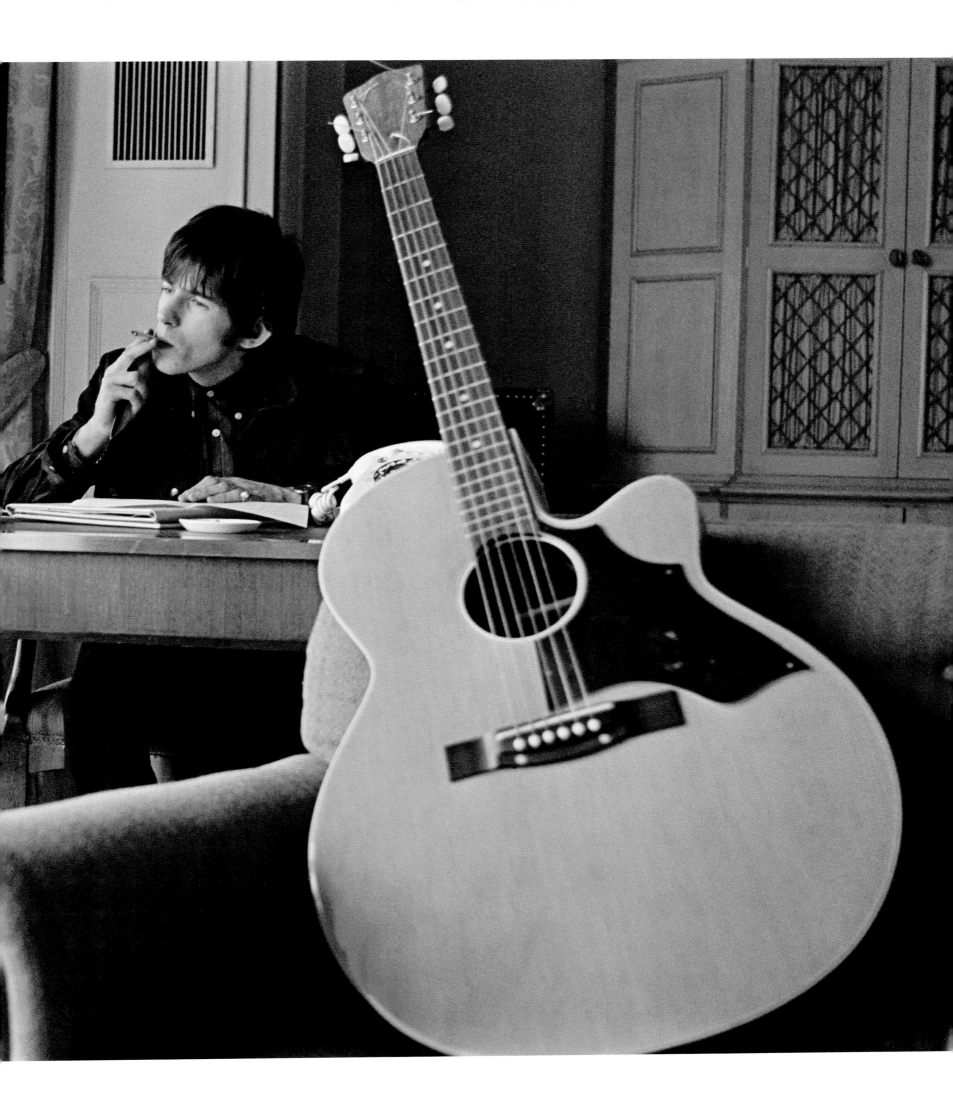

"I shot these pictures of Keith after we came back from Germany in September. Having shot the other Stones 'at home' I was glad that I was at least able to pretend that the Hilton was Keith's home. He certainly had the most elegant 'home' of all the Stones!" BR

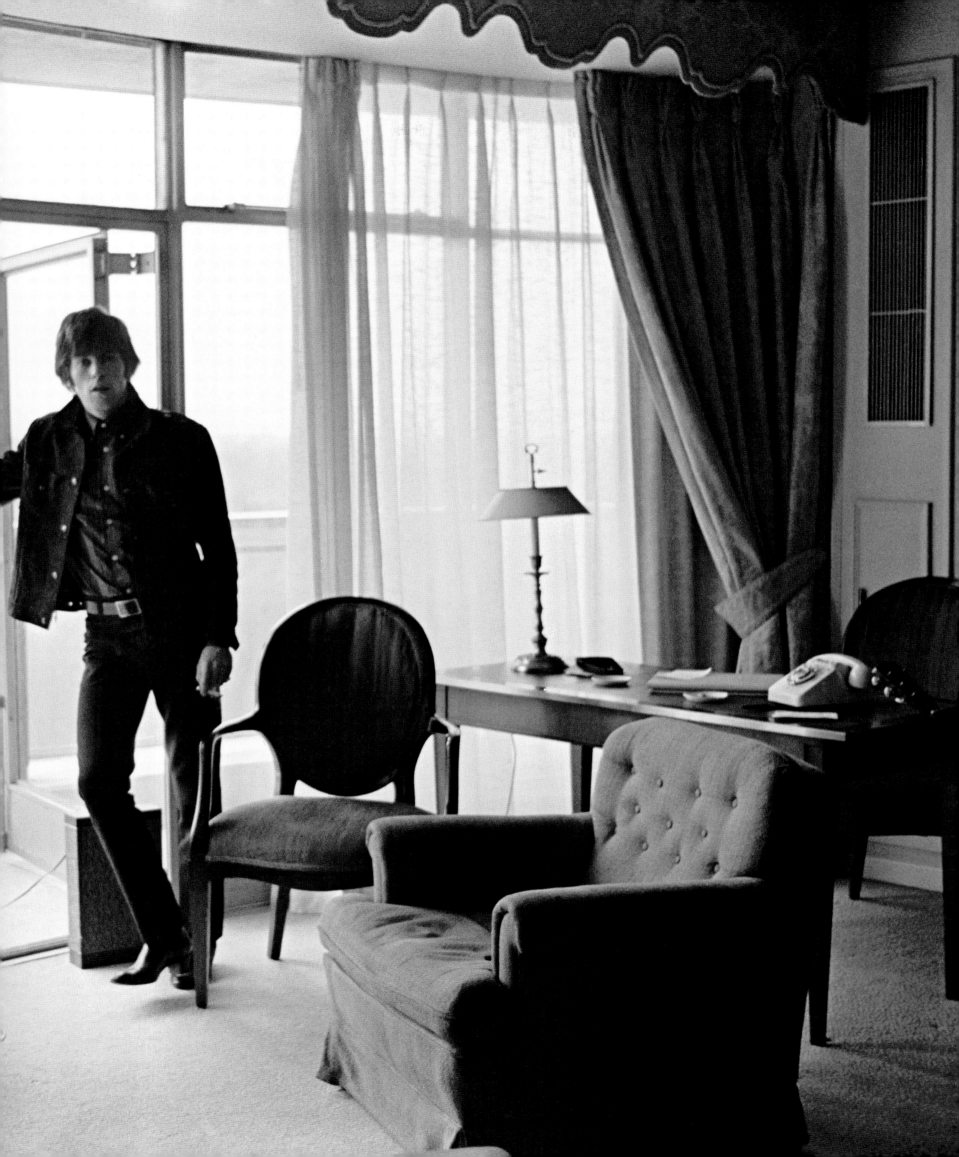

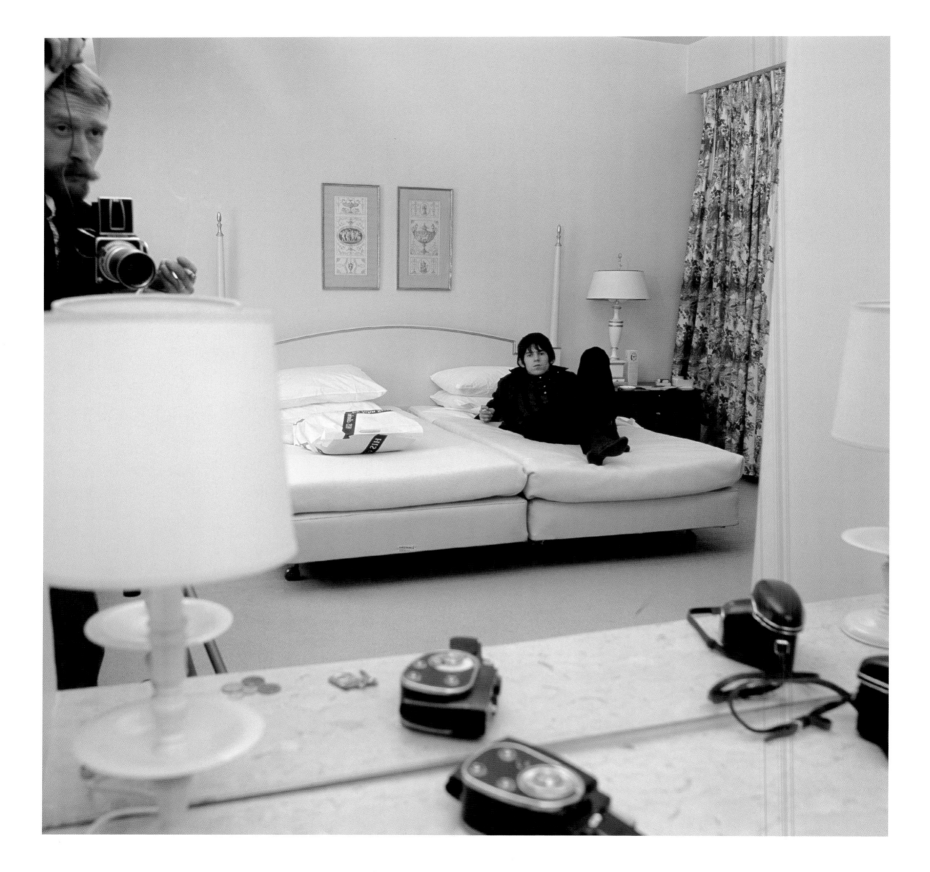

"This shot of Keith's bedroom, complete with newly delivered hotel laundry, shows camera equipment on the dressing table. It's not mine but Keith's, as he was a keen amateur photographer." BR

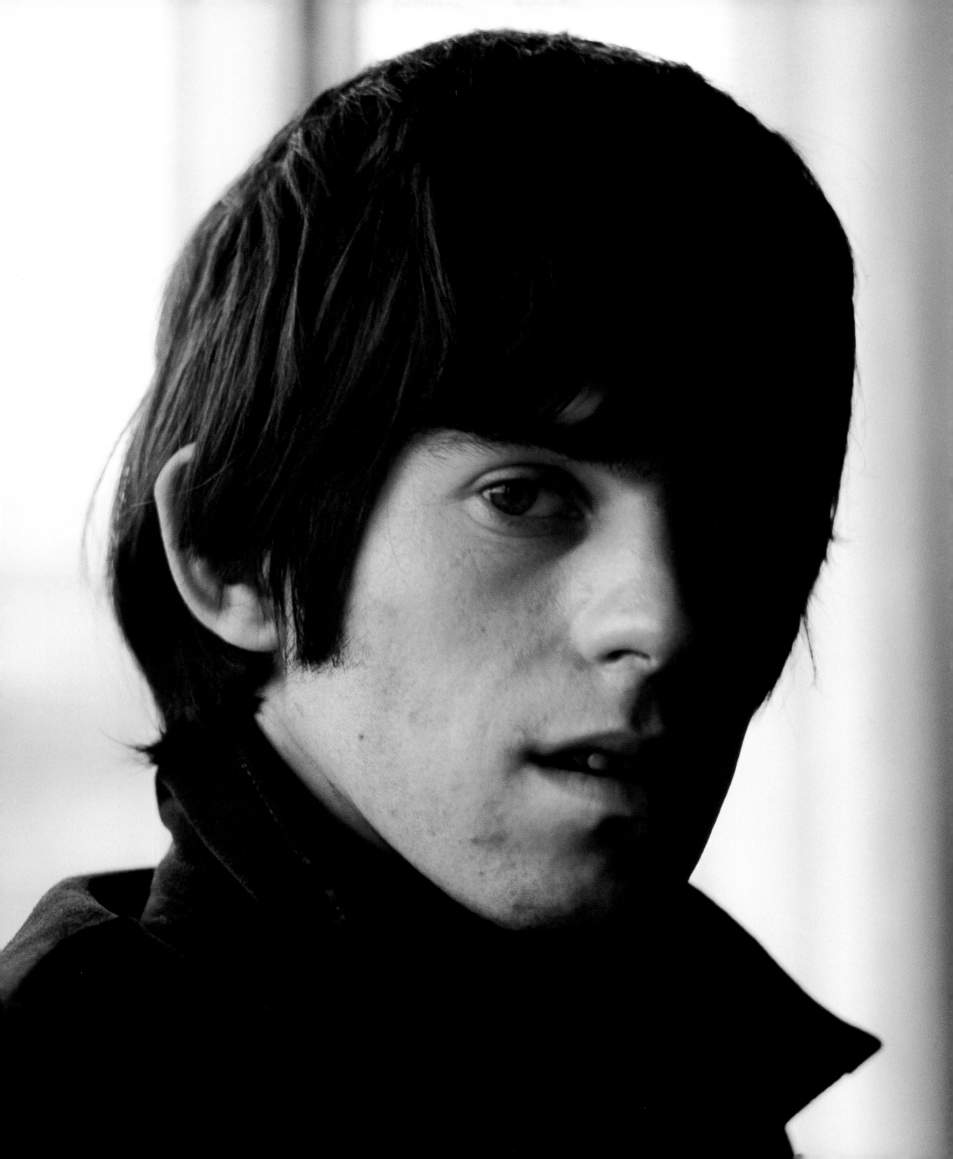

"Like all the other Stones, there were always plenty of new records lying around ready to be played.
On the table is Keith's cassette recorder on which he used to tape song ideas." BR

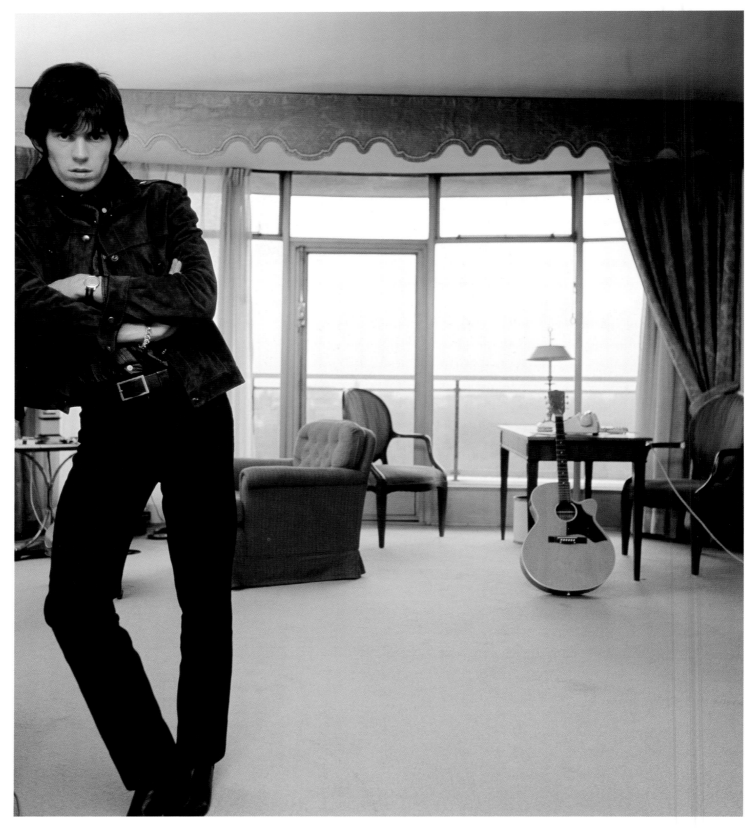

"I cannot remember if this was the day that Keith was having a look at the Bentley Continental with the idea of buying it or whether he had just bought the car. Whatever were the precise details of the situation, there was one problem for Keith – he had not yet passed his driving test. Brian was just about to buy a Rolls-Royce Silver Cloud which shows that real money was becoming more available to the Stones." BR

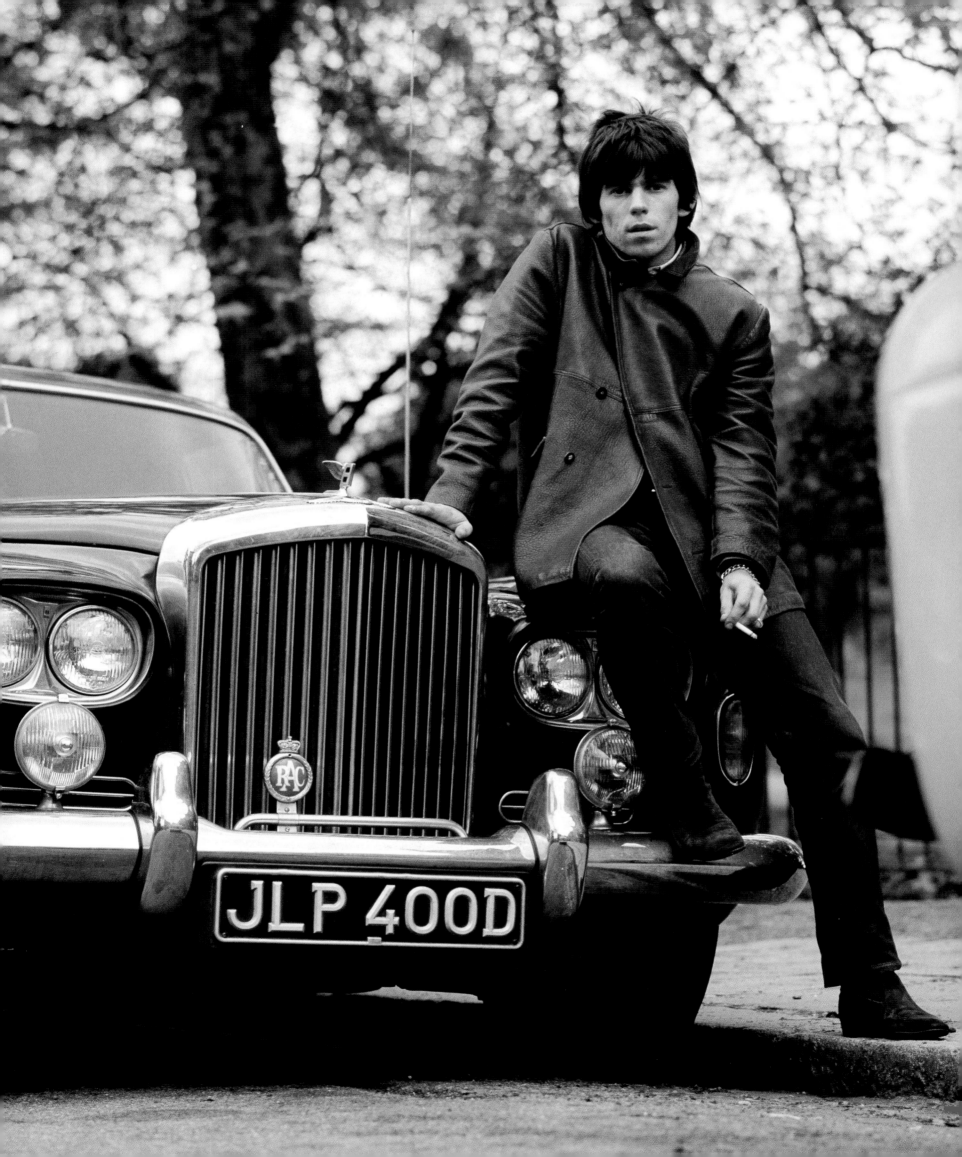

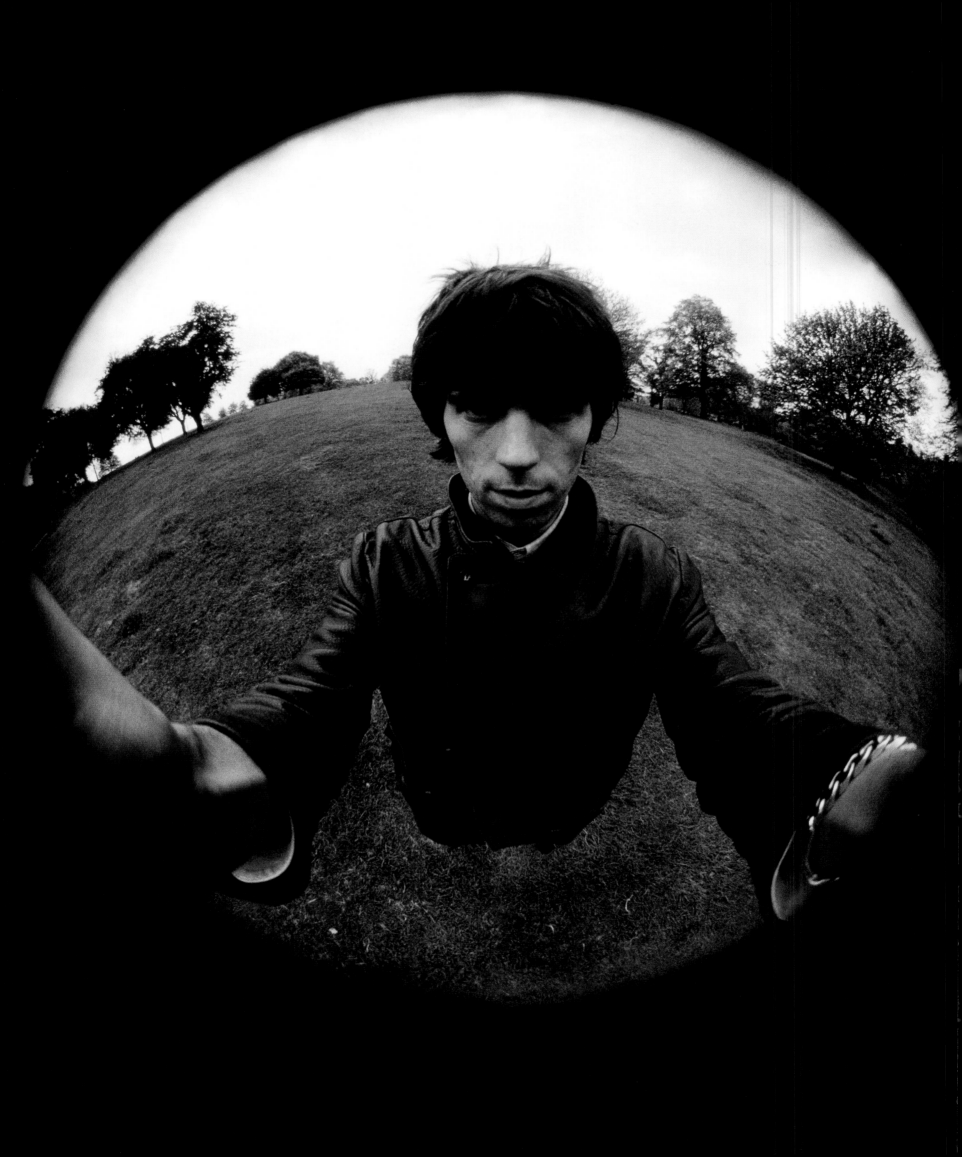

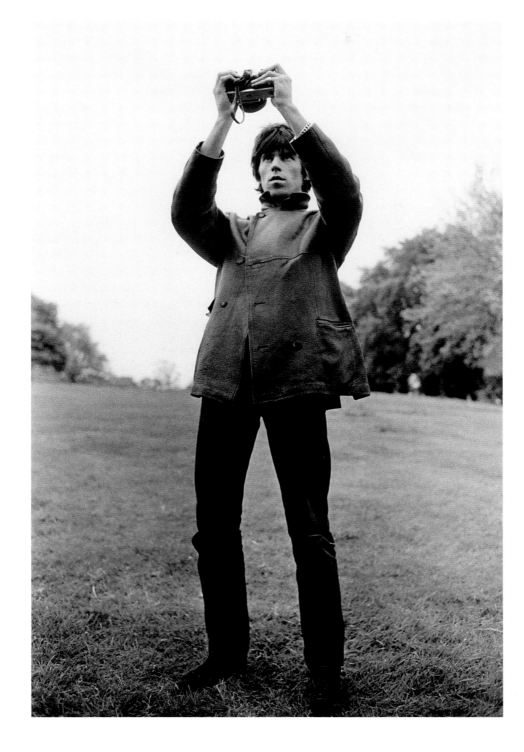

"With Keith's interest in photography, he liked to play around with my fish-eye lens. This self-portrait was done in Hyde Park and my photograph shows how he did it." BR

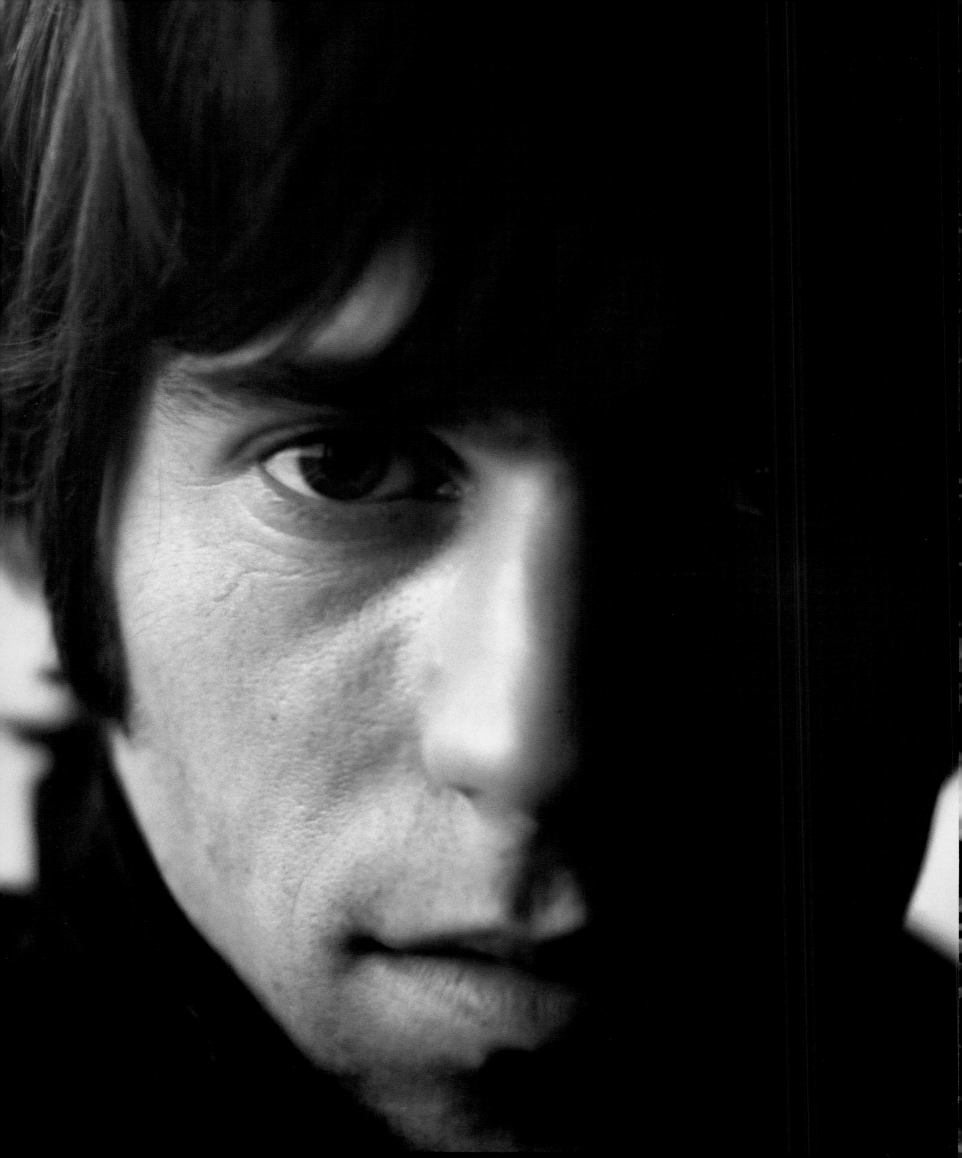

"Keith is always quick to make a funny remark, a humorous comment on what he sees going on around him. Like the rest of the group he also loves a practical joke – mostly giving them rather than receiving them. You could even call him the most childish one in the band but, of course, he is the youngest.

"To me Keith is not the most noticeable member of the group – maybe it's because he is shy. Not that he stands in the shadows or keeps out of the limelight; it's just compared to Brian and Mick who are the two most noticeable members. I have found Keith the hardest to get to know, because he is not somebody who lets people get close to him, although he's very close to the others in The Rolling Stones.

"Having written three No.1 records with Mick, I have found that Keith is growing in confidence even over the time that I have known the group. Establishing himself as a songwriter is important to Keith, in that he feels more important. He is happier to pose for the camera, even more so in Germany than he had been in Scandinavia. There's no doubt that Keith feels the most comfortable – the place where he is totally his own man – when he has a guitar around his neck. When he's on stage, and especially when he's playing **Satisfaction**, you can tell that he loves it. While Keith is always playing his guitar at every opportunity, he is always listening to records.

"He is also a sharp dresser, very conscious of his appearance and quite often he's the smartest member of the group, even if Brian is still the most stylish; maybe he's even a little vain. Staying in a hotel suits Keith because he can always get his laundry done, which helps him stay smart." BR OCTOBER 1965

Perhaps the last word should go to Keith who had this to say shortly after Bent had photographed him 'at home' in London: "Regarding the future, all I know is that I don't want to go on for years. I want to retire gracefully before I fade out. I'm just glad that it has lasted so long. I certainly never thought it would when we started. When I do stop, I suppose it'll be song-writing full-time."

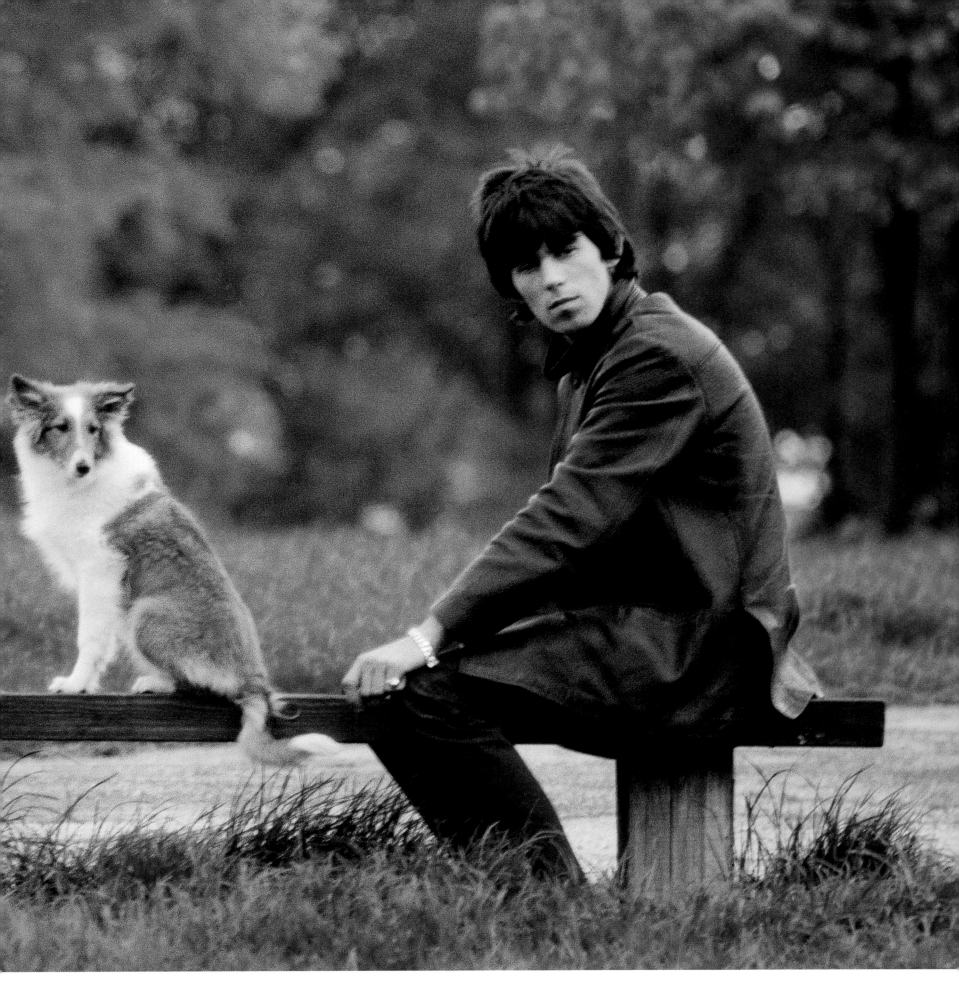

"Keith had been given this dog he named Ratbag in America as a puppy. When Keith, Andrew and I flew home from New York in November 1964 Keith smuggled the puppy through customs underneath his coat." BILL

PRIVATE LIVES

When Keith was interviewed in April 1965 for a music paper he explained what it was like to be a Rolling Stone when he and the others in the band were not performing. "People think it's difficult for us to go out in the evening without being recognised and mobbed, but it's not. We just go to the more expensive places where most teenagers can't afford to go. The clubs aren't much different except that they're more expensively decorated and instead of paying 2/3d for a small Scotch, the price is likely to be 4/3d. When we go to clubs it is to relax and not to talk shop, but if we meet somebody we admire or like, we don't mind talking shop right through the night. We don't always mix in business circles, but some of the clubs we go to are frequented by artistes and impresarios and you can't avoid meeting them. On most nights Charlie, Bill and myself go to the Ad Lib or Pink Elephant clubs in London's West End, where we can have a meal, a drink and a chat without being pounced on by autograph hunters. If I don't feel like going to a club, I sometimes go to the pictures, but I do have to make certain arrangements beforehand. I ring the manager of the cinema I intend going to and fix a time for my arrival. Then I just rush into one of the boxes and watch the film. After it has ended I wait five or ten minutes and then walk out – it's as simple as that. People are mistaken when they think we live a cloak-and-dagger existence, always going out in mufflers, dark glasses and a hat pulled down right over our eyes. If we want to go out, we go out, but we often prefer to stay at home and either sleep, listen to records, or in my case, take the dog out for a walk. I'm not keen on walking, but the dog seems to enjoy it."

Given that Charlie was married it was probably a little bit of poetic licence by Keith when he said that he was out every night, but Bill, Brian and Mick would certainly have frequented the clubs that Keith mentioned. Other London clubs that they would have visited around this time included Blaise's (Queensgate), Dolly's (Jermyn Street), the In Place (Allsop Place), the Pickwick Club (Great Newport Street), Elbow Room (Carlisle Street), and Tiles (Dean Street).

By early 1966 Bill who, unlike Charlie, spent a little more time out on the town, explains some of what he got up to. "I often went to the Scotch of St. James Club in Duke Street, as did Brian and Mick. We would bump into all sorts of friends like Patti Labelle and The Bluebelles (over on tour), Glyn Johns, Tara Browne, Keith Moon and John Entwhistle (of The Who); I also met Otis Redding there. Another hang-out was the Cromwellian Club, in Cromwell Road, and one night I saw Lee Dorsey perform. One night we went to a party at Mick's flat; John Lennon, George and Ringo were there, it was a chance to catch up, as we hadn't seen them in months. If you were in the Kings Road you would likely have seen Mick and Chrissie having dinner at The Casserole, a favourite haunt."

Mick first met Chrissie Shrimpton in 1963, but finally broke off their relationship at the end of 1966; he'd been seeing Marianne Faithfull for several months. Brian could often be found eating at Alvaro's Restaurant in Chelsea. In February 1966, Brian told "Record Mirror" "I'm moving soon. I want to get a big flat in London, then a big house with a minstrel gallery. I'm going to build a Go-Kart track in the grounds. I'd like to put down all this rubbish that's been started about Anita and me. I'm getting rid of my Rolls soon. I'll probably get a Mini for Anita and one for me."

Keith was often seen around town and often ate at La Terrazza Restaurant with his regular girlfriend during the period, who was somewhat confusingly named Linda Keith. Another place that both Mick and Keith liked eating at was Alexander's Restaurant in the Kings Road. When Mick got tired of eating out he had an account at Selfridges for his groceries. Charlie and Shirley were happy to spend time at their new home in Lewes in Sussex.

When it came to shopping the Stones were all very keen on buying clothes and shoes and would buy things from Anello and Davide (Oxford Street), Chelsea Antique Market (Kings Road), Chelsea Cobbler (SW7/Fulham Road), Countdown (Kings Road), Granny Takes A Trip (Kings Road), Guy (Kings Road), His Clothes (Carnaby Street), John Stephen (Carnaby Street), Lord John (Great Marlborough Street), and Quorum (Radnor Walk). Brian, who was more image conscious than any of the other Stones, shopped at Michael and Jane (Ormsby-Gore) Rainey's shop, Hung On You, Chelsea Antique Market, and Dandy Fashions. He also swapped clothes with Anita after they began living together.

Cars were the other big thing in the band's life. Beside Keith buying a Bentley, and Brian a Rolls-Royce, Bill bought a Morris Traveller but soon changed it for an MGB sports car and bought his wife a Triumph 2000. Mick bought an Aston Martin DB6 in April 1966 and a few months later was involved in a minor accident with the Countess of Carlisle's car.

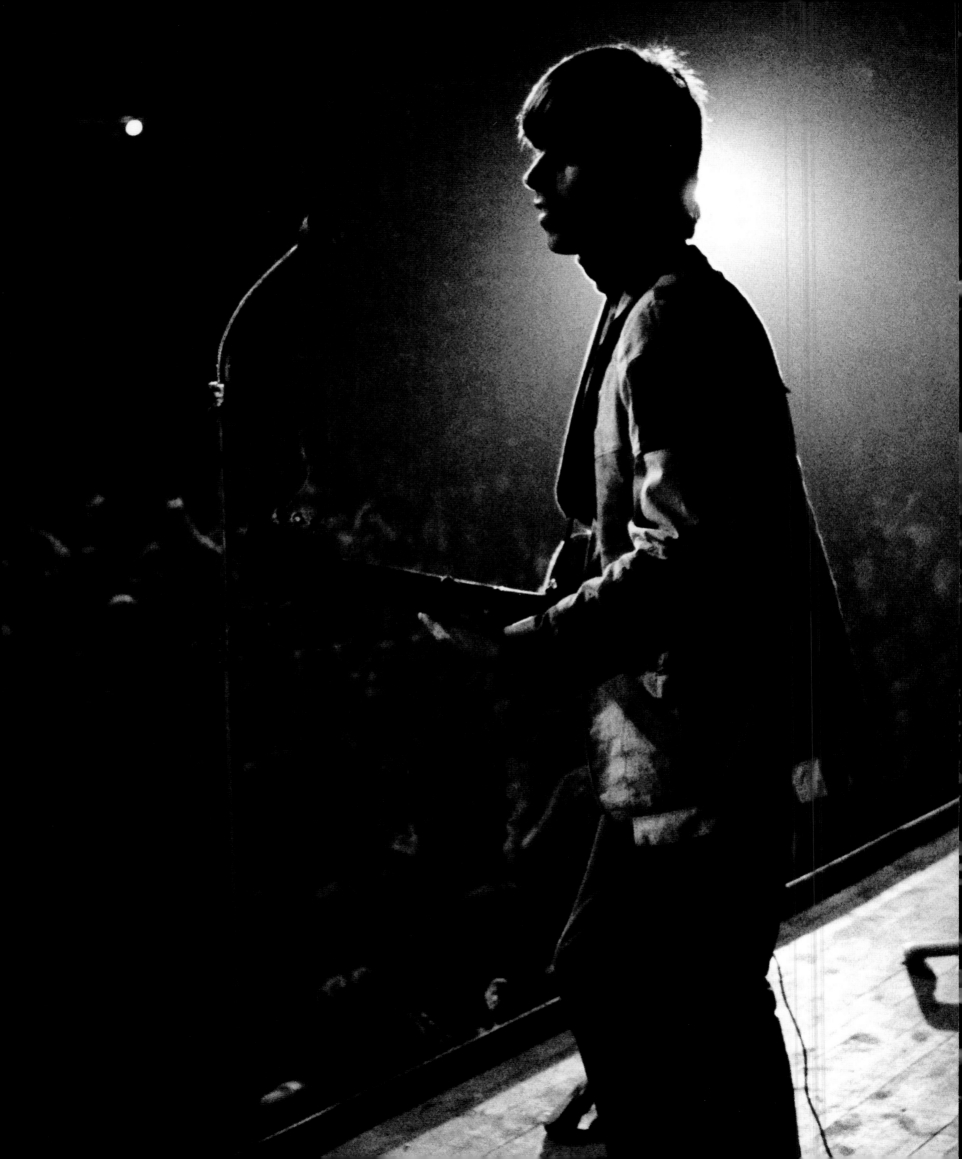

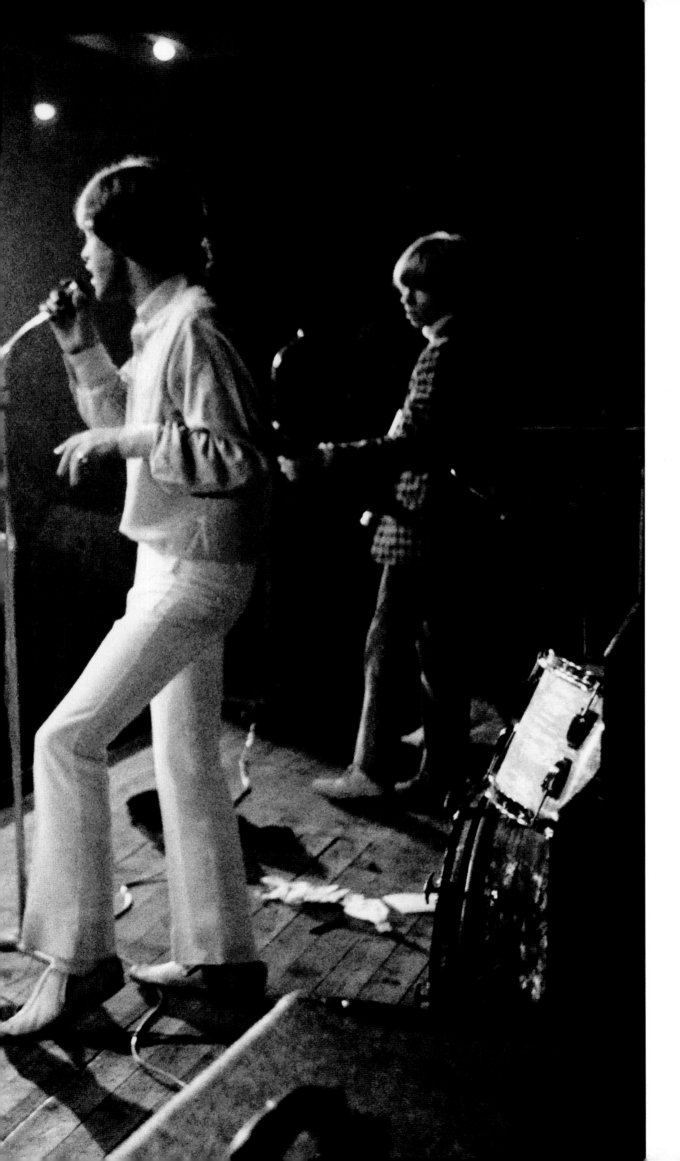

After a short tour in France, Holland, Belgium, and Sweden, which had followed the tiring tour to Australia and New Zealand, as well as recording sessions in Los Angeles at the RCA Studio, the Stones played the K.B. Hallen in Copenhagen. Because of the trouble at earlier concerts, three venues had banned the Stones, and so this was the only one available to them. The band was not as sharp as they had been on previous trips to the Danish capital according to local critics. Whereas before, the fans had threatened to overrun the stage, on this occasion they failed to even demand an encore. While the critics put it down to tiredness, maybe it was just an off night.

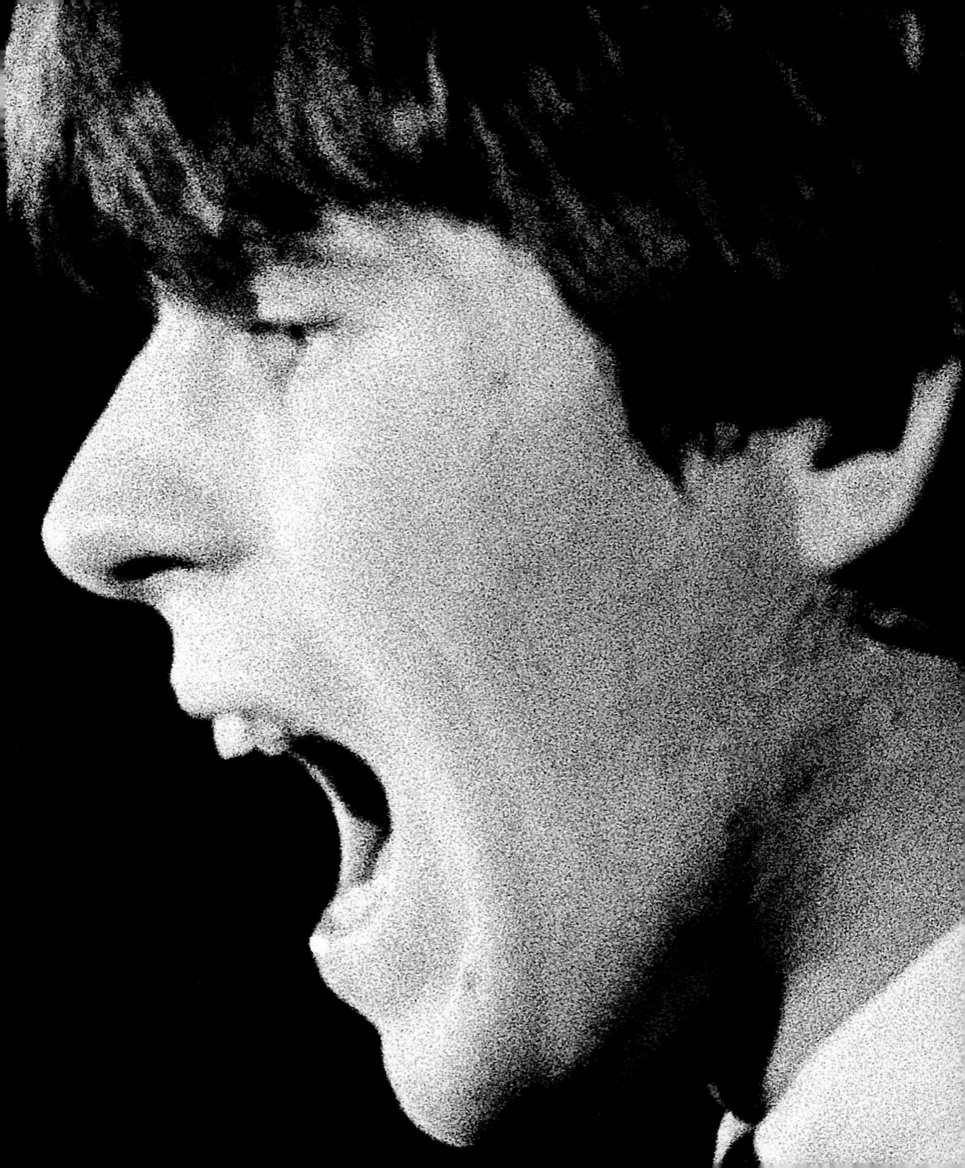

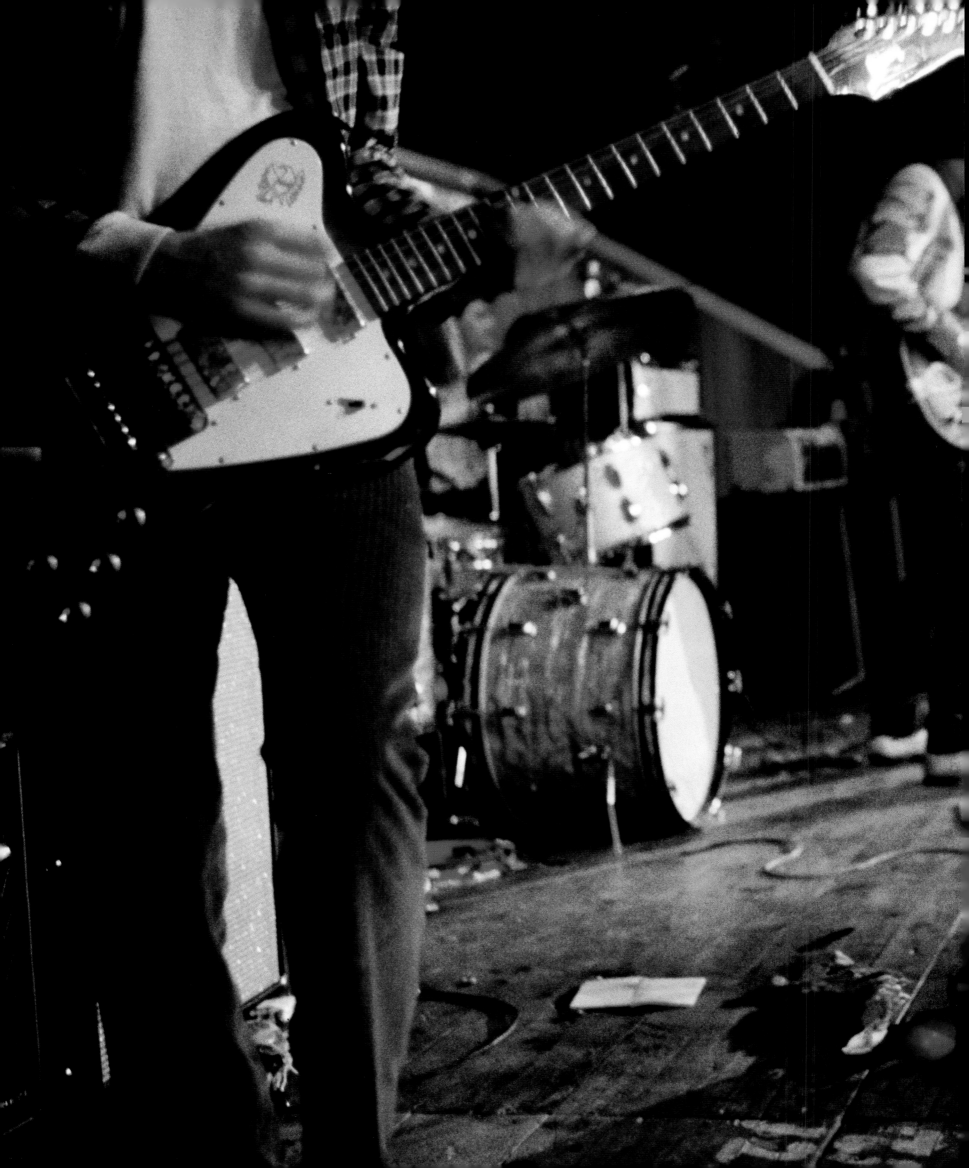

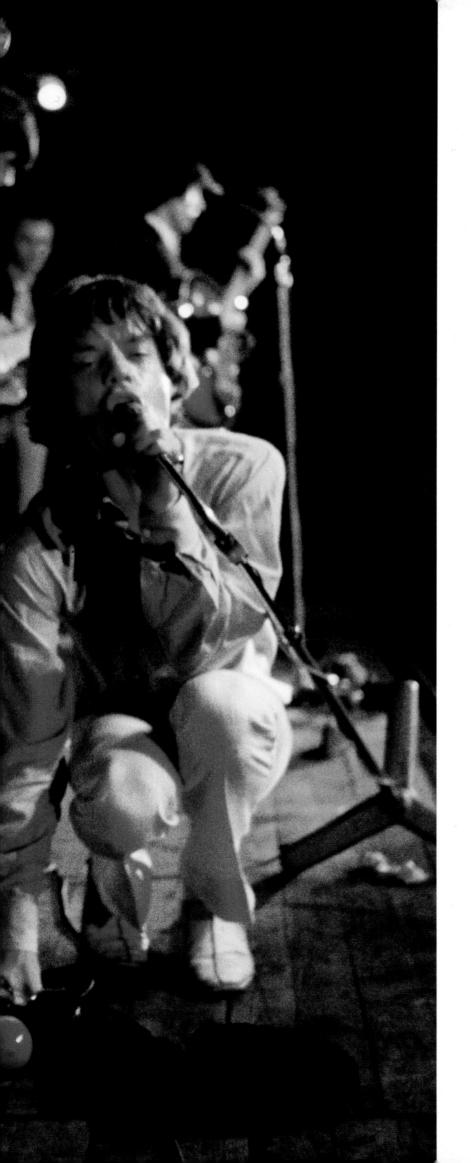

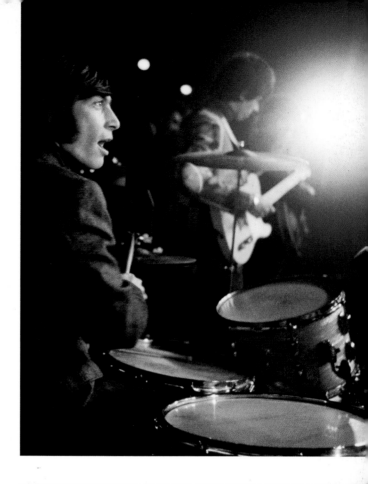

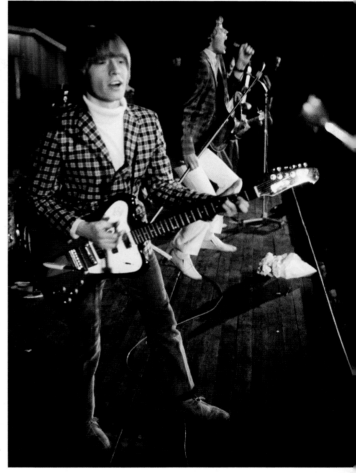

"At the gig in Marseilles Mick was hit by a flying chair leg which made a gash as well as giving him a black right eye. It was covered by make-up in Copenhagen." BR

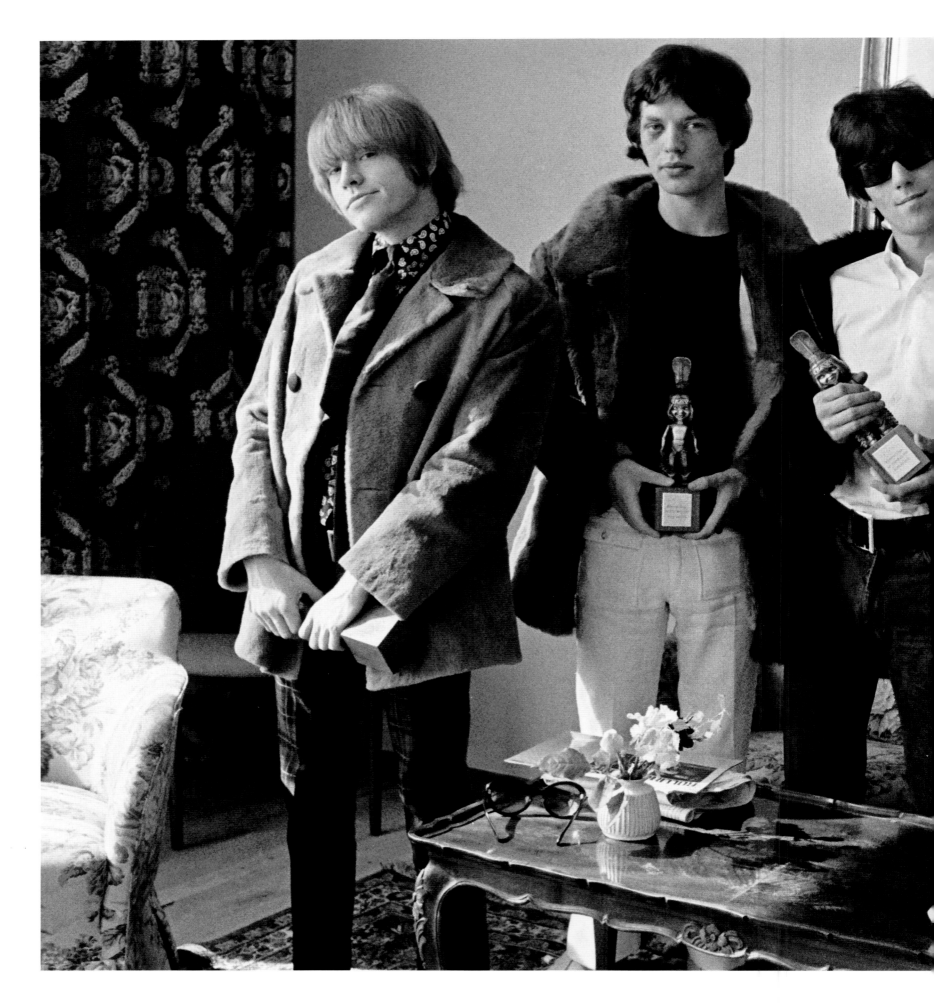

The Bravo Award, presented in Copenhagen 6 April 1966

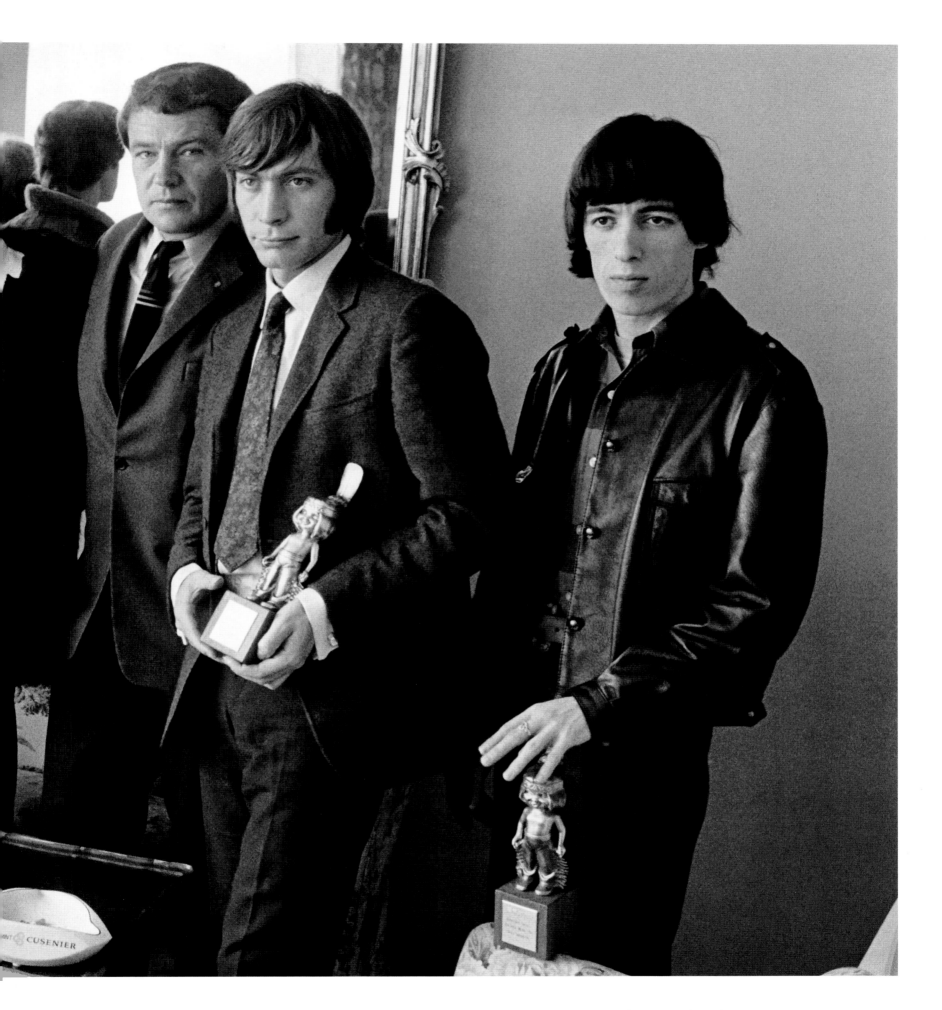

"Thomas Bayl, editor of Bravo, presented us with our awards at the hotel on the morning of our departure to London. I still have mine!" BILL

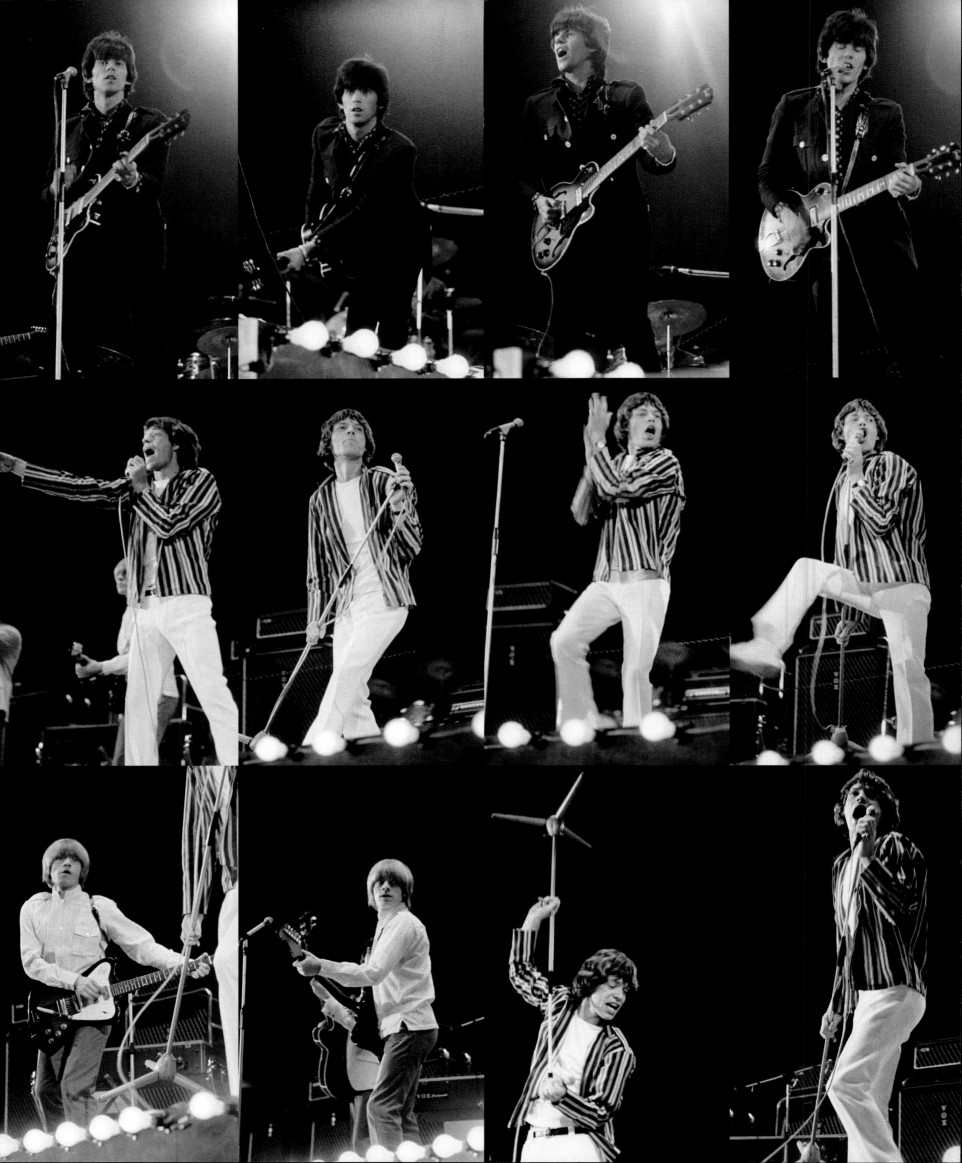

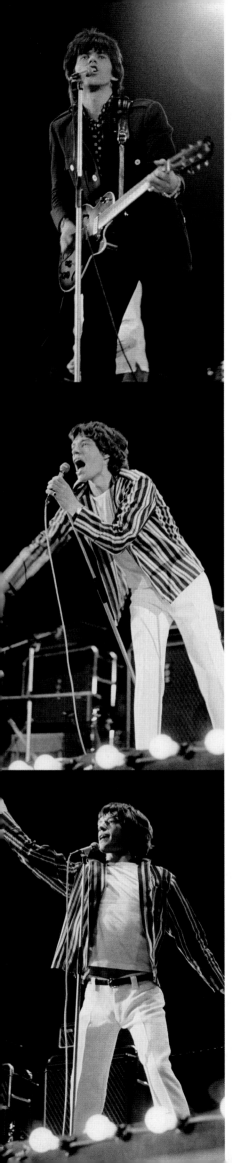

The NME
Poll Winners' Concert:

The Last Time

Play With Fire

Satisfaction

The Sunday concert was the band's first show in four weeks. Also on the bill were The Beatles; The Spencer Davis Group; Dave Dee, Dozy, Beaky, Mick and Titch; Cliff Richard and The Shadows; The Walker Brothers; The Who; The Yardbirds; and Crispian St. Peters. According to the Daily Mirror, "The Beatles and Stones refused to face the cameras. They said that the sound system was not good enough. ABC TV paid £8,000 to film the concert. The Beatles and Stones will be missing." Standing far right (on pages 294-295) is Maurice Kinn the managing director of the NME, and the actor Clint Walker, who starred in TV's "Cheyenne" and the film "The Dirty Dozen", is second from the right. The day after the Poll Winners concert, Brian received a phone call from Anita Pallenberg, who was in London to do some photographic modelling. They met up and a few days later she moved in with him.

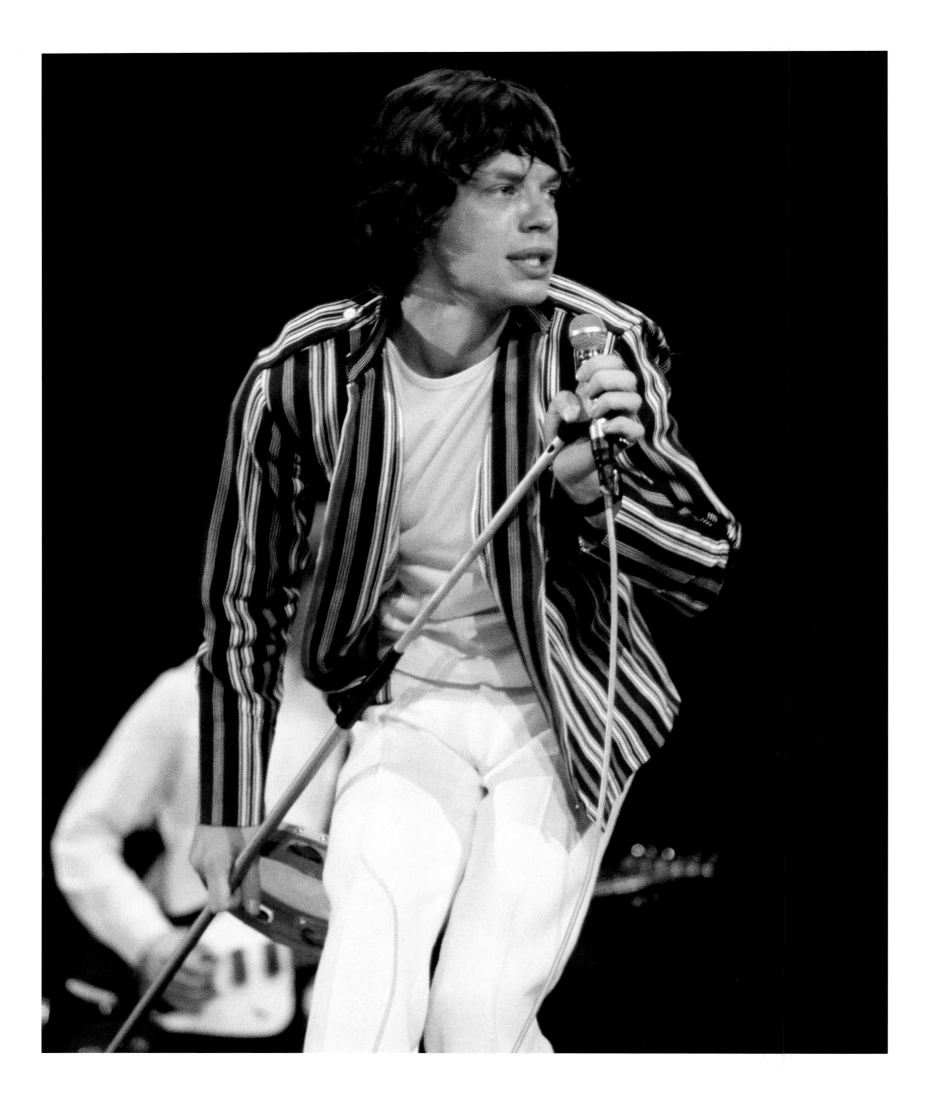

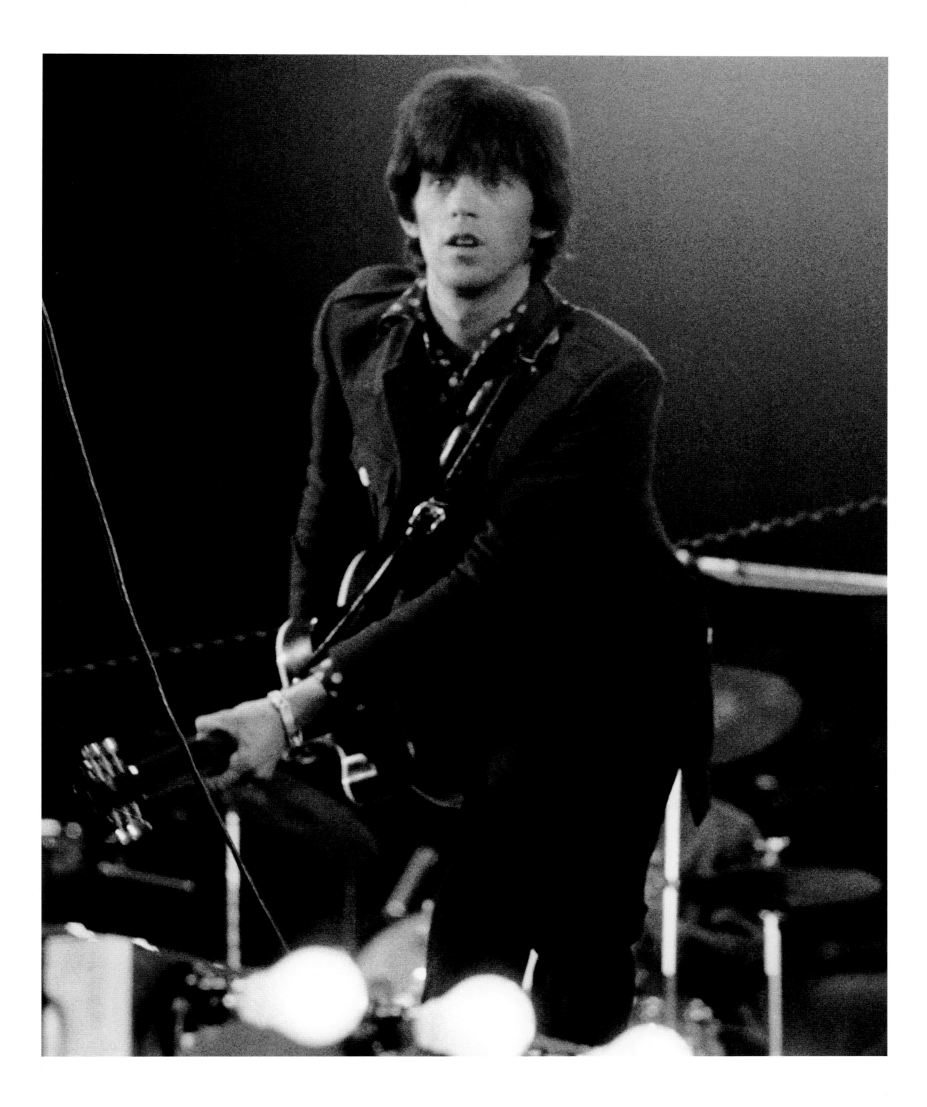

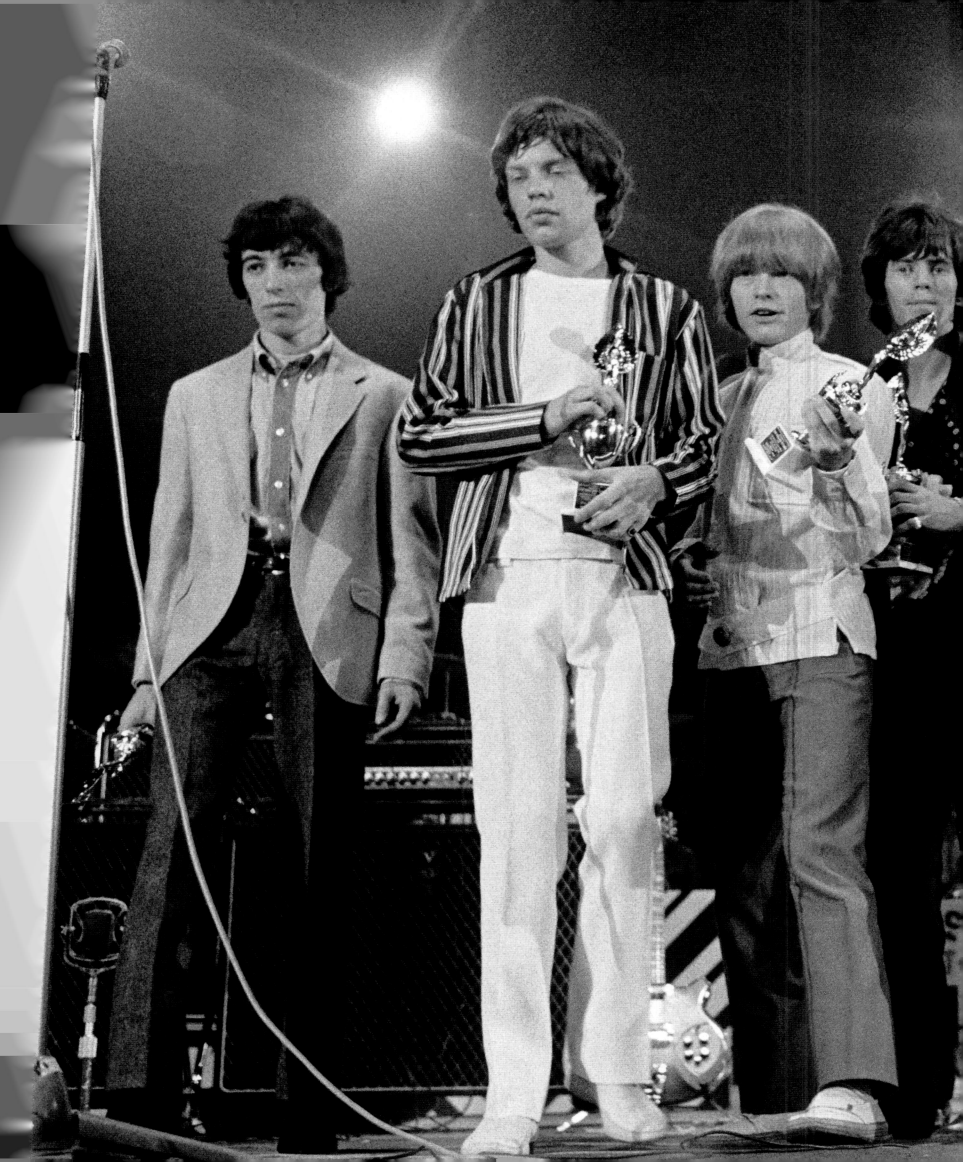

The Management

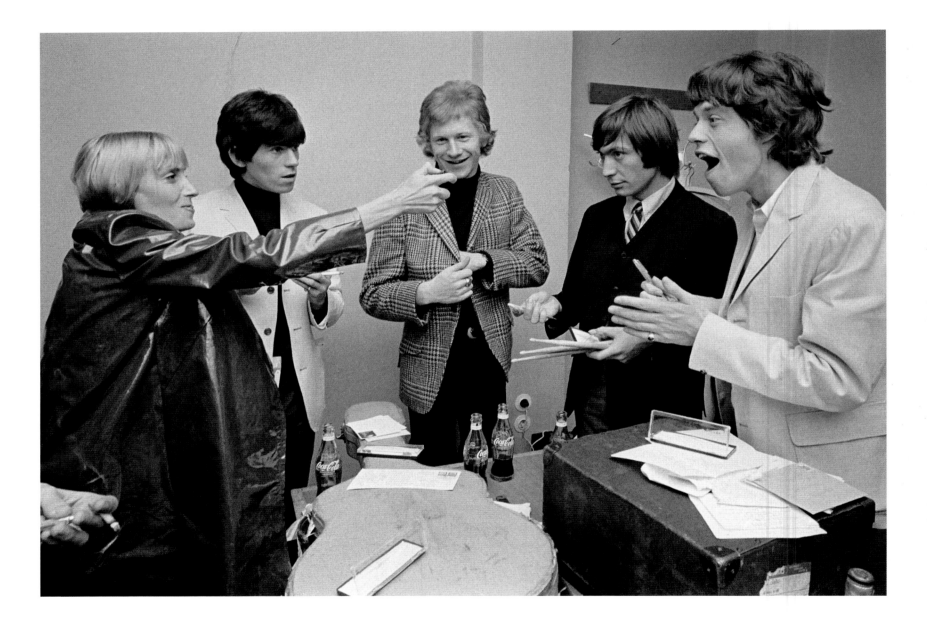

"When I first met the Rolling Stones in Copenhagen, in March 1965, Andrew Loog Oldham was not with them – he did not go on every tour. My first introduction to him was in Germany in September of the same year. I quickly saw that Andrew – who was a month younger than Keith, the youngest of the Stones – was quick to join in the fun and practical jokes. No one ever confirmed this to me but I always had the feeling that Andrew approved of me taking my photographs. Maybe it was because I was around the same age as the band that he felt I could be trusted." BR

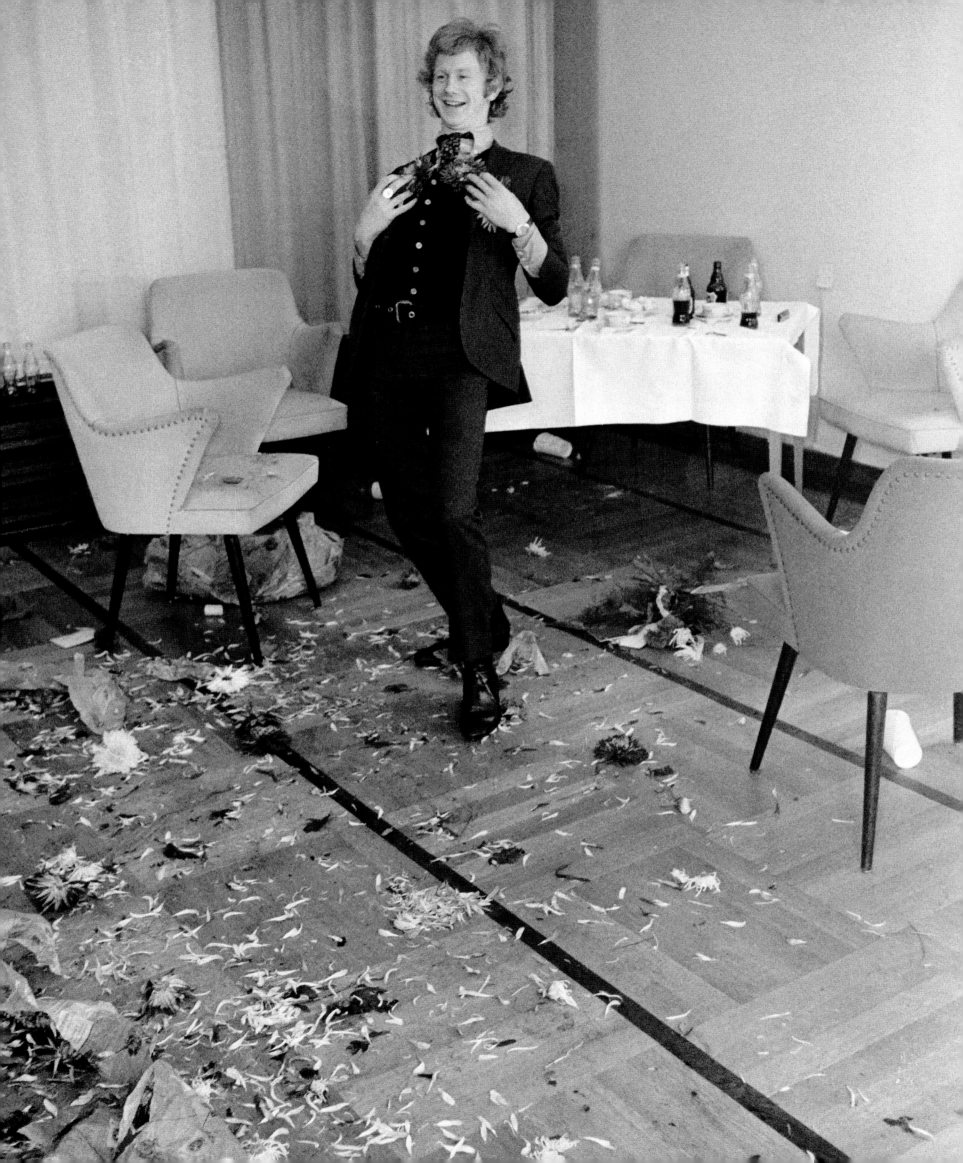

ANDREW LOOG OLDHAM

Music business managers from the Sixties usually have a bad reputation — and as often as not it's a fair assessment of them. Mostly they were older men who knew every trick in the book, who had no hesitation in exploiting their charges. Andrew Loog Oldham was different. He was actually younger than the band he was managing and, unlike the older generation of managers, he invented a whole new box of tricks to promote the Stones.

Andrew is the illegitimate son of Celia Oldham and Andrew Loog, a Texan of Dutch origin, who served in the US Army Air Corps during World War II. Celia had her affair with Flight-Lieutenant Oldham in the spring of 1943, and he was killed in action in June 1943. Andrew was born on 29 January 1944, making him a little under a month younger than Keith.

Schooled at Wellingborough public school, Andrew grew up in North London. His career after leaving school included a spell working for Mary Quant before he gravitated to the world of pop. He worked for The Beatles for a while through Brian Epstein's NEMS organization. It was the editor of Record Mirror who told Andrew to go and see the Stones, and before he did he spoke with Eric Easton, an established agent and promoter, and persuaded him to go out to the Crawdaddy club on the last Sunday in April 1963. The day after seeing the Stones at the "free Turkish bath" as Easton described the Crawdaddy, Andrew talked to his future co-manager: "I felt that with my knowledge of the pop world and his business experience, we could provide a good service for them." Andrew called the Stones' office (which was actually Stu's work phone number at ICI) and Brian agreed to meet at Eric's office in London's Regent Street, to discuss a management deal.

When the Stones signed their contract with Andrew in May 1963 it very definitely favoured the management. Impact Sound (Andrew and Eric's company) received a 14 per cent royalty from the Stones' recordings, but only paid the band 6 per cent to share between them. Of this 6 per cent, Andrew and Eric took a 25 per cent management fee (the five Stones shared 4.5 per cent and the two managers 9.5 per cent); the Stones knew none of this until Allen Klein came into their lives. The Stones were not much different financially to most every other band at the time — but they were probably on a better deal than The Beatles at the time.

It's arguable that without Andrew's genius and flair then the Stones may have ended up a very different band. As soon as they began working together Andrew the Hustler went on a roll. The record deal with Decca was vital in that it provided the band, and Andrew, with a platform from which to work. Andrew's strategy, if you could call it such a thing, was no carefully worked-out plan to be followed to the letter. It was a much looser, more organic, possibly even anarchic, collection of cunning stunts that

created an identity for the band that matched their sound. One of Andrew's first moves was to buy the band uniforms, so that they looked like every other Beat band. It got them on TV's Thank Your Lucky Stars, but pretty soon they were back to their old ways of wearing whatever came to hand when they got dressed.

Perhaps most important was Andrew's innate sense of how to position the Stones as the antithesis of The Beatles. If the boys from Liverpool were the living room, the Stones were the bedroom. Before long with ALO's subtle, and not so subtle, pronouncements, every parent, teacher, establishment figure, in fact almost everyone over the age of about thirty "hated" the Stones, which of course meant that everyone under thirty "loved" them.

As the Stones arrived in Denmark, the newspapers reported a superb example of Andrew's skill. "The Stones are in trouble again, this time, with organizations representing thousands of blind people. On the cover of their latest LP are these words, written by Andrew Loog Oldham: 'Cast deep in your pockets for loot to buy this disc of groovies and fancy words. If you don't have bread see that blind man, knock him on the head, steal his wallet and lo and behold you have the loot. If you put in the boot, good, another one sold'. A bid is being made to have the words struck off the cover." By the time that the venerable chairman of Decca, Sir Edward Lewis, got involved the Stones had had incalculable free PR. "I am told that this inscription was intended to be humorous, but I am afraid this jargon does not make sense to me." Maybe not, but he moved to have it removed.

Andrew Loog Oldham invented a style of management and marketing that has often been replicated, but never bettered; it's one that's been imitated by countless others, all of whom lacked his creative genius. The image Andrew helped to fashion is one that the Stones have been living up to ever since.

epilogue

By the time Bent Rej stopped regularly taking photographs of the Stones they had already discovered sex in a big way, were just beginning to find out all about drugs, and were well on their way to becoming a Rock and Roll band. From Bent's pictures it's clear to see how much the Stones had changed in just twelve months. Some of this was as a result of Mick and Keith finding their feet as songwriters — it gave them both confidence and credibility — but as significant were the changing tastes of the audiences that were increasingly tired of the pop of the Beat Boom. Was it the fact that events were playing into their hands or that they were leading the revolution? Whatever the case, the fans wanted something altogether more exciting and stimulating than the simpler fare served up by the majority of the suited and booted groups that still held sway over much of the British and American charts.

At the Stones' New York press conference, in advance of their fifth US tour in June 1966, their new-found confidence, possibly even arrogance, was plain for all to see. While 1966 was to be the quietest year for touring since they had formed, they did manage a tour of the UK in the autumn. There followed a period of huge change for the band; six months into 1967 there had been drug busts, arrests, and prison sentences, which were all a serious threat to the band's future. For years the press had complained about the length of their hair and the cut of their jib — now they really had something to get their teeth into. Perhaps most significant of all was the fact that it was a year of musical under- achievement, both in quality and quantity, than hitherto. Mick and Keith had lost focus — for obvious reasons — and Brian was feeling increasingly isolated and marginalized in his own band.

Their Satanic Majesties came out in December 1967 and it seemed that many people's worst fears were coming true. After playing second fiddle to The Beatles in most of the pop polls and as often as not on the charts, the Stones produced an album that was derivative of **Sergeant Pepper's**. The problem for the Stones was that their efforts lacked the guiding hand of a musical genius like George Martin. In fact, Andrew Loog Oldham severed his connections with the band during the making of **Their Satanic Majesties**, an album that has been described as "a bad idea gone wrong" by at least one respected music guide.

It was as though this album horribilis was the kick in the ass the Stones needed. They hired Jimmy Miller, an American in London, to act as their producer. Together, from the jaws of defeat, they not only snatched victory but also crafted one of the greatest Rock records of the last fifty years:

Jumpin' Jack Flash is a masterpiece and has become one of their trademark riffing rockers. All the while Mick and Keith were managing to hold themselves in check, relatively speaking, while Brian was slipping farther and farther down the slippery slope of drugs. In June 1967, Brian had been the "Hippy King" of the Monterey Pop Festival but, by the time of the release of **Beggar's Banquet** in December 1968, their return to form album, he was looking dreadful and, more to the point, becoming an increasing liability for the band. Following more court appearances it meant that in all likelihood Brian would not be granted a US visa, which effectively meant either the Stones went without him or they didn't go at all. Instead of touring they appeared in their own anarchic TV spectacular, "The Rock and Roll Circus". Not that Brian was the only one struggling to keep on the right side of the law; Mick was busted in May 1969 for possessing cannabis. A month later, on 8 June 1969, things came to a head when Brian left the band he had formed seven years earlier. Tragically, a month later Brian Jones accidentally drowned in the swimming pool of his home in Sussex.

Before Brian died the Stones had recruited a brilliant new guitarist, the twenty-year-old Mick Taylor, late of John Mayall's Bluesbreakers. His first appearance on a Stones record was another milestone recording: **Honky Tonk Women** was released on Friday 4 July, the day before the band played their famous free concert in Hyde Park in front of 250,000 people. The Stones were rusty, were far from their best, the sound was awful, and some even said they were out of tune — but no one cared. It was that kind of a day.

Following Mick Jagger's appearance in the film "Ned Kelly", the Stones embarked on a tour of America in late 1969 during which the phrase, "the greatest rock 'n' roll band in the world" was first used. For the time this tour was huge as they played to over 335,000 people in 17 cities; it was the dawn of the modern-era Stones' touring juggernaut. The tour finished up with the infamous free concert in Altamont where the Stones could have been killed — either on stage or as they left the concert site in an overloaded helicopter. Synchronistically, the album that came out a few days before the Altamont concert was **Let It Bleed**, and it heralded a new recording era for the band. Although much of it was made during Brian's final months in the band, there is precious little of him to be heard on the final product.

A new decade and a new logo: the arrival of the Stones "tongue" — undoubtedly the most famous piece of branding in Rock, and arguably the world. By the summer of 1970 the band were back touring Europe, which is when Bent took his final few pictures of the band — for old times' sake.

To prove conclusively that they were the greatest Rock 'n' Roll band in the world, they released **Get Yer Ya-Ya's Out**, a live album recorded in Baltimore and New York on the 1969 tour of America. As The Beatles were breaking up, the Stones really began to find their true calling – but they decided to leave the country. High tax liabilities forced them to move to France in April 1971 following a short "farewell" tour of the UK. Their leaving present to the fans was **Brown Sugar**, a nasty, rampant and raw record that demonstrates everything that's best about the Stones. It was also the lead-off track from **Sticky Fingers**, their album that came out a week later.

Living in France meant that a new way of working had to be found. A studio was needed for recording. To make matters easier for Keith it was decided it should be in his house at Nellcôte on the French Riviera. It was a difficult time for all, made worse for those who didn't take drugs by the prodigious quantities consumed by those that did. The outcome of the long sessions that took place in the basement of Keith's home was, of course, the double album **Exile on Main St.** – the third in the triple bill of the band's finest albums, made up by **Let It Bleed** and **Sticky Fingers**. **Exile** came out in May 1972 and topped the album charts on both sides of the Atlantic.

The tour of North America that followed was massive, and demand for tickets meant that millions were denied the chance to see the band. The Stones by this point had gone from being big stars to Rock royalty, attracting everyone who was anyone to their concerts and backstage to their parties. It caused Bill Graham, their US promoter, to declare: "They are the biggest draw in the history of mankind." After touring Australasia and then Europe in 1973 they were back in America in 1975 playing even bigger shows to even more people. However, by this time they were without Mick Taylor who had quit for various reasons, but mostly because he didn't think he was getting the credit he deserved. His replacement was the former Face, Ron Wood, the Yang to Keith's Yin, although as often as not they were both either Yin or Yang, which presented some challenges. A European tour, bigger than anything that had preceded it, followed in 1976. Throughout this period the Stones continued releasing albums on which there were moments of magic but overall were less satisfying as a whole when compared with what they had released between 1969 and 1972; it is a trend that has continued to the present day.

The concert at Knebworth in 1976 was the biggest the band had played since Hyde Park – only this time people paid. This was followed by some

torrid times for Keith with the authorities over his drug-taking. It was another period from which the band was lucky to emerge relatively unscathed and intact. But emerge they did, touring America in 1978, albeit playing to slightly fewer people, on the back of **Miss You** – one of their biggest singles but the last to top the US singles chart.

As the Seventies became the Eighties, Mick and Keith embarked on solo projects, although it had been Bill who had led the field in this particular activity. The 1981 US tour was the band's biggest to date, playing to over two million people; similarly the European tour in 1982, their first for six years. For the rest of the Eighties the band went into "semi-retirement" brought about in part by some minor wrangles between Mick and Keith. When these were resolved, the band toured the World from August 1989 to August 1990 and it was inevitably the biggest tour to that point. This tour set the tone for what has become The Rolling Stones, although there was one difference – Bill decided he had other things to do with his life and left the band in 1993. Massive world tours, every few years, have followed, tours that seem to go on longer and gross more money than any band has ever done before. Certainly it's true to say that the Stones have played to more people in concert than any band in history. While their later albums have not generated the kind of sales that their earlier efforts used to do, the creative repackaging of their back catalogue in recent years has breathed new life into their CD sales.

One thought. We shall never see the likes of The Rolling Stones again – they are without doubt…

the once and future greatest rock 'n' roll band in the world.

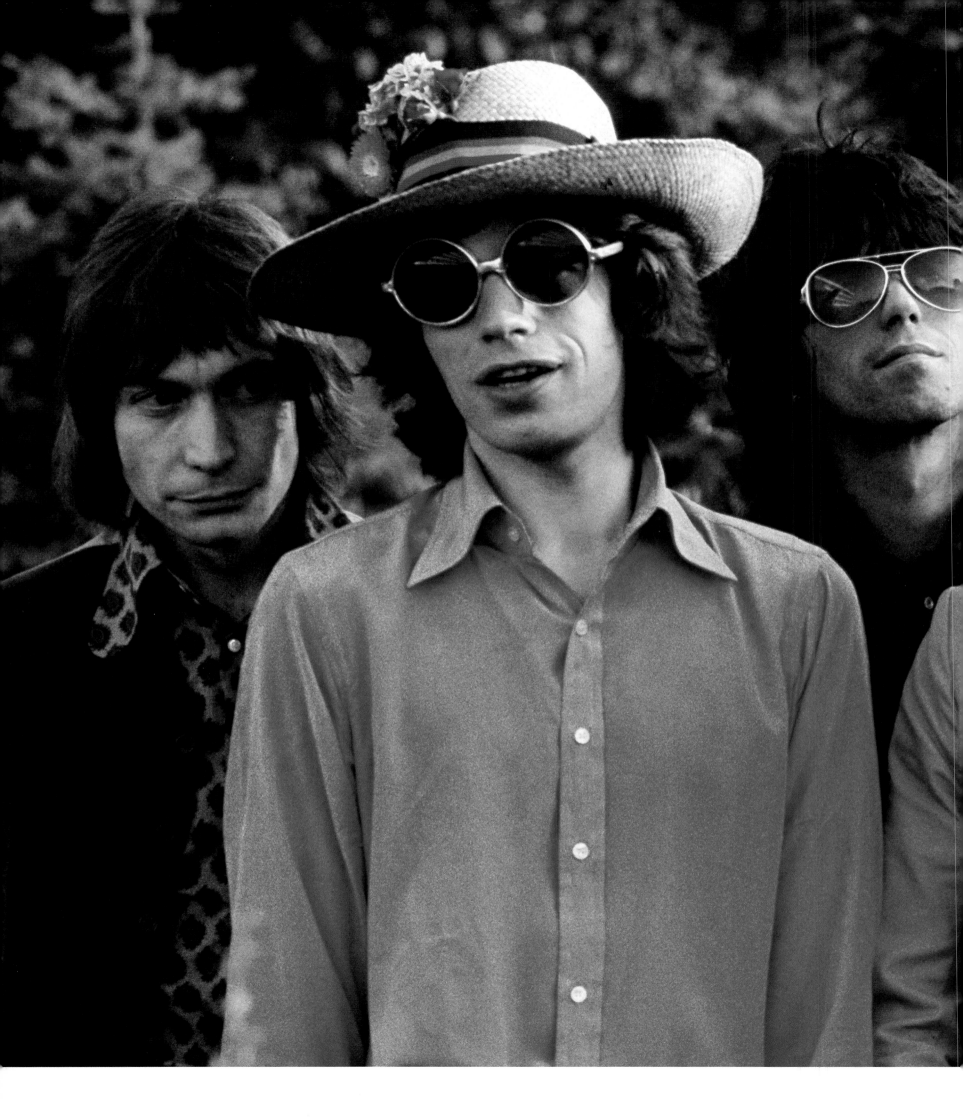

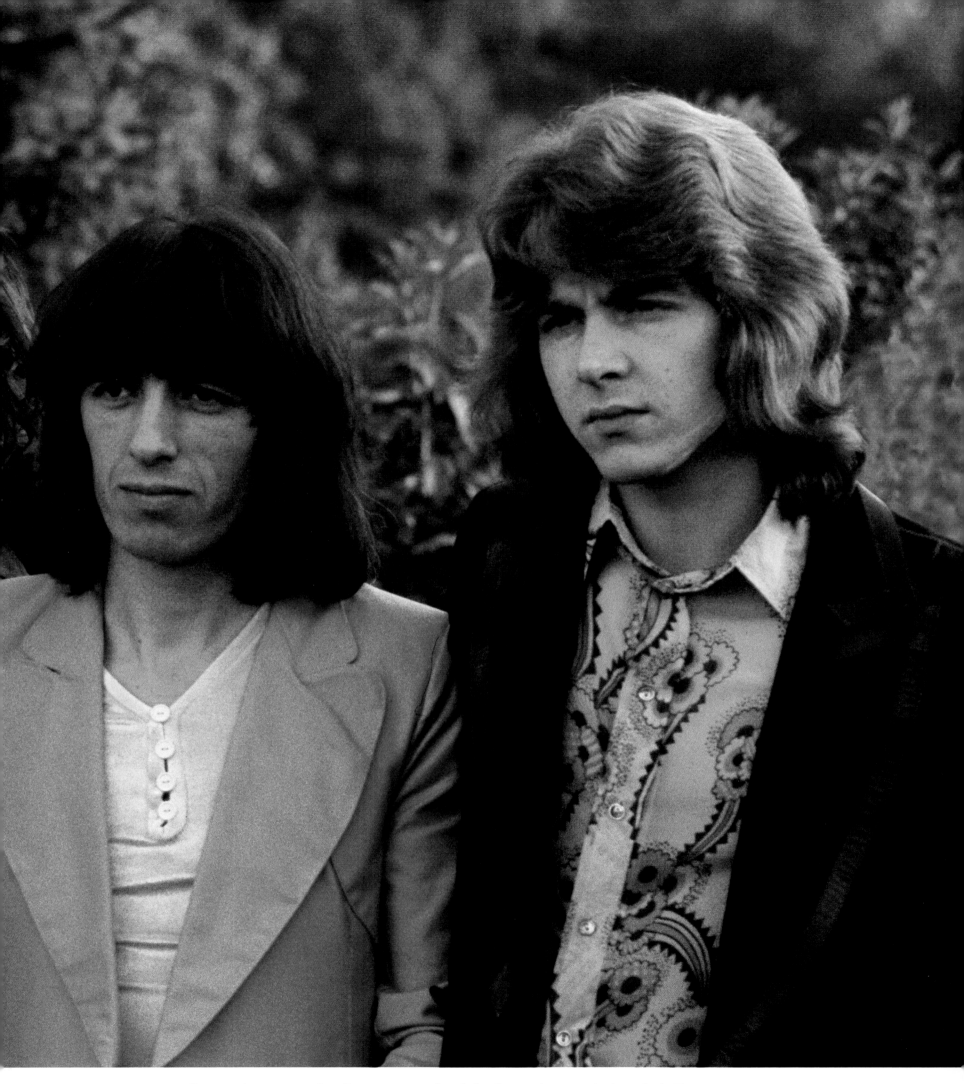

In September 1970 the Stones were back in Copenhagen during their European Tour. With them was Mick Taylor who had replaced Brian Jones in 1969.

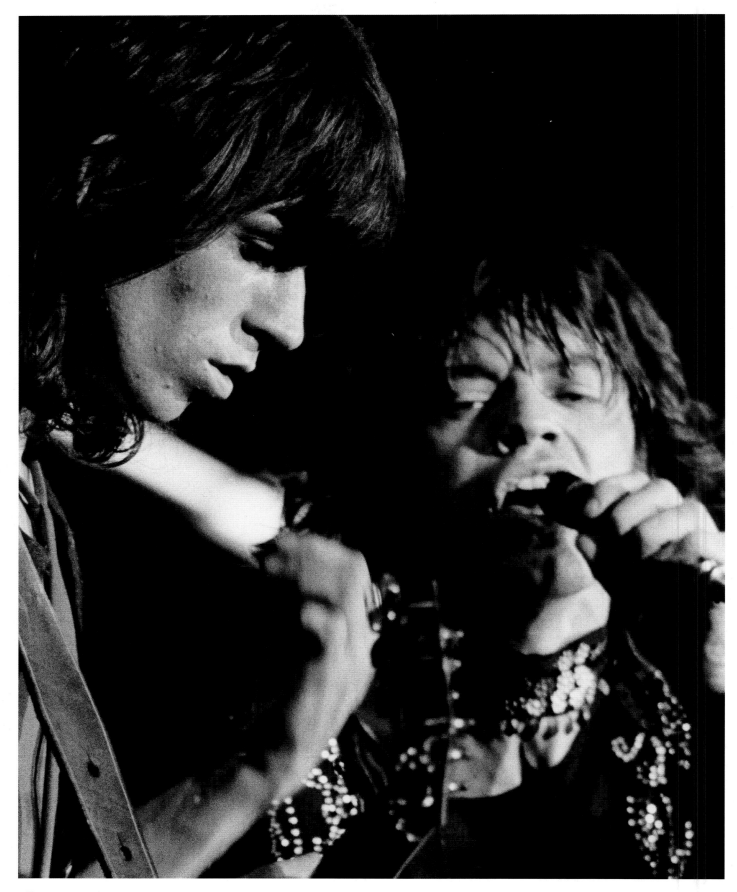

"For me their stage performances were more show, but less music, despite the fact that they played for longer! Taking these pictures was more for fun than business. What was obvious by 1970 was how much bigger everything was than when I toured with the Stones in the Sixties. Then there were eight or nine people in the touring party – four years later there were more than 50." BR

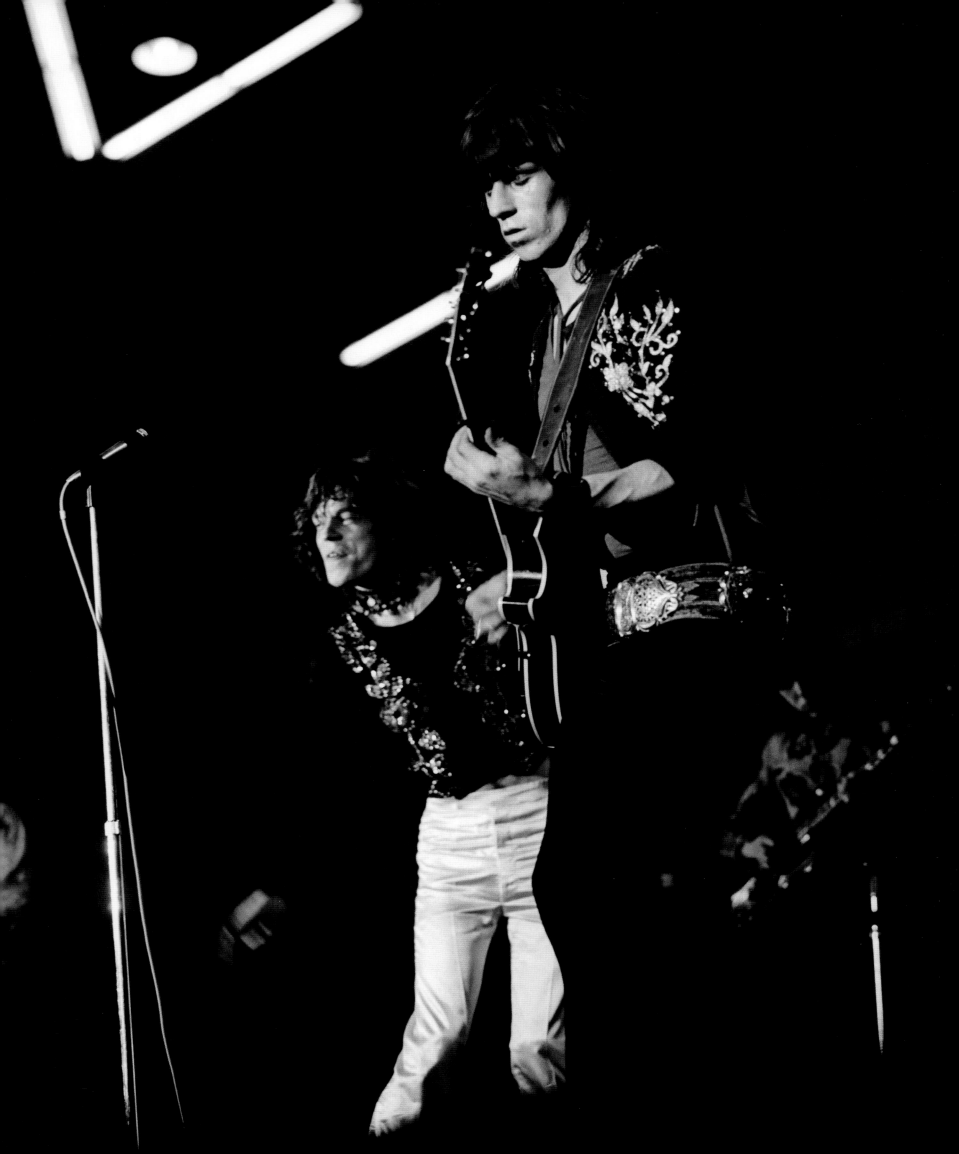

Set list:

Jumping Jack Flash

Roll Over Beethoven

Sympathy For The Devil

Stray Cat Blues

Love In Vain

Prodigal Son

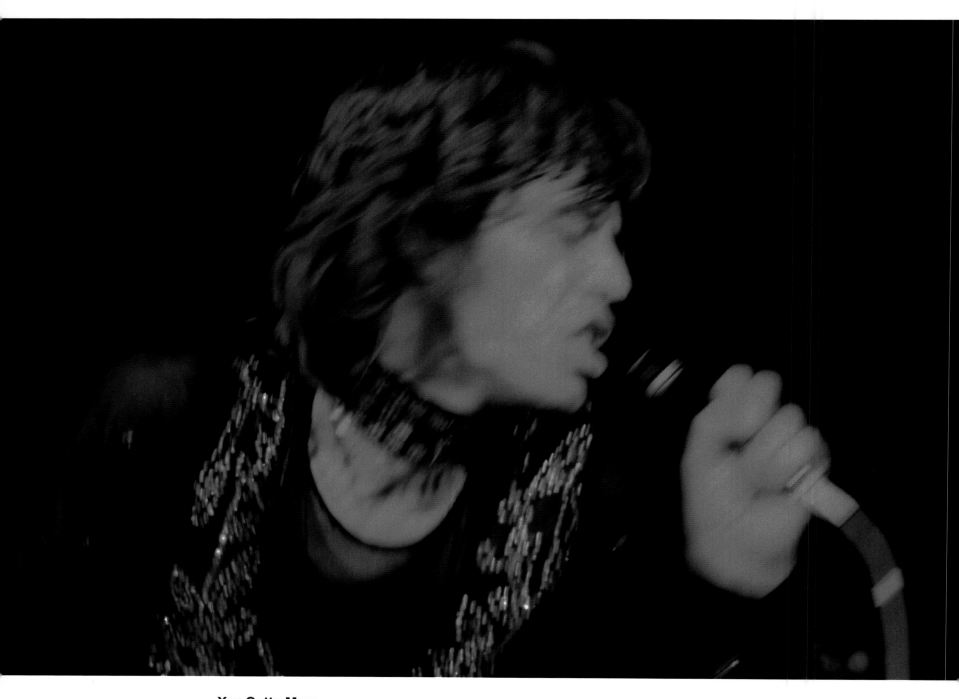

You Gotta Move

Dead Flowers

Midnight Rambler

Live With Me

Let It Rock

Little Queenie

Brown Sugar

Honky Tonk Women

Street Fighting Man

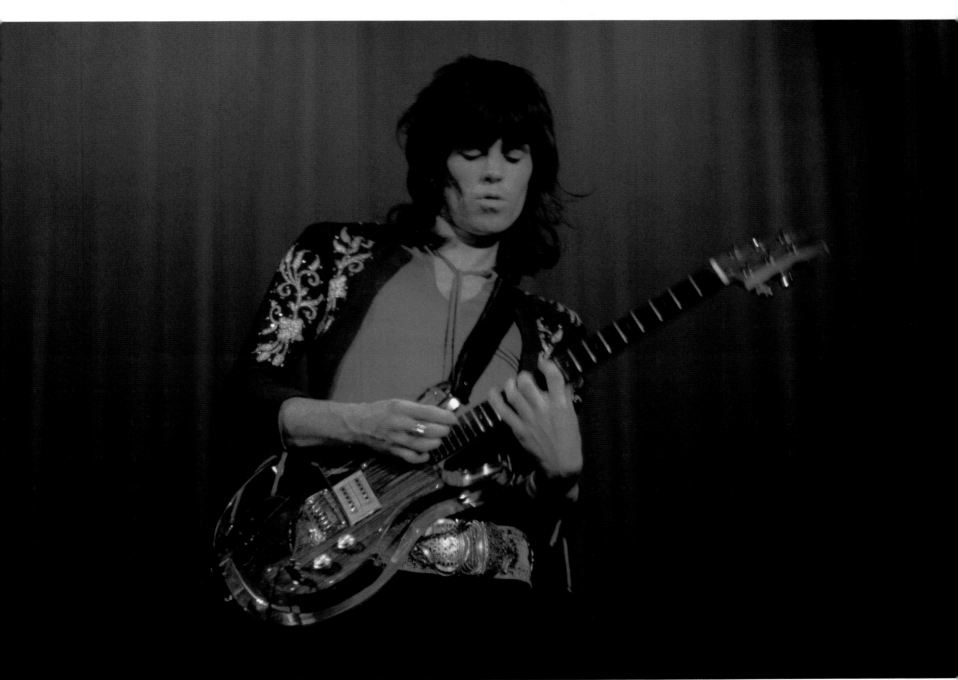

"For me as a photographer what I noticed most about their stage show was the lighting. In the 'good old days' of 1965–66 everything was much darker on stage, maybe because it was less well-lit they had to rely more upon their music. In 1970, the lighting lifted the show to a different, if not a better level. But this was just my view, the critics loved them, but then again that was perhaps because they were a new bunch of critics, people who had not seen them before." BR

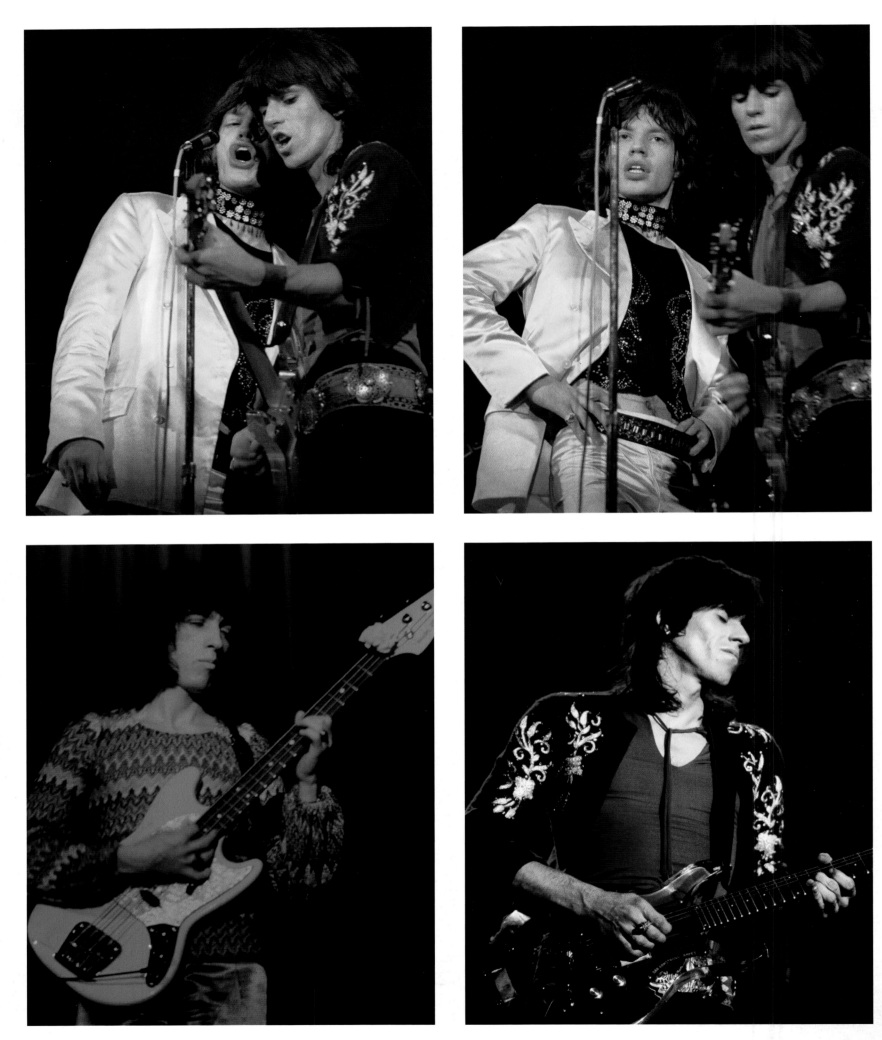

"By 1970, the Stones, and Mick in particular, got dressed up to perform; ironically it had been Brian that led the way in stage gear. The other thing that was different was the fact that there were no riots." BR

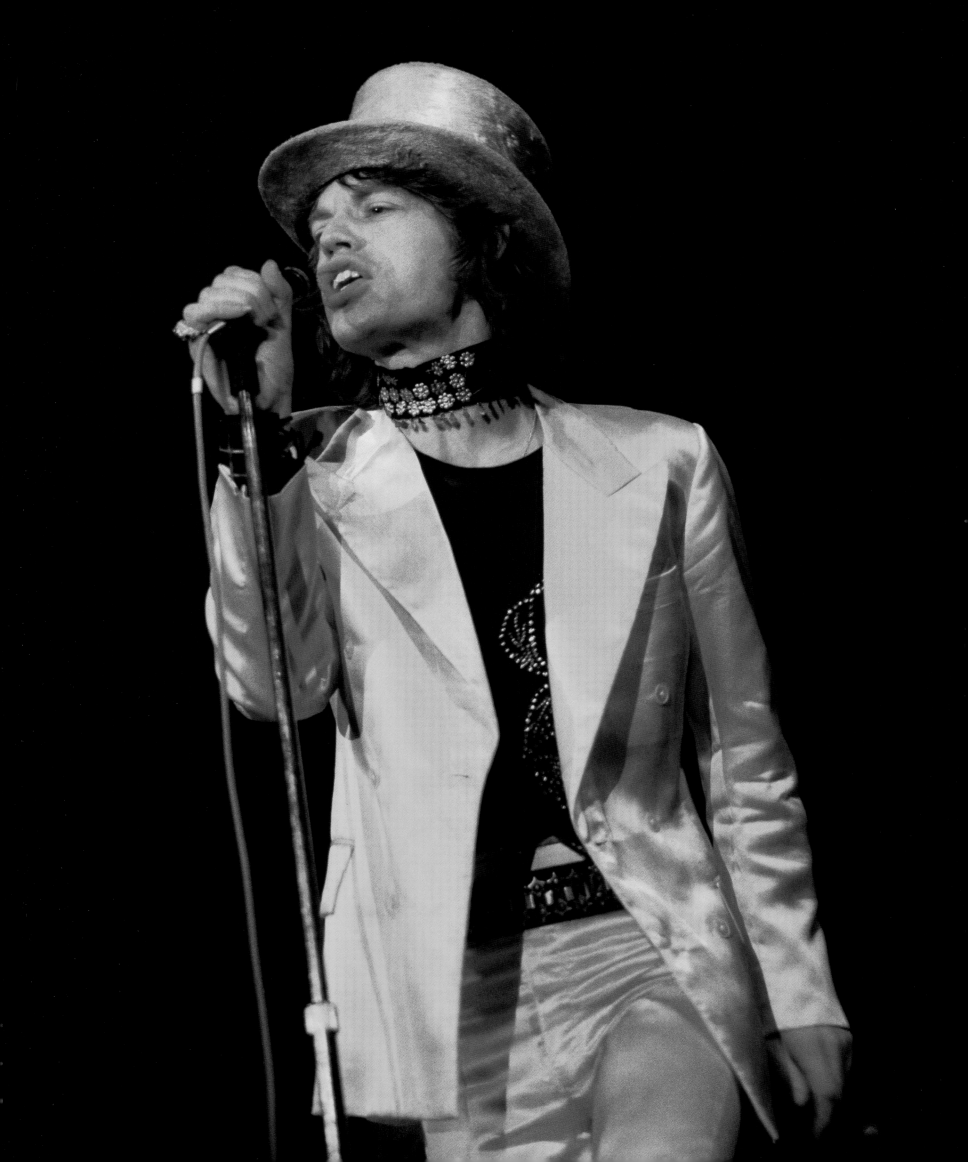

INDEX

It would be a futile and unhelpful undertaking to catalogue every appearance of the individual members of The Rolling Stones in this book, so what appears below is a selective listing designed to help the general reader to access the places, the events, and the personalities that appear in the story.

ACKNOWLEDGMENTS

First of all, I have to thank the Rolling Stones — Brian, Charlie, Bill, Keith, and Mick — for being around in the right place at the right time and for their cooperation in the Sixties. I never did get round at the time to thanking them for giving me such an unforgettable period in my life. Without them I would never have been able to do this book. Thank you! I hope you like it when you see it.

Thanks to Bill Wyman for his collaboration on this project; his Foreword, his comments, his memory, and his diaries have all helped to make this a more interesting book. To Richard Havers and his pen — who coordinated and put our pieces together. Also for his contribution to this book in general and for his enormous knowledge of the Stones, then and now (and for his love of good home cooking, which impressed my wife during his visit to the South of France).

Thanks also to Andrew Heritage for all his efforts in making this book happen, and for his final touches in editing and designing this book. And to Trevor Bounford for his work in coordinating the technical aspects of the design and layout.

Thanks to Andrew Loog Oldham for his time and for his guidance. Thank you to David Lamb and Tim Foster of Mitchell Beazley for giving us a free hand in designing this project and for having the vision. Thanks to Anders Stefanson and Niels Wenkens in helping me remember some of the times we spent together — in the good old days — and thanks to Rud Kofoed for coordinating this.

And to Thomas Furland for his brilliant work and patience with the scanning; Janne Martinussen, who ably assisted him. To Imacon/Hasselblad for lending us scanner equipment and giving us office space for this project — and free use of their canteen.

Thank you to Finn Bjerre for his massive contribution in selecting pictures and for designing this book (24 hours a day — sometimes). Without Finn it would not have happened.

To help me pace myself I have to thank my best friend Jan Duckert, who also forced me to play some golf in between work. Last, but not least, my wife Inge, my family and friends who encouraged me to go back into my archives and for being in the team that made this book happen.

Down memory lane

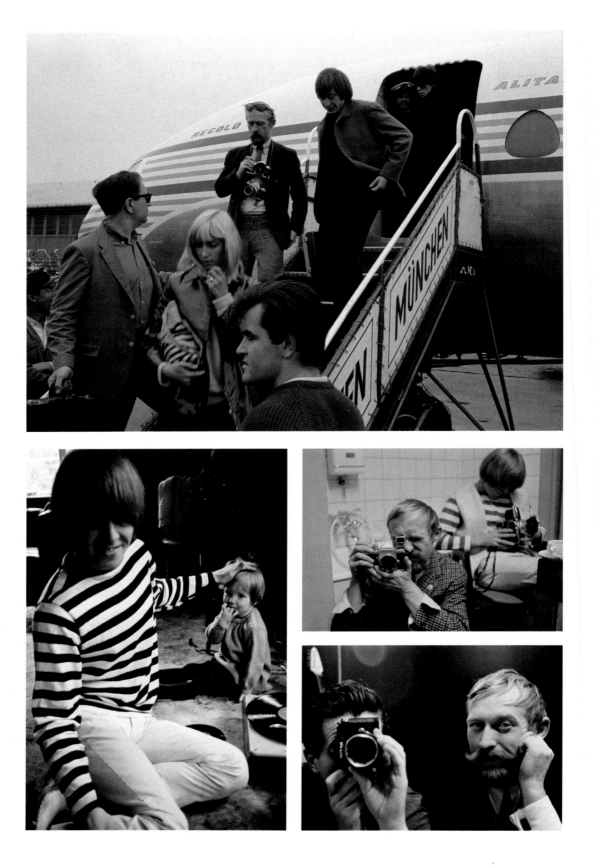

"I took literally thousands of pictures of the Stones during my short but fascinating journey with them in 1965–66. Looking back through my archive reminded me of the great days that I spent with the band." BR

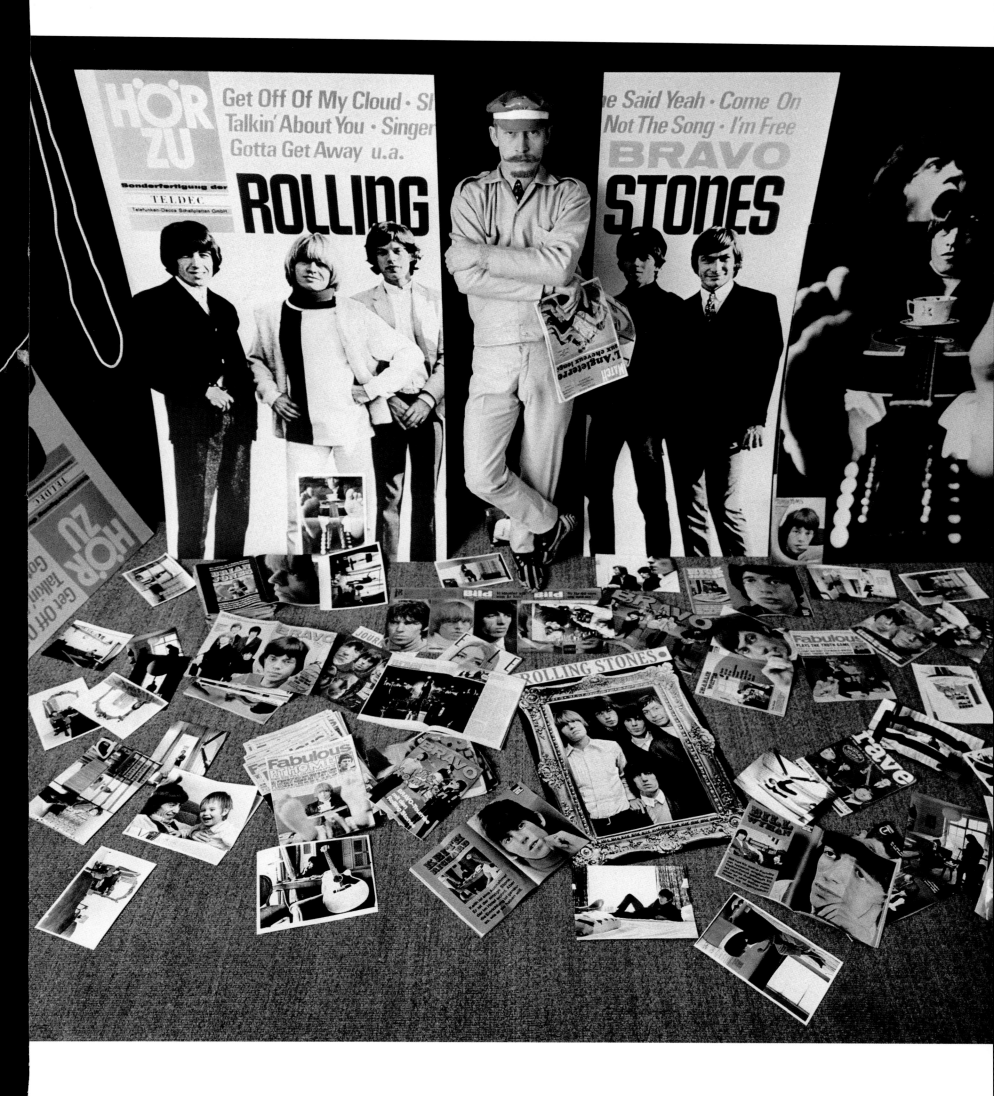

A FIREFLY BOOK

Published by Firefly Books Ltd. 2006

First published in Great Britain by Mitchell Beazley

First printing

Publisher Cataloging-in-Publication Data (U.S.)

Rej, Bent, 1940-
 The Rolling Stones : in the beginning / Bent Rej, foreword
by Bill Wyman [320] p. : photos. (chiefly col.) ; cm.
Includes index.
Summary: A collection of photographs of the Rolling Stones
that provides a unique record of the band before they became
icons of rock.
ISBN-13: 978-1-55407-230-9
ISBN-10: 1-55407-230-1
1. Rolling Stones — Pictorial works. 2. Rock musicians —
England — Portraits. I. Wyman, Bill. II. Title.
782.42166/ 092/ 2 dc22 ML421.R64.R44 2006

Library and Archives Canada Cataloguing in Publication

Rej, Bent, 1940-
 The Rolling Stones : in the beginning / Bent Rej ; foreword
by Bill Wyman.

ISBN-13: 978-1-55407-230-9
ISBN-10: 1-55407-230-1

 1. Rolling Stones—Pictorial works. 2. Rock musicians—
England—Portraits. I. Title.

ML421.R64R38 2006 782.42166'092'2 C2006-
902244-5

Published in the United States by
Firefly Books (U.S.) Inc.
P.O. Box 1338, Ellicott Station
Buffalo, New York 14205

Published in Canada by
Firefly Books Ltd.
66 Leek Crescent
Richmond Hill, Ontario L4B 1H1

Color reproduction by Sang Choy, Singapore

Printed and bound in Italy by Lego S.p.A

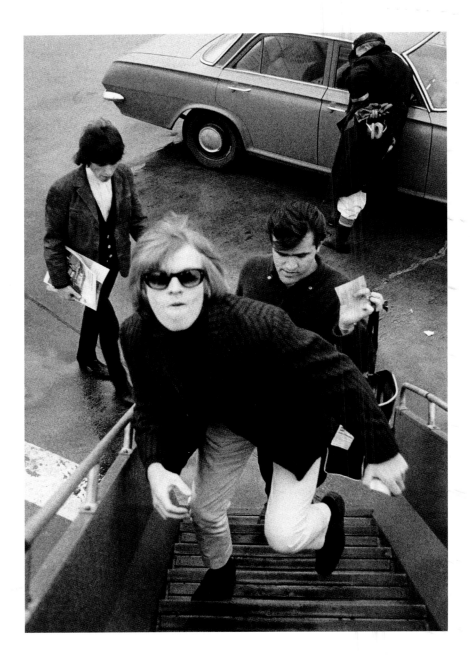

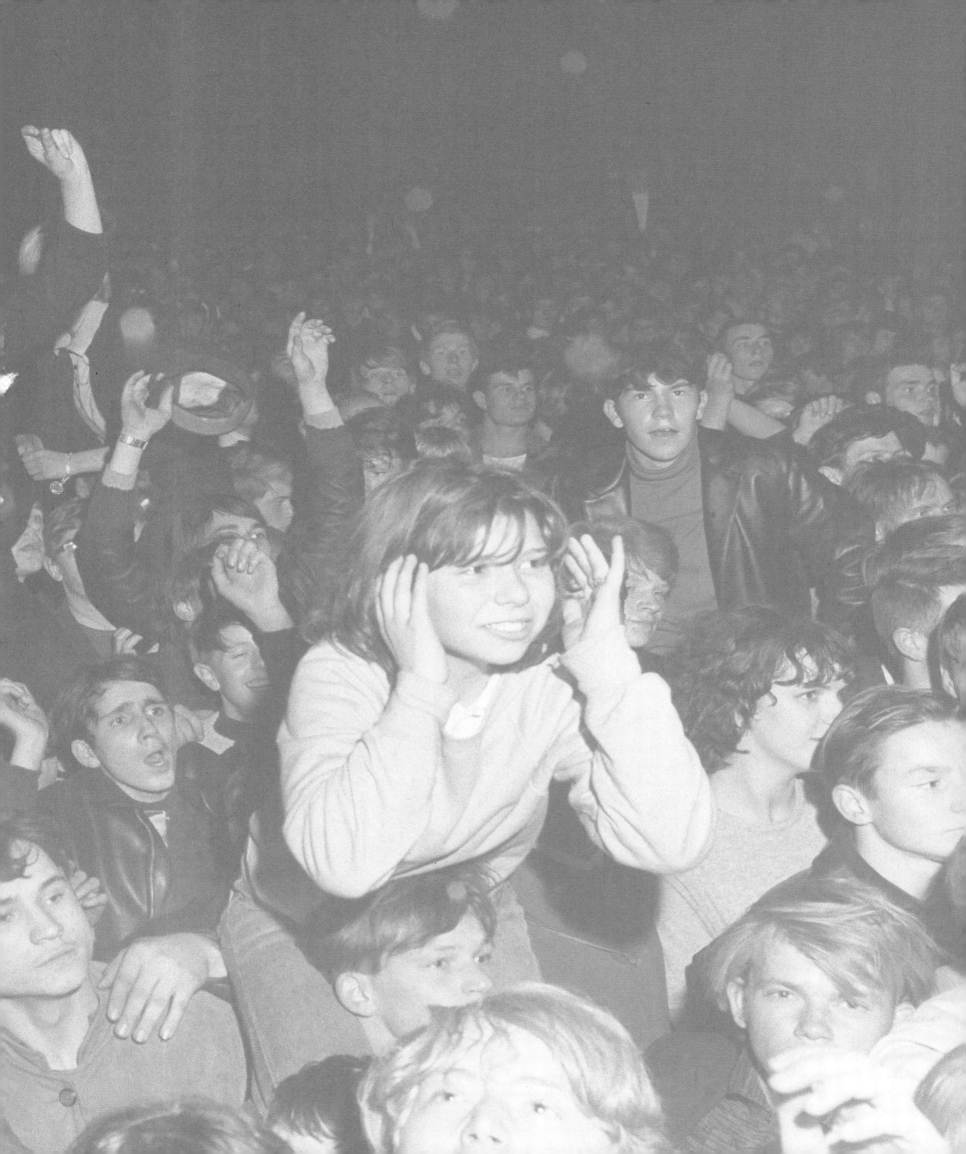